A BIRD DANCE
NEAR SATURDAY CITY

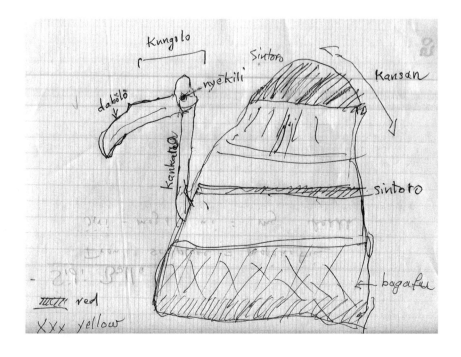

AFRICAN EXPRESSIVE CULTURES

Patrick McNaughton, editor

Associate editors

Catherine M. Cole
Barbara G. Hoffman
Eileen Julien
Kassim Kone
D. A. Masolo
Elisha Renne
Zoë Strother

Drawing by Sidi Ballo, 1978

A BIRD DANCE
NEAR SATURDAY CITY

SIDI BALLO AND THE ART OF
WEST AFRICAN MASQUERADE

Patrick R. McNaughton

Indiana University Press
Bloomington and Indianapolis

This book is a publication of

Indiana University Press
601 North Morton Street
Bloomington, IN 47404-3797 USA

http://iupress.indiana.edu

Telephone orders 800-842-6796
Fax orders 812-855-7931
Orders by e-mail iuporder@indiana.edu

The paper used in this publication meets the minimum requirements of American National Standard for Information Sciences—Permanence of Paper for Printed Library Materials, ANSI Z39.48-1984.

Manufactured in the United States of America

Library of Congress Cataloging-in-Publication Data

McNaughton, Patrick R.
 A bird dance near Saturday City : Sidi Ballo and the art of West African masquerade / Patrick McNaughton.
 p. cm.—(African expressive cultures)
 Includes bibliographical references and index.
 ISBN-13: 978-0-253-35148-7 (cloth: alk. paper)
 ISBN-13: 978-0-253-21984-8 (pbk: alk. paper) 1. Mandingo (African people)—Africa, West—Social life and customs. 2. Folk dancing, Mandingo—Africa, West. 3. Africa, West—Social life and customs. 4. Ballo, Sidi. I. Title.
 DT474.6.M36M38 2008
 305.896'345—dc22 2007046931

1 2 3 4 5 13 12 11 10 09 08

For Nicholas McNaughton

CONTENTS

PART 4. MAKING MEANING WITH A BIRD

ACKNOWLEDGMENTS

People

This book bears huge debts to the fine research and generous discussion of many colleagues in Mande studies. Pascal James Imperato was an early writer on Mande performance. He spent five years from 1966 to 1971 as a medical doctor heading a smallpox eradicating program in the Republic of Mali. He became passionate about Malian art and writes about it in elegant detail. His research on the Mande youth association (1974, 1980) and Ci Wara (1972) performances are invaluable to performance studies, and he continues to publish on many facets of Mande art and culture. Over the years I have asked him innumerable questions, and he has always had wonderful answers. He has remained a steadfast friend, always offering generous support in the tangible and intangible ways that make individuals a joy to know.

Charles Bird's work with bards, especially the hunters' bard Seydou Camara (1974), has been important to several generations of Mande scholars and very important to me. He introduced me to Seydou, and during the many hours I spent in their company, I marveled at the dialogues between them that touched insightfully on virtually every aspect of the human condition. Both Seydou Camara and Charles Bird haunt this book.

Judy Mahy and James Brink studied Bamana youth association rural theater in the Beledugu region north of Bamako in 1975. Both have left academe, and African studies has lost much, because few ethnographers have been more thorough or sensitive. James continues to publish (1978, 1980, 1981, 1982, 2001), and Judy has shared her invaluable research notes with me. Both offer insights galore, and James has given us an invaluable understanding of the subtleties and social-embeddedness of Mande aesthetics.

Kassim Kone was hired by Jim and Judy in 1975 as a teenage research assistant, and from that time on, he has never stopped doing ethnography. He has one of the most supple and wide-ranging minds I know. His works on

word performance (1995a, b, and c) demonstrate the depth, subtlety, and complexity of thought and emotion that flow through the Mande arts, and they greatly enrich our understanding of meaning in Mande performance. Kassim has engaged me in continuous conversation on Mande philosophy, spirituality, social life, and artistry, for the past twenty years. We have spent at least one hundred hours talking about the power called *nyama* alone, and when we talk, his ideas and insights, examples and experiences, prod me to marvel at the wealth that is the human condition. Without Kassim this book would not exist. Furthermore, the gracious and delightful generosity of his entire family—from a place to stay to spectacular food to eat and enriching food for thought as well—all made the summer of 1998 one of the finest I have ever had.

John Hutchison's ideas about things Mande flowed through me when we first met some thirty-five years ago, and they flow through me still. Traveling with him in Mali in 1971 was always an elegant adventure, and reading his material on Mande language is an education on how sweet Mande culture can be. (*A ka di de!*)

Jerry Cashion started research in 1975 to the south in the Wasulu. He too bypassed academe, but his research on hunters, their bards, and bards' performances (1984) is intensely insightful. Seydou Camara once said that Jerry was so in touch with the power side of Mande that he was a true child of the Kòmò.

Kalilou Tera worked with me in Bloomington and Milwaukee in 1977, and in Mali in 1978. A linguist, he had long been a researcher for the Malian government, and his passion for talking to elders, juniors, and everyone in between made him a fountain of penetrating information. His ability to distinguish between different people's perspectives made his knowledge all the more helpful. With Sekuba Camara and me, he spent weeks transcribing the Dogoduman performance songs and examining their finer points of interpretation. He too ripples through the pages of this book. In addition, his family housed me during the summer of 1978, much to my grateful delight, and while he tape recorded the event, his good friend Mamadu Sangaré helped me take all the Dogoduman photographs.

At the same time there was Sekuba Camara, the son of Seydou Camara and therefore privy to one of the deep minds in Mande. Sekuba is an English teacher in the Bamako public schools, but he was also a frequent accompanist when his father performed and, in his own right, a very good player of the hunters' harp. Sekuba learned a great deal from his father and a great deal on his own, and he has a wonderful sense of performance's place and significance. His work on the performance songs made that very clear.

Seydou Camara himself was an unbelievable source of information and inspiration to everyone who knew him. Being around him was like being with an intensely energetic encyclopedia of knowledge about Mande. But knowl-

edge is constantly an affair of interpretation, and Seydou always had a variety of interpretations on any imaginable subject and plenty of critique on all of them. His work ethic and his passion for art were themselves immensely valuable learning experiences for me. But as a performing artist who thought profoundly about the world and infused his works with his ruminations, he permeates my own ideas and dwells throughout this book.

John Johnson came to Mali as I was departing for the first time; his family even stayed in my *banco* home. His work on epics, the bards who sing them, and the society they fuel (1986) has been instrumental, and Johnny has also been a frequent source of discussion and inspiration over the many years we have shared at Indiana University.

Kate Ezra came to Mali about the same time. She documented spiritual association performance, but her work on the conceptual subtleties and social affect of aesthetics (1986) has been especially important to me. She offers an antidote to the frequent assertion that African art differs fundamentally from that of the West.

Mary Jo Arnoldi began working on Segu area youth association puppet theater in 1978 and has offered scholarship a vast new tool kit of ways to see how subtle and refined African performance arts can be (1986, 1988a, 1988b, 1989, 1995, 1996, 2001). From conceiving and creating masquerades to performing them effectively, Mary Jo's work demonstrates the wealth, depth, and complexity of one of West Africa's most dynamic and popular art traditions, while shining valuable light on its social infrastructure. She sees as well as anyone could how art bonds with social, spiritual, political, and economic life, and she has always been willing to talk to me about it.

Barbara Hoffman started her dissertation research on Mande bards in 1984. Her deeply insightful work on the real lives of bards (1990, 1995, 1998, 2000) includes a subtle exploration of their activities in actual situations, along with the sometimes-surprising consequences. Barbara has always been able and anxious to help when I was passing sluggishly through ideas that needed a nimbler trajectory or when I was not sure of myself in the face of some perplexing issue or question. She is a poised and well-considered scholar with an elegant mind and feet set soundly on the ground.

Then there was Sedu Traore, the blacksmith to whom I was informally apprenticed and with whom I spent uncountable wonderful hours. His knowledge of smithing and sculpting was most extensive, as was his knowledge of herbal medicine, sorcery, and soothsaying. He was a very circumspect person, perceptive about and sensitive to the nuances of other peoples' situations, and he had given much thought to the nature of Mande culture and the roles of art, artists, and people generally. All this showed in his dealings with other people, and I benefited from these personal attributes every day that I was with him. He was my life for a year, and his persona has never left me. I can still hear him

laugh and see him smile. I think of him like I think of my own grandfather and feel forever blessed to have known him.

Finally, there was Sidi Ballo. A person so full of energy one rarely meets. A person so accomplished, so full of the fruits of tremendous labor and dedication, is a joy to know. A person so intelligent and socially perceptive is pure pleasure to be around. Sidi gave generously of his time in 1978 when I first met him, and he did it again in 1998 when Kassim Kone and I spent time with him. He even organized a bird masquerade in our honor on short notice, providing Kassim and me with one of our most enjoyable art experiences. Sidi Ballo is the kind of artist and person that people ought to know about.

Beyond Mande, I have gained much from numerous individuals through their writings or our interactions. Many recur frequently as footnotes throughout this text. Others appear much more sparingly or might be barely visible. And yet I have been infected by their ideas, even if I do not do them justice with my own. Prominent among these authors are Arjun Appadurai (1988, 1996); Anthony Kwame Appiah (1992); Andrew Apter (1992); Kelly Askew (2002); Michael Baxandall (1972, 1985); Jerome Bruner (1986); Michael Carrithers (1992); Robert Coles (1989); Warren D'Azevedo (1958, 1959, 1962, 1973a, 1973b, 1991); Margaret Thompson Drewal (1992); Johannes Fabian (1983, 1990); Anthony Giddens (1979, 1984); Henry Glassie (1989, 1993, 1997, and a great many fine conversations); Nelson Goodman (1978, 1984); Michael Jackson (1989, 1996); Mark Johnson (1987); Ivan Karp (1980, 1986, 1987, 2000); Corinne Kratz (1994, 2000); D. A. Masolo (1994, 2000); William P. Murphy (1990, 1998); J. H. Kwabena Nketia (1988); John Nunley (1988); Paul Stoller (1989); and Janet Wolff (1981, 1983).

Robert Farris Thompson must be singled out as a constant inspiration. He has shown how critical artists are in the larger scheme of social and cultural life, and how important individuals are to art. His view of art's place in society is supple and full-bodied. His view of art history is pioneering and is worthy of the attention of anyone who wants to understand humans engaged in expressive culture. He has been my advisor and very much more.

Clarke Speed also receives deep gratitude. For years when I struggled to understand the complex dynamics of society at work, he patiently offered dialogue and insights that constantly helped to make things clearer. Clarke is always delighted with the play of ideas, and everyone should have someone like him to talk to.

Zoë Strother has been equally inspirational. Her sense of how people create and play with artworks, and use them as social instruments to maneuver through life has been an endless encouragement to me. So have her generosity, support, and friendship. I have turned to her frequently when I wondered if the directions I was headed were reasonable, and she has never failed to offer rich and thorough nourishment. The same is true of Daniel Reed, from the vantage point of popular and spiritual music; of John Hanson, for his understanding of religion, spirituality, and history; and of

Samuel Obeng, for his ability to feel the music we think about and think about the music we feel.

I have also benefited greatly from conversations with rising young scholars in the graduate program here at Indiana University. John Akare Aden and Heather Maxwell have frequently refreshed my view of Mande people and institutions. Tavy Aherne, Abigail Amols, Kathleen Bickford Berzock, Jeremy Brooke, Alice Burmeister, Amanda Carlson, Paul Davis, Karla Dennis, John Frazier, Rebecca Green, Suzanne Gott, Joanna Grabski, Jessica Hurd, Kitty Alice Johnson, Candace Keller, Baqie Muhammad, Elizabeth Perrill, Keith Romaine, Vicki Rovine, Teri Sowell, and Cullen Strawn have incessantly aided me in my attempts to make a sensible stab at the character of form and aesthetics. They have encouraged and empowered me with analysis and insights not common even among more tried and tested scholars.

Dee Mortensen has been an invaluable editor. She works extremely hard and wisely, helping us authors make our writing more accessible and more pointed, more affective and memorable. She sees the large and the small simultaneously, and her vision of what a work can be has helped me clarify and refine my own vision. My grateful thanks extend as well to the anonymous reader whose kind words and excellent suggestions are very much appreciated. And most assuredly I must thank Fenella Finn, who worked over an earlier draft and offered me much kind assistance.

Julie Copeland read a very early draft of this book, and although she would not recognize it now, she nevertheless encouraged me when I needed it. My oldest college friend, Larry Dupont, must appear here too. He read the first serious thing I ever wrote and showed me that writing could project experience and, like performance, have some affect on people. Larry has been sharing aesthetic experience with me ever since. Elizabeth Yoder read this work's last draft with great benefit to me. Her tireless attention to detail could not have been more welcome.

And then there is Diane Pelrine. As an accomplished author herself, her clear-headed thinking and writing are constant models not easy to match. Her ideas about African art and the quiet, sophisticated delight she takes in it are always in my mind. Her critique has never failed to challenge me, and I would not trade her support for anything. I thank her for all that and more. Everyone should have a companion like her. I also thank my three children, Jesse, Nick, and Meredith, who fill their lives with hard tasks and challenges and then face them with work, determination, sensitivity, and intelligence. My children offer inspiration I would like to live up to.

Institutions

The government of the Republic of Mali along with the nation's people offer wonderful hospitality and tremendous support to researchers on art and

culture. In 1978 Alpha Oumar Konaré, an archaeologist, was Director of the Institut des Sciences Humaines in the Ministère de l'Education Nationale. Later, he was elected President of Mali for two terms (1992–2002). He, along with Samuel Sidibé, Director of the Musée Nationale du Mali, and Téréba Togola, former Director of Arts and Culture and Head of the Archaeology Department at the Institut des Sciences Humaines (now, sadly, deceased), along with their staffs, are just three outstanding examples of the kind of leadership, scholarship, and dedication that continue to make Mali a haven of academic productivity. With a deep sense of respect and gratitude I wish to thank them all.

When Indiana University's African Studies Program joined with the Teaching and Learning Technologies Laboratory for a long-term project in the late 1990s, the product was *Five Windows into Africa,* a CD-ROM exploring a spectrum of African artistic, social, and political landscapes. Directing that project fell to me, and I was given the opportunity to contribute my own section, which became my first serious exploration of Sidi Ballo's Dogoduman performance and the catalyst that led to this book. I am very grateful to Raymond Smith (associate vice chancellor), David Goodrum (lab director), Dan Fitzsimmons (lab point man for the project), John Frazier (my hardworking assistant), Dee Mortensen (our editor and IU Press liaison), and the entire staff of the IU Teaching and Learning Technologies laboratory for the incredible work they did on that project.

Other institutions have also helped me greatly. The National Endowment for the Humanities gave me a grant for a different project that ended by thrusting me into this one. Earlier work on a John Simon Guggenheim Fellowship and a Smithsonian Senior Post-Doctoral Fellowship was extremely beneficial. Here at home Indiana University gave me a sabbatical at a most opportune time, and I received a Grant-in-Aid of Research from the Office for the Vice Provost of Research. Indiana University administrators have proved to be able and generous facilitators. Over several years, Ken Gros Louis and Mort Lowengrub were very helpful, and Bruce Cole was a resourceful supporter. Patrick O'Meara, Vice President for International Affairs, has been a longtime supporter. Most recently, Bennett Bertenthal, Dean of the College of Arts and Sciences, and Annie Lang, Associate Dean for Research, offered timely and crucial financial assistance.

Performance

I want to end these acknowledgments with the recognition of my debt to African performance studies. In 1978 I happened upon performance—backing into Dogoduman from Saturday City—without realizing how fine a vehicle it could be for contemplating the independence and co-dependence that individuals manifest in societies. Four years earlier, Robert Farris Thompson had opened his groundbreaking *African Art in Motion* (1974, xii) by noting the

power of deliberate movement. He said that "dancing" the artful things people make—that is, animating objects by setting them in artistic motion—amplified their dynamic presence into energy akin to aliveness, uniting the inner being and essence of, say, a masquerade or a calabash drum, with the inner being of the dancing drummer, the performing masquerader, and entire audiences. Thompson realized that motion, dance, and performance give visceral, embodied agency to what we now call expressive culture.

Also in 1974, Victor Turner published *Dramas, Fields, and Metaphors: Symbolic Action in Human Society*. He used theater and drama as metaphorical instruments to understand the conflicts, tensions, and resolutions he thought were triggered when people behaved outside social norms. Fifteen years earlier, Erving Goffman had published his famous little paperback, *The Presentation of Self in Everyday Life*. Using theatrical performance as a metaphor, he saw people's very participation in social activities as performed self-presentation, with rules established by society and success determined by individuals' expressive abilities. In 1977 Richard Bauman published *Verbal Art as Performance*. He directed the attention of folklore away from words as text to the delivery of words as artistic actions subject to local critique and capable of enhancing experience.

As a pregnant instance of coalescence with a growing interest in performance, social scientists and humanists began in the 1970s and 1980s to develop action or praxis theory. Its early formulations by such scholars as Bourdieu (1977, 1990), de Certeau (1984), and Giddens (1979, 1984) gave varying degrees of freedom to individuals but still championed a refreshing emphasis on action as the source of society and culture. Consequently, it became all the more appropriate to use performance as a broad and fluid concept that moved beyond an anchoring in actors with scripts on stages but retained an instrumental sense of human activity refracted through strategy and self-awareness as well as that quality of drama that is actually the recognition that even mundane things and happenings can be fraught with significance for individuals engaged with them. Thus a richer world revealed itself to researchers, with fruits that I have certainly benefited from and to which I have, I hope, contributed.

This richer world embraces both studies that directly explore performance and studies aimed more broadly at the performative. Often the two flow into each other as situations of everyday or ritual life reveal their load of tension and theatricality or as the people involved express a flair for enhanced artistic, dramatized behavior. The importance of this complex spectrum—from the performance of everyday life to formal performance—was acknowledged institutionally with the formulation of New York University's Department of Performance Studies in 1980.

Several overviews summarize the state of African performance studies. They range from concise (Askew 2002, 18–24; Olaniyan and Conteh-Morgan

2004, 108); to lengthy and problematizing (Drewal 1991); to a compendium of influential publications dating back to the 1970s (Harding 2002). Their publications on a wide range of performance issues and conceptualizations, along with the work of numerous other scholars working all over Africa already acknowledged above, have helped me greatly along my way.

Johannes Fabian (1990, 3–10; 1996, 247–67) has focused on moving the idea of performance from something being studied to a significant element in the exchange of information, specifically between local people and foreign researchers. Ethnographers have commonly acknowledged that their information comes from speaking, observing, and participating (along with statistical analyses). But information is also created as a collection of representations and interpretations from an elaborate ongoing juxtaposition of performances by all the parties involved in the elaborate act of communication.

A little thought will verify the reality of the dynamic, constitutive interacting that we call research. Dialogues are established that encompass gesture and speech, exposition and punctuation for effect, demonstrations and historical reenactments, along with the delivery of stories and proverbs, axioms and mores. Goffman's earlier idea about people performing themselves is very much at play here, as is an essential element in Michael Jackson's radical empiricist approach to anthropology (1989, especially 3–5). Jackson stakes strong claim on the consequential character of interaction between researchers and their collaborators, noting that their interrelationships are complex and so instrumental that they change all parties in the experience. That, he says, is where ethnography happens.

Such is the case when anyone interacts with anyone else. A kind of fusion transpires in which personalities and perspectives collide to form new ideas and experiences. And this brings us back to how performance has helped me represent individuals engaged in the intersubjective production of artistic and social realities. Events such as Sidi Ballo's discussions with me or his negotiations with townspeople to establish the parameters of a masquerade performance are not merely exchanges of information and procedures for achieving consensus. They are opportunities for individuals to deploy strategies of self-expression to help make their points and achieve their goals, which often extend beyond immediate situations to broader horizons of staked-out social space. In addition, this fusion is neither linear nor predictable, so the drama of unexpected happenings and happenstances augments the panoply of excitement, contradiction, contestation, manipulation, and negotiation that lend spice to all human endeavor.

Formal performances are prominent in many African cultures, from theater freighted with lush entertainment to social procedures and spiritual ceremonies charged with intense significance and consequence. But the scripted side of these proceedings is only part of their reality, because the performances

are manifest through nuanced and dynamic mutual engagement of performers with each other and their audiences. And beyond these canonized events are the happenings of everyday life, which possess their share of consequence and no small portion of performative enactment. All of this is what I backed into when I walked from Saturday City to watch a bird dance at Dogoduman.

This elaboration of heartfelt thanks proves how enmeshed I am in spheres beyond myself. And yet my experiences and perspectives have led me to produce a book that no doubt differs substantially from works that other scholars would write. I apologize to readers whose interests I have not satisfied and hope they will write about them. I hope too that many more books on accomplished African artists will appear to fill in the gaps I have left and to examine the issues I have managed to ignore. Westerners frequently know something about artists who have become famous for what they made or how they acted—Western artists such as Warhol, Michelangelo, Christo, and so many more. These accomplished persons deserve their place in history. We learn things about our worlds and ourselves by thinking about them and their creations. The same is true for African artists such as Sidi Ballo, Seydou Camara, Sedu Traore, and a quiet army of socially relevant expressive virtuosos unified in museums and publications all around the world by the woefully inappropriate phrase "anonymous artist." People in the West as well as in Africa deserve to know about them. I hope the time to make that possible is now. If this work contributes to that goal, it is thanks to all the people I gratefully acknowledge here.

NOTE TO READERS

In Bamarakan the plural is formed by
adding "w" to the end of a word.

A BIRD DANCE
NEAR SATURDAY CITY

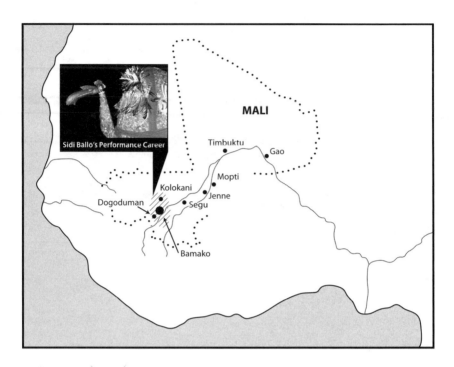

General area of Sidi Ballo's artistic activity

INTRODUCTION

AN EXPLOSION OF ART
AT DOGODUMAN

This book was inspired by a bird dance (*kònò don*), a masquerade held one June night in 1978. It remains the most spectacular performance I have ever seen—in fact, the most compelling art experience I have ever had. It resides in my mind as an explosion of art.

It took place in Dogoduman, "Sweet Little City," a small farming town that was the client community of Sibiridugu, "Saturday City," a blacksmiths' hamlet where I was doing research. There were numerous participants, virtually all of whom were talented and were a great pleasure to see and hear. Several, such as the young lady singers with calabash drums; the senior singer, Mayimuna; the lead drummer, Sori Jabaatè; and the young masked dancers, were first-rate performers who added tremendously to the event. But the featured masquerader was Sidi Ballo, and he was the kind of artist one never forgets. The expertise and experience he articulated into performance was majestic, laden to overflowing with aesthetic acumen, ideas about the Mande world, and fuel for the imagination, a powerful synergistic conglomeration of fluid and sometimes illusive qualities that I will later describe more fully as *affect*. The event and Sidi Ballo's affecting performance in it began for me a journey of contemplation that has led to this book, some thirty years later.

I had seen birds dance before, as masquerade characters in youth association performances. I knew they were popular (see plate 1). And I knew a little

about how birds are conceptualized in Mande popular imagination. Appreciated for their soaring prowess and hunting abilities, they are also considered to be beautifully voiced, sometimes full of sorcery, and sometimes focal points of soothsaying practices. My friend Abdulaye Sissoko once brought a wild owl home, intrigued by its eerie beauty and knowing it would cause a stir—even consternation—because it would be viewed as loaded with unmanaged supernatural power and therefore unthinkable in someone's house. Near the town of Markala I once came upon some riverside blacksmiths who could watch the Niger flow by as they worked. Right on the bank sat a hippopotamus skull to which a pelican was tethered on a very long leash that ended in an iron ring fastened around its neck. Periodically, the pelican leaped into the river and caught a surprisingly large fish in its huge beak. It did this smoothly and gracefully, with so much economy of motion that it looked easy. Small fish it could swallow, but the large ones would not pass the iron ring, so the blacksmiths were fishermen by proxy. Whenever the bird caught a big fish, its prowess was praised from the shore.

Magnificent and awesome, birds can serve as measures of the world. They abound in Mande proverbs, axioms, and stories, and they are characters or story line features in the musical epics so famously performed by bards and hunters' bards. Birds have a major presence in youth association performance, being articulated into numerous masquerade characters. And in fact, people all around the Mande heartland—including Baga, Nalu, Sosso, Senufo, Dogon, and numerous Voltaic communities and then all the way east into Niger and Nigeria—shape bird imagery into a marvelous wealth of sculpture types.

I knew all this before I saw Sidi Ballo's bird dance at Dogoduman. But I did not know that he had chosen bird dancing because the design of the masquerade makes it extremely challenging to manage and to manipulate into a fine performance. I did not realize that powerful amulets and supernatural energy would contribute to the performance's shape. And I certainly did not know how compelling, how consuming, that night near Saturday City would be.

That night at Dogoduman I heard fine drumming and captivating singing in patterns of call and response, tension and release, clarifying temporal structures and complicating solo riffs. All of it was delightful and part of a complex musical tradition I had experienced many times before. And all of it vibrated with the fluid texture of variation that personal skill and predilection brought to Mande music by individual players.

That night I saw lovely carved and painted masks worn by young performers in simple white country cotton pants and shirts, embellished with massive bands of lengthy fringe dyed in bold stripes of constantly moving color. The fringes were rusty red and aqua. The masks were radiant fire engine red and silvery blue that sometimes shimmered into iridescent white. The dancers made these colors into kaleidoscopes of excitement, sometimes via cacopho-

nies of energized and nearly acrobatic movement, other times via fluid and stately motions and gestures that created the impression that these were accomplished young dancers.

Also that night I saw a cloth-covered cone of pulsing energy, shaped like many Mande masquerades, with a long sleeve emerging from the middle and ending in a splendid red and black carved bird's head—the masquerade of Sidi Ballo. The cloth featured little red and white flowers budding up out of a variegated field of blue, and the whole cone was banded in thick clumps of vulture feathers, strands of luscious red ribbon, and a long fringe of white fibers dyed a lusty red at the bottom. This lovely construction glided or cascaded about the dance arena, sometimes flowing like quicksilver, sometimes speeding, shaking, and pitching like an out-of-control train, and sometimes settling to calm but mysterious stops, as if an immense amount of electricity had just been rendered tranquil but was about to spark again. The feats that this cone of cloth performed, the maneuvers and patterns the carved head described in the air, all jelled into an orchestrated performance so potent that it caught me up and deposited me in an art history paradise. It was a masterful evening.

Sidi Ballo and his Dogoduman performance made me grapple with the social, spiritual, and aesthetic power that good art carries into people, and with the qualities and capabilities of individuals that make them distinctive in life and art, no matter how intertwined they are with the social world that fuels them. It made me think about how the differences between people contribute to the construction of meaning and value, and how the strategic use of aesthetics affects people in ways that can be profound. That is what this book is about: a galvanizing masquerade event, its star performer, the ideas and other people with whom he created the event, and the ramifications of all that for the study of individuality, aesthetics, and the making of meaning and value.

While studies of African art have accomplished many fine things, the roles of individuals and the creative vitality and social relevance of aesthetics have not yet received their share of attention. The value of individuals might seem quite different from the importance of aesthetics, but in fact they are a natural match, because aesthetics comes alive through individuals, and performance is a galvanizing context in which to watch that happen.

This book is both an expression of my personal Mande experiences and a scholarly study. I have tried to garner a sense of how people might generalize about their own culture and their lives. I have earnestly sought to glean a fair characterization of the concepts and principles, the beliefs and values they use in their social and personal lives. But people do not fold into and out of their culture in the same ways. Varied arrays of experience puddle around them, to be taken up and crafted into lives by personalities quite remarkably different. Like nature, culture is in constant flux, and everyone's position in it sparks new perspectives that intertwine and meld, clash and repel, in a perpetual motion of

predictability and wonder. The notion that generalizations can emerge from so protean an atmosphere is not absurd. Our similarities amidst difference make it plausible to seek them. But the seeking finds fruition in the interactions between people, and those trillions of instances are nothing less than moments of creation. Ethnography is a paradox. But exploring experience among people and their art is a worthy venture no matter how contradictory it seems to be.

My experiences with Mande people and things slip into the foreground from between the words I use, and I am happy with that. I want you, the reader, to know how people and art have played over me. To the degree that this book gives you ideas about me, I become a kind of bellwether. In the tone and flow of the text that follows, you will see how Mande has affected at least one Western person, and I hope you will find that useful. A point on which this work balances is the deployment of aesthetics by talented people to produce affect, and I hope the effect Mande has created in me is obvious for readers to see.

This is also a book about art. But you might wonder, on many pages, where art has gone. We are used to thinking that artworks are largely visual entities, with enough associated information about culture and society to animate them. But if you consider how you experience artistry in your own world, you know there are no easy boundaries where relevance ends and the workaday begins. Art is glued to experiences that may extend so far into the mechanics of society that a modest interpretation of Panofsky's *Iconology* cannot carry us to enlightenment.

Art slides into life, so both must be known to understand either. This bird dance, with its multitude of performers, its secondary characters, and its songs that troll through history and everyday life, warrants broad swaths of Mande thought and practice to give a sense of its potential value and its fuel for contemplation to members of that Dogoduman audience. The very nature of perception demands it. Furthermore, to understand the accomplishment of Sidi Ballo, it is wise to know as much as possible about the constraints and resources he massaged into success. By rights I should have presented more, but my experiences have levied their own set of boundaries.

So a spectrum of topics awaits you. But weaving through them are the themes Sidi Ballo and Dogoduman compelled me to explore. First, individuals are important to the shape of art and social life. Even though they come together in groups, their uniqueness—too often short-changed or patronized in scholarship—is ultimately what forms society and gives rise to history, as well as giving meaning to a bird dance near Saturday City. I refer, not to the hollow fallacy of the suffering genius artist, but rather to the perspectives and capabilities of individuals that get shuffled into larger fields of play. Second, aesthetics have been treated too lightly for too long. They may engulf beauty and pleasure, but they are far more deeply cut into the tissue of our lives. They

reach into the core of our thought and behavior as effective strategies in the service of producing affect, which itself serves contemplation and action.

In a sense, the organization of what follows reflects the personal journey that began with a bird dance near Saturday City. The first part is about the Dogoduman performance: the artists it brought together and the ideas it engaged. The second part is about the event's featured performer, Sidi Ballo: his character and contributions as an individual and the value of individuals more generally in artistry and social life. The third part is about aesthetic power: the accomplishment and prowess of the Dogoduman performers, especially Sidi Ballo and Mayimuna, and the broader importance of aesthetics as elements of social dialogue that fuel thought and inspire action. The fourth part is about meaning: the ideas and values people might associate with a bird dance and the reasons individuals' associations can be so full of variety. These are the things I have struggled to understand since that spectacular night at Dogoduman when a performance planted its potential in me and never let me go.

GETTING UP TO SATURDAY CITY

Dogoduman and Saturday City, along with Sidi Ballo's home town of Tègèdo, were mostly Bamana (or Bambara) communities, making them part of that vast and fluid Mande language family and cultural zone centered in Mali and extending into many of West Africa's nearby nations. Mande societies feature prodigious histories of statecraft and business; rich blends of local spiritual practices and Islam; powerful traditions of herbal medicine, soothsaying, and sorcery; and extensive, sophisticated genres of music, proverbs, poetry, stories, performed heroic epics, and visual arts. As is typical of African societies, there is much inter-ethnic activity and blurring of boundaries. Numerous Mande lineages are associated with multiple ethnic groups. Within the enormous area considered largely Mande, there are also many residents from other ethnic groups, such as Fula, Dogon, Minianka, Songhai, Senufo, and several Voltaic language–speaking groups. This multiethnic and cultural fluidity is the logical expression of a complex entrepreneurial history that featured many great states and empires; impressive and opportunistic commerce networks and infrastructures; sophisticated farming, cattle-herding, and hunting and fishing practices; and advanced iron, brass, gold, and terra cotta technologies. From this cauldron of complex and multifaceted cultural activity the well-known Mande youth association (*ton*) arose as a wellspring of social pro-action and artistry. From the youth association came Sidi Ballo, whom I met on the Mande Plateau.

In June of 1978 I was spending much time up on the Mande Plateau, working with the blacksmith Sedu Traore, with whom I had been informally

apprenticed years before while doing dissertation research. Sedu now lived in the blacksmith's hamlet "Saturday City," Sibiridugu, near Dogoduman. These were lovely little communities nestled in the tall hills and rolling tablelands of the plateau just overlooking the great curve of the Niger River as it heads south toward the waterworks of Futa Jalon and Guinea. From Saturday City you could look down across huge expanses of cultivated fields and then see the big sweep of the river. Up above the Niger, the plateau flows north to become the vast plains of the Beledugu, "Land of Small Stones." Not too far west, two centuries ago, the famous Scottish explorer Mungo Park watched iron being smelted by local blacksmiths at the town of Kamalia.

In 1978, getting to Saturday City and Dogoduman was a delightful little excursion. You traveled west from Bamako along the road to Kita, stopping at Sebenikoro, "Under the Little Palm Tree," the first town outside the capital. From there you walked through farming fields along the base of the Plateau, enjoying spectacular views along the way. Ultimately, you ascended a cut in the hills on a steep stepping-stone path between huge boulders to a rocky ledge that regularly flooded over in the rainy season.

Another little path then took you through grass and scrub to a nearly sheer cliff face, across which you moved cautiously on minimal footholds that might not be recognized as a path by anyone but local residents. Some of those local residents loved to tell strangers about the dangerous lizards that haunted this place (poisonous, with tails that look like second heads), and the numerous poisonous snakes. Below was a pool, fed by a lovely waterfall and allegedly full of crocodiles. Such stories were good for deflecting the attention of overzealous big-city tax collectors.

Once atop this second range of hills you walked through a small oasis of wild space and overgrown garden plots. A stream ran gently toward the cliffs, catching itself up from time to time in quiet little eddies, where iridescent insects slid across the surface of the water. This was a beautiful sight, and an herbalist's delight, as Sedu Traore once told me. Here too Fula cattle could be found grazing on land leased from Mande residents.

The path then rose again, this time gently up to cultivated fields that rose and fell in an undulating landscape. Early in the mornings during the rainy season, the millet crop growing on either side of the path would be shrouded in mist. I remember finding on that path a modest conical pile of stones that Sedu Traore built to honor his deceased father, Sibiri (which means Saturday). A little further along was the blacksmiths' hamlet, Saturday City, built by Sibiri precisely on the site that afforded the best view of the Niger River, bending south to Guinea on the plains below. A half-mile further along was Dogoduman, where I would watch Sidi Ballo and listen to Mayimuna perform.

Things have changed considerably since then. A thriving and vibrant city in 1978, Bamako now bubbles over with the business of a bustling West Afri-

can capital. It has grown enormously, swallowing up landscape for many miles in every direction. Today the view from where Sibiridugu and Dogoduman used to nestle in country quietness includes a vast metropolis. I was told that the residents of Saturday City were moved down off the plateau shortly before the Traore government fell.

Individuals act and the world is transformed, and sometimes the acts that affect us most are complexly indirect. I doubt I would have met Sidi Ballo if not for Sedu Traore and his father. Sibiri Traore was an enterprising blacksmith who many decades ago had migrated south from the Beledugu plains to establish his own clientele. He could have lived in Dogoduman, where most of his work was, but he preferred to build a hamlet half a mile away, where he enjoyed that breathtaking view of the Niger River. Sibiri named his family hamlet after himself, Sibiridugu, "Saturday City." Mande people are sometimes given the name of the day they were born. Days have particular connotations, and Saturday's fate is that things that happen will often repeat themselves, for bad or for good. For me, Saturday City was very good, because I worked with Sedu Traore again, got to meet Sidi Ballo at Dogoduman, and then saw him perform again twenty years later in the Bamako suburb of Jalakoroni.

When Sibiri Traore passed away in the mid-1970s, Sedu was selected to head the extended family and its blacksmithing business. While not the eldest, he had an excellent reputation as a mediator of social affairs and as an herbal doctor, sorcerer, divination expert, and circumciser, all in addition to fine wood-carving and iron-working skills. These attributes were very useful in the family's professional relationships with their Dogoduman clients. Sedu was also quietly gregarious, contemplative, and very reasonable with other people, a good choice for family leader and also the kind of person with whom town chiefs and elders like to deal when seeking the necessary master blacksmith's approval for important community decisions. Thus, Sedu became head of his family and moved from a little town south of Bamako up to Saturday City.

That is why I was in Saturday City one June night when Sedu's nephews came rushing in to say that the renowned itinerant bird masquerader, Sidi Ballo, was negotiating with the elders and youth association leaders of Dogoduman to stage a performance the next night. At that time Sidi was living in Sikoroni, the founding suburb of Bamako. He frequently performed with the Sikoroni youth association masquerade theater but had already established himself as a popular and very successful itinerant bird masquerader. He was scheduled to perform for a wedding celebration two days hence in a town further out on the plateau. To get there he would pass right through Dogoduman, which meant the town could hire a performance at a more affordable fee. If I came to the meeting he was having with Dogoduman leaders, I could arrange to attend the performance.

At that meeting it was agreed that I would be able to "document" the performance with my friend and research colleague Kalilou Tera, and his best friend from Bamako, Mamadu Sangaré. Sangaré and I would photograph, and Kalilou would tape record the performance. I would provide a courtesy fee for the privilege, which made us paying customers just like the citizens of Dogoduman. Thus we three outsiders became the *fototalaw*, the "photo takers."

Since I had come to Mali to work with blacksmiths, I was not equipped to document a masquerade. Caught up in the opportunity but with no training and no time to think about it, there is a lot I did not do. The photographs were not always well lit or clear, and aspects of the performance, even several people who played important roles, did not end up on film or in my notes. I greatly regret, for example, that we got no shots of the elders' representative who took center stage and gave a speech, or of the blacksmiths who danced as a group when Mayimuna, the senior elder singer, sang their praises. I was able to get the drummers' names and the names of the senior women singers, but I did not get the names of the singers in the young ladies' chorus, or the master of ceremonies, or the smiths' and elders' representative.

For the most part, Sangaré shot black-and-white film and I shot color. I remained a rather stationary part of the audience except for when I was called out to dance. Sangaré moved around. Kalilou moved around too, with a tape recorder stuffed in a shoulder bag. Though our machine was of modest quality and several songs came out so faintly that they were not discernible, Kalilou was still able to pick up most of the proceedings. I think we came away with a reasonable record of the event. More importantly, I left Dogoduman late that night with an entirely new world swirling around in my head. One performance began a decades-long odyssey to come to grips with the power of individuals to manipulate the forms of their culture.

LIVING UP TO SIDI BALLO

The Dogoduman performance was a galvanizing event for me. I can still hear the crackling fire used to tune the drums, see the elegant young lady singers, and hear the cowrie shells cascading against the calabashes they swirled into the air as they sang. I can see the evening's master of ceremonies (*jamaladilala*) whistling dancers on and off the arena as he himself danced in a fine deck-of-cards factory cloth shirt. I can see stars filling the sky and young men in Ntomo-style masks performing with vigor and class. I hear the senior singer, Mayimuna, delivering her lines with delicate power and see her interacting center stage with the master masquerader. And I see, hear, and literally feel the bird returning again and again to the dance arena, making his conical costume do things I would not have thought possible and manipulating the carved

bird's head in numerous wondrous ways. All this resides vividly in my memory still, after some thirty years.

I had met Sidi Ballo the evening before, and I talked with him extensively after I wrote my description of the performance. My friends and colleagues, Kalilou Tera and Sekuba Camara, spent days with me transcribing the songs we had recorded at the performance and talking about the ideas and feelings many of the words and phrases evoked. I recorded with care the appearance and performance of Sidi Ballo's excellent apprentice, and I wrote up every movement Sidi Ballo made, expressing wonder even in my notes as I described the spectacular things he did.

By the end of that summer when I returned home, I wanted to share what I had seen in a way that would demonstrate its magnificence. The performance itself and many of its creators, such as Mayimuna and the young masked dancers, seemed so rich with grace and artistic potency. The fluid way the event unfolded seemed so well-conceived, as if each successive segment was designed to absorb the energy unleashed by the previous segment and channel it into new patterns of satisfying anticipation and release. The entire evening impressed itself upon me as a well-orchestrated kaleidoscope of emotions and ideas, articulated into gratifying entertainment by a collection of performers who worked so well together that they seemed simultaneously like individuals and an ensemble.

And then there was Sidi Ballo. As good as the other performers were, this man was clearly a master artist, and I thought students and colleagues should know what made him one and why that was significant. It was not just that he rose above many other performers I had seen. It was also his evident dedication to bird masquerading and the fact that he made it so uniquely his own, in spite of its emergence from a venerable, widespread, and very well-known tradition of performing. There are countless accomplished artists like Sidi Ballo spread across the nations and societies of Africa, whose personalities and personal attributes give them virtuosity that stands out and that give their art amplified aesthetic and social punch. These accomplished professionals need to be written about and discussed, just like the Rembrandts and Christos of the world.

So Sidi Ballo and the Dogoduman bird dance instantly entered my class lectures. I delivered papers on it at conferences and other universities, and I wrote about it, a few paragraphs or pages at a time, here and there in several publications. But I felt my efforts were not adequate. I was presenting a smattering of aesthetic and symbolic elements amidst terse descriptions of an event's unfolding and a masquerader's attributes and abilities.

The Dogoduman bird dance never stopped impressing itself upon me as an event that warranted more attention. The ways the performers fit together and the play of ideas across the event all seemed both delightfully simple and much more complex. They were so potent that I started calling these artworks

instrumental—instruments of thought and action—without knowing how to articulate that into a useful explanation. I could not stop feeling that I was not doing the performance justice. Sidi Ballo deserved a book, but I could not write it then. I had reasonable amounts of information about him and visceral, first-hand experience of his expertise, but I felt what I could write would not do him justice. I spent years frittering around the periphery of his personality and accomplishments without comprehending that I should explore how he had employed the strengths of his character and personal attributes to construct from his relationships with people and his access to cultural resources a wonderful career as an itinerant bird masquerader.

Then, some two decades later, I got to direct a CD-ROM project that produced *Five Windows into Africa*, and I suddenly realized that I could contribute a section myself and finally start to do Sidi Ballo and the Dogoduman performance justice. Years of reading, talking to people, and just working out what I thought really mattered gave me a little confidence. With my friend and colleague Kassim Kone, I even went to Mali and met Sidi Ballo again. He talked to us extensively over several days and staged a bird masquerade for us on July 4, 1998, twenty years after the performance that had so galvanized me.

Now themes and topics gushed out of me. I wrote hundreds of pages, then drastically cut back to accommodate a CD-ROM format. It was a beginning, and I kept writing. This book is the result.

It is still not enough. It leaves many issues and questions unanswered and does not do full justice to Sidi Ballo. That is not all. I devote many pages to Mayimuna and other Dogoduman performers, but these dancers and singers, the master of ceremonies, and all the other participants are certainly worthy of more information than I have to offer. There are also elements in Mande thought and social practice that do not receive as much attention as they might deserve, and others (such as joking relationships or the energy of action) that may seem to have attention heaped upon them. At base, this book exemplifies one of the social realities it takes up as a theme: it is grounded in my knowledge and sentiments as an individual and in my experiences with other people as a social creature. It covers what I encountered and what I have come to feel is important— another researcher might well have written quite a different book.

Nonetheless, I think these pages begin to show what made Dogoduman so wonderful and why individuals are significant even as they work in groups. Moreover, it illuminates enough of Sidi Ballo's career to suggest how grand an artist he has been. It suggests the importance of aesthetics in the hands of talented artists and how deeply aesthetics extend into the numerous nooks and crannies of a society's everyday business. Finally, it illustrates, I hope, how form, well-harnessed by talented artists, can generate multitudes of meanings and layers of value in the lives of people who dwell simultaneously in their own skins and in the vaster cauldrons of social commerce.

Part 1

THE BIRD DANCE
AT DOGODUMAN

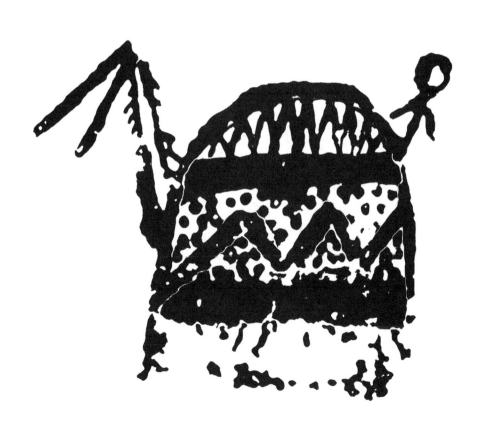

1

THE PERFORMANCE

CAST OF CHARACTERS

Sidi Ballo was without a doubt the featured artist and the very reason there was a bird dance at Dogoduman in June of 1978. Nevertheless, he was one among many performers, all of whom contributed to the shape of the event and the affect it created in the audience.

Drum Orchestra: from the Dogoduman youth association (*ton*)

Young Ladies' Chorus: from the youth association

Senior Lady Singers: featuring the very talented Mayimuna

Unmasked Dancers: very young members of the youth association

Masked Dancers: older members of the youth association, featuring the *Ntomoniw* mask wearers

Master of Ceremonies: the man in the deck-of-cards shirt, who facilitated the sequence of performers

Sidi Ballo's Apprentice: Sibiri Camara, a very talented performer in his own right

Sidi Ballo, the Bird Masquerader: already quite famous in large areas around

Bamako and an extraordinarily talented, perceptive, and intelligent artist

The Local Blacksmiths: who were called out in the midst of the event to dance in their own honor

The Dogoduman Town Spokesperson: who entered the dance arena to proclaim the support of the city for the event

The Audience: who danced from time to time and engaged the performers with knowledgeable expectations and enthusiasm.

The *Fototalaw:* the photographers and audio taper from out of town, who heard about the event the night before and came to document it. They were Kalilou, Sangaré, and me.

Together, these performers created a wonderful evening as individuals working in a group, engaged in a common project. Their individuality gave the performance character, and their individual abilities contributed to its success. The effect was an intermeshing of effort to produce something that could not have been accomplished by anyone alone. In the précis and description that follow, Sidi Ballo will most frequently be clearly in the spotlight. But to do him and the event justice, the rest of the text will cast him amongst his fellow performers and the larger collection of social and cultural webs that gave the master masquerader his medium and his opportunities for success.

PERFORMANCE PRÉCIS

Like most masquerade events in Mande or anywhere else, the Dogoduman performance possessed a rhythm and pattern. Certain things repeated throughout the evening as new things constantly emerged. In this brief synopsis, given to help orient you for the longer description that follows, I generally say "the bird," "*Kònò*," "the bird masquerade," or "the master masquerader" instead of using Sidi Ballo's name, because during a performance it is considered improper to state the name of a masquerader.

Warm-up and Preparation: The drummers tune their instruments. Drummers and singers warm up.

The *Ntomoniw* Enter: Two youth association dancers in delicate face masks begin the festivities.

The Unmasked Youths and *Ntomoniw* Again: Younger unmasked dancers perform singly and in pairs, and then the *Ntomoniw* return.

A Mande Intermission: The arena quiets as dancers take a break and the young women's chorus softly sings.

***Sigi* and *Ntomoni*:** One of the *Ntomoni* masked dancers, representing a

beautiful Fulani woman, performs a skit with a masquerade called *Sigi,* the wild bush buffalo.

Unmasked Dancers, a Second Intermission, the Bird Arrives: The young unmasked dancers return briefly, followed by a second intermission, again with the young ladies singing very softly. As the music builds back up in intensity, the bird, *Kònò,* enters the dance arena for the first time. Great drama and excitement ensue.

Unmasked Dancers, Drummers, and the Young Ladies' Chorus: As if releasing pent-up energy, the unmasked dancers take the bird's place as the drummers spill onto the dance arena and the singers circle around it. A sense of serene interlude is produced.

Kònò **Returns and Greets the Town:** The bird is back, with high-energy routines. Then he slows down and greets the musicians, important town members, and guests.

Off to the Races Again: More of the bird's high-speed dance arena maneuvering. He is now solidly establishing many of the gestures and the intricate and challenging actions that made him such a popular performer.

Kònò **Hits the Wall:** In a high-speed maneuver that comes with little warning, the bird flies through the air and slams into a house wall.

The *Ntomoniw* Dancers Return: The young masked dancers now return and execute a series of exacting and impressive dancing feats.

Children Dance as *Sigi* Hides and Waits: The very young unmasked dancers enjoy themselves again in the arena as the wild bush buffalo masquerade appears to hide off to the side. Now a new mask, representing a Mande hunter, makes an appearance.

Out Comes *Sigi*: An animal behaving badly, the wild bush buffalo emerges and joins the hunter in a hilarious skit. Then *Sigi* engages various audience members and executes a sequence of spectacular dancing.

Children, Kalilou, and Me—then a Break: With the drum orchestra playing extremely up-tempo, a group of young girls and boys come out to dance, some very dramatically. First Kalilou, then I am called out to dance. Then the audience settles into quiet conversation as we enter a long intermission.

Ntomoniw **Masks Perform Feats:** The break ends with the two young masked dancers who began the performance, this time dancing with tremendous vigor and performing arduous feats.

The Children, the Young Ladies, and Sangaré: The unmasked children return with the talented young ladies who performed just before the long break. Sangaré joins them.

Kònò Is Back: The bird returns and greets the drummers. He sways and moves slowly but seems tremendously agitated. He squawks at the senior singer Mayimuna, and anticipatory tension fills the air.

Kònò Turns Over and Dances Upside Down: In an exquisite sequence of carefully executed moves, the bird "falls" to the ground on its side and then turns completely upside down in a material reconfiguration one-third the height it has been all evening. Compressed inside, the master masquerader proceeds to slowly dance about the arena, feet not touching ground but rather the cloth top of the masquerade. It is a marvel.

Kònò Shows Us . . . Nothing at All: Still upside down, the bird becomes extremely agitated and falls over again. The masquerade bottom now facing the bulk of the audience, the master opens this hollow cone of a costume for all to look inside. Sidi Ballo is nowhere to be found.

Feather Adjustment: All this dramatic activity has caused a band of vulture feathers to come loose. The performance stops briefly as the bird's apprentice makes adjustments. Bird and apprentice then move to the singers and drummers to pay their respects.

Sangaré and I Get the Hook: The bird's head becomes a hook that pulls Sangaré and me into the dance arena, where we greet the bird and dance our respect for him.

The Bleachers: In a series of carefully executed gestures that appear to the audience quite matter-of-fact, though dangerous, the bird ascends the slippery-looking bleachers that grace the edge of the dance arena, performs in humorous fashion atop them, and then jumps off and motors about the dance arena. This feat was clearly anticipated with relish by many in the audience.

A Break for Thanks, and Kònò in My Face: A Dogoduman spokesperson enters the arena, announces the town's great respect for the master masquerader, and then publicly lists the financial contribution each community family has made to make the performance possible. He then acknowledges us, the *fototalaw,* as town guests, and I am "invited" to dance again. As I oblige, I am rushed by the bird.

The Blacksmiths, then Sangaré: Many people are now dancing with the bird. Mayimuna sings inspirational praise songs of blacksmiths, and the town's five smiths, plus me (an honorary blacksmith), dance in a line. Meanwhile *Kònò* moves to the drum orchestra and with a voice disguiser matches the drum rhythms, and then—using tones instead of full

words—he praises the smiths. A visiting blacksmith from down on the Niger River plain gives a little speech of friendship and solidarity. Then Sangaré is asked to dance again, and *Kònò* calls out all the singers and drummers to dance with him.

Something Different—the Bird's Apprentice and a Break Dancer: *Kònò* has settled quietly at the dance arena entrance, and his apprentice now takes center stage, dancing solo with great accomplishment. Then a teenager enters the arena and executes a striking sequence of what any American would have called break dancing.

Mayimuna's Salutations: *Kònò* speaks in tones to praise people. Mayimuna takes stage center and sings beautifully, as the bird spins around her.

Leaping the Bench: As the evening winds down, *Kònò* uses a bench as a prop to leap upon and over, and then he executes another furious round of virtuoso dancing.

A Calabash from Which to Drink: The bird drinks from a calabash of milk, an interesting feat in response to an honoring gesture of offering cool refreshment.

The Performance Is Nearly Over: The drum orchestra takes the arena, and most of the audience dances as *Kònò* slowly orchestrates his final exit.

Mayimuna and the Young Ladies' Chorus Sing the Evening to a Close: Mayimuna sings that she is tired and is going home. The young ladies' chorus sings their laments. The Dogoduman bird dance ends.

PERFORMANCE DESCRIBED

I wrote the following description almost immediately after the Dogoduman performance—the next day—while the event's activities were still freshly ablaze in my mind but after I had gotten enough sleep to be careful about details. Then Kalilou Tera, Sekuba Camara, and I worked for days transcribing the songs and making sure they lined up with what I wrote. This provided an opportunity to verify the accuracy of my description.

Essentially, I just wrote what I had watched untold. As the précis suggests, it is natural to divide the performance into episodes characterized by changes in action. I have added headings here that match those in the précis. Mostly they mark moments when the master of ceremonies whistled performers on and off the arena, or major dramatic shifts of action on the part of the bird.

Sometimes I will refer to Sidi's masquerade as "he," reflecting the Dogoduman audience's knowledge of who was inside the costume. Other times I will refer to the masquerade as "it" to emphasize its existence as a construction.

And sometimes I will just say "*Kònò*" or "the bird" when the dancing or skit is emphasizing that identifying quality of the masquerade. I will not refer to Sidi Ballo by name, just as no one at the performance did, because that is considered bad luck and inappropriate.

The Dogoduman performance began in twilight, but as night emerged so did a bright moon. Kerosene lanterns situated here and there augmented the lunar light. In earlier times the beautiful iron lamps made by blacksmiths would have served this purpose. Like most youth association community performances, this bird dance was held at the *fèrè*, or public plaza (see plate 2).

Warm-up and Preparation

The town begins to gather in the early evening hours, well before the masquerades appear. The musicians and a performance official are among the first to arrive. There is a drum orchestra (see plate 3). There is the young man with a whistle, the *jamaladilala*, or master of ceremonies (see plate 3). There are two young ladies with calabash drums and more young ladies to sing with them, who constitute the young ladies' chorus (see plate 4). And there are several elder lady singers, featuring Mayimuna Nyaarè (see plate 5).

The drummers tune their drums by placing them near a small fire to change the tension on the drum heads. They casually practice some of their rhythms and solo riffs, and as the performance approaches, they play increasingly longer segments of songs. The women singers also warm up. They sing bits and pieces of the songs they will perform, preparing their voices and psyching themselves for the hours ahead.

Meanwhile, Sidi Ballo is a few streets away from the crowd, preparing himself and his bird masquerade with the help of his apprentice, Sibiri Camara (see plate 6). He faces much hot, hard work (see plate 7), so he removes his shirt and changes into the baggy shorts that he will wear inside the bird costume. He also makes a sacrifice to the night's success. He puts on amulets—lots of them—and activates the supernatural side of his performance abilities with incantations and offerings. This is private, important business, carried out with matter-of-fact professionalism.[1] It is part of Sidi's expertise, part of the knowledge, sensibilities, and skills he has developed over years to become a virtuoso masquerader. When he is done, the performance can proceed.

The *Ntomoniw* Enter

The performance begins with two dancers in delicate face masks (see plate 8), popularized versions of a type that used to reside exclusively in a very different context, the Ntomo young men's initiation society. These dancers and their masks are called *Ntomoniw*, "the little Ntomo." The *jamaladilala,* or

master of ceremonies, whistles them to the dance arena's entrance. They stand there together for a moment until the *jamaladilala* whistles again, and one moves slowly toward the arena center, taking a few steps, then squatting down and bowing, over and over again. The drums are slow and subdued at first, but then they become boisterous, and the dancer moves with speed and grace, holding his arms out and spinning them in big circles with the on-beat, while swinging his shoulders forward alternately and performing staccato triplets with his feet as he first moves forward, then moves back, over and over again.

These staccato triplets are impressive, consisting of three extremely rapid little steps—left, right, left—clustered tightly together as a rhythmic node and then followed by three more—right, left, right—with each node occurring as one beat in the 4/4 music measure that grounds the drum orchestra's performance.

The *Ntomoni* does all this so quickly that he appears to be floating; he radiates great agility and balance. He holds scarves in his hands and constantly casts them out in great arcs of color that add to the performance's compelling affect. The other masked dancer does all this too, as the evening becomes charged with excitement and the importance of expert dancing becomes obvious.

The Unmasked Youths and *Ntomoniw* Again

Now the *jamaladilala* whistles these two masks out and calls a series of unmasked young men, singly and in pairs. The two young lady singers with calabash drums stand up and move around the arena's edge. Then the *jamaladilala* calls the *Ntomoni* masked dancers back, and they perform a little bit longer as the men's drum orchestra moves into the center of the dance arena briefly and then moves back to the ladies' chorus.

A Mande Intermission

There is a pause in the action as everybody stops and waits. We are about twenty minutes into the performance. The masks are gone. People sit and chat or joke, or they mill about as the young women's chorus sings very softly. The drummers are not playing, and there is a relaxed, casual feeling in the air.

Sigi and *Ntomoni*

Now a masked dancer moves into the arena entrance. The mask has two horns, and the dancer is bent over. It is the character *Sigi,* the wild bush buffalo, known to be one of the most dangerous creatures in the wilderness. Suddenly one of the *Ntomoni* dancers appears at the edge of the arena with it. The bush buffalo remains at the edge, but the *Ntomoni* is whistled onto the arena by the

jamaladilala, where the dancer prances, poses, and gestures in stereotypical fashion to suggest a satirized woman.

Soon the wild bull comes out too, with the dancer using two sticks in his hands to help carry his great, bent-over animal weight and giving the impression of four legs. He tosses his head from side to side in response to the drum rhythms, moving slowly in a ponderous way that characterizes the threat a real bush buffalo represents.

Now the bull and the feminine *Ntomoni* come together and act coy (see plate 9). With his hips the bull makes hilarious gestures to suggest sexual desire. Then the two masks separate and dance independently, come together again, and again radiate unnatural, provocative sexual allure. This comic attraction will remain unrequited, however, as the *jamaladilala* whistles the pair out of the dance arena.

Unmasked Dancers, a Second Intermission, the Bird Arrives

The unmasked dancers are then whistled back in. They perform for a quick second round, and then there is another intermission, with only the young ladies' chorus singing softly and slowly.

As people mill about again, the bird masquerade has moved into view from between two buildings and pauses at the arena entrance. As the bird, or *kònò,* moves into place, it looks huge, but then it settles down on the ground (see plate 10) and seems compact, immobile, and innocuous. It keeps quite still while the music gains speed and a sense of anticipatory tension. The whole atmosphere becomes charged with tremendous expectation.

Then *Kònò* rushes out, in an awesome gust of movement (see plate 11). You cannot see anything but the cloth costume, which vibrates so sharply and precisely that you realize he must be shaking the whole thing from the inside with his hands, in the same fast sets of triplets against drum beats that the masked dancers did with their feet. As he moves forward through the arena, *Kònò* alternates smooth and fluid movements with a jerky rocking back and forth, sometimes pitching the masquerade so sharply to the side that it seems as if it will fall over, but it does not. Next the carved bird's head sweeps out from the costume on a four-foot pole in a cloth sleeve. Through the dancer's finesse and precision, the audience's experience and expectations are engaged to create two very different effects with this bird's head. Sometimes it seems a natural part of the masquerade, a carved bird's head attached to the feathered conical costume to complete the idea of a bird. It juts forward and backward like a real bird walking on the ground, and it looks around as if it could actually see. At other times it is an abstract performance device like a baton, a cane, or a carnival character's prop, amplifying and complicating the motions produced by

the costume with interest and excitement. It sways back and forth, sometimes making figure eights in the air.

Now *Kònò* speeds up. He seems to whisk by like the wind, whipping back and forth across the forty-yard length of the arena, vibrating the costume in triplets as he takes three steps forward, hesitates, pushes strongly into another three steps, and hesitates again, over and over.

Then three things happen almost all at once. He stops abruptly and leans the entire masquerade backward while raising it and the bird's head straight up (see plate 12). It is like a horse rearing up in a cowboy movie, and it is galvanizing. In the next second, the enormous abstract bird rushes at me, hooks me by the neck with the bright red, very long-beaked bird's head, and freezes there. It is only for a moment, but it seems like forever, and then he is suddenly off again, flying like crazy and spinning the entire masquerade ninety degrees around, first in one direction, then in the other, as he careens about the dance arena.

At this point I must break out of my description of the performance to describe my own response, because I am taken aback by this bird masquerade. The quality of dancing, the sheer vigor and stamina, the absolute precision of movement, the balance and agility, the composure that seems to radiate right through the cloth costume—all of this makes the visual experience staggering. And *Kònò* has danced much longer than the other performers. It seems like forty minutes. Finally, he stops near the chorus and drum orchestra, while the ladies sing very slowly. Then he rushes out, whisking between the two buildings at the arena entrance.

Unmasked Dancers, Drummers, and the Young Ladies' Chorus

The unmasked dancers take *Kònò*'s place as the drum orchestra moves out into the arena, and the women's chorus forms a column to encircle and parade around it. The two young ladies with the calabash drums toss them spinning into the air as they walk, creating a captivating, cascading sound that adds new punctuation to the singing and drumming. This segment moves the audience into a state of calm, a serene interlude nestled between far more vigorous episodes of action.

Kònò Returns and Greets the Town

The calm does not last long. Before you have time to catch your breath from *Kònò*'s first appearance, the bird is back, motoring full throttle around the arena, while he repeatedly spins the masquerade around its central axis. As before, he stops near the women's chorus, and as the ladies sing slow songs, the bird makes bird noises with a voice disguiser he has hidden inside the costume.[2]

With this sonorous device, *Kònò* begins to greet the town (see plate 13). He salutes the town chief, who returns the greeting, calling *Kònò* the chief of his own town. He greets the elders and asks if all is calm and peaceful in their lives. They return the kindness and ask after the well-being of the people in *Kònò*-town. The young men and women are greeted, and the young unmarried women tell him, "It's been a long time," as they congratulate his spectacular dancing. Then the drummers, the young ladies' chorus, and the senior woman singer are greeted. *Kònò* even greets Kalilou Tera, Sangaré, and me, identifying us to the audience as the *fototalaw,* the "photograph takers."

Now the elder singer, Mayimuna, moves toward the arena center, where her very presence as a person most worthy of respect serves to greet and honor *Kònò*. The bird slowly circles her, spinning around its own central axis at the same time. It repeatedly flaps its large wooden beak, open and closed, open and closed, with a clapping sound that is surprisingly loud and attention-grabbing.

Off to the Races Again

Then the bird takes off again, moving very fast but seeming to glide over the ground. Jolts and ripples cascade across the rows of feathers and fringe attached to the costume as the bird continues to execute fast triplets that are becoming the signature of the performance. As *Kònò* sweeps across the dance arena space, he pitches the costume very sharply as he shakes it, first off to the left, then to the right, over and over again. I marvel over the control he maintains—how does he see out of the cloth? How does he keep his hands in the right places on the costume frame and the pole for the bird's head?[3] How does he keep his feet from stepping on that long burlap fringe or catching on the costume's lowest wooden hoop? How does he keep from toppling over? The danger seems imminent, and the accomplishment all the more enormous because of it.

Now he stops, pitching slowly back and forth like a light boat in a stormy sea, as he moves the bird's head about in grand sweeps. Then he's off again, streaking around the dance arena as he continues to perform the costume-quivering triplets.

Kònò Hits the Wall

Suddenly *Kònò* has slammed into a wall. He was moving pell-mell, with no apparent care for his direction, as he all too rapidly approached a solid house wall. Then, a split second before the crash, the whole costume simply rose up, rotated into a horizontal mode, and floated into the collision. Now the bird's body is parallel to the ground, with its base neatly huddled against the bottom

of the wall. It seems to levitate itself on the wall, not a lot but just enough so that you wonder how a masquerade dancer could be hovering horizontally in mid-air inside his costume. And then the bird's head comes out and extends up the full length of the hidden pole, looking around from a height of a meter above its own body. It is as if the bird is wondering how in heaven's name he came to be in this position.

The audience is thrilled, and the moment is alive with drama. *Kònò* knows it and holds his position for half a minute or more, as if to draw out the audience's collective breath. Then he abruptly rushes off the dance arena.

The *Ntomoniw* Dancers Return

Now "the little Ntomo masks" come back, each entering separately and executing a quick but precise routine of three forward steps and then a part squat, part bow. These dancers bend so deeply at the knees that their bottoms nearly touch the ground. And yet, through strength, grace, and subtle head movement, the overwhelming character of the movement is a bow, not a squat. The mask dips just slightly forward, and the entire gesture is transformed into a dignified bow.

After repeating this movement many times, the *Ntomoni* dancers move quickly around the arena, rushing past the drummers to regroup at the arena entrance. Together, they work slowly across the middle of the arena, repeatedly taking several steps and a bow. Then they accelerate tremendously, making consecutive somersaults and finally sliding to a stop on their knees. From their knees, they perform little hops and spins. Then they're up again as the *jamala-dilala* whistles them out. They do the triplets, three crisp and rapid steps to the left, then to the right, then the left, then the right, until they are out of sight.

Children Dance as *Sigi* Hides and Waits

Sigi, the wild bush buffalo, moves to the entrance but hides behind a building, just as he might in the bush to ambush hunters. As he hides, the unmasked young boys take the arena again. They are numerous and probably no older than ten. Some are not very good dancers, others are excellent. They all enjoy the moment and give it their best shot.

Now a new masked dancer takes the arena with his own three-steps-and-a-bow routine. After a bit he stops and seems to evaluate the crowd with a slow, deliberate, sweeping gaze. Then he bursts into high speed, slides along the ground, turns, and kicks his legs up into the air. Then he stands up and just stands there as the unmasked youngsters dance all around him.

Even though this new mask resembles those used in the *Kòrè*, another Mande initiation association (this one devoted to elder men and refined,

philosophical, esoteric knowledge), this masked dancer seems to be playing the role of a hunter, in a modification of a skit that is widely appreciated in the youth association theaters all over Mali. Usually the hunter carries a gun, and, after either serious stalking or satirical shenanigans, he shoots a lion character. Now at Dogoduman, however, we are about to get a new twist.

Out Comes *Sigi*

Sigi, the wild bush buffalo, moves into the arena, throwing his head sharply about in a ferocious and agitated manner and leaning heavily on the sticks that make him into a four-legged beast. His gestures give the impression of the great, ponderous, dangerous weight that characterizes the real animal. Then he stops and flings his rear end up into the air in a gesture that powerfully mimics a seemingly unstoppable sense of animal sexuality. That is something no one has seen a real *sigi* do.

The masquerader playing the hunter catches this perverse sexual spirit in spite of the fact that in real life hunters and bush buffaloes are mortal combatants. So, in defiance of nature, the hunter moves to *sigi*'s rear, where the two create an unmistakable gesture of misplaced love. It is provocative and resoundingly humorous.[4]

Now the wild buffalo takes a turn around the dance arena. He sits next to a lady in the crowd, creating much excitement. He sits next to others with the same effect. Then he moves to the drummers and squats down next to them. And then he is up again, and very slowly, with sharp, strikingly crisp steps, he swings and sways his way into arena center, always in the bent-over posture of a beast. All of a sudden he boosts the velocity while still bent over, moving so rapidly that he uses the sticks in his hands to literally pull himself along as puffs of dust appear on the dance arena floor. The visual effect is spectacular.

Children, Kalilou, and Me—then a Break

Now the *jamaladilala* whistles the buffalo off, and young girls and boys come out to dance. The drums proceed at a feverish pace, and many of these youngsters are very good dancers. Several young ladies dance dramatically—they jump up and bend their knees so their calves are parallel to the ground, in repeated gestures of power and elegance that are widely seen in Mande dancing.

Kalilou is called out to dance. Then I am. We dance for about three minutes, and then there is a quiet pause. The only sounds heard are the children laughing. We are now well along into the performance, and this will be a long break. The interlude is clearly welcome, as audience members chat quietly among themselves.

Ntomoniw Masks Perform Feats

When the break is over, the *Ntomoniw* return. At first they move slowly, but then the *jamaladilala*'s whistle catapults them into high gear. They run, jump (see plate 14), and spin, all at the same time. They dance singly and then move together, facing and touching each other. One puts a leg up over the other's shoulder, and they hop around together like that, maintaining their balance with apparent ease while moving precisely to the beat.

One masker gets down on all fours, belly up, and the other stands on his stomach (see plate 15). They hold this position for a moment, and then it's off to the races again, and again it is simply fantastic. All night these masked dancers display tremendous ability. They are a pleasure to watch.

The Children, the Young Ladies, and Sangaré

The unmasked children are called in again, along with the dancing young ladies. This time our companion, Sangaré, is called upon to join them, and he proves to be an excellent dancer.

Kònò Is Back

There is no break, and *Kònò* is back. He greets the drummers as he sits quietly before them and then moves off to the far end of the arena, making a huge amount of noise as he returns to the drummers again. He is flapping his wooden beak! He blows his horn-whistle! He seems to be very agitated! He does all this as the ladies sing softly, and he sways slowly back and forth before the drummers. Finally, he uses his voice-disguising instrument to squawk impertinently at Mayimuna, which is somewhat startling, given her stature as both a singer and a representative of the elder generation. It is hard not to feel a certain tension and anticipation. Something dramatic seems about to happen.

Kònò Turns Over and Dances Upside Down

Many times up to now the bird has acted as if he might just fall right over, tumble out of verticality, and crash to the ground. He has done it by listing over so severely that you wondered how he stayed erect at all. And when he did this, he made the costume quiver so that it seemed to leave the realm of his control or the earthly realm altogether.

Whenever this occurred, the crowd grew silent. Dangerous things can happen when these masquerade constructions tumble over with the weight of a person inside. The wooden scaffolding is lashed together so that it is bent into

circles under tension. It can break up and spring apart, the sharp edges puncturing a luckless dancer.[5] No wonder that every time he seemed about to fall, *Kònò* has intensified the tension and excitement in the audience.

After squawking at Mayimuna, the bird moves into the arena's center, and there he seems to both hover and descend simultaneously. He really falls over this time (see plate 16), all the way to the ground. On the way down, while almost horizontal, almost parallel to the ground but essentially in mid-air, he shakes the entire costume as if his heart were beating through his skin. But of course it beats in perfect time with the drummers. As it goes over, the costume also seems to squish together as if it were in the process of becoming momentarily two-dimensional.

While on the ground, he begins to execute something truly spectacular. First, the bird's head goes up (see plate 17), looking around like a periscope. As he does it, he hops about horizontally on the earth. Then he manages, from inside the costume and evidently in a squatting position, to turn the costume completely upside down so that it is bottom up. He has also pulled the circular wooden scaffolding together[6] and caused the huge burlap fringe to flop over the costume's natural opening at the base, which is now the top, so that no one can see inside. It is as if the bird masquerade has become an enormous, colorful, feather-laden, ribbon-wrapped sack (see plate 18). But it is a sack that remains upright on its own, and it is about to perform other marvels for the audience.

During this tricky maneuver, I lost track of the bird's head. It emerges again, flipped over in its long cloth sleeve, so that it remains properly oriented even though its visual source of support, the costume, is inverted. And as the audience watches the bird's head move about, I realize to my absolute astonishment that the bird masquerader is dancing inside his inverted masquerade, in a highly constrained squatting position, feet squarely on the solid cloth top of the bird costume. No part of the dancer's body is directly touching ground. There is the cloth of the masquerade between his feet and the earth. And yet he is dancing. In fact, he is moving about quite beautifully as if to suggest the happy intervention of powers beyond the ordinary. I am in awe.[7]

Kònò Shows Us . . . Nothing at All

Now the performance takes another astounding turn. The bird, still upside down, becomes extremely agitated again. The entire costume shakes violently, and once again he falls over. But he stops half way and returns to his upside-down posture, only to go over again, this time completely, so that the bird costume once more lies on its side. The base of the costume, closed over with that huge burlap flap, faces the portion of the arena with the largest group of audience members (including me). The wooden rings of the costume are pulled so that the base is not circular but elliptical, and therefore partly closed. The

flap covers it completely. But now the masquerader opens up the bottom so that we all can look inside: right inside (see plate 19), and, for those in the best position, straight up the inside to the top of the masquerade. Amazingly, no one can find the masquerader; no one can see any trace whatsoever of him. He must be in there, but it seems as if he is not. He is challenging us to find him, and no one can. He is in there, to be sure, but he isn't.

The audience, deeply appreciative throughout this whole evening's virtuoso performance, is now beside itself. We are all amazed. And to make it more amazing, the dancer rolls the masquerade over on the ground, and still we see nothing inside but a long, hollow, conical, empty costume.

Finally, *Kònò* turns himself upright again and moves toward the arena entrance as if planning to leave. He is rocking the whole costume radically back and forth as he moves. The huge burlap flap hides his feet when the masquerade is tipped sharply over, making you realize again that it is almost completely underfoot when the costume is upright and the dancer is moving about at top speed. Once again, the dangers attendant upon this performance become evident, and respect for the dancer swells. He has used danger to create high drama.

Feather Adjustment

The upper ribbon of feathers has come loose and is hanging free down the side of the masquerade. Not much has come loose, but this stops the proceedings for a bit as *Kònò*'s apprentice steps up and repairs the hanging ribbon. Then bird and apprentice head to the arena entrance as if to leave, but return to pay their respects to the singers and drummers.

Sangaré and I Get the Hook

Suddenly *Kònò* is right next to me—I'm not even sure how he got there so fast. This proximity is simultaneously disquieting and titillating. It quickly becomes more dramatic as *Kònò* uses his own carved bird's head as a large and ominous hook to haul both Sangaré and me out into arena center. There he greets us and indicates that we are to greet him back. It then becomes clear that the bird and the entire audience expect us to pay our respects by dancing.

The Bleachers

The bird moves off to our left, to the large bleachers made of tree-trunks, set under a huge shade tree where town elders pass their time during the day. The bleachers are between three and four feet tall, and the hardwood from which they are constructed has been polished smooth over years of use. I have often thought they look slippery and could be treacherous to stand on. There is no danger if you plan to just sit. But *Kònò* has other ideas.

In a single fluid movement, the bird leaps, or rather seems to float up to a standing position on top of the bleachers. I get the distinct feeling from barely audible exclamations that many audience members have awaited this with excitement and anticipation. *Kònò* just stands there for a moment, and then he bends precariously over toward us and wiggles his rear end preposterously, while Mayimuna stands in the center of the arena and sings.

Kònò stands still again while some children dance below. Then he begins to bob back and forth slowly. He takes some steps, shakes, takes some more steps, shakes again, moving with an initial tentativeness that slides into confidence, generating the impression that what he is doing is most difficult. Suddenly, he leaps off the bleachers (see plate 20), lands, and motors rapidly across the dance floor. He goes back and forth, running at top speed, spins around, moves off again, sweeps over to the side, and moves back and forth some more along the arena's edge. His apprentice follows suit and then goes over to dance near the young ladies with the calabash drums. *Kònò* rushes over to join him, then rushes over to Sangaré and me, then back and forth some more, and then, finally, stops. Stops!

A Break for Thanks, and *Kònò* in My Face

A community spokesperson—a man in ordinary clothes—moves to the arena center, where he stands and speaks to the audience. He moves around a bit, and with no music at all he announces the town's great respect for *Kònò*'s performance. Then he announces the names of every town citizen who has contributed money to make it possible to hire this spectacular masquerader. He even announces how much each person has contributed. This man is a representative of the town's ruling council of elders, and he has just executed a social strategy that honors solidarity and generosity, while pointing out who has given nothing or not enough.

He announces Sangaré and me as town guests (Kalilou is off to the side, unnoticed), and I am asked to dance again. The members of the young ladies' chorus are on their feet singing, and *Kònò* rushes over to me, straight at me, while holding the masquerade sharply sideways. He stops on a dime, as he has done all night long, right there in my face. There are no eye holes in his costume, and it is not a very brightly lit dance arena. Nevertheless, wherever he is going, the bird always stops exactly where he needs to, no matter how difficult his audience may believe that to be. Again I marvel at this bird's performance expertise.

The Blacksmiths, then Sangaré

Many people are out in the arena dancing with the bird. Dogoduman has five blacksmiths, and the senior singer Mayimuna has started singing heroic smith

songs in their honor. They are all in a line, out in the middle of the arena, dancing. As an honorary apprentice smith, I am out there with them. Mayimuna sings three smiths' songs, the lyrics of which are designed to evoke strong emotions and deep personal soul-searching. Then *Kònò* moves over to the drum orchestra and uses his whistle-flute, first to match the patterns of the drums and then to speak tonally, praising the smiths. They give money to Mayimuna, and we all clap. A blacksmith visiting from below the Mande Plateau gives no money, but he does make a brief speech, saying that he is the same as the people of Dogoduman and that he used to climb up here frequently to tie the knot of fraternity. He finishes with his best wishes for the town and for cooperation among towns.

Then Sangaré is called upon to dance again, which he does again with distinction. *Kònò* calls out all the singers, the two calabash drummers, and the whole male drum orchestra. They all dance with Sangaré.

Something Different—the Bird's Apprentice and a Break Dancer

Kònò rests quietly at the arena entrance while a wicker mat is placed in the center. The music speeds up dramatically and gets very loud. The bird's apprentice performs by himself, with elegant precision, speed, and grace. He is a most accomplished dancer. *Kònò* just sits at the entrance, watching.

Then a boy in his mid-teens takes the floor and dances. Suddenly, he leaps up and swan-dives to the ground, tumbles, descends onto the mat, and there performs many most impressive acrobatics. He spins around endlessly, kicks his legs up into the air, rolls over on his shoulders, stands up, and does the whole thing again, twice more.[8]

Mayimuna's Salutations

Kònò takes the stage again, speaking in tones, as praise is offered all around. He is sweeping at modest speed across the arena when Mayimuna moves to the center. There she stands and sings with profound beauty, and the bird comes and spins figure eights around her, while at the same time revolving around his own central axis as if he were a spinning top, like he did much earlier in the evening.

Leaping the Bench

The evening is winding down, and I imagine that *Kònò* must be exhausted by now. A long bench about eighteen inches tall is moved out into the arena's center. *Kònò* pauses near it, then leaps onto it, stops atop, leans way over, and leaps off. Backing off, he takes a long run at the bench and leaps over it two more times, the second time actually knocking it over. Is he getting tired?

Now he rushes back and forth, shaking the masquerade costume violently. You might think of feathers and bird's head in a hurricane, and the characterization this motion produces is indeed just like the wind. It even sounds like the great sand and dust storms that hit these savanna lands every year. *Kònò*'s violent shaking, however, remains briskly precise.

Then the bird's head is out all the way again, moving in large figure eights as he spins, hovers, and rushes about the dance arena.

A Calabash from Which to Drink

Kònò has been performing for at least three hours. Except perhaps for knocking over the bench, he shows no signs of fatigue. Now a young man moves to the arena center with a calabash full of milk. The bird's head comes out all the way. The beak's tip descends into the milk. And *Kònò* actually drinks it, as a song of high praise tells everyone that this cool, refreshing beverage is just for the spectacular bird. Then he returns to his back-and-forth movement again, numerous times. It is nearly one a.m.

The Performance Is Nearly Over

Now the drummers move into the dance arena and almost everybody dances. *Kònò* dances too, but heads toward the entrance. The music speeds up. The chorus of young ladies clearly do not want him to leave. *Kònò* speeds up too, still heading for the entrance. Then a senior lady who has not yet sung sings a song, and the bird comes back to her and settles to listen quietly. Finally, *Kònò* leaves, and the drummers move to the arena's center, while the whole town dances in the space that the bird has filled so splendidly all evening.

Mayimuna and the Young Ladies' Chorus Sing the Evening to a Close

All night long the senior singer, Mayimuna, has alternated songs with the chorus of young lady singers. Now she decides that the evening must come to an end, so she sings that she is going home to sleep. The young ladies' chorus responds with two very short songs, one expressing great joy for the evening, the other expressing regret that it is over.

And so the bird dance at Dogoduman comes to a close.

2

HOW TO VIEW
A BIRD DANCE

The Dogoduman bird dance can be viewed as simplicity itself. It was composed of essentially clear-cut segments. Its participants played readily discernable, complementary roles. And it could be described, even by local audience members, as straightforward entertainment. Many Dogoduman citizens certainly viewed it that way—as nicely orchestrated, well-executed fun.

But much more was available for audience members to consider and engage. The performance could be viewed, and was in fact viewed by many, as an intricate web of interacting people, ideas and beliefs, artistic and social practices, emotions, and values. The sheer number of performers gave it complexity. Their backgrounds and positions in the community amplified it. The subject matter in the songs and the skits compounded it. And the immense talent of its featured performer, Sidi Ballo, and such supporting talents as Mayimuna Nyaarè, made it significantly more interesting and multidimensional. At any moment during the pleasurable proceedings or anytime thereafter, audience members could pick from a wealth of materials if they were inclined to contemplate their society or their lives.

Many of those social and cultural materials are presented in the chapters on Sidi Ballo, aesthetics, and meaning. In this chapter, I would like to consider the structure of the Dogoduman performance and some of the ideas, values, and

emotions audience members could associate with the performers and their inter-actions, depending, of course, on the their particular interests and knowledge.

THE NIGHT BEFORE

The Dogoduman performance started for me the night before, at the meeting of Sidi Ballo with the town elders and youth association leaders. Kalilou and I arrived in the middle of the negotiations, and after a while Sidi turned to us and said we were welcome to attend the event.

He had only one stipulation, which he explained in this way. Because it would be night and he would be dancing by flashlight, firelight, and the illumi-nation from kerosene lanterns, camera flashes would create a disorienting brightness, temporarily impairing his vision and jeopardizing his performance. He could avoid looking into the flash if we warned him each time we were about to take a picture. We merely had to shout one of his masquerade's praise names, Kulanjan, "The Long Anvil," and he would recognize our voices and look away.

As I learned the next evening, audience members were often inspired to shout praise names for Sidi. When he did something spectacular, or when someone felt moved by the moment, they would call out "Eeee Kulanjan" or one of several other laudatory phrases that had come to be associated with his mas-querade. So if Sangaré and I were to do the same thing, it would not seem out of the ordinary or interrupt the flow of the performance. It would, however, sug-gest to everyone that visitors, even one from overseas, recognized outstanding performance when they saw it. The fact that three people from out of town were attending the event was already an accolade for the featured performer. That we would be moved to praise his work so frequently—every time we shot a picture—was just one more contribution to his constantly growing reputation.

Thinking back on all of this, I enjoy its elegance. There really was no better way to announce our flashes. Simultaneously, Sidi's reputation was aggran-dized every time we shouted. But since Sidi's performance was equal to the praise, it felt perfectly natural to be yelling "Eeee Kulanjan."

It was obvious that night before the performance that Sidi Ballo was an effective image builder. He knew how to exploit situations to advertise his vir-tuosity and promote his career. The meeting at Dogoduman demonstrated that and primed Sangaré, Kalilou, and me for the night to come.

PERFORMANCE STRUCTURE

Huge numbers of Mande people find masquerade a compelling form of enter-tainment. Anticipation, excitement, and appreciation all come together to

produce tremendous levels of pleasure. People anticipate performances for weeks, and performers spend at least that much time preparing for them (Arnoldi 1995, 1). When the event finally arrives, the excitement is palpable.

Performances are anything but passive. During the event, energy swells up out of the performers and gets caught up in the audience. Often audience anticipation is shaped by knowledge of what to expect. When expectation meets execution, performers and audiences are joined in an aesthetic dialogue. They may also be joined in an exchange of ideas stimulated by the imagery, the songs being sung, and even the quality of the performances. When audience members know dancers, another layer of dialogue can be added as viewers find themselves intermingling thoughts about the performer's everyday persona with evaluations of their performance acumen. All this generates pleasure and may also stimulate deeper reflection on social or personal issues that well up out of associations encouraged by the imagery or knowledge of the performers. Masquerades can thus become memorable life experiences.

The structure of Sidi's Dogoduman performance facilitated the manipulation of excitement and audience interest while providing a stage for local performers to display their artistry and developing talents. Sidi Ballo and his apprentice appeared in segments that lasted from fifteen to twenty-five minutes, sometimes a little longer. Inside the masquerade, the master created stylized impressions of bird behavior, intertwined with humorous gestures and characterizations that made even large predator birds seem hilarious. Simultaneously, many of his gestures and masquerade manipulations produced crisp impressions of masterful, artistic motion. And ever so frequently, his gestures and motions would create strong impressions of immediate danger. Logic screamed that he would surely topple over, trip, or otherwise lose control of his masquerade. Frequently too, as if by optical illusion, Sidi could move in ways that made the masquerade seem ponderous and hard to handle.

Sidi's apprentice was always in the dance arena with the bird. His multiple roles included monitoring the masquerade for disarray after demanding maneuvers and "translating" into greetings the sounds Sidi made with a kazoo-like voice-disguising instrument. The apprentice was in constant motion, dancing in a complementary relationship to the bird and creating an interesting visual punctuation.

Sidi and his apprentice had the most time in the dance arena. But Dogoduman's youth association dancers got ample performance time and appeared in a sequence linked to a hierarchy of competence and seniority (Imperato 1972, 1980). Generally, the young boys in their very early teens came first.[1] They wore no masks and danced for ten to fifteen minutes. They were good and quite entertaining. Two masked dancers in their mid- to late teens came next, and performed for fifteen to twenty minutes. They were even more

accomplished. Their skits were from the youth association repertoire, as were their acrobatic feats. These youth association performers were whistled on and off the arena by the master of ceremonies, the young man in a deck-of-cards shirt. The sequence did vary, but it was essentially unmasked dancers, masked dancers, and then Sidi and his apprentice. Occasionally even younger children had a brief interlude on the dance arena. Once most of the youth association danced, and near the end most of Dogoduman came out onto the arena.

Dogoduman's youth association drum orchestra performed whenever anyone was dancing or singing. They were the first to arrive, tuning their drums with a small fire as the heat of the day began to wane. A chorus of young ladies, also youth association members, sang songs of love, romance, and praise for all the dancers.

Three Dogoduman elder ladies also sang. One, Mayimuna Nyaarè, was clearly the most accomplished and experienced. The other two occasionally spelled her. Their songs were about duty and responsibility as well as praise for the master masquerader. Thus the interests of maturity and stability alternated with the interests of youthful pleasure and passion.

The alternating types of songs (pleasure and responsibility) generated a cycle of point-counterpoint, producing a kind of predictable rhythm in the performance. It also generated audience anticipation that musicians, dancers, and Sidi Ballo himself used to create surprise and excitement, especially when singers veered from the pattern or dancers moved or gestured in ways that were out of sync with the mood of the music.

The regular sequence of dancers also built anticipation. The young, unmasked boys danced to the obvious pleasure and approval of the audience. They displayed a youthful energy that made their developing dancing skills enjoyable to watch. The older, masked dancers brought power and precision to the dance arena. They were more controlled, poised, and refined, and their presence was more commanding. Their dancing generated considerable excitement. And because they did some skits from the youth association, such as the inept hunter tracking the cagey bush buffalo, the audience could enjoy the unfolding of a theatrical scenario that always seemed to please.

The audience enjoyed these different levels of skill. The youth association is a forum for developing into successful adults. Performing does not just produce pleasure in accomplishment for the performers and entertainment for the audience. It displays the ways these young people are expressing their growing sense of selves and how they are filling out as people. That produces its own sense of excitement, pleasure, and pride.

But as the audience enjoyed their own young people, they anticipated Sidi Ballo's arrival, knowing that spectacular things would transpire. Without detracting from anyone else's performance, there was always palpable excitement in anticipation of the bird's next segment. It was as if the event's structure

allowed a cycle of repeated crescendo, which made the evening all the more exhilarating.

This tension, excitement, and counterpoint must ultimately be attributable to the performers themselves. The delightful point-counterpoint encapsulated in the songs would have lost its luster if the singers had not been so skilled. The pleasure in watching the dancers and anticipating the next appearance of Sidi Ballo would have been tarnished if the dancers had not been so talented. People created the structure of the Dogoduman performance, and particular performers were essential to its success.

Social life is a constant melding of many personalities, all of them changing from their engagements with others, even as those others are being changed by them. They need not lose themselves in this larger conglomeration, although some do. What makes groups interesting is that the uniqueness of constituent members contributes immensely to the character of the group and to the effectiveness of its actions.

The Dogoduman performance is a good example of this. Sidi Ballo's success there was part of a broader fabric of skilled interaction. The sensitivities, interests, and talents he brought to the performance were linked to a multitude of others who helped shape the event. Sidi stood out, but audience members would remember him as part of a whole event, produced by the skills and personalities of many players. And part of Sidi's success came from his ease at working with other players and situating himself effectively within this broader fabric of performance.

THE DOGODUMAN DRUM ORCHESTRA

The drum players were very good and very entertaining. As they tuned their drums before the event, they indulged each other in low-key banter, punctuated by just a little bit of swagger that suggested they knew how to handle themselves in the limelight of performance. Theatrical self-possession remained a part of their stage presence throughout the evening's festivities, and it was a pleasure to watch them during lulls in the dancing. Even if a masquerade is principally about the dancing, drumming and singing are tremendously important. The music they make is a critical contribution. Beyond sound, good musicians contribute emphatically to the character of the event with gesture and posture, well-timed penetrations to center stage, and the aura of confidence and vigor.

Drumming is a major part of Mande music and performance. There are many different kinds of drums. Judy Mahy (research notes, 1975) describes seventeen in the Beledugu region. They range from small two-headed, hourglass-shaped drums called *tama* or *tamanin,* played most frequently by bards,

to huge bass drums called *baraba*. Some are made of wood, others of calabash, and still others of metal. They are played with hands, sticks, or one hand and one stick. Each drum has a history of use in particular performance contexts, but drummers are constantly adding to and transforming that history, so it can be difficult to make general statements about specific types at specific performances.

A *baraba* bass drum was used at Dogoduman, along with a slightly smaller drum that was held at the side with the left hand and played with a stick in the right. The principal drum was a *bòmba,* also called *bòmjon* or *bòma.* It is a rather large wood drum with one skin, worn with straps over the shoulders. Generally played with one hand and one stick, it is frequently associated with youth association performances. At Dogoduman, one *bòmba* was used to play backup rhythms, and another was used by a very competent musician to play lead.

Mande lead drumming is complicated and often impressive. Each drum in an orchestra plays a set rhythm or series of rhythms for every song. Individually they may sound simple, the basic beat of the *baraba* being a good example. But the assembled sound is complex, with multiple tones and textures melding into patterns that can be intricate. Lead drummers weave off-beat phrasings, counterpoint, and fluid improvisations into these patterns, adding even more complexity, aesthetic tension, and excitement.

You can understand this by imagining four-beat measures of music that can be filled with half, quarter, eighth, sixteenth, and even thirty-second notes, making measures sonic spaces to be occupied. Mande lead drummers love to occupy that space complexly by placing their beats at varying distances from the beats of the other drums so that the idea of regular audio spacing evaporates. Sometimes lead beats are placed so close to others that they are barely distinguishable, as if one has slipped off the other. That goes on for a few measures, and then the lead beats are moved away so that a sense of even spacing is reestablished. Sometimes lead beats come rapid-fire in staccato patterns that are so fast that you must hear them several times to figure out how many strokes were actually played. And those too will move around in the measure, sometimes coalescing closely around other players' beats, other times pulling away from them to create a kind of fluid undulation. This audio mobility is executed with precision so that, taxing as it may be to a Westerner's expectations of regularity, it is nevertheless obvious to Mande that it is being performed with high degrees of finesse and exactitude. Great excitement mixed with very pleasurable tension is generated. It is audience expectation meeting virtuoso improvisation.

Around the world, the best known Mande lead drumming is associated with a drum called *jembe,* and the lead drummer at Dogoduman performed like a *jembe* drummer. The *jembe* is similar to a *bòmba* except that where a

bòmba has a rounded, almost tear-drop-shaped profile, a *jembe* is more angular. It is very large, made of heavy wood, and worn with straps over the shoulders. Usually large, thin metal wings are attached near the drum head and loaded with little rings set in holes around the edges, which wave and create a metallic rattling as drummers play and move around. *Jembew* (plural) are played with two hands, held at various angles and in various finger-and-thumb positions to produce three or more different tones. Combine the profound and exacting speed of expert *jembe* players' beats with the patterns of tonal variation they create, and you have expertise as awesome as it ever gets in music anywhere in the world. It is riveting and commanding.

Jembe drumming has become world famous because of such virtuoso drummers as the Republic of Guinea's Mammary Keita and America's David Coleman. Frequently in the Mande world, the lead drummer at festivals is a *jembefola,* "the one who makes the *jembe* speak." He is also known as *golobali,* the one who performs the improvisations, and *tigèlikela,* the drummer who cuts the rhythms, that is, divides up segments of music into taxingly complex new patterns. As a song progresses, he will suddenly come in with his improvisations—often strongly off-beat, powerfully discordant, tremendously complicated, and imaginative. These drummers bring audiences to attention.

These same skills are also associated with other good Mande drummers, such as the young man who played lead *bòmba* at Dogoduman. Such virtuosity becomes a prominent, moving part of performances. Good dancers respond to it, even anticipate it. They will stop, then throw their shoulders into a solo, so their lower bodies mark major rhythms in the basic beat, while their upper bodies complement the drum solo. When the drummer speeds up dramatically, so do the dancers, some even somersaulting forward or backward. These contiguities between the dancing and drumming become as important to the event as the musicians and dancers are individually, amplifying the event's aesthetic tension and excitement. They absorb audience members into the performance, expanding the likelihood that the evening's experience will be remembered as compelling and influential, something to think about.

Dogoduman's lead *bòmba* drummer was named Sori Jabaatè. He sometimes discarded his stick and played *jembe* style. He was a very good player, and during the performance his abilities were acknowledged in a song of praise. Another time the whole Dogoduman drum orchestra was praised with a song that originated as a praise song for a great *jembe* drummer named Bakari and later became a song of acknowledgement for all good drummers. At Dogoduman it was also modified to praise Sidi Ballo.

> Village with its charming drums.
> I ask you to play the drums.

I ask you to play the drums.
Charming.
Griot drum player, play the drums.
For the bird named Kulanjan.

Dugu n'a sarama dunun.
Ne k'aw ka dunun fò de.
Ne k'aw ka dunun fò.
Sarama.
Dununfò jali ka dunun fò.
Kulanjan kònò ye.
(Camara, McNaughton, and Tera 1998, 5/35)

"Griot drummer" refers specifically to Sori Jabaatè, identifying him by his clan's profession. As the song moves along, all the other drummers are praised, as are the singers and various audience members such as the town chief and the youth association leader. Sidi is praised with reference to the wondrous potency described by his praise name Kulanjan, "The Long Anvil," a legendary and extraordinarily powerful blacksmiths' apparatus.

Sori Jabaatè was a member of the Mande clans of bards, or griots, called *jeliw.* All the other drummers bore the last name of Camara, indicating membership in the Camara clan of blacksmiths. This made every young man in the drum orchestra also a member of the large grouping of diverse clans called *nyamakala,* who comprise what Mande conceive of as the special professions. They are generally agreed to include blacksmiths (*numuw*), whose men work wood and iron and whose women work clay; bards (*jeliw*), musicians and historians who perform the genealogies and epics of Mande's great leaders and heroes; and leather workers (*garankew*), who make all sorts of leather products, including tooled covers for amulets. The origins and histories of these groups are complex, with tremendous variation in specialized activities and also in the social structures that purport to govern the groups quite strictly but that in practice are porous and flexible. In addition to their specialized physical labor, the *nyamakalaw* clans are also held to be especially laden with the energy or force called *nyama,* the power behind all acts, the force that underpins and gives character to the world, the energy that animates the universe. *Nyamakala* is sometimes translated as "handle of power," suggesting that these special clan members manage and provide access for other society members to the benefits of deploying this power. It is, however, potent to an awesome degree, and Mande often see it as exceedingly dangerous. Thus "handles of *nyama*" clan members also create a buffer between ordinary citizens and the tremendous forces that shape the world and, ultimately, everyone's lives (McNaughton 1988, 1–21, 156–61; Conrad and Frank 1995; Hoffman 2000).

It is interesting that all the Dogoduman drummers were *nyamakalaw.* Members of those clans are raised and trained in ways that predispose them to be performers, from psychological and social points of view.

We can understand this with reference to the broader social system. Most people belong to the *hòròn* clans. This name has been variously translated as "noble" or "freeperson," which distinguishes its members from the special professionals. It also distinguishes them from another, now defunct but formerly sizable portion of the population, slaves (*jonw*), who were tied to the households of freepersons. Historically, leaders have been drawn from the ranks of freepersons (*hòrònw*), and while the majority are generally farmers, a great many also take up such enterprises as commerce and various kinds of artistry, along with the full panoply of urban-based professions such as banking, business management, government agencies employment, and airline industry jobs such as pilots.

Nyamakalaw and *hòrònw* are raised very differently in a number of significant ways. One of the most important is how they are taught to perceive and respond to the energy called *nyama.* Most *hòròn* freepersons find *nyama* threatening, even though they must work with it, at least to some degree, in daily life. Most *nyamakalaw* special professions have a more positive interpretation of *nyama.* They see the energy as a resource they can manipulate to enhance their artwork and harness—for good or ill—on behalf of other society members. Working with it is part of their long years of training.

Another important difference between *hòròn* and *nyamakalaw* is how they are raised to conceptualize their public demeanor and interactions with others through a social principle called *malo,* "shame" or "constraint" (Arnoldi 1995, 150; Brink 1980, 419; Kone 1998). Mande characterize *malo* as people "controlled by another's eyes" (Brink 1982, 419). It weds protocols of social behavior to psychological comfort, as individuals constantly weigh their own actions against the expected responses of other people across a spectrum of power and social authority and against the mores of the collectivity.

Hòrònw (freepersons) are raised to be restrained and subdued in the face of other people with more power or authority. At least theoretically, they keep their emotional responses relatively guarded, and they generally feel uncomfortable with social attention focused on them. They are taught that speaking and acting are best done with caution and that reticence is preferable to exuberance. Kone (1998) notes that this constraint or shyness is considered noble, while behavior that attracts attention can be humiliating.

There is considerable variation in how *malo* influences *hòròn* behavior, according to age, personality, past experiences, and specific situations. But it is, in a sense, a top-down conceptualization of social order, because it privileges an established status quo and therefore, often, elders. Brink summaries its potentially chilling effect as individuals being "socially constrained by

another's power, authority, or social position, and ambivalent about how one's behavior might be interpreted and reciprocated." A person who yields to its stifling effects "submits to exterior social controls and is disarmed by them, and is thus incapable of projecting himself as an individual into social situations" (1982, 419).

Too much of this could throw society into stasis by dampening people's dynamic action in the world. And the dynamic action of individuals, the fulfillment of personal potential, and the ability to ride competence to success are all pronounced Mande values that are repeatedly authenticated by Mande history and Mande art. Thus it is not surprising that for many Mande the effect of *malo* is to sharpen, rather than inhibit, social action. Its constant presence in individuals' living experiences encourages the development of social perception and analysis as well as the skills to engage people and situations with subtle acumen, thus creating individuals of substance and affect. Developing these abilities is an important measure of growing maturity and a necessary means to social, political, and economic success. Youth theater and masquerade are vital forums for this personal development because participation places performers directly in the scrutinizing gaze of others (Brink 1980, 1982). For *hòrònw,* performance is an opportunity for individuals to reconcile discomfort and ambition.

As members of *nyamakala* clans, the Dogoduman drummers did not feel *hòròn* disquiet because they were raised to be comfortable as the focus of other people's scrutinizing attention. They are more easily self-assured, commanding, glib, elegant, even charismatic in the limelight, and they are also quite capable of being loud, rude, and even a bit ribald. They are taught to handle attention proactively in their youth, because many of their professional activities later will demand it. For example, blacksmiths are frequently social intermediaries and mediators of civic affairs in their communities, while bards also fill these roles, often being spokespersons for important and powerful people. Bards in particular are trained to master public protocol, to guide and manipulate events, and to be at ease engaging all of the personalities and characters that constitute an audience. All this suggests that Sori Jabaatè should have been readily at ease as Dogoduman's lead drummer. And indeed he was.

The other Dogoduman drummers were smiths, and blacksmiths and leather workers are as comfortable with attention as are bards. Many set up shop in a city street or in ateliers with waist-high walls so that passers-by can easily see them. People often congregate at these work sites, sometimes just to talk or enjoy the ambiance. At a smithy, when the iron is red-hot, the hammer blows are resonating, and the sparks are flying, that ambiance is dramatic and exciting. Many smiths grow comfortable at the center of it, enjoying the attention. Sometimes smiths show off their prowess at festivals by dramatically working glowing iron with their bare hands, employing full-scale showmanship to enthrall the crowd.

Leather workers have less overt drama in their production processes, but everybody knows that they too handle the potent energy called *nyama.* They have a wonderful collection of cutting and incising tools and can handle them with a deftness and precision that is hypnotic to watch. Some develop a working personality that emphasizes a mild, self-confident flamboyance, while engaging with ease in conversations about people and current events. I once watched a leather worker who always seemed to have a crowd around him. He worked in downtown Bamako, on a main street near the Grand Mosque. As he sat on woven mats, the physical movements of his profession—cutting, folding, sewing, incising, and dyeing—flowed easily into stately, crisply dramatic postures and gestures. He joked about the powers he manipulated as he worked on public items such as knife scabbards and bags. But as clients arrived to drop off private little packets or pick them up later as finished, leather-covered amulets, this artist made a show of deftly hiding them in his palm or pulling them almost magically out from under his mats. He transformed discretion and secrecy into theater. Like many other *nyamakalaw,* he was an artisan who chose to infuse his work with flair.

The concept of *malo* is embedded in other Mande concepts, so that the principles that characterize it are rendered more complex and more parts of people's live are affected by it. In the context of performance, *malo* commingles with the concept of energy called *nyama* and with aesthetics. All actions require *nyama* to fuel them, and the more difficult or complicated they are, the more power is required. For example, hunting, statecraft, and performance are difficult. So hunters, leaders, and performers who have abundant *nyama* also have an advantage. In addition, possessing *nyama* and knowing how to manipulate it is advantageous in dealing with *malo.* Thus the *nyamakala* drummers at Dogoduman were doubly fortunate.

But *nyama* is also vented into the social atmosphere as a by-product of action, and again, the more difficult the action, the more *nyama* is unleashed. Performing is difficult, and engaging *malo* with action in performance arenas is also bound to unleash some energy. Mande are quick to say that the presence of *nyama* can be disturbing. It can overwhelm people, make them sick, sterile, unlucky. It needs to be controlled, and excessive accumulations ought to be avoided. Happily, as *nyamakalaw,* the drummers at Dogoduman were well equipped to control *nyama,* even though they themselves possessed more of it and were more likely than *hòrònw* to radiate it.

Good drumming produces beauty, particularly when it is crisp, complex, and challenging. Beauty in Mande generates its own *nyama,* and once again, the greater the beauty, the higher the levels of this decidedly potent and dangerous energy. The Dogoduman drummers were thus firing with both barrels, as *nyamakalaw* and as good drummers.

But *nyama* is experienced more complexly than as just a force to fear. Its potential danger adds an edge; it generates a kind of excitement. Its presence can be simultaneously scary and thrilling. So you could say that a drum orchestra full of *nyamakalaw* added excitement to the performance at Dogoduman. Some audience members would not give it a thought. Others most certainly would.

Good drummers do not have to be from *nyamakala* clans. But the fact that they were at Dogoduman gave the event a particular flavor in the perceptions of audience members. So too did the fact that Sidi Ballo was also formerly a practicing blacksmith from one of the *nyamakala* smiths' clans.

MAYIMUNA NYAARÈ AND THE WOMEN SINGERS

Music is called *donkili,* "the egg of dancing." It is the embryo from which dance springs, the foundation on which dance builds a performance. Like drummers, singers bring their own kind of life to music, and in masquerade performances they provide critical conceptual underpinning. Their songs identify, explain, and elaborate upon masquerade characters; and many, like many masquerades, present ideas and values for audience contemplation. The songs interact with the motion and gestures of the masquerades to create a kind of meta-dialogue on social life. This music—the drumming and singing—flows into the perceptions of participants and is as central to the experience of masquerade as the visual elements of the event. Arnoldi (1995, 38–39) says that when women singers contemplate the history of masquerade, they think of the talented singers who have come before them.

Like drummers, many singers get their start and then their support from the well-developed infrastructure of the youth association, or *ton.* This institution has a branch in nearly every town, and its history and character is well known in the literature (Arnoldi 1995; Brink 1980, 1982; Imperato 1972, 1980; Monteil 1924). It is a hierarchy of age grades and youth leadership, with a mandate to carry out public work for the community and to stage ambitious, greatly appreciated masquerade and rural theater performances that revolve around the agricultural cycle. The *ton* was the catalyst for Sidi Ballo's career, because he began as a youth association dancer. At the 1978 Dogoduman performance, it provided the other dancers and masqueraders, the drummers, and most of the singers. Only the elder ladies were not direct members of the *ton.*

Two choruses (*dònkilidalaw*) of women sang at Dogoduman. The young ladies' chorus (*npogotigikulu*), consisted of youth association women in their late teens and twenties. Two played *gitaw,* calabash drums with strings of cow-

rie shells attached, which the ladies swished and swirled to create a cascading ostinato that played off nicely against the drum rhythms. They were the lead singers (*tèrèmèlikelaw*), meaning they sang the main lines of the songs, while the other young ladies, *dònkililaminelaw* (the response singers), sang response lines and the refrains.

The chorus of senior women (*musokòròkulu*) also consisted of lead and response singers. The principal lead was Mayimuna Nyaarè, a very good singer who had earned the accolade *dònkilidalakònò*, "singing bird," given to accomplished vocalists. Mayimuna sang nearly all of the senior songs. A woman named Salikènè spelled her a few times, and once a woman named Hawa sang lead.

Usually the young ladies' and senior ladies' choruses alternated songs, although sometimes each would perform several in a row. Also, in general, the chorus of young ladies sang songs of romance and praise for great deeds—including outstanding masquerade performing—while Mayimuna and the senior chorus sang songs about ethics, proper comportment, social responsibility, and fidelity to tradition, with some songs of praise as well. These divergent themes created different moods, which were enhanced by the singers' phrasings and tones, their physical gestures, and their presence as dynamic young ladies or respected elders in the arena.

As a rule, when the senior ladies sang, *Kònò* was relatively still, though he frequently made squealing sounds with his voice disguiser. Silence was an indication of thought or reflection: *a bè suman k'a hakili sigi*, "he is cool and lets his mind repose." Squealing or making laughing sounds brought a controlled sense of youthful irreverence. When the young women's chorus sang, *Kònò* became much more animated, accelerating around the dance arena as if to emphasize his youthful vigor, suggesting that he was full of energy and enjoying it: *a bè jaman*, "he is excited, stirred up, animated." Such coordination between music and masquerade amplified the effect of each, creating a synergy that added impact to the performance.

The conceptual division of labor between the senior and junior singers, intensified by the bird's audio and visual action, added a level of meaning and value grounded in a Mande social precept that engenders patterns of behavior in every zone of social interaction. For Mande, age matters. People are aware of the age of virtually everyone in their lives and thus are so acutely mindful of age differences in all their acts that this chronological knowledge becomes a social sixth sense. Younger people must show deference to older people, and truly senior people should be treated with the utmost respect. This is manifest in relations between family members and friends, in the rules of inheritance, in the youth association age grades, in the politics of succession, and even in the aesthetics of performance protocols. This might seem to bespeak a rigid gerontocracy, and in a sense this is

true. People are careful about the way they talk in the presence of their seniors and also of the things they say. They are also well aware of the sorts of things they can and should not do in the face of their seniors, and of things they should and should not do in general, because of their age, even if elders are not around. At the same time, however, there is much fluidity in junior-senior interactions, based often on social savvy. Young people very frequently find ways to work the system or adjust its strictures to their own needs. And there is also a balance created by reciprocity, the other side of authority being responsibility. For example, older people can treat younger people like virtual servants, particularly within families. But those older people can also find themselves engaged in energy-draining, time-consuming activities to help their younger relatives in all kinds of social, economic, and even legal situations.

Given the nature of human psychology, these beliefs, strictures, and protocols, with the nuances and subtleties that individuals add to them, naturally generate tension and contestation. Some elders are obstinate and cantankerous, and some are oppressive and authoritarian. Some youth are rebellious and disrespectful, and even when they are not, there are still large discontinuities between the values and desires of elders and youths. This was reflected at Dogoduman by the more sensual songs of the young ladies and the more duty-and-obligation songs of the elders. It was also reflected in the squawking of the bird when Mayimuna Nyaarè sang. Masquerade theater is a forum for people to examine their society's character and to experiment with the ways they can engage it. To a considerable degree, performers have license to stretch and even challenge everyday mores in the service of entertainment, social exploration, and self-discovery. As an example, in one of the songs of praise for Sidi Ballo, a young lady improvised a verse to state that she would happily give herself to the bird masquerader, something she would not say in the everyday presence of elders. Thus, the rules between old and young—this powerful force in social life—commingle with the powerful force of people testing and manipulating those rules, adding to the excitement of masquerade performances. It is the intersection of expectations derived from social formations and the character of real people in specific life situations.

There is another layer of complexity to this "battle of the generations" that feeds potently into masquerade. At once practical and philosophical, it is a grand Mande mapping of the cycles in people's lives. In a broad, sweeping way, Mande generalize about times of life. From their mid-teenage years until their mid-forties, men are in their time of opportunity, "the prime of their life" (Arnoldi 1995, 153–54). It is a time for bold, youthful adventure and the confidence of physical and sexual prowess, and it is also a time for the development of social and professional accomplishment, a time for working hard to gain experience and expertise in order to become a person of substance. This is the time

when most men, in effect, build their lives. While there are ample similarities, women's prime time (*npogotigi*) is more quickly left behind as they enter their time of child rearing (*musomisèn*).

Both men and women hope to enter elder time (*cèkòrò* and *musokòrò* respectively) as respected individuals, enjoying the esteem and support that, ideally, they have earned. As elders, they want to be held in high regard by their families and their communities as figures of authority, and they want to be treated with great deference. Theoretically, their years of learning about, and living in, the world have given them the acumen of accumulated experience, while their years of social networking have given them a constellation of valuable relationships with other people as well as the knowledge and abilities to maneuver in the social world with intelligence and suppleness. They can be conceived of as ripe (*mò*) with all this expertise, and that translates into large quantities of the energy called *nyama*. An extreme way of imagining this amassing of experience and power is with the appellation *nyankaran*, "one that walks alone," designating wild, powerful animals that, in old age, have become too dangerous to be near. It is used to suggest individuals rippling with supernatural energy and therefore formidable and worthy of the utmost respect. A more everyday way of considering this human accumulation of experience and power is by realizing that it is part of what gives authority and clout to heads of households, members of town councils, and town chiefs.

An image that reflects the essence of elder's time can be seen every day all over Mali. In town squares (*fèrèw*), on large log benches under even larger shade trees, sit old men whose families support them with the physical labor they no longer need to do themselves. But they are not just retired. They are veritable spigots of information on community affairs, current events, and even many local family matters. These gentlemen command respect and can detain passers-by with the insistence of proper greetings or even lengthy conversations. These old people are said to be full of the wisdom of the world. Thus, if you come to them with issues, questions, or dilemmas, they may respond with *mògòkuma*, "elders' speech," which is held to be very clear, deeply insightful, and frequently philosophical.

Elders often use their tremendous authority to promote conservative values. It is a little difficult to generalize about those values, because many younger people share some elders' more conservative points of view, while many old people are more liberal. Ultimately, the interpretation of values resembles the interpretation of songs: people may adjust meaning to suit their own perspectives and desires. Nevertheless, there are generational perspectives, which are projected and tested in masquerade.

All of these qualities were perceived as being situated in Mayimuna Nyaarè's songs at Dogoduman. They invoked respect, honor, and warm-hearted

devotion to the status quo beliefs of her generation. And they were not to be taken lightly, both because of deference for age and because elders are a major power block in Mande society.

These same town squares where elders congregate to dispense their clear and authoritative speech are the sites of masquerade and rural theater performances, where Sidi Ballo danced and Mayimuna Nyaarè sang, where the beliefs and vested interests of elders and youths were launched into the crowd with characterizations by dancers and verse by singers. In their youth, Mayimuna and all elders accepted, modified, and adapted the *sirakòrò*, "the old, true path," the "traditional way" of being and doing that their elders tried to impress upon them. Now, as elders themselves, they strive to inculcate the version of the true path they created into a new generation of youth, which is, of course, busy shaping its own social reality.

The realities of elders' long lives are reflected in the imagery and metaphors of their songs. Mayimuna Nyaarè's songs were eloquent and brimming over with nuance that could evoke tremendous feelings of beauty, nostalgia, and duty. One song combined frequently repeated praise for Sidi Ballo with the theme of dying young (*sa joona*). Dying young is a deeply lamentable turn of events, accompanied with great sadness and heartfelt loss. In song, it can have complex overtones that conflate grief and the importance of personal accomplishment. Thus, Mayimuna Nyaarè sang these lines as a refrain throughout the song:

> The one who dies young has lost his opportunities.
> The one who doesn't can accomplish much.
>
> *Sajoona mako salen.*
> *Sabeli mako nyalen.*
> (Camara, McNaughton, and Tera 1978, 5/12)

Here, to die young is to build nothing with your life, as if you had never existed. An unripe fruit cannot be eaten, and in the realm of human affairs, to become ripe is to grow into an elder, with its concurrent accumulation of importance and *nyama*. Sekuba Camara translated the first line above in a gentle way, but Kassim Kone (1997) notes that a harsher translation is also valid: "He who dies early is surely a loser."

A widely asserted interpretation of this line is that it is wise to busy yourself early at the enterprise of gaining expertise in useful ventures and to live within established Mande mores so as not to risk premature death. This is admittedly helpful advice and often very good for young people to hear. But it also squares nicely with elders' vested interests in having the young accomplish much so that the old can be well cared for.

The song's next two lines amplify this interpretation by heralding the universally acknowledged accomplishments of the bird masquerader Sidi Ballo:

I address Kulanjan.
The one who does not die young.

Ne ye n'sarala Kulanjan na.
Sabali de.
(Camara, McNaughton, and Tera 1978, 5/3)

"Addressing someone" in song is a very popular and effective way of praising. It incorporates two deep-seated Mande values. First, most Mande have an intense love of music, finding it beautiful and very moving. So to be referred to in song is highly gratifying. Second, it is widely believed that having your name and accomplishments remembered in history is most worthwhile. Songs are part of Mande oral history, and people who are driven toward fame want to have songs sung for them—or better yet, to have songs created for them. The praise for Sori Jabaatè, the drummer, and Sidi Ballo, the dancer, at Dogoduman were local adaptations of established songs and so partook of the Mande mechanism of gratifying praise.

To follow lines proclaiming the value of accomplishment with lines of praise for someone very accomplished highlights the social value of Sidi Ballo's virtuosity, while urging the less accomplished to greater effort. Those dual effects are made all the more potent by the fact that everyone knew Sidi Ballo was still a young man, *kamalen,* in his prime of life. To amplify that youthful achievement, Mayimuna Nyaarè chose to call Sidi "Kulanjan," the one among his several praise names that invokes great power and strong references to a glorious Mande history, by referring to characters in the Sunjata epic, as we shall later see. In short, Mayimuna reconfigured an established Mande song with a strategy that articulated the elders' vested interests, an ideology of the status quo.

In another song, Mayimuna sang of the intermeshing of people that can help make someone successful:

Someone with no advisor
in his life.
You cannot be anything but
A man among the masses.
A bird who doesn't have
a good mother as advisor,
A bird who does not have
a good father as advisor,
A bird without

a solid sibling as advisor,
A bird without an advisor in his life,
You can be nothing but
a man among the masses.

Kun tè maa min na
Dinye na.
F'e m'i yèrè kè
Maa fè maa ye.
Kun tè kònò min na
Woloba nyuman si kun tè,
kònò min na
Wolofa nyuman si kun tè,
kònò min na
Balema jòlen kun tè,
kònò min na dinye na
F'e m'i yèrè kè
Maa fè maa ye.
(Camara, McNaughton, and Tera 1978, 5/24)

Interesting things transpire in these lines. Mayimuna begins with a gen-
eral word for person or man (*maa*), but thereafter refers to the bird, as if she
were giving the renowned bird dancer personal advice. She is an elder, after all,
and the protocols of age make that natural. Next, the idea of personal advisor
is stressed. Mande feel individuals need advisors to become accomplished. An
advisor is a *jatigi*, a "master of the soul," or the owner of your soul. It is some-
one of profound importance to you who teaches, guides, helps to empower,
and protects you. Your *jatigi* may be a wise and highly respected person, an
elder of substance and clout, a powerful sorcerer, or a Muslim marabout. A
proverb suggests that without a *jatigi*, you cannot be successful: *Kò tè maa min*
na nyè tè malo o ma. Sekuba Camara (1978, 3/24) offered this interpretation: "A
person without a back cannot be respected by persons with faces."

Without someone of substance backing you and showing the right way,
you will not garner success in the eyes of your social peers and seniors. And of
course, one's soul master will be, perforce, someone older and established in a
network of accomplishment and social values, someone who very likely repre-
sents an elder's perspective. In addition to a *jatigi*, family and lineage must also
stand behind an individual. Mayimuna Nyaarè emphasizes that aspect, thereby
drawing audience attention toward family values as well as the necessity of a
soul master. So again, Mayimuna articulates elders' vested interest by linking
them to other important ideas and components of successful social life.

Clearly, Mayimuna Nyaarè was an effective elders' spokeswoman at Do-
goduman. Her songs were sung with great beauty, eloquence, and tempered,
restrained passion. A strong aura of dignity permeated her presence, her

gestures, and her movements in the dance arena. Usually she and the elders' chorus sang from the periphery of the arena, near the drum orchestra. But she took to the arena several times during the performance to interact directly with the bird as she sang. Whenever she did, the master masquerader paid her immediate attention, circling or doing figure eights around her, rearing up in front of her, or settling down before her and squawking to her words. Those were galvanizing moments, fraught with the weight of two significant individuals playfully at odds with each other through art. The audience loved it. The subtle force of Mayimuna's personality, evident in her bearing and demeanor, was in part created by her elder status. But, in equal part, her bearing and demeanor contributed to that status, helping to shape and authenticate the very concept of elder's time in Mande.

The songs performed by Mayimuna Nyaarè and her elders' chorus were very well received at Dogoduman. But the younger generation was also well represented by the youth association drummers and dancers and by the young ladies' chorus. Their perspective is complex, combining the need to cooperate with elders, the desire sometimes to emulate them, the desire at other times to strike out on their own, and the need to express the realities of their developing experience. Often the dancers' skits and the young women's songs demonstrated their accumulating successes as they moved into adulthood and ultimately created their own true path and traditional way (*sirakòrò*). Sometimes they seemed to adopt elders' values. Sometimes they satirized elders' foibles.

The members of the young women's chorus were full of the charm of their youth. Their songs were sensitive and lilting, and during performance breaks, they spoke and laughed quietly among themselves in a way that suggested dignified, understated sensuality. From time to time while singing they would leave their place at the edge of the arena and promenade around its perimeter. As they made their circle, the two lead singers would repeatedly toss their large calabash *gitaw* into the air, spinning them to make the cowries rattle in crisp, regular, repeated patterns that added elegant precision to their performance.

In general, the young women's songs were shorter. Their feeling of romance and passion derived from the gestures, tones, and personalities of the young ladies singing them, as well as from the aspirations and experiences of the young persons who listened. And this sense was very much a part of the event, creating subtle contrasts with the performances of Mayimuna Nyaarè and the senior women singers.

The young ladies' chorus always sang when the masked dancers from Dogoduman's youth association (*ton*) were in the arena. Often they sang songs of praise for the budding achievements of these young men. One song, sung with tremendous speed and energy, kept likening the masked dancers as well as the bird masquerade to powerful wild beasts, a very honorable

form of Mande praise. The words came by so swiftly that an impression was created of a blur of wild creatures, which gave the praise an almost awe-struck quality:

Tall, beautiful, powerful horse of Saliso.
The Ntomos are lions.
Ah yes, the day the Ntomos come out,
The bird is a lion.
Dogoduman hyena, the day it comes out,
The bird is a lion.
Ah yes, the day the bird comes out,
The buffalo is a lion.
Oh yes, the day of the battle,
Ntomos are lions.
The day of the battle of Dogoduman,
The Ntomos are lions.

Gunbe Saliso.
Ntomonun ye wara ye.
Iyee Ntomo bò don de,
Kònò nin ye wara ye.
Dogoduman nama bò don de,
Kònò nin ye wara ye.
Iyee kònò bò don de,
Sigi nin ye wara ye.
Iyee kèlè kè don de,
Ntomo ye wara ye.
Dogoduman kèlè kè don de,
Ntomo ye wara ye.
(Camara, McNaughton, and Tera 1978, 5/2)

This song used the rhythms and the first line of a well-known song dedicated to Saliso, a famous warrior from the Niono region north of Segu, who is said to have fought the Segu state leader Da Monson and the Fula state of Macina in the early 1900s. This associates the glory of a hero with the young masked dancers of Dogoduman. From the second line on, the song becomes a poetic review of the Dogoduman dancers. Each masked dancer is named in turn, with the Saliso line following each time as a refrain.

The first line does double duty by invoking the huge, powerful, and beautiful horses called *gunbew*, which are generally owned by kings. From then on, all the Dogoduman dancers, including Sidi in his bird masquerade, are likened to lions, evoking, for many Mande, images of courage and perseverance as well as strength and grace, even though these days lions are said to have disappeared from Mali. For many Mande, references to lions also invoke the Lion King Sunjata, one of Mali's most widely known heroes, who

founded the Mali Empire. The "battle" mentioned toward the end of the song does not refer directly to war, but rather to the kind of courage it takes to fight the "battle of life," which is the struggle to become someone worthwhile.

No matter how much they are transformed to suit particular occasions, songs still generally belong to categories that are appropriate for particular kinds of performances, for particular times in a performance, and for particular kinds of masks and masquerades. For example, toward the end of the evening at Dogoduman, after much spectacular dancing, it became appropriate for the young women to sing a particular kind of praise song while the bird was offered a respectful, refreshing drink of milk or water in the middle of the arena. Their song included these lines:

> Drink!
> Drink the water, Kulanjan.
> This is your drinking water.
> The water is very fresh.
> Drink the water.
>
> *I men de!*
> *Ji min de, Kulanjan.*
> *I minji ye nin ye.*
> *Ji sumalen tòntòn.*
> *Ji min de.*

These were repeated numerous times as a refrain, and interspersed among them were lines like these:

> If you need a silver bracelet.
> I will give it to you.
> If you need my gold earring.
> I will give it to you.
> If you need my white waist band.
> I will give it to you.
> If you need my sweet talk.
> I will say it to you.
>
> *A mana kè ne boloba wari ko ye.*
> *Ne n'o d'e mò de.*
> *A mana kè n'na tulo rò sanu ko ye.*
> *Ne n'o d'e mò de.*
> *A mana kè n'na julabayajè ye.*
> *Ne n'o d'e mò de.*
> *A mana kè kumakan duman ye.*
> *Ne n'o f'e ye de.*
> (Camara, McNaughton, and Tera 1978, 5/46)

Milk and water are Mande drinks of hospitality, offered to visitors in ordinary social situations and to performers in artistic situations. To describe it as "very fresh" is to emphasize its welcoming capacity. All the gifts the young women mention are considered precious, particularly the white waist band, which says indirectly that the lady is willing to give all of herself to the gentleman. Thus, the desires and sexuality in youth's experience enter the performance.

At Dogoduman, members of each chorus chose their own songs, and once in a while another chorus member would say that one was not appropriate for the moment. Once one of the leads in the young women's chorus mentioned Sidi Ballo by name, and she was stopped immediately by the others because to state his real name is bad luck and only his praise names are used while he performs.

There is no doubt that Sidi Ballo was the most important performer at Dogoduman. The town hired him to be featured in an event that would not have taken place without him. But like the drummers, the singers were critically important and did much to shape the performance. Mayimuna Nyaarè actually ended it by singing that she was tired and was going to go home, and the young women's chorus gave the evening its final sentiments.

After hours of entertainment, Mayimuna sang:

> Hey, Kulanjan
> I'm going home.
> To go to sleep.
> Let me go to sleep.
> Kulanjan, let me
> go to sleep.
> Kulanjan.
> Let me.
> I'm going home.
>
> *Ee, Kulanjan kònò*
> *N' bè taa so.*
> *Ka taa n'da.*
> *Ka n'to n'ka taa n'da.*
> *Kulanjan ka n'to*
> *N'ka taa n'da.*
> *Kulanjan kònò.*
> *Ka n'to.*
> *N' watò so.*
> (Camara, McNaughton, and Tera 1978, 5/60)

To this the young ladies' chorus responded with two very short songs. First, a song with just two lines, repeated a number of times:

Joyful solidarity.
The one who comes goes.

Deli yo.
Nabaa de ye taabaa ye.
(Camara, McNaughton, and Tera 1978, 5/62)

Yo is just filler, adding exclamation, and rhythmic counterpoint to the *ye*.
Deli does not translate easily into English. It means a feeling of attachment
between people that has come from spending a long evening together at a per-
formance such as this one. "The one who comes, goes," is a phrase used at
funerals and can be applied to other events to express the sadness of separa-
tion.

And then they sang:

I say if you can do nothing but go.
Ah, Kulanjan.
If you can do nothing but go.
I regret it, but must let you leave here.

Ko n'i ma nyè taali kò.
Ah Kulanjan.
N'i ma nyè taali kò.
Ne b'i bila yan.
(Camara, McNaughton, and Tera, 5/63)

At Dogoduman there was a master of ceremonies who directed much of
the masquerade traffic on and off the dance arena. But clearly the singers could
do some directing of their own. Their songs were important to the character of
the event and so were their performance personas. Performances are supple
intermeshings of multiple personalities, which can be chaotic but can also
produce a rich and stimulating quality of open-endedness.

THE AUDIENCE

Performers provide entertainment for audiences. But their interaction is by no
means one-way. In fact, the symbiotic relationship between the performers
and the audience is nothing short of artistic co-dependence. Performers feed
off audiences, who often share a familiarity with the characters, ideas, and
values the performers put at play. This mutual familiarity fuels the excitement
of anticipation, the evaluation of execution, and the appreciation of improvisa-
tion, and all of that together takes the event out of the realm of mere spectator-
ship and into the realm of created experience. Good performances are

wonderful enactments of intersubjectivity, because many people contribute to their form. This is especially true where audience members may be called out to perform themselves, as in Mande masquerades.

Mande make broad distinctions between sacred and secular performances (Arnoldi 1995, 21–24). Sacred performances have restricted audiences, generally members of a spiritual association who coalesce around bodies of secret knowledge that are pivotal in the association's activities and central to its artwork. Managing, expanding, and activating power through that knowledge are important goals of these organizations, and because the knowledge is esoteric and the power extremely potent, performances are considered serious business, what researchers frequently call *ritual*. Often these events incorporate sacred objects, such as the distinctive headdresses of Kòmò, musical horns covered with sacrificial materials, or the amorphous, bovine-like constructions called *boliw*. Often too, association leaders call spirits into action, and sometimes spirits are associated with the sculptures. Audiences for these kinds of performances are especially prepared to deal with the energy (*nyama*) that emerges from such objects, the spirits, the ritual procedures, and the leaders. If they were not, they would be at risk. Thus, serious is an apt way to describe these proceedings. Arnoldi (1995, 207) and Brink (1980, 95) note that they are called *nyan, nyene, nyene-fe,* or *nyan-fe,* meaning "before the power object," which shows how central and fundamentally important these amuletic devices are.

Secular performances, such as festivals or youth association theater and masquerade, are conceived of quite differently, as the kind of play, or *tulon,* called "amusement or entertainment," *nyènajè* (Arnoldi 1995, 21). This sort of pleasurable activity can also be called *yele-ko,* "comedy," or *tlon-ke,* mimesis framed as play in theater (Brink 1982, 423). These secular, public activities have larger audiences than sacred performances. They include a wide spectrum of ages, from very young children to people in middle age and even senior citizens, though some elders prefer not to attend some performances, particularly those emphasizing social satire. Also, such audiences are of mixed gender, whereas the audiences of secret association ceremonies are most often gender-restricted.

While entertainment performances are conceived of as play, many of the ideas embodied in their characters, choreographies, or lyrics address important social issues that audiences may consider as they enjoy the event. This gives play a serious side.

Another serious side involves the amulets Sidi Ballo wore when he performed. Secret knowledge and the articulation of power are not focal points of these secular performances, but many performers and member of the audience believe such knowledge can improve performance abilities and protect participants from mishap. Therefore, performers often fortify themselves with

amulets and other forms of power that bring *nyama* into the event. Also, becoming an accomplished performer and thereby earning renown can make some people in audiences jealous, and they may try to inflict sorcery upon the performer. So performers, even in secular contexts of play, often protect themselves with such supernatural devices as amulets (*sèbènw*). Thus, veiled motivations and secret enactments of sorcery can also be part of Mande secular audiences, as can the energy called *nyama*. In addition, some performers also employ materials in their masquerades that everyone knows are loaded with *nyama,* injecting nervous excitement into an audience because proximity to accumulations of that power sometimes proves dangerous. This is a dimension of West African performance that has no real Western counterparts.

The Dogoduman audience was like Western audiences in several ways. They expected an interesting, entertaining experience. Some expected opportunities, through character, gesture, and verse, to think and talk about arrays of practical and philosophical ideas. Many expected to experience a gamut of emotions. And many anticipated the opportunity to evaluate the performance aesthetically. But the Dogoduman audience was also different from Western audiences of performance in another significant way: its citizens knew that individuals among them could be called to everyone's attention or even called out to dance.

Sidi Ballo greeted many people during the performance. After a dynamic segment of cruising around the dance arena with his apprentice close at hand, he would stop near people with a swift deceleration that gave the impression of the end of motion, followed by the settling of dust. It was as if a whirlwind had suddenly stopped, sometimes so close that you could practically hear breathing inside the bird.

In that location, he might sit quietly for a little while, or he might commence right away making sounds like those from a kazoo. The audience would hear tones that resembled those used in speech, and Sidi's apprentice, Sibiri, would immediately translate those tones loudly into Bamana greetings. The drummers were greeted this way, as were the singers, youth association leaders, and town officials. All responded with a few words or gestures, greeting the bird back.

Sometimes people came out to dance on their own accord, such as the very young children, the youth association membership, and, near the end, nearly the entire town. Songs or town spokespersons can call people out, as when Mayimuna Nyaarè sang for the smiths and they formed a line and danced. And sometimes masqueraders can come and get you, as Sidi Ballo did to me. He arrived tumultuously, rearing up and changing shape. Then he hooked me with his carved bird's head while issuing a tonal invitation with his voice disguiser. The invitation was not refusable, as I was pulled onto the arena to do a duet with the bird, as the object of everyone's amused attention.

Some people would enjoy the opportunity to participate like this or to dance with pizzazz before the town, while others would feel self-conscious, and still others would feel both simultaneously. Such Mande audience participation would seem to fly in the face of *malo*, "shame," but while some people are shy and demure in the arena, others take possession of it with spectacular dancing and sometimes even acrobatics. It is an opportunity to demonstrate capacity and to be admired and remarked upon by others. Mande use a word that praises this fine dancing by audience members and formal performers alike. It is *sendonduman,* a compound word meaning "to participate beautifully, sweetly, with facility," and it acknowledges people who dance so well that they capture the rest of the audience's eyes.

Dancing is for pleasure, but it is also communication. It punctuates and validates through pleasurable participation the specialness and solidarity of many social events, such as weddings, baptisms, youth association theater, and Sidi Ballo performances. It amplifies an individual's intellectual and emotional involvement in an event through sensual engagement, and it manifests the value of a focused collectivity. It is a moment when audience members contribute their own impact to that being generated by the performers.

THE *FOTOTALAW*

Three strangers, *dunanw,* attended the Dogoduman performance. We were the *fototalaw,* or "picture takers": my friend and colleague Kalilou Tera, his best friend Sangaré, and me. With camera in hand, Sangaré moved around the periphery of the dance arena taking black-and-white photographs. Being in the audience, he was not a disturbance to the performers. Kalilou, on the other hand, as we had arranged the night before, carried a tape recorder in a black shoulder bag and stayed near the drummers, and especially the women singers. His goal was to get as much of the music as possible on tape, and he was conspicuous from time to time as the guy in the yellow jacket following the ladies around. I sat peacefully in the audience, shooting color pictures but otherwise minding my own business. I was, however, part of Sidi Ballo's business.

As people from out of town and not known locally, we three were a little intriguing. As a foreigner, I was especially novel. Since we were all photographing or recording the event, Dogoduman citizens correctly surmised we were there on the strength of Sidi Ballo's masquerading fame. Because our attendance had been negotiated the night before, people expected us to be there. During the performance an older man nearby occasionally spoke to me about Sidi, but the rest of the audience did not give us much thought most of the time. Even the mobile, yellow-jacketed Kalilou was largely ignored. But Sidi Ballo did not ignore us.

For the master masquerader, we were resources he could use in his construction of the evening's entertainment and the enhancement of his reputation. Since we were guests of the town, it was proper for the bird to greet us. Since we were strangers, the rest of the audience would find it very entertaining to watch us dance. And with the attention he paid us as *fototalaw*—documenters of the event—Sidi Ballo could remind everyone that he was a renowned masquerader.

So the bird greeted us. And he returned to "park" near me, often with a dramatic flourish. I received the bird-head hook, sitting beneath a rearing, towering masquerade as that big, bright, pointed red head descended to entrap me. Kalilou, Sangaré, and I all spent time center stage, dancing for the entertainment of Dogoduman.

The stranger, *dunan,* is a Mande social category. Strangers are viewed with caution, but also as potential resources. Engaging them with intelligence is conceived as possibly bringing prosperity, useful skills, and worldly knowledge to a community or region (J. W. Johnson 1986, 16). Oral traditions are full of stranger stories, and there is an aura of pleasant contemplation around the concept in popular imagination. For Dogoduman, we *fototalaw* were entertainment resources, adding a touch of exotica and humor. By deploying Mande performance protocols of politeness, Sidi Ballo articulated our presence into more fun for everyone while simultaneously enhancing his reputation as a virtuoso masquerader. Greeting us, paying occasional attention to us, and conscripting us to dance, combined with the arrangement we made the night before to shout his praise name Kulanjan as we made our photographs, was good performance and business acumen.

Ethnographers used to nourish a myth of invisibility, coupled with objectivity, to authenticate the purity of their data—as if anything involving people were ever pure. This myth began to crack when Laura Bohannan, writing under the pen name Elenore Smith Bowen, published her personal account of doing research in Nigeria, *Return to Laughter,* in 1954. It began to crumble as ethnographers adopted approaches that acknowledged the reality and necessity of participation. Finally, it became a widely recognized ruse as well as a liability when scholars such as Michael Jackson (1989, 1996) put powerful emphasis on the interactions between ethnographers and local citizens as moments that sparked the greatest knowledge and richest insights. People engaged with each other lead to understandings that are the most human, because they bear the suppleness of extemporaneity and the dialogue of multiple experiences coming together. Dancing as a guest at a masquerade is not a watershed research activity, but for the dancer it does pull a variety of ideas and emotions together into personal experience that adds perspective to an understanding of performance.

TON DANCERS AND THE MASTER OF CEREMONIES

When Sidi Ballo negotiated his performance with town leaders the night before, he wanted to incorporate members of the Dogoduman youth association, or *ton,* and association leaders wanted their members to perform. Performance is a major focus of the *ton,* good performance a major goal, and performing with someone like Sidi Ballo a delightful opportunity to show your accomplishment in association with a master.

It would be hard to overestimate the importance of the youth association in Mande social and artistic life. Virtually every town in Mali has a branch, and virtually all inhabitants participate in youth association activities during the first thirty or forty years of their lives. Leaders of the *ton* can be in their thirties or even forties, which might seem old, except that the Mande time of vigorous youth can include those years. Moreover, women singers like Mayimuna Nyaarè can retain a warm affiliation with the *ton* at even older ages. Youth association leadership and the structure of the association has much independence from civic authority, and in fact, the *ton* is recognized as a potent social force in communities, along with families, town leadership, the special professional clans, and the spiritual associations (*jow*).[2]

Ton is a social space, even a power base, where solidarity with age mates and a fine-tuned chronological hierarchy within the time of dynamic youth takes precedence over other affiliations. It offers unofficial education when older members teach younger members how to function and prosper in Mande society. The youth association is fully sanctioned by civic leaders, spiritual associations, and the elders. It even performs public work, repairing roads and bridges or tending a needy family's fields. In addition to its relatively independent leadership, it has its own economic infrastructure. So many citizens are either members or former members who remain devoted to it that it is hard to imagine Mande culture without it.

Beyond age-grade solidarity and the independence it offers youth, *ton* claims people's devotion because of the highly organized, very complicated, and potently affective entertainment it offers. In the northwestern Mande regions, the *ton* stages annual performances of *kote-tlon,* a costume theater that features a cornucopia of marvelous, often satirical and hilarious, socially relevant characters and skits (Brink 1978, 1980, 1981, 1982). Closer to Bamako and then east to the environs all around Segu, the theater emphasizes elaborate masquerades and puppets depicting characters in the same sort of skits (Arnoldi 1995, 1996; Imperato 1974, 1983).

This performance system, which trains musicians, actors, and dancers and facilitates creativity, is an impressive artistic institution—a fact that au-

thors such as Arnoldi, Brink, and Imperato have made elegantly clear. It not only includes drum orchestras and women's choruses but also offers the means to build and maintain masquerade and puppet characters. It establishes, nourishes, and encourages an atmosphere of dynamic creativity, where innovations in character and skit development are fostered and members have the opportunity to mix and remix ideas and elements of audio and visual expression to keep the theater exciting and compelling. And it offers established and well-publicized performance venues, with groundswells of excitement and anticipation constituting all the "advertisement" any performance could ever need.

Every year at harvest time there is a theater season during October and November, with a secondary season occurring during the spring rainy season in May and June. Towns in a region stagger their performances so people can travel and attend many events. *Ton* branches with especially talented drummers, singers, or masquerade dancers are invited to tour their region, often performing many times at numerous venues. Competition between towns and even espionage may occur as *ton* branches assess and perhaps borrow from each other's skits, music riffs, costumes, masquerades, and puppets.[3] This is clearly an environment of vigorous artistry, and nearly everyone who sees its productions is smitten with it. Arnoldi emphasizes that with the very first words of her book, where she describes a vibrant cacophony of sensory stimulation, "awe and surprise," and the "palpable energy and anticipation of the crowd" (1995, ix).

Given all this socially embedded artistic power, it is no wonder that *ton* performance is a place where young people can develop and display the acumen and accomplishment that later makes them successful in business, politics, other arts, and even farming. To be a good performer is to become patient, persistent, dedicated, perceptive, knowledgeable, hard-working, socially sensitive, self-confident, strong, and stylish—all helpful qualities for a successful life. Remember, *ton* is a recognized forum for demonstrating maturity and developing those qualities that can, in turn, lead to social clout. Here awareness of the "shame" and "constraint" of *malo* can be transformed into techniques for maneuvering effectively in society.

Given the degree of social relevance and the sheer artistic reverie youth association performances can generate, it is also not surprising that many young people set goals of becoming outstanding performers as drummers, singers, or masquerade actors and dancers. To be sure, most *ton* members will ultimately leave these activities behind. But a few move beyond the *ton* in a different way, by becoming itinerant performers who never give up the intense levels of artistic achievement that the association helped them to reach. In fact, that is a good characterization of Sidi Ballo, a quintessential exponent of the *ton*.

Sidi had performed at Dogoduman as a member of his town's own touring youth association many years before, and he still appeared with them when called upon. He understood the value of the *ton,* and he especially valued its masquerade performances, believing it was important for people to experience their culture at its most dramatic and artistic. The youth association is designed to be a natural forum for that.

As an itinerant performer, Sidi understood very well that he needed a performance structure to which audiences could relate and which would also offer him an established artistic form that he could play off, improvise against, and amplify. He also needed a way to sustain interest over a long evening, and he knew that the addition of local characters and performers would help do that. Finally, he needed to be spelled by other performers so he could take breaks, because dancing a bird masquerade is as hard as Mande public performance gets.

Thus, it was agreed the night before that in addition to the drum orchestra and women's choruses, the Dogoduman youth association would also provide unmasked and masked dancers along with a whistle-blowing master of ceremonies.

Each association branch has its troupe of unmasked and masked dancers. There is a panoply of established characters. New ones can be added. Old ones can be dropped. And masquerade components, dance steps, and songs can all be modified and remixed to produce reinvigorated forms. In whole or in part, masks and performance forms from outside of the *ton,* such as Mande's numerous sacred spiritual associations, can be brought in and transformed into new or revitalized youth association characters and skits. Arnoldi (1995) presents these processes at work and shows how vibrant the results can be.

At Dogoduman, the wild buffalo mask (*sigi*), which is a common part of *ton* masquerades, was painted silver so it looked almost like chrome. The hyena mask (*nama*) that also appeared was borrowed from the very senior men's initiation association called Kòrè. In addition, the Dogoduman youth association had appropriated the delicate face masks with surmounting rows of horns that belong to the Mande Ntomo, an initiation association with powerful spiritual and social components. In some areas, the Ntomo, along with various other Mande spiritual associations such as the Kòrè, are in contemporary decline, and many of their art forms are brought into the youth association, where they gain a new, remodeled life (Imperato 1970, 1972, 1980).

At Sidi Ballo's bird dance, the appearance of the two *Ntomoni,* or "little Ntomo," contrasted sharply. One had been painted in the palest shade of greenish blue enamel. The other was done in a bold pattern of bright red with white lines, dots, and stripes; and the wearer of that mask wore a kerchief up over the back of the head to suggest a woman.

Good dancing is decidedly important in the youth association. It is certainly a wonderful and worthy form of entertainment, but it also embodies accomplishment. Learning to dance well requires dedication and hard work, especially in societies where rhythm patterns are complex and dancing often demands that you respond to different patterns with different parts of your body. In addition, various feats of athleticism are incorporated into Mande *ton* dancing, and performers must develop both the strength and the agility to carry them out. The combination of hard work and elegance that good dancing engenders offers a line of sight into a person's character.

Kassim Kone and I saw this in action at an early summer performance of the youth association in 1998. It was in the small town of Soso—home base of Sumanguru Kante, the blacksmith sorcerer king who lost a budding state to Sunjata Keita's Mali Empire. As association members danced en masse, community members awaited with great anticipation a series of solo dancing and acrobatic feats that would be executed by some of the accomplished young men. Members of the audience included respected and important community figures, and they could be heard expressing their anticipation, along with their concern that the individual performers make a good showing. When dancers did make a good showing, these spectators heaped expressions of satisfaction upon them and then continued to talk about it after the performance and into the next day. This enthusiastic response offers acknowledgement and affirmation that young *ton* members are developing in positive ways.

The young men of Soso, meanwhile, knew they had performed well. They were visibly pleased that they had impressed their audience, including the young ladies in the crowd whom they were courting or wished to court. They left the arena walking and talking in ways that radiated physical presence and the power of youth, with a touch of rebelliousness that gave them a bit of their own solidarity.

The Dogoduman youth association dancers were also very good. The youngest was the group of unmasked dancers of around ten years old. They had the least amount of dance experience, which is why they had not yet been awarded the right to perform in masks. Nevertheless, they made a good showing.

The four *ton* masked dancers were terrific. They were older boys of around fifteen. In white cotton outfits punctuated with long colorful fringe and highlighted by large pieces of cloth held in their hands, they performed with tremendous energy and soaring elegance. Sometimes they spent their arena time dancing with precision and grace. Sometimes they executed acrobatic feats. And sometimes they did skits, such as the one depicting a befuddled older hunter being seduced by a bush buffalo, a very humorous little vignette because real hunters are supposed to be tough and smart, while bush buffaloes are extremely dangerous, especially around hunters.

The master of ceremonies, also provided by the *ton,* controlled all of the performers except the bird, which basically controlled itself. Wearing a brown factory-cloth shirt with a deck-of-cards pattern, he kept a whistle in his mouth much of the time, with which he directed dancers into and out of the dance arena. He used the whistle to signal his instructions but also directed with his hands or just told dancers when to enter and when to leave. He worked from the area around the arena entrance, but he also mixed it up a bit from time to time, dancing to complement or contrast the movements of the other performers.

Mande audiences are expected to be attentive and to behave properly, to be responsive, to clap when requested, and to dance when called upon. That is one reason for having a master of ceremonies, who is called in Bamanakan a *jamaladilala,* "the crowd maker or repairer." *Jama* means "crowd," *la* is a causative prefix, and *dila* is "to make or repair." The final *la* is a suffix that identifies the maker or doer. The *jamaladilala* keeps the audience in order, organized, and in control. He repairs a disorderly crowd (Camara 1978; Kone 1998).

This idea of order is elastic. Every so often at Dogoduman, the master of ceremonies, whistle blasting and deck-of-cards shirt swirling, would himself shoot into the dance arena, chasing the bird or crisscrossing in front of Sibiri, the apprentice. He did it with style and dynamic flair and with a facial expression that exuded confidence. Naturally, these actions added dynamism and drama, increasing the event's tally of excitement.

SIBIRI CAMARA, SIDI'S APPRENTICE

Sidi Ballo's apprentice in 1978 was Sibiri Camara. Sibiri was in his middle teenage years and had already become a very good dancer. During the entire Dogoduman performance, he was in the arena accompanying Sidi Ballo's masquerade. He had a metal bicycle horn with the rubber squeeze ball removed, and he frequently put this in his mouth to blast out kazoo-like squeals of exuberance. He always placed himself in a position that visually complemented the activities of the bird. While he was never in the way, he was always close at hand to absorb audience interest if they tired of concentrating on *Kònò.* He had an excellent sense of theater, which showed particularly in his eyes and his expressions. As he worked the arena, he generated much emotional intensity. He moved with precision and vigor, and the looks on his face often seemed to encourage the notion that this performance, this place at that moment, was the best place you could possibly be. Clearly, he was learning much from his master, and he danced with distinction at Dogoduman.

Sibiri did not have an elaborate costume. He wore a cotton shirt made from thin black and white cloth strips. It was thickly machine embroidered at

the pockets, around the neck and down the chest, and at the bottom of the sleeves. The embroidery thread was clear sky blue, so that when it was caught in the lights illuminating the performance, it became almost iridescent. That color effectively attracted attention, especially on the sleeves, where the embroidery amplified Sibiri's arm movements. The shirt's bottom had been cut into fringe, adding a modest visual rustling effect as Sibiri moved about the arena.

Sibiri's pants, rolled up to just above the knees for mobility, sported thin red and white stripes that complemented his shirt and corresponded to the colors in Sidi's masquerade costume. They had coordinated their respective performance appearances very well.

Sibiri held the bicycle horn in his right hand, while in his left, he held a piece of cloth. Like the horn, the cloth complemented and punctuated his movements and gestures. At times it swirled out from his torso, creating an afterglow of motion. At other times, it visually complemented the rhythms that his body followed as he danced with Sidi. Thus, everything about the apprentice and his performance outfit was effective.

In the years that followed the Dogoduman performance I often wondered if Sibiri had gone on to establish his own independent dancing career. Unfortunately, he did not. I learned from Sidi in 1998 that Sibiri had discontinued his apprenticeship and that, in fact, he took up residence at Dogoduman. Masquerade dancing is very difficult, and Sidi noted that it was hard to keep and train apprentices. Many were just not good enough to go on. Others did not have the resolve. Sibiri Camara certainly had the physical skills and the kind of intelligence that led to good performance decisions, but he did not have the desire to spend a lot of time coping with sorcery. In spite of the fact that he was from a blacksmith clan, he did not want to expend the time, energy, and economic resources to protect himself from sorcery attacks and take his performing to a higher level. Sidi Ballo noted, and many people in the general Bamako region confirmed, that not effectively handling sorcery and the energy of *nyama* through the acquisition of spiritually potent herbal recipes (*daliluw*) was the undoing of many performers, and the factor that keeps many others from becoming truly outstanding. Clearly Mande entertainment has a very serious side.

SYNERGY PRODUCED BY PEOPLE

Synergy helped make the Dogoduman performance excellent, for it combined the intersubjectivity of many different contributors—from musicians to dancers to audience members—through artistic endeavor. Complex agency, the complicated coming together of many different kinds of actors in numerous

capacities, is strongly manifest in these kinds of performance. As a concept in social sciences and humanities, it emphasizes how interlocked and co-dependent all the actors are and how far beyond each of them the final product can go.

This was true of Dogoduman. I find myself envisioning that wonderful June evening as a complex conglomeration of people whose performance personalities played off against each other for the audience members, who, of course, knew most of them as fellow community members. I think of the confident and competent master of ceremonies, smiling as he whisked people on and off the arena or chased after the bird masquerade. I think of the drummers and that little bit of swagger that got caught up in the ways their hands moved over their instruments. I think of the young lady singers and their melodious voices, parading around the arena while swirling their calabash drums into the air with such graceful cascading effect. I think of the Ntomoni dancers with their precision and utter elegance, all wrapped around their youth. I think of Mayimuna Nyaarè with her subtle, graceful competence, engaging the master masquerader. I think of the ever-energetic and marvelously precise Sibiri Camara, who did not end up making a career of performing. And I think of Sidi Ballo, fast and slow, ponderous and fleet of foot, always somehow anticipating what people where ready for and always paying attention to little performance details like pacing, location, and the effective play of quietude and frenzy. Even Sidi Ballo was known to the citizens of "Sweet Little Town," though not as intimately or immediately. Some citizens knew him personally; others knew his reputation and then watched it play out in the personal characteristics he infused into his performance. So all of the performers were more than just characters. They were known personalities.

And pinned to the public personalities of all these players were Mande ideas and values that were part of the shared experiences of Dogoduman's citizens, along with the local histories of both people and institutions such as the *ton* that made up people's social and personal lives. The performance, therefore, was more than just an orchestrated collection of characters and skits and songs. It was engagement with personalities who carried and qualified, refracted and gave particular twists and nuances to all those things that scholars call social and cultural formations. However, to think of the Dogoduman bird dance as a collection of social formations is to subtract from it the instrumentality of people that gave it life and meaning and made it memorable.

Part 2

SIDI BALLO AND THE DISPOSITION OF INDIVIDUALS

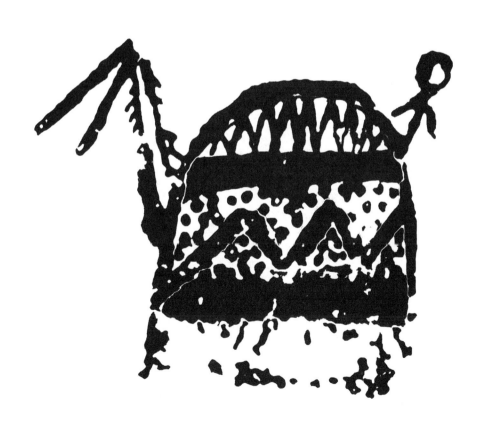

3

SIDI BALLO AT
DOGODUMAN

Sidi Ballo was more independent at Dogoduman than any other performer. He was not from the local youth association or even from the town. He was the star performer and held in high enough regard that deference was paid him and a certain insulation surrounded him. He was essentially unconstrained by the deck-of-cards master of ceremonies. He was free to perform as he saw fit.

Many members of the audience knew a lot about him, however, and a large number of them had seen him perform many times. So he did have links to Dogoduman. Furthermore, his independence as itinerant did not make him immune to the abilities and personalities around him. Quite the opposite—he was very sensitive to both. He synchronized with the drum orchestra right away and constantly produced counterpoint gestures with his masquerade that richly complemented the rhythms—masquerade gyrating visibly and feathers swishing audibly on the beat or against the beat as Sidi found appropriate. His interaction with the young lady singers was wonderful. He matched their slightly demure youthful energy with vigorous energy of his own, and the way he maneuvered around them produced the impression that the bird found them charming. He had a powerful sense of how to play the audience. He seemed always to know when he should slow down, when he should give people a rest by resting himself, and when he should give them a thrill by storming up to them and stopping on a dime or flying past them so closely that

his back-draft rustled their clothes. Sidi Ballo did not operate from a set bag of tricks. He behaved more like a soothsayer, constantly divining the state of his audience.

His interactions with Mayimuna Nyaarè were most overtly terrific. Their arena dispositions seemed so different—she the very dignified, authoritative senior lady who moved with grace and the sort of measured pace you would associate with a no-nonsense elder commanding respect; he the edgy, sometimes respectful, sometimes impertinent and cheeky, sometimes almost wild and out-of-control creature that could generate an aura of humor and danger simultaneously. But when Mayimuna ventured into the center of the dance arena, magic happened. The bird never failed to approach her, sometimes at very high speed. And then he would either stop, full of respect, or dance and swirl around her in most audacious ways, even sometimes executing big bold figure eights with his carved bird head or spinning around like a toy top. She, meanwhile, produced in her expression and gestures a very obvious quality of tolerant, even bemused indulgence, which sometimes shifted to clearly displayed respect. Whenever they were together in the arena there was the sense that they knew each other well and loved to play with and challenge each other. The effect on the performance was extraordinary.

A valuable conclusion can be drawn from all these interactions. Sidi Ballo, the outsider at Dogoduman, was in a position to behave the most like an individual—one might even have expected him to perform in many ways without much regard for his co-performers and his audience. And yet the opposite transpired. Because of Sidi's character and his passion for bird dancing, he was supremely attuned to personalities and nuances around him, and he adapted to them, synthesized them into his gestures and movements, and in general engaged them with an improvisational acumen you might expect from a jazz musician. The individuality of Sidi Ballo allowed him to fit very effectively into the group, making the most of everything and bringing out the best in everyone.

THREE CRITERIA FOR SUCCESS

When I saw him at Dogoduman, Sidi Ballo was fourteen years into his career as an itinerant masquerade performer. In that time, he had built a strong reputation and was very popular in a large area around Bamako. He was still happy to perform with his hometown's youth association branch during their annual events, but he also performed on his own by commission for weddings, all kinds of festivals, and government affairs. Sidi explained his popularity by saying that while many dance, he was the best in the region, so he was in high

demand. He cited three reasons for his prominence: the beauty of his masquerade costume, the quality of his dancing, and the fortification provided by his particular array of power devices.

SIDI BALLO'S MASQUERADE

The masquerade construction that Sidi used at Dogoduman was indeed beautiful and quite well-designed. It was elegantly shaped. All of its material components were visually interesting and worked effectively together. Its overall composition was appealing, including the size and shape of the carved bird's head and the cloth sleeve from which it emerged. Sidi's use of color was both bold (the bright red bands) and subtle (the delicately patterned blue cloth). The masquerade's frame was designed to facilitate changing shape. He spent about a month in 1964 creating it, in spare time while he was still a practicing blacksmith. Fifteen days went into making the bird's head, the rest into designing and constructing the masquerade costume.

Sidi's bird construction emerges from an extremely rich West African tradition. Mande masquerades present a fantastic array of characters across a broad spectrum of creativity. This creativity goes back at least to the court of the Mali Empire, where Ibn Battuta reported that "poets," called *jali*—perhaps the predecessors of the *nyamakala* bards called *jelew*—adorned themselves in elaborate bird masquerades and came before the emperor to praise, inspire, and challenge him (see Hamdun and King 1975, 42–43; and Levtzion and Hopkins 2000, 293). Masquerade history between then and modern times is little known. Konkoba, a massive, dramatically imposing construction employing bright red cloth beneath a "head" of bird's feathers, became prominent in what is now southern Mali and northern Guinea. Its owners, members of the Kouyate clan of bards, say it goes back to the time of Sunjata (Reed 2004). In the early 1820s William Gray (1825, Appendix XX, p. 383) was lucky enough to encounter a traveling masquerade that he described only minimally but portrayed as appearing like a unicorn. Just these three examples[1] suggest wideranging artistic imagination that is borne out in the modern history of masquerade.

For more modern Mande masquerade, Arnoldi (1995, 1996) and Imperato (1972, 1974, 1983) provide abundant testimony to a grand tradition that is refined and richly developed, a wellspring of aesthetic energy and artistic skill. There is an enormous range of characters and creative constructions, and there is a potent facility for sweeping current events into the performances. When the Chinese came to help Mali build factories in the middle decades of the last century, Chinese workers became puppet characters in the theater. When a new international airport was being constructed south of Bamako in

the early 1970s, I saw a masquerade team dance a 747 jet plane construction, complete with flashlights on the wings. It "landed" in the middle of the dance arena, and a young man, the captain, crawled out from under the cloth bottom. He gave a speech to the crowd about the value of tourism for Mali, crawled back in the plane, the flashlights were turned back on, and the plane took off and left the arena. The audience loved it.

New masquerades and the constant revision and transformation of old masquerades constitute a potent atmosphere of creativity that typifies this art world. The analytical and synthesizing thought processes involved are often well developed. Arnoldi documents these processes convincingly, as does Steven Wooten (2000) for Ci Wara, another form of Mande performance. It is from this context of effective imagination and elaborate performance composition that Sidi Ballo must be seen.

Bird masquerades are very popular among Mande, and there is tremendous variation in their construction and appearance. They can be small or huge, covered in cloth only or in cloth and feathers, and the kind and number of feathers will also vary. Some are so inundated with feathers that no cloth is visible at all.

Beneath the covering that audience members see is a support structure that also varies dramatically. Most frequently, this scaffolding is made from cut strips of flexible wood that are bent, tied, and joined to other pieces to form either cones or tent-like structures. But they can also be constructed with assemblages of poles thicker than broomsticks, lashed together, sometimes in large numbers, to form a solid conical wall. Dancing and manipulating masquerades made with these two divergent types of internal structure demand completely different approaches to performing, with different repertoires of motion and gesture. The former is light and flexible, and presents more opportunities for dangerous maneuvers. The latter is rigid and heavy, its stability making it both safer and more rapidly exhausting. Sidi has created and performed both, but for the greatest part of his career his virtuosity was built around the lighter, flexible type, which is what he used at Dogoduman.

In fact, Sidi's masquerade was a marvel of effective design. He fitted printed factory cloth over a scaffolding of three flexible wooden hoops connected with several vertical elements. Over the cloth he festooned strings of vulture feathers, along with three horizontal and four vertical bands of wide red ribbon. The factory cloth featured little flower designs in red and white on a predominantly blue background. The ribbon added a festive effect. He said he had arranged it to cover the parts of the cloth that sat on the wooden frame, but he also wanted it to add beauty and visual intensity to the masquerade. Color was important to Sidi, and with red, white, and blue he said he felt he had a complete color ensemble.

Sidi added strings of vulture feathers to enhance the "birdness" of the costume. But vulture's feathers are also charged with high levels of *nyama,* and this added excitement and titillation to a performance.

From inside the construction, Sidi manipulated a finely articulated, intensely red bird's head, carved from wood and mounted on a three-foot pole concealed within a cloth sleeve. The crest on the top of the head was complemented by a strong protrusion on top of the beak, and that was countered by two subtler protrusions on the bottom. All this gave the carving weight and presence, so that when Sidi gestured with the head, its theatrical capacity was emphasized.

The head had a separate lower beak that was mounted in such a way that Sidi could pull on a hidden strip of rubber inner tube that would cause the beak to flap open and closed, making a sound like castanets. Built into the carved head and its pole "handle" was a long hollow tube. I am not sure how it was done or exactly where the opening was, but Sekuba Camara and Kalilou Tera assured me that other bird masquerades also have it. With this accommodation, Sidi was actually able to drink water or milk from a calabash.

At the bottom of the costume was a wide fringe of dusty burlap sack that did not always show and was often underfoot while Sidi danced, mimed, and powered his way around the town square. The fringe was there to help hide Sidi's feet when he lifted the whole masquerade up to change shape and tower over audience members and also when he did things like leap over benches. But it also had the effect of amplifying the danger in Sidi's dancing and making that danger seem extraordinarily dramatic.

All of these elements added up to a delightful masquerade. But Sidi also designed it to accommodate his skills as a masquerader. He danced this beautiful construction beautifully, using all of its features—from the dramatically articulated bird's head to the flexible scaffolding and the burlap fringe—to great effect.

SIDI'S DANCING

Sidi named good dancing as the second element of his success, and it would be hard to overstate his virtuosity. He danced his bird masquerade into omniscient, riveting animation, performing feats that were often dramatic and even dangerous, should he trip or lose his balance. When not executing spectacular feats and grand gestures, he articulated the costume with a basic quality of movement that made it seem somehow alive.

In my personal experience, this impression of a living masquerade is important. Sidi prepared for performances in private, away from the crowd, so people did not generally see his masquerade set up but empty. If you did,

however, before ever having seen Sidi perform it, that masquerade would appear interesting but inert, a nicely conceived and constructed inanimate object. But once you had seen Sidi dance it—articulate it into the impression of a living being with gesture and motion—it would be hard forever after to see it empty and not still find it magnetic, almost ominous with electric potential. For me it is as if experiencing Sidi dance the masquerade adds an indelible element to the apparatus that makes it seem alive—not actually, because it is clearly cloth and wood, but nevertheless in some sense an animate being. That is exactly how I felt when Kassim Kone and I saw the masquerade set up behind the scenes in July 1998, waiting for Sidi to enter it and perform.

This phenomenon of animation is like the kind of magic Kris and Kurz (1979 [1934], 61–90) describe in their study of the nearly mystic power of artistry, especially in the Classical and Renaissance West. It is very much a part of my experience of Sidi's masquerade, and it spotlights the void that exists around danced objects rendered stationary in museums. It is not just knowledge of an artwork's operational and conceptual context that helps us understand it; what we commonly perceive as ethnographic context is not enough. The context of personal creativity and talent, the character an individual artist brings to the art, and the dynamic union of person and art mobilizing each other all become a seminal part of an audience's perceptions and impressions, a part of the experience a performance has given them. In masquerade, at least, art history cannot hope to take us far enough if it believes it must begin and end with the object.

For Mande, because of Sidi Ballo's blacksmith clan membership, there is another significant dimension to this animation. The sense of life force instilled by Sidi into his masquerade aligns a little bit with the concept of *nyama*, that potent force behind all life, action, and sorcery. Many people feel that all art, even public secular masks and masquerades, gets charged with that radiating power, if only in small quantities. This is partly because people perceive practical links and conceptual similarities between all material imagery and the monumentally powerful imagery—the headdresses and other sculptures—used by supercharged sorcerers in the power associations (*jow*) such as Kòmò, Kònò, and Nama. It is also because blacksmiths are generally the sculptors of images, including the carved heads and puppets used in masquerades, and smiths are considered to be brimming over with *nyama*, which bleeds out into all of their work. Thus, the fact that Sidi had the talent to perform his masquerade into an apparent sentient state readily combined in people's minds with the knowledge that he was a *nyama*-laden member of the blacksmiths' clans and therefore all the more able to pour power into an event. I think this double dose of animation added excitement and drama to his performances.

Animating the masquerade was Sidi Ballo's virtuosity. As the young men's drum orchestra and women's chorus performed, Sidi moved with deft author-

ity, sometimes smoothly gliding, sometimes rapidly careening about the lantern-lit space. When dancing in slow mode, he seemed to hover as he worked the space with deliberate grace, bringing the music to visual life by making his costume vibrate precisely to the drum rhythms or the accentuated lines of the songs. His masquerade appeared to slide to and fro around the dance arena with a pronounced quality of elegance.

When dancing in fast mode, Sidi tilted the costume and motored full throttle, stopping suddenly here and there for long moments, while his bird's head moved about as if looking into the lives of the people in the audience, acting a little like a fowl dumbfounded to be caught up in so much humankind. When he danced at full speed, literally shooting across the arena, he produced a sense of momentum that carried the perception of vibrant power into your imagination. From fast to slow to full stop, motion was arranged in sequences that helped instill a sense of life while effectively holding your interest.

Inside the apparatus, the motion is quite different from what the audience sees. Sidi holds the back end of the bird's head pole in his right hand and a hoop of the wood scaffolding in his left, lifts the whole affair up off the ground just a bit, and moves. To make the masquerade seem to glide, he must carefully measure the bounce and length of his gait, while evenly balancing the masquerade or tilting it forward to suggest speed, or sideways to suggest the possibility of falling. He can pull the scaffolding together to make the masquerade appear thin, and push the whole thing upward to make it appear very tall, while his feet remain hidden behind the burlap panel.

To learn to do this so well that it begins to feel natural and easy is a feat most people cannot conceive. If you are a professional dancer—in ballet or modern dance, for example—or if you have mastered a musical instrument with great competence, then you can have an inkling of just how hard and often frustrating it is, just how much endless practice and experience you need to make your own movements feel elegantly removed from effort. All of that complexity must transpire with fluidity, grace, and ease on the dance arena without your having to think about it at all. If you have not gotten so good that you can make it happen with natural ease, then you are in no way prepared to face the assortment of dance arena situations that will invariably arise. You will not be able to improvise. You will not be able to respond to people and situations with fluid instantaneousness as Sidi Ballo did at Dogoduman. In the hands of a lesser dancer, a bird masquerade looks cumbersome, its movements clumsy. It is not the image a masquerader wants to project.

In Sidi's hands, the costume becomes like a second skin. With the subtlest of gestures, he shakes the costume three times in rapid succession over and over again to create the visual effect of rhythmic triplets, which he nestles into the flow of the music. When he shakes out these triplets, the feathers rise and fall, the cloth ripples a little, and the whole masquerade makes a subtle rustling

noise but in rich staccato time that would not be possible if the dancer were not an expert.

In addition to the interior manipulations that articulate the masquerade costume, Sidi must constantly be maneuvering the carved bird's head to create his repertoire of bird characterizations and expressions. It looks about, constantly changes angle and elevation, seems bemused at one moment and authoritative and commanding the next. Sometimes it clacks its beak loudly, often for the whole of a song, to create the impression of the bird laughing. All this invisible activity makes the costume even harder to control, because Sidi must constantly change his body, arm, and hand positions inside the masquerade while maintaining control of the whole thing. And he must do it all with the kind of natural, easy grace that only comes from countless hours of practice and ample volumes of dance arena experience.

Audio gesturing was also a part of his expertise, as was the ability to keep control of the device he used to transform his voice while both of his hands were generally busy. When Sidi performed, he held in his mouth a bamboo and resin device that combined elements of a flute, a whistle, and a horn and sounded much like a kazoo. He used this instrument to create the tones of the Bamana language, which his apprentice would then translate into words. He also used the device to make bird noises, a cross between chirping and squawking, said to suggest that the bird was satisfied with what was going on around him (Camara 1978). As a counterpoint to his elegant sweeps and frenetic motoring around the dance arena, he would stop dead still and move his beak slowly while making those satisfied bird chirpings.

Thus a collection of very different movements is responsible for the production of what an audience sees, and clearly they are not easy. But emerging from this basic flow of motion are Sidi Ballo's grander feats, and to the audience, these appear to be much harder. At Dogoduman Sidi jumped over a bench placed in his path—reasonably impressive, given the cumbersome masquerade with its treacherous fringe. He leaped into the air and slammed his masquerade sideways into a wall—exceedingly impressive, given what he had to do with both his body and the masquerade to accomplish it. He climbed atop slippery bleachers, danced, and jumped off—quite impressive, just because it could be dangerous both up there and on the way down. And he turned his masquerade upside down and danced in it, with his feet on its top instead of the ground, and still made the costume move around the dance arena. This took impressive to a whole new level.

Described tersely and in isolation like this, these feats range from noteworthy to extraordinary, but the whole of their effect is lost out of context. In the ambiance of the performance's grander sensuality—the cacophony of sights and sounds, the feeling of motion, the unfolding of all the players' abilities and activities—Sidi Ballo's feats become far more compelling. With the

sequence of dancers from skilled to most-skilled; the pattern of anticipation and excitement built up and released; the music traveling from slow to fast, soft to loud, sweet to serious; and the array of ideas and emotions offered up by the characters, skits, and songs, an aura built up that seemed to flow into the masquerade, causing it to spark and ripple with the power of its magnificent presence amidst so much else that was wonderful and worthy. Sidi Ballo built his masquerade with his skills as a blacksmith and designer. Then he created its performance character with patterns of motion and gesture, and he infused tension, drama, and excitement with his daring and often dangerous feats. And finally, he crafted a spectacular presence by tuning his every move to the rest of the event. In a context such as the Dogoduman performance, where the rest of the event rose to meet him, synergy erupted out of the whole to produce something memorable. It was not because the whole was greater than the sum of its parts. It was because the character and abilities of the people playing their parts carried the event to the heights that make group artistry worthwhile. We have already seen that the other players certainly held up their parts. The more we examine Sidi Ballo's contribution, the clearer it becomes that he did too.

In performance as in social life, parts and wholes play into and off of each other. Sidi's part is best understood within the fabric of a broad whole that includes the Dogoduman performance, the tradition of youth association masquerade, and his inherited profession of blacksmithing. From these vantage points, the originality of Sidi Ballo is obvious enough for everyone to see. So too are his skill and fortitude. Seydou Camara, the hunters' bard (*donson jeli*), used to sing a wonderfully understated phrase that heaped the highest praise on the toughness, smartness, skill, and courage of hunters: "The man of the house and the man of the bush are not the same" (Bird, Koita, and Soumaouro 1974, line 232). That kind of praise would also fit the man beneath the masquerade.

LOOKING THROUGH CLOTH

Good masquerade dancing is hard, not just because of its complexity and required finesse, but also because it is exceedingly physically demanding. Even if the masquerade construction is light, it soon becomes heavy, and constantly manipulating the scaffolding and sculpted head is as tiring as aerobics and weight lifting. Even when the arena floor is watered down to reduce dust, it soon dries, and the inside of the masquerade fills with an oppressive smog of particulate matter, so that the heavy breathing associated with athletic activity is far from unencumbered. Even at night, when it is cooler, the temperature inside the masquerade rises to make it stifling, sweltering, oppressive. And

even when the arena is well lit, it is not always easy to see out into the audience or track the other performers. Sidi's masquerade at Dogoduman had no eyeholes to peer through. From inside he had to look through a layer of cloth, which made people, house walls, and other obstacles difficult to see. Yet it was very important for him to know where everything and everyone was, both so he would not run them over and so he could interact with them effectively. If you have ever tried that, particularly in dim light, and especially while manipulating a cumbersome apparatus as you work hard not to fall over benches or trip on your own costume fringe, you can imagine the adversity that Sidi Ballo overcame.

To my mind, looking through cloth is a metaphorical measure of his orchestrated performance. When I think back on that night, somehow the idea that Sidi had to look out through a layer of cloth sums up and stands for all the layers of difficulty that he negotiated to articulate a thrilling performance. And for me it goes beyond the physical fact that was his encumbered view of the dance arena.

By 1978 Sidi Ballo was a seasoned performer. He was lean and strong. He had a presence that was deliberately outgoing. Watching him engage people before and after the Dogoduman performance and just talking to him made it clear how important perception and assessment were in his personality. His gaze was intense and confident; he looked at people as if he were analyzing them. He was very observant and made quick assessments of what he saw. When he engaged you in conversation, you realized that he was the kind of person whose consciousness seems to wrap around you and everything else in the immediate environment.

This is not an intangible thing. I think it is a kind of mind-body focus that he was inclined to and then so thoroughly cultivated that it became a habitual part of his persona. It spilled into his performances. He did not just dance and manipulate his masquerade. He made an endless string of evaluations and decisions about his audience, the other performers, and the dance space itself. Where split-second timing is incessantly critical, Sidi was always in the process of observing and deciding when to execute elements from his corpus of routines, when to execute improvisations, and how to join improvisations to routines in ways that successfully engaged and directed the flow of the evolving performance. And he did it in that swift mode of consciousness that seems to just happen without being deliberate, though to get to the state where you can do that takes much practice, experience, and deliberation. This was a very refined part of Sidi Ballo's expertise. Returning to my metaphor, at Dogoduman he exercised it even while looking through cloth.

It is significant that much later, as Sidi became a surprisingly durable older performer, he built a new masquerade that was designed to accommodate his

advancing age and to make certain things safer and easier. That one had a port-hole that he could look through.

DANCING NAKED

Looking through cloth is my metaphor. Sidi Ballo had his own metaphor that described his third element of success. He only wore a pair of shorts when he performed, which gave him a little more freedom of movement and kept him a little cooler. He said he danced naked, but by naked he meant it was just him and his array of amuletic devices that fortified his performance. That is how much he valued the part of performing where the ordinary and extraordinary meet.

Amulets and power devices (*sèbènw* and *basiw*) are created in Mande by using an extensive, sophisticated, and ever-changing body of knowledge called "the science of the trees," *jiridon*. Through this science, discrete units of information and action called *daliluw* are used to generate concentrations of *nyama* that are dedicated to helping accomplish specific tasks (McNaughton 1979, 1982a, 1982b, 1988).

There are *daliluw* for a vast array of activities, from treating a myriad of illnesses to finding happiness in marriage, being successful in one's profession, and dealing with the world of sorcery. A large and ever-growing literature has explored the science and ritual involved in this Mande enterprise, and scholars invariably find it to be centrally important in Mande social, political, economic, and, of course, spiritual life (see also Cissé 1964, Frank 1998, Hoffman 1995, Imperato 1977, McNaughton 2001, and D. Traore 1965). It is serious business. For example, it is at the heart of the artwork and the activities that constitute the secret initiation associations such as Kòmò. But there is also a serious side to public, secular entertainment, and many masqueraders such as Sidi Ballo are well versed in the world of power devices and *nyama*.

For Sidi, the management of numerous *daliluw* constituted an essential foundation for success. He told me repeatedly that this was as vital, as valuable, as necessary to his dancing expertise as was his physical ability. In his array of amulets there were many that protected him from a variety of potentially dangerous mishaps and enabled him to accomplish feats that he felt would not be possible otherwise, such as leaping great heights and becoming invisible. There were others designed to detect and counter the use of sorcery against him. These were fundamentally important too, because in Mande, sorcery is often used by jealous individuals against good performers, or by ambitious individuals with few scruples who want to make a name for themselves by damaging performers and usurping their *nyama*.

Over the years, from his earliest days as a serious dancer, Sidi worked hard to acquire *daliluw* helpful to his performing. He felt that so much power was wrapped into his masquerade that he considered it a mystery to other people, and unless he had taught them a great deal about its (and his) secrets, they could not be present when he prepared himself and the masquerade for a performance. When Kassim Kone and I visited him in 1998, Sidi joked about our having to be initiated to see his masquerade before he donned it for performance. He humorously but half seriously suggested it had trafficked in enough power to become the sacred object around which a cult could be formed.

ART IS EXPERIENCE

Effective art is memorable. Its array of elements can leap into imaginations and glow with ideas, emotions, and recollections. It glides into your consciousness months or years after seeing it, sometimes by chance, sometimes as you consider the situations, issues, and problems that populate your life. True, it may simply be a memory that offers you pleasure, and that in itself is fine and worthy. But this memory may also serve you as a resource of contemplation in the self-evaluation and social negotiations that constitute making your way in the world. You may recall a Sidi Ballo performance, for example, as you think about a challenge in your life and use his virtuoso dancing as inspiration to set a high goal and work hard to achieve it. You may even think about the bird he dances within, and consider Mande stories about the prowess and knowledge many birds represent, and use that as additional inspiration.

The effect of an artwork may remain with you for weeks or months, be part of your internal and social dialogues, and then fade into the recesses of remembrance. Or it may carry weight with you for years because of the initial power it visited upon you, or because its significant form retains relevance in your life. When Kalilou and I sat at the meeting between Sidi Ballo and Dogoduman leaders the night before the performance, I had no idea that what I would experience twenty-four hours later would take up residence in me for the next thirty years and more.

The Dogoduman performance remains vivid in my mind, so large, so emotive, and so valuable, that I feel almost as if I could just step back into that June evening up on the Mande Plateau. A hundred recollections come to me: the blue and red of Sidi's cone moving in leaps and arcs, the young ladies' chorus parading with modest confidence, Mayimuna Nyaarè engaging the bird, the young men drumming and exchanging sassy glances. I feel other audience members pressing up against me, adding to the charged atmosphere that swells up out of focused, punctuated social events, which are both public, so every-

one shares them, and private, so everyone submerges themselves in them. And expertly dancing through it all is the masterful bird.

Works of art are intricate constructions. They fold the minds and skills of people into collections of materials, concepts, and social configurations to produce entities of meaning and value. An artist I know sees this process as constant experimentation (Strange 1990).

In my classrooms every year I face young people who are not accustomed to thinking of art this way. Many Americans give the impression of taking art lightly, partitioning it off in their minds as entertainment or leisure-time pleasure. But the reality is that art has its own tensile strength and the capacity to infiltrate and influence us because it is made from the material and social components that permeate our lives, by people who are compelled by their nature as humans to engage in dialogues with others.

Art is potent because it pours out of deep and embracing relations among people, within their conceptual and social lives. Encountering an artwork is an experience freighted with the weight of social exchange and the labor of imagination. So it can nestle in among our vast collections of other experiences that help us guide ourselves through life. Mayimuna Nyaarè may no longer be singing. Sibiri Camara is no longer dancing. And Sidi Ballo considers himself retired. But that night near Saturday City and the persona of Sidi that grew out of it and into me will never go away. That is testimony to the significance of art and the power of virtuoso artists.

4

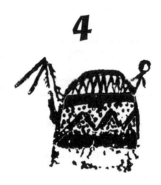

A CLOSER LOOK
AT SIDI BALLO

Not everyone could become as good a drummer as Sori Jabaatè, as good a singer as Mayimuna Nyaarè, or as good a masquerader as Sidi Ballo. Desire, drive, and dedication; the capacity to acquire the talent; the years of work to do just that—all these and more are required. Many people would not want to become such artists. Others might want to but would not have the ability or the fortitude. And plenty of people would not have had the good fortune of opportunities and resources falling into place. Character and personal history play important roles.

Because we are so social by nature, we like to know biography. We enjoy stories about people's personalities, the things they have done, and the lives they have led. Knowing a little of Sidi Ballo's biography and character is interesting just for its own sake. But it also gives insight into the reasons for his success.

Dogoduman's citizens knew a bit about Sidi Ballo. Some, especially the very young, had simply heard about him as a tremendous bird masquerader. Others, especially people in their teens and twenties, knew one thing or another about his exploits in the youth association or his travels as an itinerant performer. Still others, somewhat older, were in the youth association themselves when Sidi Ballo had danced before in Dogoduman with his own youth association troupe from Sikòròni, and some of them might have been involved

in the interaction and competitions between youth association branches.[1] All of this fueled the perspectives and imaginations of the 1978 Dogoduman audience when Sidi came to town.

So now let us look a little closer at Sidi Ballo. We start with a short biography, followed by a consideration of the personal characteristics that made him effective on dance arenas. To gain a little extra background and flavor, we then move to Sidi's relationship with the town called Sikòròni, where he was living when I saw his Dogoduman performance. We finish with an examination of ideas and activities that bring Sidi's accomplishment into a cultural focus that lets us see how he was appreciated locally.

A BRIEF BIOGRAPHY

When I met Sidi Ballo in 1978, he was thirty-six years old and living in the small urban hamlet of Sikòròni. He had been performing the bird masquerade since he was twenty-two and was still using the original carved bird's head he had sculpted when he started. By then his career had included performing as a member of two different community *ton* branches and working on his own as an itinerant dancer.

Sidi was raised in a small farming town named Tègèdo, only about twenty miles north of Bamako. This was back in the days when Bamako was a wonderfully bustling but much smaller version of the enormous metropolis it has become today, and Tègèdo was a truly rural community. Sidi's father was a practicing blacksmith who specialized in mortars and pestles and various kinds of masks. He trained Sidi, who specialized in agricultural tools and sculpted wood figures (*jirimògònin*) carved as playthings for children. Sidi was a talented sculptor. The bird's head he carved for his first masquerade was beautifully proportioned and elegantly articulated. With large, beefy protrusions on the top and bottom, the head was dynamically shaped to give it a powerful presence. Some people become good at whatever they set their minds to do. Sidi Ballo seems to be that kind of person.

But while Sidi was being trained by his father in a typical Mande smith's apprenticeship, he was also becoming an excellent masquerade dancer in the Tègèdo youth association. He had a passion for performance, and he proved himself an accomplished, hard-working dancer. As Imperato (1972, 1980) notes, bird masquerading is near the top of the *ton* hierarchy of complexity and dancing difficulty. When a generation of masked dancers got too old at Tègèdo, Sidi was asked to take over their bird masquerading. He loved it, but he told me he did not choose it. The elders and leaders of the youth association chose him for it because, he said, it is the old men who know who will be outstanding performers.

Bird masquerading definitely suited Sidi, and his passion for performing grew. Not long after assuming the bird masquerade for his *ton,* Sidi acted on his aspirations to became itinerant. He continued to dance with the Tègèdo *ton,* but he also began to establish himself on his own as a professional traveling performer. This was no small career move, because by far the vast majority of masqueraders dance primarily in their own towns as part of their youth association branch. To remain a blacksmith and dance as an avocation would have been much easier for Sidi for a number of reasons.

A major reason is economic security. Postcolonial Mali has never had a flush economy. For most people, life can be hard and times can get tough. To be a full-time traveling masquerade dancer, you have to find support. First, you will have to be good enough to get paying gigs. And you will need to get them in many different towns because paying for a performance is not easy for a community, so they cannot do it often. Every town's own youth association supports itself with gifts resulting from their volunteer labor, and they pour their resources into their own performances. Thus, an itinerant performer has to be good enough to make paying for him worthwhile.

Expenses are substantial for an itinerant bird masquerader. Creating, maintaining, and updating a masquerade is a burden in a thin economy. So is traveling to venues with masquerade and apprentice in tow. In Sidi's case, as with many performers, there was also the expense of traveling to other towns, sometimes at considerable distance, to find and purchase performance-oriented *daliluw* useful to his desires and orientations as a dancer. Even if Sidi had wanted to earn a living as a smith, paying for all this on the side would have been difficult, especially with a family to support. As a *ton* dancer, he could count on the association's infrastructure for financial support, creative labor, and performance venues. Outside the *ton,* he had to manage his own finances and tend to his own promotion, along with being a good enough performer to make financial management necessary and "marketing" possible.

There were more complications for a person performing outside of his own youth association. For example, Sidi had to negotiate his own performance events with an eye toward making his host community and its youth association happy while also getting the kind of backup that would suit his performance and help bring out his expertise. He had to maintain his own apprentice, who could learn all that was needed, be an asset to the act, and travel wherever Sidi needed to go. This, especially, was not easy, because accompanying a virtuoso like Sidi with a complementary amount of ability demanded dedication and commitment as well as a strong sense of adventure, plenty of self-confidence, and a personality that excelled in the limelight. Travel arrangements were also not easy, particularly because the bird masquerade needed to be transported, both carefully so it would not be damaged, and with

discretion so it would not be obvious that a potentially powerful link to the world of sorcery was in other travelers' midst.

These components of itinerant performing could obviously be prohibitive, but Sidi Ballo was fortunate. Other people of means saw his merits as a person and a performer, so he seems always to have had support in the form of a backer. Sidi said that, ideally, performers have backers who offer financial support and more. Backers are generally successful community members with social and economic clout. So in addition to financial support, they also help their performers network, obtain venues, and get some initial recognition. They can and do offer advice and critique (some of them used to be performers themselves) on managing one's career. Some backers are also sorcerers, and they can help their performer acquire *daliluw*. But being a good backer is a lot of work and a serious commitment, so the performer needs to show enough promise, enough wherewithal, and enough gumption to make the commitment worthwhile. Meanwhile, to be a backer one must be a bit of an adventuresome soul, or have social and artistic vision, or be a good business person, and have faith that your dancer has what it takes to succeed or at least be worthy of a chance.

The resources tied up in a masquerade construction can also lead to relationships between people. Since making, maintaining, and repairing a masquerade is expensive, Sidi said it was rarely feasible for an individual to actually own one. As Sidi put it, you have to "give it to the village." This generally means that you work out an arrangement with the *ton*. Sidi's situation was a little more complex, because he had worked out more than one such arrangement. Long before I saw the Dogoduman performance in 1978, Sidi had moved from his hometown of Tègèdo to live in Sikòròni. He managed to create an agreement with the Tègèdo *ton* to take his masquerade with him, so Tègèdo had to replace it. At Sikòròni, he had to create another arrangement so that the *ton* there would "own" and therefore put maintenance and repair resources into Sidi's bird construction. Decades later, the Tègèdo replacement was stolen. In the meantime, Sidi had both moved to yet another place and had replaced his own masquerade. The new one was quite different and definitely expensive. Because Tègèdo needed one, and because Sidi would find it much easier to maintain it with their financial support, he gave his new one to his old hometown of Tègèdo, even though he did not actually live there.

Complicated relationships arise here. The masquerade is Sidi's, his inspiration, his hard work, and his devotion. But giving it to the Tègèdo *ton* gives *ton* leaders a stake in—some would say control over—the masquerade. So when Sidi wants to perform on an itinerant basis, he must have the *ton*'s permission. This means he must always maintain good relations with the *ton* leadership. Furthermore, when they want his *kònò* to perform in one of their youth association performances, he, or now his brother Solo, since Sidi is more

or less retired, must do it, because only Sidi and Solo understand and control the many *daliluw* built into the masquerade. Thus, an itinerant masquerade dancer who has given his masquerade over to a town *ton* must have ample people skills as well as knowledge of the personalities who are maintaining his masquerade or else the necessary cooperation will be lacking. Sidi's situation is even more taxing because his new masquerade is too heavy to compress and carry by hand about the countryside. So when he plans to dance anywhere else, he must retrieve it from Tègèdo with a cart.

Sorcery is another important consideration for an itinerant masquerader. All around the Bamako region, small towns (in 1998 Sidi named over a dozen) have bird masquerade dancers. But Sidi alone among them is willing to travel extensively and perform on his own. Sidi says the reason is they fear the attacks of other people, the use of *daliluw* against them. Competition among performers can be extremely fierce, and in the heat of their attempts to best one another, many are willing to resort to the unpleasant activation of *nyama,* the energy of action. It is widely held that such attacks are potentially deadly and can be debilitating and career-ending in a number of unnerving ways. So, at least in many parts of Mande society, being a good performer often means having to be well versed in various aspects of sorcery.

This is particularly true of artists who travel on their own to venues in towns to which they are not intimately attached. Sorcery is infused into social dynamics in several different ways, and one of these is the way secrecy plays out among people. People tend to be very careful about keeping their occult knowledge and devices secret. Of course, many of their friends, relatives, and neighbors will have seen and heard enough to have at least an inkling of how to measure those powers. Out-of-towners are more likely to be in the dark. Thus, traveling provides its own special kind of vulnerability for independent performers, and you could say that being an itinerant masquerader brings a whole new level of adventure to your life.

Sidi actually loved that adventure. He was good at managing all the financial, social, and supernatural intricacies necessary to success, and he did have a backer. He was a spectacular masquerade dancer, overflowing with passion for it. The result was that his venture into itinerancy was extremely successful.

As his traveling career developed, he ended up dancing once with the youth association of a little hamlet just beyond the very north end of Bamako called Sikòròni. The youth association, the elders, and apparently everybody in Sikòròni loved him, and they invited him back to perform his bird masquerade with them again and again, so that Sidi was becoming a regular feature of Sikòròni's *ton* performances. Then, many years before I met him, the elders of Sikòròni decided to offer Sidi the gift of a home, reasoning that if he moved there, he would perform even more frequently with their *ton.*

So Sidi moved to Sikòròni and did perform regularly with their youth association. At the same time, he continued to expand his itinerant career. By the time I met him in 1978, he said he had performed in some five hundred different towns in an ever-growing circle around Bamako, and he had also been invited to perform with Mali's national dance ensemble at a festival in Lagos in 1977.[2] He performed with them in Mozambique as well. In addition, a successful friend who had moved to Gabon invited him to come perform there, and so did another successful friend living in France. By July of 1998, he said he had performed in some 1,500 towns, mostly small communities like Dogoduman, between Bamako and Kolokani, a major city about fifty miles north of Bamako. At one point he chose to cut his traveling area back, because when he was younger he used to perform as far away as the large city of Segu, 150 miles to the east.

After three decades of successful performing, Sidi began to feel his age and found it prudent to redesign his masquerade and recreate his performance so that some aspects of his dancing would be easier or safer. When I visited Sidi again in 1998, the masquerade and dancing routines we saw were completely different, even though superficially the masquerade itself looked quite similar to the costume and bird's head Sidi had used at Dogoduman in 1978.

The new masquerade and performance strategies extended an already exceptionally long career. But still, as Sidi entered his fifties, he was feeling the strain. At fifty-five Sidi decided it was enough. As he put it, whatever you do physically at that age, you are going to pay for it later in aches and pains. So he handed the dancing responsibilities for his masquerade over to his younger brother, Solo, along with all the knowledge Solo would need to handle the *daliluw* Sidi had deployed in it. Sidi would still perform from time to time, for example, at the main annual *ton* performances at Sikòròni and Tègèdo, but he now entered semi-retirement.

About the time Sidi decided he would retire, the city of Bamako, which exercises jurisdiction over Sikòròni, decided to do a little city planning and eliminated Sidi Ballo's home. So he both retired from dancing and moved out to the new neighborhood of Djalakòròji, on the very northern edge of Bamako, in another of the Mande Plateau's valleys. He gave his new masquerade to his hometown of Tègèdo, where he or Solo must go to fetch it when they have a performance to work. To help support his family, he took up farming, which he says is far easier than masquerade dancing but gives him a way to spend his energy.

In 1998 Sidi was still a very vigorous man. He loved to meet new people and sit with them talking. He walked nearly everywhere, with a spring in his step that many younger men wish they had. In semi-retirement he could still wield a masquerade as well or better than most other dancers. He believed in the value of the career he had enjoyed. He felt he had helped pass Mande

culture on to the next generation and had offered the thrill of theatrical perfor-
mance to women and children, who were not supposed to see such dramatic,
sacred performance spectacles as Kòmò celebrations. He had survived sorcery
attacks, traveled extensively, seen much of the wide world, and faced it all like
an adventurer. His zest for life had always been matched by his intelligent and
talented engagement of it, and those qualities had helped make him a success-
ful and valuable person, a person of substance. At Dogoduman, a song was
sung about people without value or accomplishment, people like elephants
light enough to carry on your shoulders. Sidi, as a model and a member of his
community, had always been the opposite of that.

PERSONALITY AND PERFORMANCE: SIDI BALLO'S CHARACTER AND ATTRIBUTES

I don't think it is possible to separate Sidi Ballo's performance from his person-
ality. As I learned about him from our conversations and from other people, I
came to feel that what he accomplished as an artist flowed out of his personal-
ity. His dedication and drive, his attention to detail, his devotion to engaging
people, his enthusiasm for the sorcery side of performance, his aesthetic
vision—these were all developed and refined as he created his career. But the
inspiration for them, the willingness to build them, and the capacity to put
them all together successfully came from within.

In many ways, Sidi Ballo is a lot like most other people, and, like everyone
else, he is in many ways unique. To passion, knowledge, and talent, add dedi-
cation, toughness, hard work, social savvy, creativity, and an analytical mind
and you have summed up Sidi's character and broadest personal attributes.

Physically, Sidi possesses a lithe, wiry strength. He is tall and very thin,
with broad, straight shoulders and absolutely vertical posture. He has an ath-
lete's manner of carrying himself, and even at fifty-eight he walks with so
much bounce that gravity seems barely to apply to him. Dancing bird mas-
querades demands excellent cardiovascular capacity, and Sidi Ballo has it.

Dancing a bird masquerade also demands tremendous strength. The sim-
plest things are demanding, such as just holding the structure off the ground
and using the hands to propel it up and down, forward and back, or into crisp,
rapid-fire vibrations that cause the entire costume to pulse in time with the
drummers' rhythms. Sidi did this expertly. In addition, there is lifting the
whole affair up for running jumps and leaps onto bleachers or into trees. And
while doing all this, there is the need to control the carved bird's head on its
long pole. Both head and pole can be quite heavy, and just thrusting it forward
and backward all night to mimic a bird demands muscle. But Sidi amplified

the demands by frequently swinging the head and pole around in large figure eights, while keeping the whole masquerade under control. This is the kind of strength that athletes acquire, and Sidi Ballo had ample amounts of it.

The average career of a Mande masquerade dancer in the Bamako region, according to the dancers themselves, is five years. There are the physical demands, and then there is the effect on the lungs. Even after dance arenas are watered down, thick dust will rise up from masqueraders' feet in little more than half an hour. It accumulates inside masquerades and is breathed into lungs to the point of being extremely unpleasant and sometimes unbearable. In such a difficult environment, it is remarkable that Sidi Ballo's career spanned thirty years instead of the average five, particularly since during much of that time he was also a heavy smoker. He even smoked cigarettes inside his costume while performing.[3]

The physically taxing nature of dancing masquerades is hard to overestimate. Yaya Traore (1998), an elder who had been a leader in the youth association at Sikòròni and a mentor to Sidi in his earlier years of dancing, had also been a bird masquerader himself for a few years. He described it as so exhausting that all many dancers think about is just managing to get through the performance, with nothing so refined as strategies of movement or audience response entering their heads. Sometimes this is obvious. I once saw a bird masquerader so tired that he kept dropping the pole holding his carved wooden birds head when he tried to extend it out away from the masquerade to create a dramatic effect. Sometimes you could see his hand inside the cloth sleeve, struggling to retrieve the pole, but generally he could not pick it back up, and his assistant had to come over and hand it to him, repeatedly, in the midst of the performance. The last time it happened, perhaps out of exasperation, the assistant literally threw the bird's head back at the masquerader. This bird dancer spent lots of time just standing, as if trying to recover his energy.

Sidi, on the other hand, always had the energy to add class and finesse to all of his moves. He made all of the time he spent in a dance arena interesting and exciting for audiences. When he settled to a stop, he was certainly able to rest. But he often did not really need to, so his stops were always at opportune times in the overall flow of his choreography, at just the right moments to give audience members a break from the excitement and a sense of anticipation for what was to come. Sidi could give people as much drama standing still as he did in motion.

To provide an idea of just how much stamina Sidi had, consider him at the age of fifty-eight. When Kassim and I arrived at his home in 1998, it did not take him long to propose that he stage a bird dance. Then he kept insisting that he was an old man and could not be expected to perform. But in fact, he performed for an hour non-stop, with plenty of vigor. He stayed up until 3 a.m. managing the other parts of the performance, and then he accompanied a sick

neighbor to the hospital before dawn. He did not go to sleep again until the next night, when he finally admitted to being tired. When younger, he could stay up three days in a row without feeling the worse for wear. In short, Sidi Ballo is built for bird masquerading.

Sidi's intelligence has played an equally important role in his career. He has a perceptive, quick-witted presence. In fact, he is one of the most mentally swift people I have ever met. He assesses people and situations rapidly. He has a fast, piquant sense of humor. When he talks to people, he has a way of taking them wherever he wants to go in a conversation without dominating it, while giving them every opportunity to express their ideas and feelings. He could be an outstanding ethnographer because he possesses a pronounced social intelligence.

Whenever he meets people, Sidi begins asking them questions and taking their measure to determine their potential for pleasurable banter. One of the great pastimes in Mande is establishing, developing, and exploiting a venerable and dynamic institution known as joking relationships (*sinankun, senenkun,* or *sanankuya*). It is no coincidence that, just as he is a great dancer, Sidi is also a great joker.

Joking relationships are socially sanctioned humorous exchanges between people that can be highly public and generously laced with satire, insults, and stereotyping. They are a wonderful form of social engagement that facilitates interaction among people and often leads to acts of mutual support. They are highly valued components of the oil that greases the Mande social machine. Many people are constantly engaged in them, and virtually everyone enacts them often enough to know a great deal about them. They are a perfect proof of scholars' insistence that people are unquenchably social creatures (e.g., Carrithers 1992). Joking relationships play out along a vast range of intellectual levels but frequently demand labyrinthine intelligence. Often too, they generate hilarity so intense that it is hard to maintain dignity when listening to the onslaught of complex and imaginative insults being hurled back and forth with delight and gusto. They are a major form of Mande social expression and an endless source of entertainment.[4]

To foreigners they may seem aggressive, because people are striving mightily to profoundly insult one another. But they are rich forums for interaction that bring quick intelligence, history, and humor together with wonderfully entertaining results that are simultaneously of great social value. Because they can be complex, demand very quick thinking, and require much social confidence, they reveal a great deal about people engaged in them.

We can see a Mande joking relationship as a state of potential discourse present whenever people engage one another. Individuals can invoke or ignore it as they choose. Its characteristics include license to tell the most outrageous tales about each other to their faces and to hurl insults that most Americans

would consider litigious but that Mande consider good clean fun. At the same time, joking relationships can involve substantial material, emotional, or social support between the very people insulting each other, because they often develop close friendships and really care for one another.

Joking relationships inspire empathy, sympathy, and a softening of the harder edges of people's social personae. Those engaged in the strident banter of *sanankuya* share a tacit agreement to cut each other slack, which can be a very useful social resource. Joking relationships invoke structures outside of ordinary patterns of apparent aggression and possible retaliation; they create a kind of neutral zone. Kone (1998) notes they also carry a kind of power to neutralize potential resistance or hostility; they are disarming. Thus, Mande say of an enacted joking relationship: *a be a fari faga,* "it kills their muscles," meaning it will soften people, making them useful to you, preventing them from getting offensive or aggressive. Smart people such as Sidi Ballo know how to use such a resource to gain social advantage, and also simply as instruments in the wondrous and never-ending business of engaging people in ways we all find fascinating and fruitful. Sidi used joking relationships in these ways all the time.

As Kassim Kone pointed out to me, quick-witted people can create joking relationships with anyone, but there is a foundation of established patterns. Particular Mande clans have pre-established joking relationships between each other. For example, the Jara and the Kone have an established joking relationship with the Traore. In addition, ethnic groups and special professional clans also have established joking relationships. The non-Mande Fula maintain a *sanankuya* with Mande blacksmiths. So when a blacksmith clan member such as Sidi Ballo meets a Fula, or a Jara meets a Traore, each is in a sense related by humor to the other. A teenage Jara can call a Traore elder "little brother," and the two of them may be expected to do all sorts of helpful things for each other.

Joking relationships can be established where they do not already exist. A person can say that another looks like, or their name sounds like, that of a clan with whom they have a joking relationship. One can claim that another has said or done something that reminds them of a particular clan. A person can even forego the pretext of seeking such a relationship and simply begin talking to someone in a joking relationship style and see if they are willing to respond. Once both people accept this charade, a *sanankuya* is up and running, and a wild ride may well follow (Kone 1998).

On a June day in 1998, a man passed the residence of Kassim Kone's brother and stopped to greet Kassim, his family, and me. A respectful ensemble of inquiries about family members and health ensued, and then, as is customary, last names were exchanged. The man said he was a Traore, and then the fun began. Kassim opened with the salvo that, oh, he had just left a Traore

pulling a donkey cart, and from there on, with much laughter from everyone present, it was an excursion into some of the most delightfully biting humor imaginable.

Another time a man came by and the usual greetings were exchanged. But the man was not paying attention when another person present told him their last name was Jara, and he thought he heard *jiri* (tree). He supposed they were talking about a newly planted little tree right next to him that was being propped up by a much larger dead tree. Playful laughter engulfed his confusion, but he recovered quickly, and as a Traore, he said his clan is like the strong dead branch supporting the needy little tree, *jiri,* that he then likened to the Jara clan. This quick comeback was highly appreciated, and additional hilarity continued.

The most dynamic joking relationship exchange I have ever seen also took place in June of 1998. At the end of a hot, exhausting day of work, Kassim and I arrived at the big taxi depot on the edge of one of Bamako's major markets, Sugunikura, looking for a ride home. Sometimes just getting a taxi involves a test of wit and will, because the hawkers who find rides for the drivers can be aggressive in their attempts to get you into a vehicle at the highest possible price. We approached a row of cabs, and a particularly assertive hawker and Kassim suddenly transformed their price negotiations into a full-blown *sanankuya* engagement. The hawker was a Traore, and he knew how to stick it to a Kone. One big joke between the two clans is each clan's insistence that the other loves to eat beans, no matter how hard they work at hiding it. With Kassim, this particular Traore just would not let go of the beans insult, and things got so hot that Kassim challenged him to see if he was tough enough to ride the rough and tumble roads in the cab out to where we were staying. Instantly, this Traore delegated his job to an assistant and hopped into the cab with us. We spent the next twenty-five minutes in a maelstrom of information, ranging from more negative data on the Kone and Traore clans to facts about the topography, the wild life around Bamako, and all sorts of other topics. When we finally got out of the cab at Kassim's brother's house, the day's exhaustion had melted away as we considered the high points of the good time that had been had by all, and Kassim commented on what a fine fellow that Traore was.

Early the next morning, however, Kones scored a major victory over the Traores in the *sanankuya* arena at that same cab depot. This time Musa, Kassim's cousin, was with us, looking to greet a woman named Traore who worked at the depot and whom they had not seen since their high school days. Imagine the exaltation and sense of poetic justice when they discovered her, right there in the middle of the depot, eating beans for breakfast. (In fact those beans, with garlic, onion, and a bit of greens, all cooked up in palm oil, make a delicious breakfast.) Kones like to call beans "The Traore's Big Rice" (*Traore oka malo kiseba*) as a particularly hilarious insult, and given the hawker's powerful

emphasis on Kone bean-loving the evening before, this breakfast was just too good to be true. Heaps of information on Traore proclivities issued forth as photographs were taken to document the event and everyone struggled to maintain dignity in the face of mirth that we would enjoy for hours. As we left the taxi depot, it was said that this was a great day for the Kones.

These examples suggest that joking relationships offer great social pleasure and a delightful medium for the exercise of an individual's quick wits and intelligence. Some people are especially inclined toward them, and among such people are Kassim's cousin Musa and Sidi Ballo. Musa is a most interesting man. A professional driver (specializing in both city and country driving, two very different experiences in West Africa), he is also an expert roadside mechanic who has also managed a car rental business in Bamako. He is a man-about-town, a person who is endlessly greeted by people from every walk of life all around the capital. He thinks deeply about current events and enjoys conversations about values and responsibilities. He is also a tremendous joker and provocateur who has cultivated the slurred style of speech popular in his hometown of Kolokani, a style he uses to put people a bit back on their heels when he is embedded in hot banter around Bamako.

When Sidi Ballo and Musa Kone first met, an intellectual sizing up began instantly. They found no clan justification for a joking relationship, so they quickly trumped up an excuse for one and then engaged it whenever they were together over the next several days. One of the big payoffs in these relationships is the sheer pleasure of astounding one another with ideas juxtaposed in unexpected ways or expressed in unexpected places. Sidi did the latter at the masquerade festival he staged for us on July 4th.

Musa tape recorded the event with a small portable machine that he would hold at shoulder level with the microphone extended out in his hand. He was trying to record the chorus's songs when Sidi cruised up and parked his bird masquerade right next to him. For the audience, this would be one of those moments to reflect on what Sidi had just done and enjoy the anticipation of what might happen next. But for Sidi and Musa, it was another episode in their joking relationship. Under his breath so that no one else could hear, Sidi whispered very rude insults at Musa, who of course was holding the tape recorder. Sidi actually challenged Musa to respond to him. But Musa told him they should be quiet until later, suggesting humorously to the master that he was ruining his own performance.

This sort of thing is typical of Sidi. He does not talk to anyone for more than a few seconds before he is plumbing the social terrain for a joking relationship. And in all of his conversations—with family, friends, community members, and foreign researchers—he exercises a commanding conversational presence, obviously grounded in extensive social and cultural knowledge. His facility with joking relationships and his propensity to engage in them are an

excellent index of his disposition as a person, and I think that disposition has contributed hugely to his masquerading success. He is an individual who wants to be engaged with other people, to be endlessly propelled into dialogue and interaction.

This disposition was obvious in dance arenas. For example, he loved to rush up to audience members, settle ever so near them, and then just sit. This strategy can easily be compared to the almost in-your-face nature of joking relationships. Even Sidi's spectacular invisibility—when he lay on dance arena dust and opened the cone to intimate perusal by audiences—fits with his inclination to involve others in dialogue and interaction. And this disposition to engage has most certainly helped shape his success, because it generates excitement in audiences and a constant concern for them on Sidi's part. To me, it is a good example of how an individual artist's personality is all wrapped up in his or her artistic production. Sidi Ballo's conversational presence is part of a broader social presence that patinates his art.

Twenty years ago, when I first met him, Sidi Ballo's social presence had a tough youthful edge, a kind of verbal swagger that fit very well with his masquerading prowess. He was in his time of youthful accomplishment, his *kamalen waati* (Arnoldi 1995, 152–61), and he presented himself as such. At fifty-eight, Sidi's commanding conversational presence had changed in style. The swagger had dissolved into a soft-spoken, dignified but potent aura of intelligent authority. His voice is high and not at all loud, and sometimes he hesitates just an instant in his speech as if measuring it out so as not to overwhelm his listeners. But the powerful sense that rides along on his words is that he is a person who knows what he is talking about.

Earlier, when we talked about Mande stages of life, I said that elders are supposed to enjoy stature and respect because of their accomplishments as they worked through their time of dynamic youth. Some were simply responsible and productive. Some just grew old, and their age alone garnered them respect. And some accomplished a great deal in their time of youth and have become renowned. Sidi jokes about his age, suggesting that the years have no more encumbered him than does gravity slow his gait. In a sense he has become an ideal elder. He is a mature older man who worked mightily to build a successful career. Younger men would do well to model themselves after Sidi, and in fact, some do.

Sidi has a strong social presence, created by his sharp mind and conversational ken and by various other elements of his persona. His wits, his physical vitality, his age, and his deeds as a masquerader all roll into compelling social force. Since he belongs to a blacksmith's clan, he also possesses that aura of *nyama*-laden danger and very extroverted *nyamakala* behavior.

But people do not just traffic in their birthrights as they negotiate their mutual relations. They also traffic in their personalities, with their brains and

their skills. Sidi's social clout among non-smiths extends well beyond descriptions that most of the literature would apply to Mande blacksmiths. He is authoritative in his expectations of how people should respond to him. Smiths can behave with flamboyant abandon among other people. Yet Sidi's public manner is fluid and relaxed, while being constrained and concise at the same time. Even though he enjoys extensive conversation, he gets things done with a minimum of discussion, and he is, in fact, very effective at organizing activities, no matter what the actors' social background. The generalized literature on blacksmiths' clans suggests they are instruments that do the bidding of the *hòrònw*. Sidi, like numerous other effective smiths, often reverses this.

This was made clear when we met again in 1998 and Sidi decided to throw an ad-hoc bird masquerade festival for Kassim and me on the night of July 4th. It would be preceded by a grand feast at his home for the neighborhood elders and leaders. He gave himself fewer than two days to organize the event. This included arranging for senior and junior female singers, a drum orchestra, about fifty youth association members to dance unmasked during bird masquerade intermissions, a couple of crowd organizers (masters of ceremony), a number of elders for the audience, and some three hundred additional audience members, many of whom would also dance during bird intermissions. In addition, his masquerade had to be retrieved from storage twenty miles away in Tègèdo; and this was no small feat because, as you will recall, he had completely redesigned the masquerade, and this one was much heavier and not the least bit collapsible. In addition, it needed to be repaired and refurbished, as masquerades usually do before a performance. It turned out the retrieving had to be done on foot, because a car was not available.

This is a great deal of organizing for so short a time, and most people could not have done it. But Sidi managed without a hitch. Kassim and I dropped by his home in the late afternoon to find an immense amount of rice in the final stages of preparation. Two hours later his family compound was overflowing with at least fifty local persons of consequence, all enjoying a fine meal. Sidi's younger brother Solo (Solemane), who has taken over most of the masquerade performing since Sidi retired, was on hand to dance first, and at about ten that evening the bird masquerade embarked on yet another successful performance, which lasted until three in the morning.

The potential for contention, extended negotiation, and organizational difficulties of all kinds was considerable. But Sidi's effective social presence was the necessary enabler, and this capability is an insightful measure of the consequences of an individual's personal history, an appropriate measure of the man. It suggests a thorough and authoritative individual, willing to undertake the out of the ordinary and see that it gets done.

I love the continuity between Sidi's social personality and his dance arena presence. In social settings Sidi uses topic choices, word choices, and

joking relationships to keep him well embedded in the midst of a conversation, not egotistically or oppressively, but in a way that makes it impossible for people to forget he is there or to take him for granted. In the dance arena, he joins movement and gesture to his sense of people's anticipation and excitement to keep their attention riveted on him. In conversations, he has a way of producing intensity by taking people right up to the edge of what they are comfortable talking about, and then backing off a little with a humorous, even self-effacing statement, spoken in a soft voice full of gentle, self-aware humor. He does the same thing in dance arenas by pushing people to the edge of dramatic intensity with the suggestion of falling over, then righting himself and proceeding as if all is well. He did it too when he lunched himself horizontal at high speed into walls. But as in conversation, the finish is important, so once against the wall he remained there, becalmed, with the bird's head moving about slowly, just long enough for people to absorb what he had done as they calmed down a bit from the thrill of it.

I do not know if his way of social being is done with deliberate attention or if it is, or has become, a natural part of Sidi that he does not even think about. It is manifest, however, with commanding, easy grace. It is a type of social perception and understanding of how to negotiate social space that I think is inseparable from his awareness of how to compose, moment by moment, a masquerade performance. It is part of his masquerading success.

Another important measure of the man is his dedication to *daliluw, nyama,* and the sorcery side of performance. This dedication is an aspect of his intelligence and his unwavering will, and it also impregnates his physical persona, an important aspect of his commanding social presence. It is what he referred to as "dancing naked."

Remember that the Mande world of power can be described as a system of cause and effect. Amulets (*sèbènw*) and power objects (*basiw* and *boliw*) provide large quantities of the energy of action (*nyama*), amassed and dedicated to a particular task through the enabling means of a recipe (*dalilu*) that identifies a problem or a need, provides a list of ingredients and procedures for assembling them, and explains how to deploy them to help solve the problem or address the need. This is all done with reference to an enormous body of ever-growing, ever-changing knowledge called "the science of the trees," or "knowledge of the trees" (*jiridon*).

Using power in this way is considered by Mande to be a major essence of their worldview, because everything that happens is driven by this energy called *nyama*. But using it is not an easy thing. It is considered absolutely, awesomely potent, and most people describe it as dangerous. Many people describe it as totally negative.[5] And everyone recognizes that being involved in manipulating it has perils as well as benefits.

Mande who traffic extensively in this world of power are seen as sorcerers. Having the power of sorcery can be an end in itself for many people. For many others it is a means to an income, since people commission sorcerers to harness the world's energy in order to help them achieve specific ends, such as successful marriages, good crops, positive business ventures, political victories, trouble for rivals, and so forth. For others, such as Sidi Ballo, it is a means to personal success in an enterprise or profession.

In 1978 Sidi talked extensively about the tremendous importance of sorcery to enhance his performing. As central as was good dancing and the hard work needed to become good, for him it would never be enough without the assistance of *daliluw*. From the very beginning of his career, Sidi recognized this and dedicated himself to acquiring as many as he could. This meant frequent travel to find people who had *daliluw* he could use, and large amounts of money to pay for purchasing their knowledge and the rights to use them. It also often meant being able to demonstrate that he was a worthy person. *Daliluw* owners have the right to withhold sale if they are not convinced that they can trust (*danaya*) the buyer to be worthy of the ability the *dalilu* bestows, to use it well, and to keep its secret (*gundo*).[6]

In addition to these requirements, collecting *daliluw* also meant having the mental abilities to handle all the information involved and the physical capacity to be exposed frequently to large quantities of the energy (*nyama*). Finally, it necessitated nerve, the psychological confidence to be frequently exposed to something dangerous. Being from a blacksmiths' clan was helpful, since smiths possess more *nyama* than other citizens and are often trained in its manipulation. But here, as in other areas involving the special birthrights of clans, it is not the birthrights that count so much as how individuals develop what those birthrights offer. Many Mande blacksmiths use their extra capacity with *nyama* for nothing more than working iron, a task said to demand and emit large amounts of it. Sidi, on the other hand, chose to develop his use of *nyama* extensively in other fruitful ways.

He emphasized this fruitfulness many times when we spoke in 1998. I brought a number of photographs from the 1978 Dogoduman performance, including one of Sidi about to begin his performance preparations. What he enjoyed the most in these photographs was recalling his amulets (which were often so well hidden that I could not see them in the pictures). Several times, in a voice filled both with glee and confidence, he would speak with satisfaction about how potent an amulet had been and how important to his career. In his view, *daliluw* had contributed as much to his success as anything else.

The Mande world of *daliluw* and sorcery is not easy or comfortable. But to write of it as endlessly and unremittingly fearsome, as many Western authors have, is to detach it from the individuals who practice it. It is dangerous and

not to be trifled with, certainly. It is also, however, profoundly and practically enabling.

Sidi Ballo's performances, such as the one he organized for July 4, 1998, would begin with a master of ceremonies offering a welcome and a warning. He greeted the assembled audience and bid them a most enjoyable time. But then he said that should anyone present be contemplating the enactment of sorcery against Sidi or his brother Solo, such an act would meet a response. Similar statements are often made on behalf of performers at the opening of Mande performances.

That was an understated warning. It meant that anyone attempting harmful sorcery would face the powerful sorcery of Sidi. It was a warning not to be taken lightly, because although many people have deployed sorcery against Sidi Ballo in thirty years of his performing, no one succeeded in deflecting his career. His own sorcery, his battery of *daliluw*, have always been up to the task of protecting him, which implies that unpleasant consequences could be visited upon anyone trying to harm him. This is the dangerous side of sorcery.

The enabling side of sorcery is manifest in what Sidi and many good performers can do with it. They and their audiences believe that sorcery can make an event spectacular, can help fill it with bold, dynamic feats that boost the performance quality measurably. This is so true that in some areas, many Mande consider bird masqueraders who don't use sorcery to be second-class performers. Some towns will not even invite performers without this power to participate in their events.

Sidi is well aware of the terrors of sorcery—from not being able to handle one's own attempts to amass power, to being harmed by the amulets of others. But without ever revealing secrets, he speaks matter-of-factly about their value, from both an artistic and a business frame of reference. He told me that he never feared other people's *daliluw* because he was always busy acquiring so many of his own, quite a few of which were designed to guard him from the malevolent attacks of sorcerers. As Sidi put it in 1998, he spent a lot of money on protection.

Other people have not been so lucky. Over the years Sidi himself has had some fourteen apprentices. Two became really excellent, nearly as good as he, but one was brought down by malevolent *daliluw* before he had performed on his own for two years. The other met a similar fate. Any kind of performing makes you vulnerable to the dark side of Mande power. Itinerant performing—traveling and working among strangers—exacerbates the danger.

When Sidi talks about the Mande world of sorcery and his involvement in it, he makes it clear that he accepts and prepares himself for its hazards, while taking great pleasure in its benefits. Other Mande may feel overwhelmed by sorcery's unsavory side, but many Mande approach the realm of *daliluw* and *nyama* as Sidi does, with a practical bent of mind.

Sidi's practical mastery of sorcery is a definite component of his commanding social presence. In any gathering of people there will be some who fear sorcery and some who see its good and bad aspects and are cautious about its practitioners. There will also no doubt be some practitioners. But since one of sorcery's major rudiments is secrecy, practitioners may be in the dark about each other's exact capabilities. The net result of this is generally respect: practitioners respect each other (even when they duel) and non-practitioners respect them all. The possible abilities of sorcerers factor into the complex arrays of Mande social ideas and practices, so that in people's practical dealings with one another, they consider the potential for sorcery in the light of their relative positions in society and their respective social and spiritual networks. They also consider the character of people with whom they deal and weigh the probability of their behaving in aggressive or cooperative ways. Thus, the hard edge of sorcery is blunted by broader social realities, and this is another area where much scholarly writing is over-simplified. Sorcery works in a maze of social configurations, and that maze is composed of some people who are a bit like Sidi Ballo and some who are very different from him. So Sidi's mastery of sorcery, important though it is, does not dominate, but rather melds into the other components of his persona.

To sum up, Sidi Ballo's persona is complex. He is a man of strong character and resolute personal responsibility. In 1978, he noted more than once how hard one had to work to be successful. In 1998, he noted many times how hard masquerade dancing was and how many apprentice dancers never made it. Sidi's strength, intelligence, fortitude, and resolve to succeed gave him years of fame. The institution of Mande masquerade dancing offers people the opportunity to become great performers. But it is individuals such as Sidi who manage to do it.

This is not much detail about Sidi's life and disposition, but it is enough to show that great things do not happen simply because people work with the resources and constraints society gives them. Certainly, people are made in large part by those resources, but they are also made in part by themselves. In the process they reshape, revitalize, even transform those resources—institutions, expectations, and modes of thought and action—so cultures change and history transpires. Works of art cannot exist without the resources that a culture and society provide. But they also cannot exist without the individuals who make them, and this is as true in the history of African art as it is of art anywhere else in the world.

People are not interchangeable. Placed in the path of the same elements of society and culture, they will not grow in the same way. Sidi is more than a man who found a niche on the artistic side of Mande social formations. By virtue of all that constitutes his particular persona, bird masquerading is itself changed, and so are the people around him.

SIDI BALLO AND SIKÒRÒNI

Sidi Ballo lived in Sikòròni during much of his performing career. Besides be-
ing given a home there, he found an accommodating spirit, I think, with ar-
tistic and social values that in large measure complemented his own. In 1998
to get to Sikòròni you went to the north edge of Bamako, then traveled a mile
or so over a large field and down a hill, to find yourself in a lovely little com-
munity that is actually considered by many to be a detached suburb of the
capital city.

Several oral traditions illuminate the founding of Sikòròni and Bamako.
I first heard one wonderful story about the founding of Bamako in 1971. A
group of merchants were seeking a location for a crossroads town, a place that
could become a central entrepôt for commerce along the Niger River and to
the north and south. They had decided on the general location but wanted the
precision that divination might give them to enhance their final decision. So
they consulted a soothsayer. He told them to move along the river until they
heard crocodiles speak, and that would be the best site for their city. They did
just that, and named their new town Bamako, "where the crocodiles spoke."
The town prospered, grew, and ultimately became the capital of the Republic
of Mali. Another story (Diallo 1997, 3) says Bamako was founded as a hunting
camp by a hunter named Bamba Sanogo, around 1640.

It is widely held (Kone 1998) that the original habitation of Bamako was
some five miles off the river, tucked into one of the little valleys formed by the
steep cliffs of the Mande Plateau across the city's northern edge. From this lit-
tle community, Sikòròni, members of the venerable Nyara clan moved down
near the river to what is now called Niarela, which is said to be the oldest quar-
ter in the metropolitan zone. Sikòròni remained detached, like a separate little
community, with the field and hill serving as a buffer zone. This is somewhat
remarkable, because the ever-expanding capital has jammed itself right up
against the base of the rocky plateau in many places.

Sikòròni is quite different from the hustle and bustle of melting-pot Ba-
mako. It is cleaner and quieter, which is typical of many capital city's sub-
urbs all over the world. Fewer young people roam Sikòròni's streets at night,
and fewer spend time playing "littlefoot" (foosball). When you pass the
northern end of Bamako proper and go through the buffer zone, upon reach-
ing the little suburb you feel a bit as if you have entered a calmer, more staid
world.

In 1998, Sikòròni's youth association was strong and thriving, with excel-
lent and authoritative leadership provided by a man well into his thirties who
took his position very seriously and was wholly dedicated to the association's
success. Sikòròni's youth were very involved with the *ton,* and they seemed to
have a strong sense of purpose, discipline, dedication, and a strong work ethic.

That does not mean they lacked the passions of young people. One of their prominent masquerade dancers had a very sexy poster on his bedroom wall. But at the same time, he was a decidedly serious *ton* member and masquerade dancer.

On a July afternoon Kassim and I talked to six members of the Sikòròni's youth association, two of whom were masquerade dancers. We gathered in the open space in front of the dancers' home. They were in their late teens and lived on their own. Off to the side, next to their rooms, were several masquerade costume frames ready for service whenever the need might arise.

When we were searching for Sidi Ballo, these youth association members knew how to find his new residence, way off to the northeast in another newer suburb named Djalakòròji. They were well aware of his great performing and his fame. The two whose rooms we sat facing had the purposeful attitude seen in people very dedicated to attaining something. They were deeply absorbed in the conversation, although, respectfully, they would only speak when given leave to by their *ton* leader.

At one point in the discussion, while we were talking about how Sidi's masquerade used to look, one of these serious masqueraders invited us into his room to show us something. As we waited, he disappeared and returned with a carefully wrapped bundle out of which he gently pulled a carved wooden bird's head made for a masquerade. He considered it loaded with amulets and wanted to compare it to a photo we had of Sidi's 1978 bird's head. He had thought they might be the same, but they were not.

This young man was fit, as a good masquerade dancer should be, and moved with the kind of controlled grace that made you think he would know what to do inside one of those costume frames by the side of his house. He struck me as being completely caught up in the business of becoming an outstanding performer. The value he placed on the bird's head he had acquired gave indication of that. This young man took inspiration from his predecessor, Sidi Ballo. He is part of Sidi's Sikòròni legacy.

Big African cities are generally sites of social transformation, where established values must be fluid because they face the turmoil and stress that compacted, melting-pot living can generate and the challenges that numerous outside influences can bring. But just off the edge of Bamako, Sikòròni's *ton*, with its ongoing vigor and its significance as a source of strong Mande values, seems to me to offer a kind of balance, and it is people like Sidi Ballo who have helped make that true.

Sidi always wanted to perform Mande culture as affectively and as spectacularly as possible. He wanted to expose young people to it. He could have been a tremendous Kòmò masquerade dancer. He was a blacksmith, and he was effective at and comfortable with the use of *daliluw*. He had everything a dancer would need to animate a Kòmò headdress and costume with superb

effectiveness. But he said he did not want to perform in a forum that excluded women and children. In the final analysis, Tègèdo, Sikòròni, and Djalakòròji all benefited from Sidi's decision to be a public masquerader.

It is not always easy to sort out people's influences on one another. Human interaction is complex. Interests, predispositions, and capabilities tumble around each other in a social conglomeration that sometimes makes the concept of cause and effect seem simplistic. It might be more fruitful to think of the distribution of influence among people as a sometimes empathetic, sometimes deliberate, and sometimes haphazard and intricately multifaceted dance. Sidi Ballo found opportunities in Sikòròni that enhanced his blossoming career, and he also found great appreciation for his accomplishments and abilities. The little town added a star to their performance troupe and thus garnered enhancement to an already strong reputation. We can say that Sidi Ballo and Sikòròni were very good dance partners.

SIDI AS HERO

Sidi Ballo's personal characteristics piloted him to a successful career. The society that provided resources for Sidi to build that career also provides a conceptual framework that brings Sidi's accomplishments into celebratory focus. It is a multifaceted social construction that blends ideas, activities, and emotional states with people to produce an embracing and rewardingly tangible atmosphere of success. Simultaneously, it puts a cultural spin on hard work and accomplishment and effectively articulates success to the benefit of Mande society.[7] It carries substantial weight in popular imagination and is yet another example of how individuals and societies use each other, sometimes at one or the other's expense but often to their mutual gain.

Mande have rich, complex conceptualizations about heroic behavior. Hardworking farmers are honored with heroes' songs. So are hardworking blacksmiths. Hunters with talent and a propensity for adventure, who save communities from peril or behave with valor in the bush, earn accolades and often fame. Leaders and empire builders who accomplish grand deeds—build, save, or revive a state, for example—become renowned and have songs or even epics created for them. Some of Mande's greatest art, the oral traditions such as the Sunjata Epic (J. Johnson 1986, Niane 1965), the hunter's epic of Kambili (Bird, Koita, and Soumaouro 1974), and the cycle of traditions about the Bamana state of Segu (Conrad 1990, Belcher 1999), are elaborate, awe-inspiring representations of how heroes are said to have earned their stature.

There is practical elegance in the ideas Mande use to compose their concepts of the hero. Hard work and success from hard work are a baseline, a foundation of heroic behavior. Families, communities, and regions must be

cared for, economically, socially, politically, and spiritually. A hero's behavior includes the arduous labor and sometimes personal sacrifice needed to achieve that care. In Mande communities, tremendous respect is accorded people who work with dedication, intelligence, and skill. Some of the songs sung at Dogoduman attested to that.

There is also a powerful sense of competition in Mande societies and a complicated, supple set of ideas people use to think about it, maneuver within it, and enact it. Competition, covetousness, and jealousy are not strangers to any society. In Mande, competition for resources and renown begins at the family level and expands all the way out to society and state. Although there are well-established principles for wealth inheritance and leadership succession in patriarchal, polygamous Mande families, in practice, siblings still struggle, sometimes fiercely, to better themselves in both realms.

Two interlocked concepts help Mande measure this social landscape. *Badenya,* "mother-childness," refers to children who share the same father and mother. Theoretically, they also share affection, devotion, and selflessness toward each other. *Fadenya,* "father-childness," refers to children who share a father but have different mothers in polygamous households. Theoretically, they are rivals and are likely to share as little as possible with each other. In reality, the members of families vary a great deal in their dispositions and experiences, and the whole gamut of emotions, from affection to rivalry, can be found in siblings, no matter who their parents are. Furthermore, as everyone knows, rivalry and affection between individuals frequently coexist and play out in complicated ways.

Nevertheless, these concepts are extremely useful as instruments of analysis and principles of action, constituting an important feature of local social theory. They are used in every imaginable social situation and are readily expandable from the family to the community and society. At these broader levels, "mother-childness" references "stability, cohesion, accommodation, respect and cooperation" (Bird, Koita, and Soumaouro 1974, vi). It spotlights unity, solidarity, and putting the group before the individual; and it emphasizes mediation, understanding, and always behaving by the rules. "Father-childness" refers to instability, dissension, and opportunism. It spotlights personal gain, disruption, and the individual over the group, with emphasis on success by any means and a complete disregard for rules and norms.

Among the things that people compete for is fame, in the form of renown, and a degree of accomplishment and success that leads to widespread recognition—or, even better, one's name being entered into oral tradition. "Father-childness" applies here, because, as Bird succinctly states: "To gain a name sung for posterity means not only overcoming one's contemporaries, but also overcoming the deeds of one's predecessors" (Bird, Koita, and Soumaouro 1974, vi).

The road to fame can incorporate much stridently aggressive behavior. Heroes may be ruthless, unsympathetic, and conflicted characters, driven by complex motivations and not beloved by all. People can be hurt or killed. Sorcery can be used with calculated abandon. Trusting and cautious people can be deceived in some of the most intricate and indirect ways imaginable. In the hunter's epic *Kambili,* for example, intelligence, skill, and raw nerve help the hero save a community. But it can also be said that through subterfuge and trickery, Kambili manufactures the danger from which the community needs saving. He creates the reason a hero is needed and then becomes that hero (Bird, Koita, and Soumaouro 1974). The great hero-savior of the Maninka, Sunjata, founder of the Mali Empire, was no angel, as John Johnson (1986, 41–47) notes in a rich description of becoming a Mande hero.

People who take the predominantly *fadenya* road to becoming heroes are clearly highly competitive and aggressively individualistic. They have tremendous toughness of character (*karo gèlèya*) and incorporate a broad range of power types, from coercion, persuasion, and subversion to military might and supernatural energy (*nyama*).

But for a hero to be built, "father-childness," *fadenya,* must still commingle with "mother-childness," *badenya,* with its emphasizes on cooperation, solidarity, and generous subjugation of the self to others or the group, because heroes ultimately secure their stature by mobilizing their "father-childness" capabilities on behalf of a group. Sunjata created a thriving, fruitful empire that benefited many individuals. Indeed, in this same vein, one source of a hero's power is the positive force called *baraka,* held by many to be the product of a person's mother's successful social responsibility, a mother's "mother-childness." *Baraka* is in many ways like *nyama.* It is power that can engage and change the underpinnings of the world and fuel actions taken to effect that change. Sunjata, it is said, possessed much of this energy.

There is another route to heroic stature. It demands many *fadenya* qualities, such as being highly competitive and individualistic, having a tough character, and possessing the will to rise above other people. Also needed are brains and skills, and particular kinds of expertise such as the ability to develop and implement artistic and social strategies to affect and influence people. But this route emphasizes *badenya* qualities such as palpable social configurations of solidarity, wholeness, and awareness of the values in a unified group. People who articulate the material, conceptual, and emotional resources that compose their society, who manipulate with great artistry their culture's social formations, who know the rules and proper procedures for doing things and use them with great finesse and strategy— these people can be honored with the Mande concept of the hero (Kone 1998). Everything I have said about Sidi Ballo's life and personal attributes suggests that he is such a person.

Once, while taking about Sidi, my friend Kassim Kone said that Sidi had ridden *badenya* to the top. He had followed already established rules, norms, and procedures precisely by exercising them with tremendous expertise. This kind of hero is the person who knows how to pull every string, to push people's buttons with such dexterity and efficacy that something wonderful is created, something such as a performance so broadly galvanizing that it moves viewers to heights of emotional rapture or depths of contemplation, or to surprisingly bold courses of action (or some combination of all of the above). People who can do this are, perforce, practical social scientists and psychologists, among many other things. They are highly knowledgeable, greatly skilled, and loaded with experience of how the social world works. This is the sort of hero one would call Sidi Ballo.

In 1978 when Kalilou Tera, Sekuba Camara, and I were transcribing the songs from Sidi Ballo's Dogoduman performance, we got to talking about one that praised Sidi as a hero. Kalilou is a scholar of linguistics and culture with a deep background of Mande research. Sekuba is the son of Seydou Camara, the famous hunter's bard, an accomplished musician himself, and, as a blacksmith clan member, very knowledgeable about the artistic and social dynamics of Mande power and authority. Kalilou and I had described Sidi's Dogoduman performance rather thoroughly to Sekuba, and as we talked about Sidi and the song, Sekuba articulated a description of the Mande hero that fit Sidi beautifully. He said heroes are people who fear nothing. They never hesitate to start an enterprise. They generally respect traditions to the degree that traditions support their goals. But when traditions stand as obstacles, they do not respect them. They resist their enemies, stay powerful in spite of their enemies' attacks. They impose themselves on others. One enjoys oneself as a hero.

Sidi was most certainly fearless. He launched himself into an itinerant performer's career in spite of its huge challenges and the fact that his father had trained him in the perfectly sensible profession of blacksmithing. He overcame jealousy and sorcery numerous times in his career and prevailed where many others did not. In a *badenya* way he regularly advanced his agenda to gain economic success and social clout, using, for example, his social skills and conversational acumen. He was decidedly happy with his life in 1978 when I saw him perform at Dogoduman. And he was proud and pleased with his career when I saw him in 1998. It is appropriate to say that Sidi Ballo was a Mande hero.

There are two words for Mande heroes, each usually applied to particular professional, social, and spiritual segments of the population. *Ngana* is the word used for members of the "free people" and "noble" clans (*hòrònw*). *Ngara* is the word used for members of the special professional clans such as bards, blacksmiths, and leather workers. When bards become famous for their performances of the great Mande epics, they are generally called *ngara*. When blacksmiths become famous for their sculpting or their sorcery (one of the smiths'

avenues of professional expertise), they too are generally called *ngara* (Kone 2000). Sidi Ballo became famous for his masquerade performing, however; so having stepped outside the ordinary but ever-porous boundaries of his smith's clan profession, he could be called *ngana*—and, in fact, that was the praise name sung for him by the young ladies' chorus at Dogoduman.

CULTURE HAS A HUMAN FACE

All that Sidi Ballo has been as a member of Mande society and an individual informs what he has accomplished as a bird masquerader. And all that he is as a bird masquerader informs what he is as an individual and member of Mande society. In many ways, these three aspects of the man are too complexly inter-twined to unravel. So no one can say exactly how much Mande culture made Sidi and his performing career, and how much Sidi and his career made Mande culture as it has been manifest around Sikòròni in the late twentieth century.

Culture is in perpetual flux because of people's actions. If they were different people—if this unique and potent blend of character and attributes that is Sidi had not existed in central Mali, for example—palpable differences could have arisen, which we cannot easily fathom but should at least acknowledge. Many people have experienced Sidi Ballo directly, such as Yaya Traore, his old mentor in the *ton;* the Sikòròni community leaders who gave Sidi his house; the audiences from Bamako to Kolokani who saw him perform; and many of this generation's young *ton* dancers. For these people, the power of Sidi's persona and his performances give body and vivid presence to the institutions and other social formations they engage in the course of their lives. When scholars speak of the elements of social life that both channel people and serve as their resources, they do well to remember that those resources are manifest, articulated, and experienced frequently as individuals acting and expressing themselves. Culture has a human face—a multitude of faces—and for nearly four decades in the twentieth century, in a very large area around Bamako, one of those faces has been Sidi Ballo's.

Yaya Traore, Sidi's mentor, made this very clear. In 1998 he talked about Sidi's spectacular performances from times past and how they had affected audiences. One of the most dramatic things I saw in 1978 at Dogoduman was Sidi opening the base of his cloth costume to the audience, so they could look inside and not find the masquerader. But Yaya noted that at a great many of Sidi's performances plenty of people would come armed with flashlights. Then, when Sidi revealed his invisibility, when he opened the costume's bottom end, they would rush forward shining their flashlights into the inside of the hollow cloth cone that was the masquerade. Even with their lights, they could not find him, says Yaya, and this left them thunderstruck. Such an experience would

create many future moments of contemplation, as individuals pondered the realities of their Mande world and considered the strategies they might employ to negotiate their way through them. People considering using sorcery to help them accomplish something in the social or business world, for example, would have as an argument in its favor that night when they tried to find Sidi and could not. At that moment, Sidi was the face of sorcery, with its awe-inspiring, powerful, and somewhat scary side, and its delightful, exciting, very useful side. A lesser dancer, a lesser person, would not have generated so vivid an experience. And invisibility was just one of Sidi's many inspirational routines.

Something Yaya did metaphorically sums up the human face of culture. Like the young Sikòròni *ton* masquerader that Kassim and I met, Yaya has a sculpted wooden bird's head too. His is the beautifully shaped red one that had been part of Sidi Ballo's masquerade for so many years, the one I saw at Dogoduman. As happens with performance sculpture, part of the beak had broken, so Sidi made a new one. Yaya suggested to him that he would like the old one, and Sidi gave it to him. From the serious yet delightful way he told Kassim and me he had it, it was very obvious that this head was of great value to him.

When Yaya spoke of Sidi's career, he left no doubt that Sidi Ballo had spent many years impressing him and had served Sikòròni well. Now the bird's head he possesses is a reservoir for all those memories. It is also something more, because the head is like an amulet, a *dalilu*. It may, in fact, be charged with *daliluw* and the *nyama* they bring. But it is also charged with the residue of many years of Sidi's performing. That residue takes the form of additional *nyama* constantly being absorbed by the bird's head every time Sidi performed it, because action emits the energy of action, and the more difficult the acts, the more plentiful the *nyama*.

Thus, this bird's head that Yaya cherishes is charged with memories and with a palpable, if invisible aspect of Sidi's personal history as a dancer. Here, in a most interesting and thoroughly human way, are two individuals and an artwork deeply, richly, and indelibly intertwined. Yaya's sculpted bird's head is the face of Sidi Ballo.

5

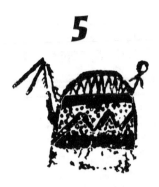

INDIVIDUALS
INTERTWINED

Now we arrive at the place in scholarship that gave me so much trouble. I did not realize it during the years after Dogoduman, but there was a reason I was not rushing toward writing this book. I thought I would. But I never really started because I did not seem to know what it ought to be about.

Sidi Ballo was ablaze in my mind. I knew he was a most impressive individual and a spectacular performer, and felt strongly that those two things were critically related. Certainly, I should write about that. But the Dogoduman performance was equally embedded in my mind as an orchestrated coming together of many participants who articulated characters, concepts, and their own personalities into a stunning whole. My thoughts about Sidi Ballo were shadowed by the grand reality of Dogoduman, so clearly I would need to write about that, too. I stumbled, however, at imagining how to balance the two, how to bring the two together. Somehow I did not think I could do justice to both Sidi Ballo and the Dogoduman performance. An emphasis on one would diminish the other. I failed to see a way to write that would avoid reducing the importance of either while showing the unity and co-dependency of both.

This practical dilemma—which I was only gradually able to express—has led me to a strong appreciation of what seems a rich paradox of being human. At the very same time that we are completely steeped in each other and almost

unimaginable as separate beings, we are also deeply and sometimes quite creatively unique. We are individuals intertwined. It is like an excess of riches in two directions, and that is what I want to explore in this chapter. For me these are the broader implications of Sidi Ballo at Dogoduman.

INDIVIDUALS

Individuals[1] matter in two crucial ways. First, they are not interchangeable, and their character and attributes constantly influence their expressive acts, which may go on to influence society. Second, like the proverbial tree falling in the woods, the realities of society and culture are experienced fundamentally and irreducibly by individuals, so if we want to understand the subject matter of social science and humanities, we must try to understand how individuals think, feel, and function. These two aspects of people in society are deeply intertwined and worthy of attention. At Dogoduman, Sidi Ballo and Mayimuna Nyaarè, for example, focused their personal perspectives and expertise on the shaping of an event that could have been quite different and possibly less affective with different performers. Even in performance moments when they presented or represented widely shared Mande concepts, their attributes as individuals and performers gave their delivery the specific character that was experienced by many audience members as moving and memorable.[2]

People are not interchangeable. Sidi Ballo can be characterized by a collection of constantly developing personality traits, abilities, and interpretations of the world. Many elements of each are shared with large numbers of other people, in and out of Mande societies. But no one is just like him. Armed thus with himself, he waded into relationships with other people and with Mande social and artistic institutions to exercise a unique presence for nearly half a century of performing in a broad region around Bamako. Many other masqueraders performed in the same area during the same period of time. Not nearly so many would have been considered professional, however, and very few would have continued to perform for so long. Some, like Sidi, were extremely talented, an ample number were good, and some were mediocre. Many would play minor roles in the memories and contemplations of local people. Some, again like Sidi Ballo, would remain strong in people's memories and even be invoked when people considered issues in their lives or contemplated ideas about their social world.

At a fundamental level, Sidi Ballo, Mayimuna Nyaarè, Sori Jabaatè, everyone that performed at Dogoduman, and everyone in every society can be characterized quite simply—they think, feel, make choices, and act. Herein lies a world of difference—between people in the same society, community, even family. The thinking may be brilliant, insightful, passable, or slipshod. The

emotions may be displayed or hidden, held at bay or harnessed. The choices may be careful and deliberate, or by the seat of the pants, or almost unconsciously "in the moment." Actions may be skilled, adequate, or incompetent as well as dynamic and energized or lackluster and without notable commitment. The variables are pronounced. But they are the tools that individuals bring to the scaffolding that is their society. The important point is that individual people are all different, sometimes strikingly, so what they think and how they act can vary significantly.

As individuals, people possess and develop different intellectual, physical, and emotional capabilities and orientations, even though they still share much with each other. And even social interactions can serve to expand the differences. We are, indeed, intensely social creatures, mutually malleable through our interactions with others. Interaction constantly challenges and changes us. But our interactions with others are virtually never identical to the interactions of anyone else. Rarely do two of us have the same set or sequence of involvements with the same sets of people. Thus, in the fine grain of our personal experiences, and because we can be so influenced by others, differences grow. Individuals have personal histories and dispositions that are not interchangeable, and their diversity gives texture and meaning to the numerous intertwined affiliations that constitute their lives. Different people everywhere engage relationships differently.

People vary in so many ways that it sometimes seems surprising that communities and societies function as well as they do. This variety is obvious in our social experiences. It is very apparent in any college classroom, for instance. Every class has character because its students have different ways of thinking, different attention spans, different kinds and degrees of interest, different academic and social skills, different backgrounds and perspectives, and different levels of maturity and motivation. All these differences conspire to produce a potpourri of individuality and astonishing variety in class performance. The same could be said for virtually any area of human enterprise anywhere in the world.

The blacksmiths I have known in Mali possess this same array of variety and individuality. Barbara Hoffman (2000), similarly, shows degrees of difference among Mande bards. When colleagues talk about their research lives, the differences among people they work with are evident. They are evident too in many publications, such as Paul Stoller's book (1989) on West African healing and divination, in Alma Gottlieb and Philip Graham's book (1993) on living in Ivory Coast, and, decades ago, Laura Bohannan's book on life in Nigeria (Elenore Smith Bowen, *Return to Laughter,* 1954). You can even glimpse the differences among people in the travel, adventure, and exploration accounts so popular before and during colonialism (e.g., Binger 1892, Caillié 1830, Gray and Dochard 1825, or Park 1799). All of this difference sings through our expe-

riences with people, shaping them and us in the process. And yet too much of our literature neglects it.

LITERATURE

In ethnography, studies of individuals making choices and assembling strategies of action are rare in comparison to studies that seek general principles, describe broad processes, or develop theories about larger groups at work. A sweep back in time catches on such scholarly notions as people embodying and reproducing social structures; receiving forms, norms, and modes of behavior; internalizing ideologies and practices; and being socialized into citizenship, often with such aids as awesome artwork and authoritative elders who measure out social control.

Of course, these notions are grounded in decades of thoughtful research by dedicated scholars and cannot be dismissed as wrong. They are present to be encountered in every family, every town, anywhere in the world. No matter how pronounced the variety in people, nestled amid differences are commonalities, and intermeshing with personal agendas are common interests. People can work toward common goals in a shared enterprise that makes families, communities, performances, societies, and nations work. Sometimes the process and the results are messy, inequitable, and burdened with contestation, but sometimes too they are elegant, poetic, and harmonious. Such is the bane and beneficence of our nature.

Perhaps in part because of this commonality amid diversity, ethnographers have often seen their role as finding patterns, models, and behavioral standards to explain as much about societies as possible. For most of the twentieth century, this emphasis included the backgrounding of the people making and experiencing culture to the point that generalizations about people were emphasized, order was exaggerated, and variation and variability were neglected (Vayda 1994, 320). Certainly, individuals live in and express themselves through relationships with other people, from small numbers to huge groups. Society's products—its institutions and beliefs, its social constructs and cultural formations—emerge from people in groups relating to one another. Somehow, though, the products, the groups, and the relationships became prominent focal points for research, and the individuals who make them up got lost.

People are always awash in relationships. We are bolstered and fortified by them, carried along by them, constrained by them, damaged and diminished by them, or inspired and aggrandized by them. From birth to death, our lives are so inscribed and intertwined with the lives of numerous others that it is simply not feasible to conceive of ourselves as autonomous actors in our

worlds. For example, Carrithers (1992, 1, 10, 11, 43, 84) says we know ourselves, exist, and act in relation to one another. He calls relationships the "basic stuff of human life" and asserts that even our seemingly personal ideas and perspectives are actually interpersonal. We belong to "incalculably complex" webs of "social, political, and economic relations." Piot (1999, 18–19) goes further, saying that we would be well served to see people, not as having relations, but rather as being relations, and that the self is fluid and unbounded, permeable and diffuse to the point that we are all infused with the presence of a great many others.

These are venerable positions. John Mbiti (1969, 141–42) expressed them more than thirty years ago in his classic text on African religion and philosophy, and it is present in ideas about complexity, sociality, and interconnectedness in scores of ethnographies and theoretical explorations by numerous fine scholars.[3] Just as Sidi Ballo did at Dogoduman, the works of these authors testify to people's being intertwined and to the social momentum born of this multitude of unions.

That social momentum sometimes masks the value and the roles of individuals. Veiled, for example, are many intellectual, emotional, and even social processes not easily observed or readily explained with words. Negotiations among people in relationships may be tacit, grounded in practical (unvoiced) knowledge or physical manifestations, and slow to reach fruition. They can easily be misconstrued or missed altogether by researchers. Many individuals would find it strange to reconstruct the thought processes, feelings, and personal histories that led to their particular kind of involvement in an activity with others. The understanding and skill that Bordieu (1977, 2) calls "practical mastery of a highly valued competence," which people apply to much of their living, is not always readily translated into words. Many parts of our lives, including some involving art and ritual, are enacted without self-conscious deliberation, and thus are not always subject to recollection or systematic personal scrutiny, much less accurate reporting to researchers.

Meanwhile, the rules and principles actors may be using are frequently just templates far simpler than the reality they address, even though they have emerged from social interaction as idealizations or ideology by stakeholders, or just ad hoc summaries that have grown up around people acting in the world, summaries that are often tinkered into new configurations as new people face new situations. They are not as fixed as observers often imagine.

All of these contingencies (and more) make it hard to understand the roles individuals actually play in relationships, group actions, and the production of society, artwork, culture, and history. Therefore, even the most painstaking scholarship must confront the reality that understanding is a patched-together approximation of how social and cultural things work. At the most atomized level of social structure, individuals are the least readily fathomable of all there

is to study, even though everything above them in the hierarchy of complexity—relationships, groups at work, and social products—depends on them for fruition and character. Thus, ironically, the wild card in ethnography is people.

Over the past several decades, various outstanding scholars have recognized this. Warren D'Azevedo (1991, 102) makes a very cogent observation about the literature influencing him as a young researcher in 1957. In it he found

> . . . the latent yet frequently manifest theme of human inventiveness and intractable creativity. Among the works that come readily to mind were those of Malinowski, Nadel, Firth, Linton, Benedict, Gluckman, Bateson, Barnett, and especially of Radin and Herskovits, whose insistent reiteration of the role of the individual as creative agent in culture struck a resonant chord.

T. O. Beidelman (1986, 9–10) noted complexity and creativity most eloquently:

> Society is a world of myriad relations that require constant work precisely because they are subject to continual change and contradictions; to be one's self within society also requires constant labor, both to absorb and to use the gifts that society and culture provide, yet also to control, perhaps even to triumph over or fend off, those impingements so as to gain some measure of one's own being.

Unfortunately, most of the literature does not examine the significance of individuals. D'Azevedo (1991, 103) notes that the theme of individual creativity was not sustained against a dominant "emphasis on a standard ethnological format and the functional analysis of crucial institutions." Laura Nader (1994, 84) observes a similar neglect, citing an "obsession with models, charts, and numbers" that has produced an illusory impression of concreteness in institutions and procedures that allows very little room for the maneuvering of individuals. In a critique of ethnophilosophy and ethnography, Ivan Karp and D. A. Masolo (2000, 7) acknowledge as true the common assertion that meaning resides in collective practices but call it incomplete "if it fails to show how change is produced by human agents."

Tangled up in this neglect of individuals is the residue of exploitative colonialist fictions. The odious legacy of colonialism included a lingering rubric of fabricated assertions about how individuals in African societies allegedly behave. In Western scholarship and popular belief, "group-think," the dogged adherence to tradition and ritual, and a lack of personal initiative were claimed for African people, while science, logic, circumspection, and social criticism were declared to be absent (Karp and Masolo 2000). In traditions of scholarship going back more than a hundred years to Durkheim and Mauss, Western individuals could be characterized by their personal attributes, while individuals in

other cultures were characterized by their social relationships. Shaw (2000, 26–29) argued recently that this view persists in many strands of Western thought and still needs rethinking.

This facet of the Western "us-them" dichotomy has been quite obvious in writing about art. Western art history offers a veritable parade of individual artists. There are ample numbers of biographies, autobiographies, fictionalized biographies, and scholarly studies on particular artists. There are treatments that marginalize artists as oddballs, misfits, mavericks, and tortured souls. And there are studies that show artists as important to society. Beyond the printed word, there are feature films as well as growing numbers of educational and popular videos, DVDs, CD-ROMS, and Web sites. People with interest in Western art are readily able to associate specific artists with particular subjects, topics, and issues. They find it easy to populate their imaginations with individual artists when thinking about periods, groups, or places (Michelangelo for Renaissance, Picasso for Modern, Christo for Central Park).

No such orientation has existed for African art history, except now for artists being labeled contemporary. Early Western encounters with Africa produced frivolous assertions that African art was exotic and primitive, then moved to turgid interpretations of African art as rigidly functional, devoid of aesthetic concern, and an agent of social control that was essentially anonymous even in its own habitat. Scholars in the later decades of the twentieth century worked to eradicate these erroneous notions, and in the process a number of studies of particular African artists were produced.[4] However, they have not garnered the same kind of attention that is given to studies of Western artists.

Perhaps we have not yet overcome the inertia of earlier preconceptions. But for the most part, Westerners interested in African art think in terms of peoples or regions, not individual artists. When we think of antelope headdresses, for example, we think of Bamana Ci wara, which is a dreadful shame because, as scholars such as Imperato (1970) and Wooten (2000) have amply demonstrated, there is a tremendous history of creativity and innovation in the development of these complex artworks.

A different approach has been taken in the world now called contemporary African art. Here individual artists are consistently recognized, although in this budding area of scholarship there are still too few publications that cover artists in depth. And a problem is evolving that may well deflect even more attention from artists such as Sidi Ballo. The groundswell of interest in world-scene African artists and expatriate African artists is hardening another false dichotomy—one that distinguishes "contemporary" from "traditional" without giving any sophisticated thought to what either of these concepts mean. Modern and contemporary are too frequently viewed as phenomena centered in Europe and America, with waves of influence that radiate

into other parts of the world. They are also perceived as oppositional instead of being viewed as each penetrating into the other to produce a fluid kind of interaction and complementarity.

A far more accurate, fruitful, and respectful view is that modern and contemporary are concepts always linked to particular places and times, and can be found everywhere (Appadurai 1996, Knauft 2002). Furthermore, in any given place, ideas and practices that are contemporary are infused with, and themselves infuse, ideas and practices that are well-established and ongoing. Sidi Ballo is every bit as contemporary as the spectacular Malian photographer Malick Sidibé. They travel in circles that both overlap and are distinct. They both engage the world they live in now. They both articulate and play with ideas and beliefs that are currently important in their society. They both absorb and reckon with the past while helping to create the future. They are both simultaneously traditional and contemporary.[5]

There is hope, however, for a better understanding of both this grand photographer and this grand masquerader. We may be now in the swell of a growing sea change, in which the significance of roles played by individuals is recognized. Carrithers (1992, 83) states that while we must be able to see societies abstractly so we can understand people as "acting with a generic set of obligations and rights," we must also grasp "the particularity of one person rather than another." Goodenough (1994, 262) notes that much current writing seeks to accommodate individuals "each different from the other and all bent upon their own purposes . . . defying custom, creating new ways of doing things, and negotiating with one another the terms by which to conduct their affairs."

In 1987 a conference in Sweden punctuated this shift in emphasis in social science by which the knowledge, skills, personal characteristics and lived experience of people are factored into studies of culture and society. Jackson and Karp (1990, 15–17) succinctly characterize this evolving vision of the person as including the senses and emotions, intuition, and the body and its involvement with the world. They cite as important "the *experience* of personhood in all its modalities" and insist on the necessity of learning how people "actively and creatively interact" with their world. They quote Meyer Fortes (1973, 287): "The individual is not a passive bearer of personhood; he must appropriate the qualities and capacities, and the norms governing its expression."

There is more. To cite just a few examples, V. Y. Mudimbe (1988, 1994) has demonstrated how completely the notions of Africans as non-individuals are Western constructs. D. A. Masolo (1994) has presented a picture of thought in pre- and postcolonial Africa that highlights rich traditions of rationality and creativity with ample room for personal expression. Barry Hallen (2000) demonstrates that the careful study of practical everyday language in an African society can reveal a vocabulary primed for tremendous depths of self-reflection

and realistic critical appraisal of people's situations in the world of experience. Corrine Kratz (1994) shows how complicated and multivoiced the social and artistic elements of ritual can be, how they effect transformation in people, and how people affect the outcomes of ritual. These and many more fine-grained studies show that individuals in African societies live rich, complex interior lives, think independently and critically about their culture and experiences, and possess the personal agency to create change and contribute significantly to their social environments.[6]

Thirty years ago, most Africanist scholars would have said the individual is not an appropriate subject for study. Now we can see that our explorations of society and culture should account for the fertile framework of potential and consequences that individuals proffer. Jackson and Karp (1990, 16) made this point strongly by emphasizing the importance of "variability, multiplicity and negotiability in modes of personhood," with the acknowledgement that people's actual experiences are critically significant to any understanding of the person. Catherine M. Cole (2001, 3–4) sums up the fruitful directions contemporary research is taking "from structure to process, from the normative to the particular and historically situated, and from the collective to the agency of named individuals in the continuous flow of social interaction."

ART HISTORY

At last we are beginning to address the individuality of people that nourishes the vitality of culture—the variation of character and attributes they bring to communal activities and the ways they fit or challenge the social slots in which they allegedly sit.

We should move along this same direction in the study of African art. The limitations of older scholarly thinking that backgrounds individuality becomes apparent by talking to Mande people, who think of particular artists when considering the genres, topics, and issues that constitute their experience of expressive culture. Many Mande know the names of artists around their regions and beyond, and they know what artists specialize in and how talented they are. They know the names or the reputations of artists from the recent past, and sometimes of renowned artists from the deeper past. They can think of art and situate it among people, both artists and viewers, so their sense of their own expressive culture is rich and awash with human detail.

Mande artists present much variation. Some are very serious; others are not so dedicated. Some work extremely hard; others seem almost casual in approach. Some envision a lifelong career; others are having fun exploring their creativity and will ultimately turn to other professions. Some do nothing but their art; others have additional livelihoods. Some are technically su-

perb and loaded with useful knowledge; others are less talented and not all that well-versed in the ken of their medium. Some talk very articulately about their art or think deeply about it; others have no desire to talk about it and do not seem to focus much deliberate attention on it. Finally, some artists are extremely successful; others are not so effective, or never take hold in their communities.

Enter Sidi Ballo. He is very much an individual, as thoroughly his own man as anyone I have ever met. At the same time, he is steeped in the ideas and practices, the social and artistic configurations that people have created to compose Mande culture. By no means a rebel or a contrary personality, he has instead always been extremely able to accrue and deploy Bordieu's (1977, 2) "practical mastery of a highly valued competence" or Anthony Giddens' (1979, 24–25, 53–59; 1984, 41–45, 375) "practical consciousness" as a means of constructing a fine and worthwhile life in the heart of Mande cultural space. He did it by thinking, making choices, and acting, in the context of the specific individuals and situations that affected him as he affected them—that swirl of interaction that composes the personal histories of many individuals living and working together.

I think the very qualities that distinguish Sidi Ballo as an individual contributed profoundly to his success as a bird masquerader. They helped make his performances extraordinary and his work memorable and perhaps influential for others. He built his career with his intelligence and social perceptiveness, his dedication and resolve, his capacity for hard work, and the expertise that all these personal characteristics together afforded him. Completely embedded in Mande society and culture, he was nevertheless not simply inscribed by their principles and practices, nor did his activities in the world reproduce them for the next generation. He was far more proactive and creative than that.

To be sure, his social environment offered certain opportunities and did not offer others. Certainly, as he grew up and developed as a person within this array of limitations and possibilities, he sometimes moved in the flow of the people and events around him without thinking about choices or alternate paths, while other times he measured resources and constraints and was frustrated by their lack of fit with his evolving persona. But many times too, the stock he took of opportunities and limitations led to choices and actions that produced personal growth and contributed to the nature of the opportunities and limitations available to others. Many younger masqueraders knew about Sidi Ballo. They admired and emulated him as they created their own performance abilities and character.

Sidi Ballo shows the value of studying individual artists. If artworks are viewed as expanding beyond material composition to become networks of relations among people engaged in particular situations—which include

arrays of social, intellectual, and emotional content whose meaning and value are always being negotiated—then understanding artists is part of comprehending those situations.

Knowing a little about Sidi as a person helps explain his dynamic exploits on a dance arena. Aspects of his training and orientation are illuminated by knowing of his background in the youth association. His energy and aggressive command of audiences are better understood by knowing something of his personality and his mental and physical abilities. His longevity as a career masquerader is out of the ordinary, but knowledge of his dedication and work ethic help explain it. Given the tricky financial elements of success at itinerant dancing, it is instructive to know that he had a backer and that a community was willing to "own" his masquerade while another community offered him a house. Why people would be so interested in Sidi is more readily comprehended with knowledge of his character and capabilities. His success and fame at bird masquerading is better understood by knowing all of this and by knowing about his intensely social nature, which oriented him toward effective interaction with people both on and off the dance arena. Finally, knowing of his success and the personal qualities that contributed to it helps us understand the dynamism and intensity of his former youth association branch's present generation of dancers.

Knowing these things about Sidi Ballo and his version of bird dancing contributes to a broader perspective on Mande masquerade. It provides insight on the degree of variation that masquerade traditions may nourish and more insight into why these traditions are so well supported and sustained. If you consider Sidi Ballo in relation to Mary Jo Arnoldi's material on Segu-region puppet theater, James Brink's on Beledugu rural theater, and Pascal James Imperato's on Bamako-region youth association masquerading, you begin to understand the broader dynamics of Mande popular dance theater and can better comprehend its popularity and grandeur. If you remember that Sidi Ballo is just one among many talented, successful, influential Mande artists, the complexity, vitality, and creativity in West African expressive culture comes into sharper focus. These are some of the values of studying individual African artists.

PEOPLE TOGETHER

Artistic and social landscapes change because people change them by bringing their personal attributes to bear on the situations they encounter. Society and culture are elaborate, concrete, and omnipresent. But they are also the people who compose them, like the trees that compose a forest. It is people who carry institutions, systems, and processes to one another, while maintaining, inter-

preting, and changing them. It is as if the components of our social lives were held aloft in constant motion by large arrays of people who are themselves in never-ending animation and transformation. Individuals are indeed the wild card in the life of societies, and their complexity produces mechanisms of change.

But people are intertwined, and when change is produced, it is from within an ensemble of individuals. We are complex and different from each other in wondrous ways, but the other wonder is that we work intensely and often successfully together and are rarely on our own. We are such social creatures, so socially oriented, so insinuated into each other's lives that we end up producing objects and societies and cultures that are immeasurably more complicated than isolated individuals could even imagine on their own.

Our virtually communal nature, however, does not erase us. Pronounced as the potency of our sociability is, we remain remarkable as individuals. Our entanglements with others, our dependency on them, and their incorporation into the deep folds of our interior selves only complicate our individuality. Within the intricate intermeshing of people bound together, individuals do not have to be hapless, helpless, or devoid of self-propulsion. While shaped by relationships with others, we also shape ourselves and others. Even though our characters grow from our experiences in relationships, we are nevertheless unique and potentially influential components in arrays of intersubjective negotiations, contestations, and constructions. And while the contributions of individuals to groups become intermeshed with the contributions of others, often to the point where sorting them out would not be feasible and authorship becomes obscure, that in no way negates the contributions themselves. They would have been different had they been made by different individuals.

The objects and institutions, procedures and values we make are created by proactive, less active, and seemingly inactive people, combined through happenstance and the contingencies of circumstance and situation. Individuals are not equally active or equally successful working in groups. Many seem buried and indistinguishable in the midst of society's workings, and their contributions may be dramatically transformed when mixed with the contributions of others. Through motivation, capability, and sometimes even chance, some people play more important roles than others. But they all still contribute to society's shape at any given moment, just as every performer at Dogoduman helped shape the bird dance. The web of engagement and interaction that characterized the Dogoduman performance reflects as a microcosm the vastly complex array of relationships that characterize the broader workings of society, replete with their multiple perspectives and range of knowledge and skills. The co-dependence and intersubjectivity that is a performance is also the complex agency that is the essence of social life.[7]

Both ends of the wondrous spectrum that is human activity can be seen in vivid relief at Dogoduman—the importance of both the individual and the group. The two do not simply exist together. They amplify each other. Because people are so variable and full of capacity as individuals, their social nature becomes exponentially more significant. It produces a far larger forum for generating affect and influence. More material, social, and cultural resources are available, and the pool of creativity and abilities is enormously expanded. People in groups multiply the possibilities of contestation and even disaster, but they also multiply opportunity. Their interrelationships provide fields for action, avenues through which actions are transmitted, and resources the actors use to the best of their abilities and according to their circumstances. Relations are the stage on which people play. Dogoduman demonstrates that.

At a most basic level, the Dogoduman bird dance would have been less exciting had Sidi Ballo performed alone. All of his skill and entertainment savvy could have been deployed, but the event would have been decidedly less interesting, less compelling, and less memorable. The performance's complexity and careful orchestration are obvious. So is the intensity produced by a multitude of musicians and a hierarchy of supporting dancers and masqueraders. The performance builds upon itself in great crescendos of interaction, interlocked activity, anticipation, and release. No single person could have accomplished anything approaching it. But many people with complementary talents working together produced a spectacular evening. People are almost always intertwined, and while that can seem to reduce the individuality of many people in many situations, it can also amplify the possibilities that individuality portends.

In every community of every society, people are endlessly engaged with one another. But there are still people whose accomplishments could not have been duplicated by others in every profession, from soothsaying, healing, and all kinds of political and commercial enterprises, to masquerade performing and every kind of artistry. People bring individual strengths, attributes, and dispositions to bear on the sensory, social, emotional, and conceptual input derived from their involvement with others; so they interpret and use that input differently, develop differently as people, and act differently in situations. This is much of what makes society and human life vital. If we were to strip people of the uniqueness of their individuality or see them as just parts of larger wholes, we would lose track of how history is made, how societies change, and how persons can articulate their sociability to live fulfilling lives.

Relations among people are not simply given or static. Overtly or tacitly, deliberately or through the flow of action, by talk or by deeds, individuals are constantly in the process of negotiating their relationships with others in their lives and constantly infusing those relationships with their own personae. For decades ethnographers have talked about the unequal distribution of resources,

status, and power in societies. That inequality always has a history, the tangled but tangible product of individuals with different skills, knowledge, personalities, desires, vested interests, and agendas who are engaged in myriad complex relationships with one another.

So the ways people work together emerge from their individual qualities and personalities, their experiences and personal histories. These differences between people in the same community, even the same family, are as significant as those between completely different societies. These local differences propel and give particularity to social life and facilitate the change we call history.

HISTORY

It is individuals intertwined—the rich assortment of knowledge, skills, experience, and motivations, coupled with the vaster panoply of resources and potential lodged in groups—that have produced so rich a history as that found all around the Niger River's middle reaches.[8] The empires of Ghana and Mali are widely acknowledged as having been enormous, powerful, and sophisticated, with their vassal and partner states, their complicated allegiances among clans, their constantly developing infrastructure of markets and commerce, their always-evolving configuration of professions and specializations, and their apparently enormous capacity to meet ecological challenges with innovative approaches to farming, hunting, fishing, and cattle herding. There was also the Soso usurper state, the Bamana states of Segu and Kaarta, the fluid Muslim warrior state of Samory Touré, and numerous other less-well-published polities that testify to the dynamic capacity of individuals in groups to work together. Growing evidence presented by such archaeologists as Téréba Togola, Susan Keech McIntosh, Roderick James McIntosh, and others[9] suggests that leadership in this enormous area engulfing the great bend of the Niger and extending west into the Sene-Gambia may have been *heterarchical,* meaning that authority and power were always being negotiated among leaders and members of a variety of ethnic groups; professional specialists such as hunters, farmers, fishermen, metal workers, and merchants; and an array of political and spiritual organizations (McIntosh 2003, 2). Heterarchical leadership shows the importance of individuals who possess the qualities and resources that allowed them to work effectively in complex networks of relations to create, sustain, and promote the cause of state and empire—no doubt along with personal causes—while frequently changing the networks of relations in the process.

Creativity and innovation articulated by individuals in groups has long extended into every social nook and cranny of this huge region. Sidi Ballo hails from the clans of professional blacksmiths that belong to what has come to be called a West African caste system. Linguistic and historical evidence

suggests a complicated, vigorous, and highly entrepreneurial indigenous history for the development of this system among ancient Mande and neighboring people (Tamari 1995, 61–85). In fact, the fluidity of the system is almost astounding. Tamari states that "castes have often modified their vocational emphases, or even changed occupations entirely," and notes that extensive and recurring cultural interchange among the many peoples of western West Africa must be invoked to explain the sheer complexity of these professional groups' linguistic profile (1995, 76, 79). This dynamic history is the fruit of entrepreneurial individuals intertwined.

The broader picture of social and economic history appears no less suggestive of individuals dynamically at work in groups (MacDonald 1994, 1998; Roderick McIntosh 1998; Susan Keech McIntosh 1999; and Togola 1993, 1996). Along the Middle Niger flood plains and surrounding savanna and sahel, impressive developments transpired in such activities as farming, herding, hunting,[10] fishing, product manufactures (including copper, iron, and clay), mercantilism, and probably spiritual expertise. Along with professional specialization, there was clearly the development of regional resources that included technically sophisticated exploitation of micro-ecological zones and complicated networking to connect regions for the exchange of resources. Peoples' movements, both seasonal and more long-term, were pronounced, and evidence of elites or top-heavy hierarchies of leadership is absent, in spite of the fact that the Ghana Empire extended into the Middle Niger, while the subsequent Mali and Songhai Empires inundated it. Implications of the evidence include the necessary presence of many skilled and knowledgeable individuals negotiating to establish, and then maneuver within, complex societies and elaborate polities.

Mande expressive culture also has a dynamic history that must be credited to creative individuals intertwined. The ancient Arab author Al Bakri (see Levtzion and Hopkins 2000, 63, 80) stated that Ghana Empire administrators kept a power object in their sacred woods, perhaps some form of sculpture. Oral traditions strongly suggest that Kòmò masks were well-established by the early years of the Mali Empire (McNaughton 1979, 17–19; 2001, 175–83). Some traditions even create a verbal image of Sunjata Keita's general Fakoli as having a head like a Kòmò mask, and he is said to have used his head, his mask, and the association to further the Maninka (Malinke) cause that defeated the Soso and established ancient Mali. These dramatic horizontal helmet masks and their users clearly inspired many people's imaginations across an enormous area and were effective spiritual, political, and economic instruments. Very similar masks form a diaspora over three thousand miles broad. In addition, similar power objects and similar associations proliferated throughout Mande lands and continue to thrive into the twenty-first century (McNaughton 1991, 1992, and 2001, 167–74).

There is no shortage of additional examples in the audio and visual arts of Mande peoples. They all testify to the same phenomenon. When the uniqueness of individuals is joined into groups, proactive creativity is a likely result. The big picture that is society in action is a mosaic of powerful people and instrumental resources constantly intermeshed in acts of articulation. When scholars address the centrality of relationships among people in this big picture, they aptly acknowledge the mechanisms that make the social world work. When they ignore the foundation of individuality from which the big picture emerges, they fail to account for the agents that make the mechanisms, fuel them, set them in action.

INTERIOR LIVES

The broad view of society, then, must account for the variety and creativity of individuals and the complexity of people working in groups. A more fine-grained view is also important. It is the interior lives of individuals—that personal consciousness that interfaces with the social world while hosting the never-ending internal dialogues that people use to measure experience, explore potential, and cobble life into viability. People are simultaneously public and private: capable of intense, sustained, intimate social engagement, and just as capable of deeply personal contemplation and reverie. There are no firm borders between social and personal. They are so deeply embedded in each other that they penetrate and perpetuate each other in a continuous stream of revelation. But that does not reduce the importance of either one. We have private, interior lives that are fueled by relationships in society, and we have discourse and action in society that are fueled by contemplation, evaluation, and revelation in our interior lives. Both are critical.

Even the quietest, most placid individuals have interior lives that emerge from engagement with the world. Individuals, be they dynamically active or relatively inactive, are the sites where social action is experienced. Their interior lives are filled with internal dialogue with which they mull over and explore their experiences in the world. Constantly recharged with new experiences, and constantly vented into everyday realms of public discourse, where they are both transformed and transformative, the contemplative grounds of people's interior lives ultimately and constantly become the stuff of social interaction and a mainstay of complex agency. Our interior lives are the stage where social life is played. They are the seat from which we think, make choices, and act. What happens in there can sometimes be shared (with ethnographers, for example, or readers of literature), but often it is too personal or fleeting or unaccommodating to linear expression. Nevertheless, it is a potent part of our existence.

All people live from the vantage points of their spots on the earth, their places in the world, their experiences. More than twenty years ago, Paul Riesman made the important observation that when we glimpse how life is experienced from inside the minds of people, we can no longer view culture as "simply acting on a person" (1986, 103). Lila Abu-Lughod (1993, 27) expands upon this, noting that life at the level of individuals is always eventful, even though it is not always visible. People are the multitude of focal points where even an apparent status quo is the product of significant mental, emotional, and social activity. As Abu-Lughod shows through personal biographies, down in the fine-grained dimensions of actual lives, there is no such thing as the uneventful maintenance of the given world. Rather, there are people "wondering what they should do, making mistakes, being opinionated, vacillating, trying to make themselves look good, enduring tragic personal losses, enjoying others, and finding moments of laughter" (1993, 27). As Reisman (1986, 104) said, much of life is lived by the seat of one's pants.

Scholars may not be able to plot out everyone's lived experience, but they must account for it.[11] This is as critical as comprehending the broader sweep of things, because at any given moment individuals' lived experience helps produce that broader sweep and then contends with its consequences. Both production and consequences are important, since they are endlessly fused by people into new productions and consequences. Thus, Michael Jackson (1996, 22) insists on individuals as the places where even seemingly impersonal productions such as language and history "find expression and are played out." This is where "life is lived, meanings are made, will is exercised, reflection takes place, consciousness finds expression, determinations take effect, and habits are formed or broken."

The dialogue, evaluation, and personal exploration that compose our interior lives offer valuable perspectives on what constitutes social change. Change is relative to people's experience, so inside and outside perspectives can diverge. An institution or a belief may appear stable and enduring (even static) to outsiders, but from the vantage point of insiders' interior lives, there may be much involvement with new insights and ideas. Individuals going through initiation, for example, are themselves engaged in the deepest forms of change. Elaborate and sophisticated activities using a multitude of resources can go into the effort. From the outside, this appears as tradition renewed. From the inside, it is a whole new form of existence (Kratz 1994). To ethnographers, the life of a community may seem stable over decades or generations, but from the interior lives of its individuals, elements composing that very stability constitute fresh, new experience. And since ethnography is the study of people, it should aim at comprehending how individual people experience society.

The interior life is also the site where art can unleash persuasive force, infusing internal dialogues with the power of ideas and emotions, recollections

and new revelations, entangling itself with our inner existence. Art is not simply received information or entertainment, though people can certainly treat it that way. But many people ponder and examine it, measure and test it, transform it into interpretations and release it into the dialogue of their interior lives. Thus, Arnoldi (1995, ix) says of the youth association puppet theater from which Sidi Ballo's performances emerge: "Each individual performance is fashioned through the endeavors of actors and audiences, who cast a knowing, creative, and often reflexive eye upon their shared and individual contemporary experiences and upon their collective historical memories." This finds resonance with Riesman (1986, 108), who observes that "culture as subjectively experienced by Africans is not so much a constraining or shaping force on behavior, but . . . a means, like language itself, by which humans try to understand their predicament and create a meaningful life."[12]

Across its whole spectrum of manifestations, Mande performance can be chaotic, ribald, hilarious, and seemingly irreverent, or stately, serious, and punctuated with tightly focused drama. It includes many varied genres, from puppet and masquerade youth association theater around Segu and Bamako, to costumed youth association theater in the Beledugu, to the popular performances of antelope headdresses in the farming association called Ci Wara, and other public festivals that honor and feature farmers, hunters, or blacksmiths. Any of these performances can generate tremendous pleasure. But as a Mande man once told me, every performance is an opportunity for educational dialogue, should audience members choose to reflect on it and add it to their internal dialogue.

Mande performances release an atmosphere of values and beliefs that one can breathe in as if it were air. In masquerade and costume theater, characters are developed that bring life's dramas and delights into spot-lit view. In antelope headdress dances and dances for farmers and blacksmiths, good work and responsibility are pumped up with valor and floated around the dance arena. When hunters perform in public, such as at the annual celebration of the founding of San, a grand city near the Mali–Burkina Faso border, nerve and great deeds seem to materialize from the rifles and amulet-laden shirts for members of the audience to contemplate. And when Sidi Ballo performed at Dogoduman, some two hundred miles to the west, an atmosphere of hard-earned capability invoking images of heroes permeated the event. Whenever audience members take this air as more than entertainment, either by deliberate choice or because the performance itself overwhelms them, reflection settles in. And reflection is the foundation of growth and change. It can inspire new thoughts and encourage new activities. In this way, performance becomes instrumental as it engages people in their most personal of places, their interior lives. Sidi Ballo shaped his career from that complex place where experience collides with the internal dialogues of interior life.

To really understand performance art, then, we must comprehend its residence inside us. But this is difficult terrain. Audience members cannot always easily explain their engagement with performances like the bird dance at Dogoduman. Many do not care to even talk about it, finding words tiresome in the face of so splendidly evocative an orchestration of sight, sound, and motion.

Art sometimes dwells in realms where the formulation of descriptions is not adequate. Art captures or creates experiences that defy linear accounts. That does not mean that people are not caught up in its afterglow. Their contemplations may be lush combinations of ideas, images, feelings, even words that are complicated, fluid, and shimmering away from straightforward exegesis. To be sure, verbalized responses can emerge from that efflorescence. Decisions about oneself or others, about situations or courses of action, can all come out of it. And people do discuss what they heard and saw.

But the whole experience of an artwork can be vaster and less compactly tangible than the ideas and elements of discourse that emerge from it. This bigger and less tractable thing—the experience of art's engagement—is an important form of power inside people. Its very amorphousness, its lack of a linear profile, its protean nature, is an aspect of its power. In fact, art provides us with a valuable form of mediating and exploratory experience, where verbal analysis would be impossible or reductionistic. Even though part of its power is its irreducibility to simple statements, we need to state that it is there, in the internal dialogues that illuminate people's interior lives.[13]

Bruce Wilshire (1982, 5) says of theater: "If the 'mirror' of art is the only way, or one of the irreducibly fundamental ways, to see ourselves, and if seeing ourselves is fundamental to what we are as selves, then to come to see oneself is to effect change in oneself in the very act of seeing." Thus, in the midst of an utterly public event such as Sidi Ballo's bird dance near Saturday City, a major effect is deeply personal. We wonder in the heady atmospheres of our interior lives, engage ourselves in dialogues that have no clear separation from events in the busy world outside our skins, and cast ourselves into the flow of that bigger world, where everyone else is doing the same thing. This is a schematic for the nature of being human, and penetrating to its very depths are the works of individuals such as Sidi Ballo and his colleagues at Dogoduman.

Part 3

FROM DOGODUMAN
TO AN AESTHETIC
OF AFFECT

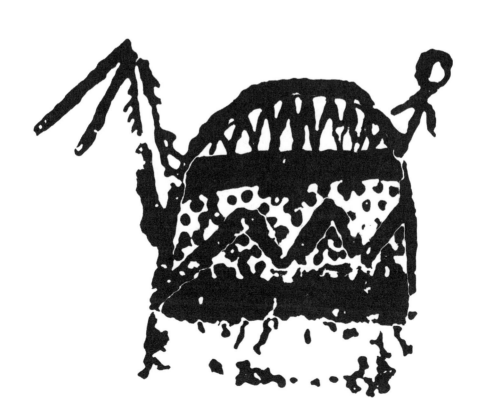

6

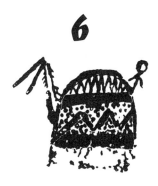

SIDI BALLO'S
AESTHETIC MILIEU

I want to characterize artistic form as material articulated into vehicles of the imagination, instruments that invoke experience and facilitate dialogue. I want to describe physical form as more than physical, which by dint of our very nature involves activity well beyond what we ordinarily conceive of as seeing. By extension, then, I want to consider aesthetics as ideas and values artists use as strategies to shape form into immaterial potency, and as ideas and values audiences use to bring that potency to fruition and to evaluate it. Many perspectives on aesthetics and form circulate through academe and popular culture. I have arrived at mine only after lengthy struggle, over years of thinking about Sidi Ballo and the Dogoduman performance.

Sidi Ballo walks with elegance. Even at the age of fifty-eight, when I last saw him, there was a lilt to his step and an almost poetic way he held his body that was readily discernible. He did not project an overly bold or self-centered disposition; he did not displace more than his share of weight in the world. But his physical presence was refined and a little out of the ordinary. He could walk down the street with a cap pulled over his head, and everyone would still know it was him.

This is not an artificial thing. Sidi Ballo is a man laden with grace, which you can see in everything from the way he holds his head to the ways he moves his hands. It is in his speech, his intonations and phrases, and even in the way

he laughs. It is not accidental. He may have been predisposed to elegance from early in his youth, but years of thinking about and developing a performance personality have made it a palpable part of his everyday self. Aesthetic presence permeates Sidi Ballo.[1]

That aesthetic presence galvanized me when I saw it working at Dogoduman. There was such a poetic flow to the movement he produced from inside the masquerade. It was more than just graceful articulations of his own body in space. It was the precise manipulations of the costume and bird's head that created grace in the masquerade. In his early days that must have been a painstakingly studied thing, captured and gradually made intuitive and natural with great amounts of experimentation and practice. But seventeen years into his career, when he played Dogoduman, he owned poetic motion so thoroughly that you could not separate it from him, even when he purposely made his masquerade seem heavy and ponderous—and dangerous to be inside or near. The impression of elegance he produced for his audience rippled right through me. It put a glow on the whole event. It was ripe with affect.

Aesthetics most certainly played a prominent role in Sidi Ballo's career. Of his three criteria for success, two (his masquerade and his dancing) depended directly on aesthetic accomplishment, and the third (*daliluw* fortification) quite strategically contributed to the overall aesthetic effect of his performances in numerous ways. The same would be true for any talented Mande artist, no matter what the media. Good art radiates the produce of aesthetic harvest, and good artists possess numerous aesthetic strategies that are sometimes easy to see and sometimes tucked away in Mande social ideas, values, and practices that we would tend not to relate very closely to art. To give full credit to good Mande artists—to fully appreciate Sidi Ballo's accomplishment—we need to consider these strategies carefully.

From the time I first watched his bird masquerade captivate the dance grounds of Dogoduman, through all the years until now as I write, aesthetics stands out in my mind as a principal instrument that Sidi used with focused attention and as a tacit part of his performance persona to make a successful career. Surely this demands attention, not just aimed at the master masquerader but also at the milieu of artistry and aesthetic acumen from which Sidi Ballo emerged and harvested a cornucopia of performance strategies.

In African expressive culture studies, however, aesthetics is a lost domain for several reasons. To begin with, the very definition and components of aesthetics are not readily or easily agreed upon. The history of the term's use is highly fluid. Ebong (1995, 43) nicely sums up the impediments: "So relative, open-ended and complex is *aesthetics* that philosophers, scholars and aestheticians, since Plato's time, are still far from reaching a definitive consensus about its properties, application and meaning."

A near-baffling array of seemingly contradictory orientations—from beauty as pleasure for the privileged and elite, to compositions that inspire a citizenry, to utopian states of democratic thinking, for example—lend testimony to aesthetics' protean nature. So too the impressive inventory of thinkers who have helped produce the cacophony. While philosophers are preeminent, there have been art historians and critics; scholars of music and literature; anthropologists and sociologists; and artists, writers, and musicians. There is tremendous food for thought in this massive array of thinking and writing (e.g., Podro 1982), but Africanists have not engaged it fully or frequently.

Art history studies generally tend not to feature aesthetics, focusing more on issues of representation, interpretation, and evaluation. Aesthetics, as a branch of philosophy that began in earnest in the eighteenth century,[2] explores broader issues, such as definitions of art and beauty; how the arts interrelate; the nature of an aesthetic experience and meaning; how judgments and value are established; how art, ethics, emotion, and knowledge are related; and to what degree all of this is culture-specific.[3] Many of these subjects are relevant to art history studies. But in practice they have largely been partitioned into a very specialized branch of philosophy, with expositions and findings featuring amazing volumes of detail that barely trickle into art history.

Meanwhile, the history of African art studies adds more difficulty. In the mid-twentieth century, Africanists found learning about the meanings and uses of African art hard enough without adding the burden of understanding aesthetics. More problematically, many Africanists incorrectly asserted that Africans did not have aesthetics, that their art was completely utilitarian, and they were unconcerned with how it looked. This was contradicted by the existence of huge numbers of profoundly subtle, sophisticated, and beautiful artwork from all over the continent.

This rejection of aesthetics was also a reaction to midcentury impressions held by many Africanists that Western art history dwelt too exclusively, and perhaps frivolously, on form and style without linking art strongly enough to social and cultural issues.[4] By the 1980s, many Western art scholars felt the same way and rejected an emphasis on form, and especially beauty, in favor of more socially relevant topics.[5] Meanwhile, African art studies made a hopeful move toward socially relevant aesthetics in the early 1970s and then, with a few exceptions, moved away again. Groundbreaking studies by d'Azevedo (1958, 1973a, 1973b), Fernandez (1973, 1977), and Thompson (1968, 1973a, 1973b, 1974), for example, demonstrated a clear and strong importance for aesthetics in culture and even in everyday society. Robert Plant Armstrong (1971, 1975, 1981) wrote three innovative books that reconsidered the nature of aesthetics and showed how art is laden with evocative, affecting power. The challenge

these authors' findings offered other Africanists has never been fully taken up.[6]

Many art scholars follow a popular twentieth-century shorthand for aesthetics. They boil it down to beauty, and there is justification for this. The history of aesthetics' Western development begins with an ancient Greek emphasis on sense perception but moves to an eighteenth-century emphasis on beauty and subjective sensuous pleasure and a nineteenth-century emphasis on taste. Baumgarten, who crafted aesthetics' modern Western character, linked it to the production of art but wed it deeply to beauty, as did many Western thinkers after him (Williams 1985, 31–32). As a consequence, beauty has become a kind of leading edge for aesthetics. But frequently that edge is detached from the other rich issues and concepts that aesthetics can carry. And late in the twentieth century, it was that detached leading edge that was designated a frivolous diversion from the serious social business of art by many scholars and critics.[7]

But beauty and its larger body of aesthetics should not be jettisoned so easily. From the 1700s in the West, beauty and aesthetics have received scholarly attention as being potentially of noble use, as an instrument of harmony and civil society (Kester 1997a, 920–25), a strategy for stimulating social thought and sometimes change (Hickey 1993), a measure of ethical behavior grounded in bodily responses (Kester 1997b, 38–45), and a moral force in society (Scarry 1999).

There are also practical reasons to revitalize beauty. Its embeddedness in aesthetics from both scholarly and popular perspectives makes it a fulcrum of appreciation and a gateway to compositional analysis, exploration of style, and critical assessments and interpretations that go beyond artwork and expand out into the world again. And it is not just beauty per se but also beauty on a continuum that extends toward ugly and gruesome, creating fields of perceptions able to generate impact and emotive power (Thompson 1968, 44–45; 1973, 51).

Beauty is, indeed, a form of power. In fact, the whole continuum—from lovely to grotesque—offers its own measure of potency, relevant to cultural forms and norms, as Armstrong suggests (1971, 10–16). Beauty can move us, inspire us, influence us, affect us, as can every other position of expression along that spectrum from lovely to horrendous.

This is an important essence of artistry that neglecting aesthetics encourages us to forget. It may be difficult to say exactly why (Dissanayake 1992), but elements of composition, compelling imagery, evocative references, or combinations of all three swirl into our cognitive processes and bodily experiences of the world to generate potent responses. Within the shared cultural landscapes of society, deliberately shaped objects and acts can have a tremendous impact on people. Playing with a phrase coined, and perhaps impoverished by,

the critic Clive Bell (1914), Susanne Langer (1953, 25, 32–34) called this power "significant form": an intensely articulated and sensuous creation possessing the power to express important experience not accessible by language, what she identified as "feeling, life, motion and emotion." Two decades later, Armstrong (1971, 3–6) described this profound capacity to have an impact on people as an affecting presence, the intentional production of "potency, emotions, values, and states of being or experience," a culturally inscribed "universe of feeling."[8]

The effects that beauty has on society move potently into many realms. In science, Watson (1968) describes how he and Crick used beauty as a criteria for discovering the double helix, which earned a Nobel Prize. In product design, Postrel (2003) describes the profound social and economic consequences of carefully considered style.

Beauty is also a metaphorical measure of competence, accomplishment, and success. It is readily equated with good in uncountable arenas of art and life, from sports to politics to business. In virtually every area of human enterprise, acts and processes well performed are described as things of beauty. The connotations are widely understood, even though explaining exactly what is meant can be difficult and tedious—again, beauty serves as shorthand.

These features and ideas about Western aesthetics—that beauty is important and form has power—are relevant to Sidi Ballo, because they are also deeply embedded in Mande ideas about aesthetics. Armstrong felt the principles and elements that drive aesthetics must differ dramatically among societies. The only certain universal for him was that form incarnates affect (1975, 11). He may overstate the differences among societies, but his position aims us usefully toward the ingredients and processes by which form is articulated into being.

For objects and activities to have the potent impact that Sidi Ballo had at Dogoduman, the components and processes by which form is articulated must emerge from deeply shared experience. These ingredients are part of habitus, the conglomeration of concepts, values, institutions, ritual situations, and daily activities that people engage in and embody to make their lives in society (Bourdieu 1977, 1990; de Certeau 1984; Giddens 1984, 1–40; and Kratz 1994, 30–34). They are the tangible and elusive configurations of the social mind lodged in artwork (Prown 1980, 1982).

This makes form more than appearance, a concept Mande people are extremely familiar with—a concept that compels us to rethink the nature of both form and aesthetics. It also means the power that writers such as Langer, Armstrong, and Thompson (1973a) have attributed to form is well-justified; form is significant indeed. And it puts Sidi Ballo on the same page with these authors. They say form has impact because it is fueled by a culture full of shared experiences. Sidi Ballo would agree. He was quite clear that his performances

trafficked in the grand ingredients of Mande culture, and he wanted that trafficking to be as laden with affect as he could make it.

The beauty in his Dogoduman dancing—the way he made his masquerade appear to glide with fluid grace, or swivel rapidly and then stop in chronological sequences that seemed like surrealistically arrested frames of moving pictures, or quiver in a kind of elegant sigh when he finally fell gracefully to the ground—amplified the affect his exquisite feats created. And his whole performance was most emphatically a thing of beauty, as was the singing of Mayimuna Nyaarè and the dancing of the young *Ntomoni* mask wearers. That beauty was part metaphorical recognition of pronounced skill and accomplishment, and part reality verified by the senses. Audience members would readily have testified to both.

A history of Mande aesthetics, the development of its principles and features, would surely be enlightening, judging from its contemporary sophistication. But reconstructing it would be impossible, and we must content ourselves for now with a description of some of its contemporary components. First, however, I want to provide a glimpse of the aesthetic habitus from which Sidi Ballo emerged and, simultaneously, lay to rest the last vestiges of the fiction that aesthetic dispositions and considerations are not part of social and personal life in African societies.[9]

A MANDE AESTHETIC ENVIRONMENT

Over many decades of the twentieth century there were several permutations to the tired old notion that African art is primarily functional and, by extension, something different from what is called art in the West. African art was considered too basic, or too basically a part of social life, for aesthetics to develop. Or many objects were thought to be dedicated to ritual that was frequently seen as so single-minded and devoid of playfulness that aesthetics would be superfluous. Also, Westerners were convinced that no word for art existed in African languages, which raised the question: How could we conceive of African sculpture, architecture, theater, music, and so on, as we conceive of it in the West? If it was not really art, then would aesthetics apply?

Of course, this all falls apart with the realization that art in the West has never been completely divorced from social worlds, even in modern times, and that African art has never been wholly utilitarian. A high percentage of sacred or politically charged objects from all over the continent are profoundly sophisticated in form. This is neither accidental nor unappreciated by local audiences. It is apparent that Sidi Ballo grew up in an art-rich environment where a complicated and supple appreciation for artistry and a lushly nuanced vo-

cabulary for discussing art contributed to the opportunities he harvested to build a fine career.

A word for "art" has often been a linchpin in the debate, frequently without an accurate sense of how people actually do identify artistry. If there were no overarching Mande word for art, it would not mean that there is no art. Mande people deploy a refined vocabulary to describe art and artistry, beginning with a basic distinction between two very different but often interconnected conceptual categories. Artworks used for public entertainment are considered *nyènajè,* playthings and objects of amusement. Those used in the powerful secret initiation associations and considered laden with *nyama,* are *nyene-fe* or *nyan-fe,* which literally means "before the power-object."[10] These terms identify objects just like the word *art* does, but they subdivide by indicating intent and indexing levels of power. They do not divorce artworks from the world of experience that nourishes them. Nor do works in either category fail to receive aesthetic attention or appreciation.

People also frequently refer to objects descriptively, as "little wooden people" (*jirimogoniw*), for example, or "head of Kòmò" (*Kòmòkun*). This works quite well because the identifying contexts of these descriptive phrases are widely known. Thus, there is an ample supply of words for Mande artwork, all more contextualized than the Western word for art.

There are, however, Mande phrases referring to artworks that resemble the modern Western term. Ezra (1986, 7, 10) noticed that elders often call artwork *mafilè fèn, fleli fèn,* or *lajè fèn,* which mean "something to look at" or "something to see." She found that people used these terms to suggest that works of art attract and focus attention and inspire thoughts. She writes that artwork such as sculpted masks and figures make performances and rituals more interesting, and that sculpture can even be defined as *masiri,* embellishment or decoration that makes an event more attractive and significant. In other words, Mande see art as affective form that is not fractured from the social world.

I encountered similar conceptualizations and a lively use of vocabulary (McNaughton 1988, 107–108). Indeed, there is a rich and subtle Mande lexicon of words and phrases that people use to consider characteristics of art and to assess both the works and the artists. Sedu Traore, the sculptor with whom I worked must closely, favored the word *jago* or *jako,* which he used to mean art or artfulness, or style. Things so labeled were embellished beyond practical necessity and were "pleasing to the eye," *nye la jako.* Such things were attractive and desirable, which is why *jako* also means "commerce" or "business." One basic sense of *jako* is "decoration, embellishment, innovation added to the already established" (Kone 1997; McNaughton 1988, 107–108). It can be thought of as identifying those ingredients that add interest, variation, and excitement to a fundamental form, be it a shirt or blouse, a mask or puppet, a song or a

performance. But many people use it to mean embellishment that is so much a part of the basic form that it emerges from it as style.

Brink (1981, 8; 2001, esp. 238) describes a deeper meaning for *jako. Ja* refers to identity. It is an element in each of us that mediates between and helps to relate our interior soul (*ni*) to our social group. It is in a sense an interface between ourselves and others, with emphasis on both our individual characters and their unification with larger communities: "The person's *ja* reflects his motivations, intelligence and character (*tere*), and, thereby, functions as a synthesis or portrait of the essential features of the individual's idiosyncratic and social identity, his personhood" (1981, 8). Brink goes on to say that art is the expression of a person's *ja* (9–10). *Jako* refers to the things added to basic form—of an artwork, for example, or a type of performance—that distinguish it from others, giving it individuality, vitality, interest, and a contemporary presence within an established tradition. *Jako* can be seen as an abstract reference to the kinds of creative activity that produce an art history.

Mande people use several words to indicate specific states of "decoration." *Masiri* is used by some Mande in place of *jako*, but it can also be used differently to refer to objects or materials that are added to a structure in much the same sense as Ezra indicated for sculptures used in performances or rituals. *Masiri* can also mean something more abstract, a noteworthy feature of someone's behavior, such as fearlessness or noble bearing (Kone 1997), in other words, an element of style in someone's personality.

Nyègèn can be used in place of *jago*, or it can be used to mean design, as in the patterns of design engraved or painted on something such as a door lock or a mask. *Nyègèn* can also be used as a verb, meaning the act of decorating or configuring an artwork's overall two- or three-dimensional composition to make it more appealing (McNaughton 1988, 108). Or, *nyègèn* can refer to the act of designing, painting, or embroidering (Bailleul 1981, 164). It can also mean a complex pattern, or a subtle pattern that is a little out of the ordinary, such as someone's distinctive style of walking or speaking (Kone 1997).

There is ample flexibility in the use of these terms. Some people use *jako* for *lajè fèn*, or *nyègèn* for *jago*. Some use the words more or less interchangeably; others make fine distinctions in their application. And this divergence of use does not simply correspond to art users and audiences versus artists, although it does emerge from differences in experience and interest.

Thus, Mande descriptive words and their varied uses indicate a spirited environment of aesthetic contemplation and appreciation that is reflected in the choices people make about artworks and performances. The rich semantic landscape is part of a broader disposition of sensitivity and appreciation for aesthetic form. To be sure, like people everywhere, not everyone cares about the forms that material or social things take. For some, a stool is only something to sit on, an iron lamp simply illuminated dark space, and the poetics of

ritual incantation are just vehicles for significantly powerful utterances. However, for many people the articulation of things is important—to enjoy, contemplate, and discuss. So stools are often made with an imaginative flair for design that gives them character and gives people pleasure (McNaughton 1988, plate 6). Even the simplest iron lamps (now out of use) could be made with elegantly modest embellishments of structure and decoration, and many overflowed with complexity (McNaughton 1988, 115–19, plate 56, color plate V).

This predilection to structure things beautifully and add embellishment is immediately obvious across the spectrum of Mande material culture, from clay pots and wooden containers to door locks, tool handles, hunters' equipment, cloth, clothing and jewelry, building surfaces, and all kinds of basketry products, even the new baskets made from plastic strips. Beyond material things, many people's public comportment or public speaking can be assessed on the basis of an interplay between economy and hyperbole.

Clothes are a good example of how people value artful things. Breathtaking colors, exquisite patterns, sumptuously textured embroidery, and, in formal wear, a lush abundance of material, all factor into fine-looking clothes. And fine-looking clothes are valued and highly desirable, assessed as measures of people's social substance. In the capital city of Bamako, across from the old central market, there used to be an alley clogged with cloth vendors whose shops spilled out into the street. When you walked to its other end, the alley mushroomed out into another huge market, overflowing with tailors and sales people. Packed along numerous little lanes, stall after stall was lushly stocked with some of the finest design you could hope to find anywhere, and the sound you heard was the spectacular staccato of pedal sewing machines, so many that you wondered how they all could stay in business. But they did. It was a wondrous tribute to the aesthetic power of cloth, of clothing, and of the poetics of presenting oneself in society. Now that alley has been absorbed into a riot of byways, with cloth and clothing vendors everywhere. Beautiful cloth (*fininyuman*) is available all over Mali, as are talented tailors; and the artistry in Mande cloth and clothing is so thoroughly appreciated that many proverbs are devoted to it. For example:

> There are no children of money-owners there,
> just children of clothes-owners.
>
> *Waritigiden tè yen, finitigiden de bè yen.*
> (Kone 1997)

This proverb proclaims the value of refined appearance by suggesting that the children of wealth will not be treated as well in the world as are the children of those who care to dress themselves with beauty and taste.

Just as there is a range of interest in form among Mande, there is also a range of artistic expertise. As in most other societies, we could arrange Mande artists along a scale of talent and accomplishment from mediocre to extraordinary. As I traveled around the small and mid-sized towns of central Mali with Sedu Traore some thirty years ago, sculptors would often show us their works. Some were simplistic tourist pieces with little concern devoted to detail, subtlety, or elegance. In fact, many were not even Bamana objects, but rather were local interpretations of Dogon, Senufo, and Yoruba works created by examining pictures in art history books or from ideas shared among entrepreneurial sculptors. These works were destined for the art shops of Bamako and the international art market. Other pieces we were shown, made for local use, were just fine but nothing special. They were sculpted with competence but, as Sedu would tell me later, without the imaginative variations in detail that give sculptors reputations as fine artists.

There were also ample numbers of sculptures that were wonderful, that were created with a fine sense of form, attention to detail, and personalized character that Sedu said constituted the artist's signature. This high accomplishment occurred across a wide range of creative variation that can be experienced by viewers outside of Mali by looking at the large numbers of door locks (Imperato 2001), for example, or antelope headdresses (LaGamma 2002) that populate books and museums.

This same range of expertise typifies all modes of Mande expression. Masquerade performers, for example, can be mediocre or spectacular. The bird dancer who kept dropping his carved bird's head that I mentioned in chapter 4 is a good example of the former. He spent most of the time simply sweeping around the dance arena or just standing, so that even his assistant seemed bored, and the audience, though polite, was noticeably unenthusiastic.

Sidi Ballo occupied quite a different level of accomplishment. He maintained a sizable repertoire of highly dramatic moves such as "flying" into walls and leaping off bleachers. In the middle range of dramatic effect, he had impressive moves, such as jumping at high speed over benches placed in his path and tipping his masquerade ponderously from side to side while motoring around a dance arena, so that audience members felt he was in peril of falling over.

But beneath these more dramatic articulations, the foundation of his performance was the hard-earned fluid elegance that patinated his presence in dance arenas and made him wonderful to watch. He could move as if gliding, steeped in apparent ease that seemed to defy the laws of natural human movement as well as gravity. He literally carried his masquerade from inside with a lilting grace that could make the whole construction appear at times to be weightless. This, even though at other times, when he stormed past or rushed right at you and stopped so close you felt your eye lashes might brush him if

you blinked, he could make the masquerade appear dangerously heavy and just a little threatening.

As he produced these illusions, he was also busy manipulating the bird's head with smooth and authoritative competence. By turns abstract (like a baton) or naturalistic (like a bird), these gestures were always freighted with style and most pleasing to watch. When he swept the head out in grand figure eights, far from losing control, he captivated you with the grace his gesture produced. And when the bird's head bobbed or looked about, as if searching for some delectable little courtyard scraps to eat, you thought, "What a funny bird!"

None of this was random. Sidi knew how to put all these elements together in an orchestrated array of theater that kept audiences' eyes riveted on him. He seemed to play with people's attention spans and sense of anticipation as if they were part of the materials at his theatrical disposal. And audience members made their appreciation obvious with attentiveness and highly vocal praise. Meanwhile, his apprentice-assistant, Sibiri Camara, quite a good performer himself, was busy keeping up and trying (successfully) to complement Sidi with his own pleasing performance presence. While he certainly adjusted Sidi's ruffled feathers after a vigorous dance segment, he would never have occasion to hand Sidi back his bird's head.

There are ways beyond words to express preference and recognize talent in artists. Patrons often demonstrate their judgments by choosing artists whose style they prefer. Expedience or expense can also play a role, but it is not unusual for clients to purchase works from relatively far afield just because they prefer a more distant artist's work. This can even happen in the realms of power-laden artworks such as the impressive Kòmò headdresses used in deeply spiritual associations. I remember vividly that in 1971 Sedu Traore, who then lived south of Bamako, had a commission well to the north in the Beledugu to undertake the construction of such a Kòmò headdress. This shocked me, because I understood Kòmò headdresses to be complex and highly personalized affairs, each possessing unique configurations of amuletic materials amassed according to the predilections and style of their owners, and in response to specific events and situations. Smiths who head the association, manage the masks, and dance them would be highly disinclined to use someone else's headdress. But Sedu explained that he would establish a basic foundation of Kòmò power materials in the headdress he created, and the true owner could then personalize it to suit his wants and needs.

Beyond the statement made with purchasing power, Mande use a rich vocabulary to state their approval of artistry and artworks. Some terms and phrases are linked to specific realms of art, such as the tasks of blacksmithing or music making, or at least applied most commonly to them. Others are applied more or less universally.

For the most accomplished artists, at the top of a lexicon of critique and assessment is the word *keneya,* which literally means "suppleness" and denotes the fruitful, synergistic coalescence of knowledge, skill, and perception that allows artists to respond elegantly to the situations they encounter and to affect and engage audiences. It is used the way Europeans and Americans would use "virtuosity."

Politeness and deference to social protocol inhibits insensitive public voicing of criticism, but in small groups people might call a work bad (*jugu*) and perhaps explain why. Criticizing in public is "belittling" (*dògòya*), literally "to make small," and that is considered inappropriate and damaging behavior. To belittle someone in public is to mark them in negative ways that can stick with them all of their lives. Only in joking relationships (*senenkunya*) are scathing satire and hard-hitting, derogatory jokes acceptable, because in that context they are good, clean fun. People are generally aware of inadequacies in artworks, just as they are aware of their friends' and neighbors' shortcomings. But under normal circumstances they will not speak publicly about them (Traore 1971; Kone 1997).

Positive assessments of artwork can be voiced more openly. One can say something is good (*nyi*), sweet or tasty (*di*), that it pleases the eye (*ka nyè daamu*), that it is full of good design (*jako*), that its artistry or design pleases the eye (*nyè la jako*), or that it is full of beauty or style (*coko o coko,* or *cogo o cogo*).

The different sculpture styles of particular blacksmiths can be recognized with the phrase: *Numu bèe n'a bolonò do,* "Every blacksmith has his style," literally, his signature or handprints (Tera 1977). The connotation is that sculptors' individual carving styles are as different and undeniable as fingerprints (Kone 1997), or, as the blacksmith Sedu Traore told me, as different as handwriting (Traore 1971).

Expertise in sculpting can be recognized with the phrase *A ka jiribaara be kolo kan* ("His wood working is right to the point"); that is, it is concise, elegant, and captures the essence. Mande people can also say about good work: *N b'a fe ka nin jirikun majamu* ("I want to praise this mask"), for example. Or, they can go further and say: *A ka jiribaara te son,* which means the artwork is so good that it simply does not allow any criticism. Interestingly enough, the word criticism (*lagosi*) is implied but not actually stated (Tera 1977; Kone 1997).

Just as people should be diplomatic about negative critique, they should also be careful about praising objects in poorly selected social contexts. Telling people you like particular things they possess can be construed as saying you want them to give those things to you. That may become tricky business, because your statement of admiration for a thing initiates an obligation for the owner to give it to you, which instantly puts your own possessions at risk of subsequently being requested. So object owners may assess your statement of appreciation to see if it really was also a statement of desire, or if instead it was

Plate 1. Bird image on exterior of house wall in a small town in southern Mali

All 1978 photos by the author and M. Sangaré unless otherwise noted. All 1998 photos by author and Kassim Kone unless otherwise noted.

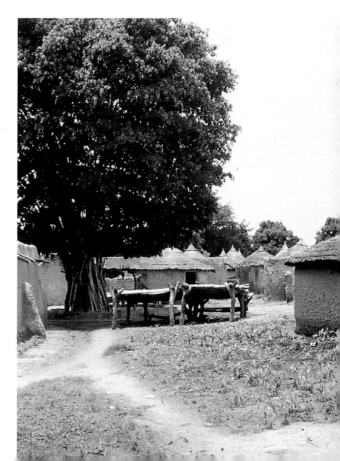

Plate 2. Typical dance arena in southern Mali

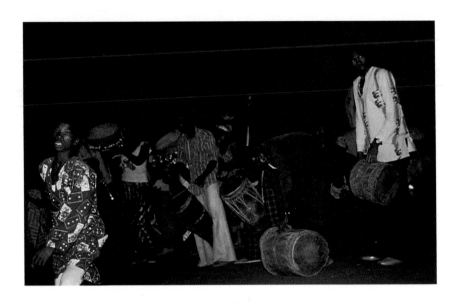

Plate 3. Drum orchestra and *jamaladilala,* 1978

Plate 4. Young ladies' chorus with calabash drums, 1978

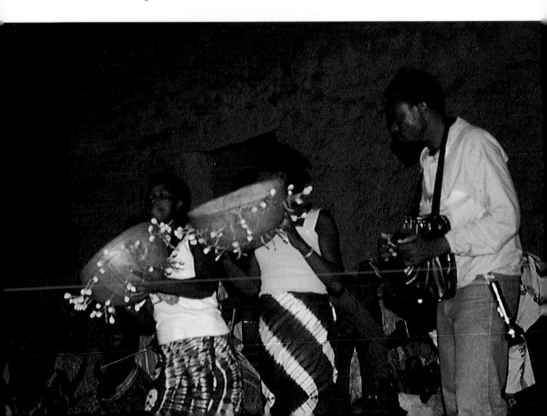

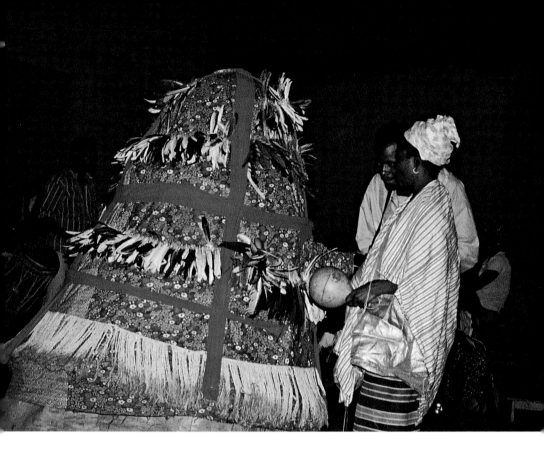

Plate 5. Mayimuna Nyaarè in the center of the dance arena with Kònò, 1978

Plate 6. Sidi Ballo (center) and his apprentice, Sibiri Camara (right), with the author just before preparing themselves for the performance, 1978. *Photo by Kalilou Tera.*

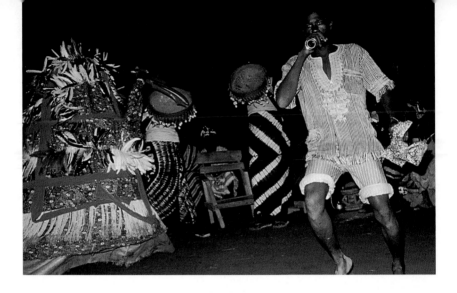

Plate 7. *Kònò* performing with his apprentice, 1978

Plate 8. Young *Ntomoni* dancers, 1978

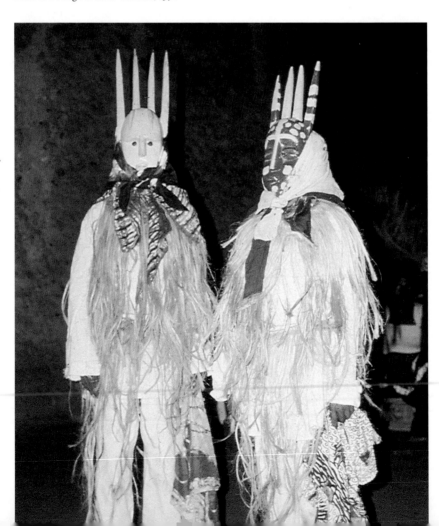

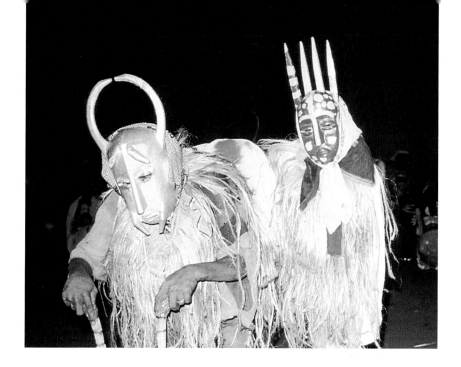

Plate 9. *Sigi* and *Ntomoni*, 1978

Plate 10. *Kònò* in the dance arena, 1978

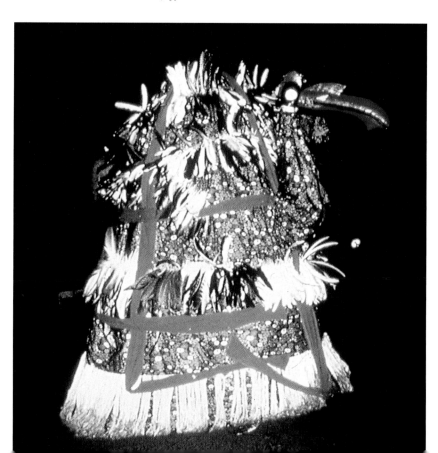

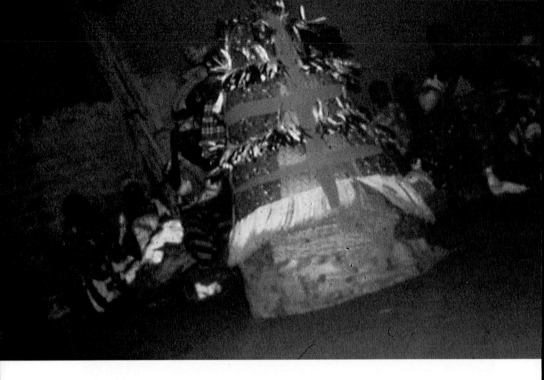

Plate 11. *Kònò* moving around the dance arena, 1978

Plate 12. *Kònò* rears up, 1978

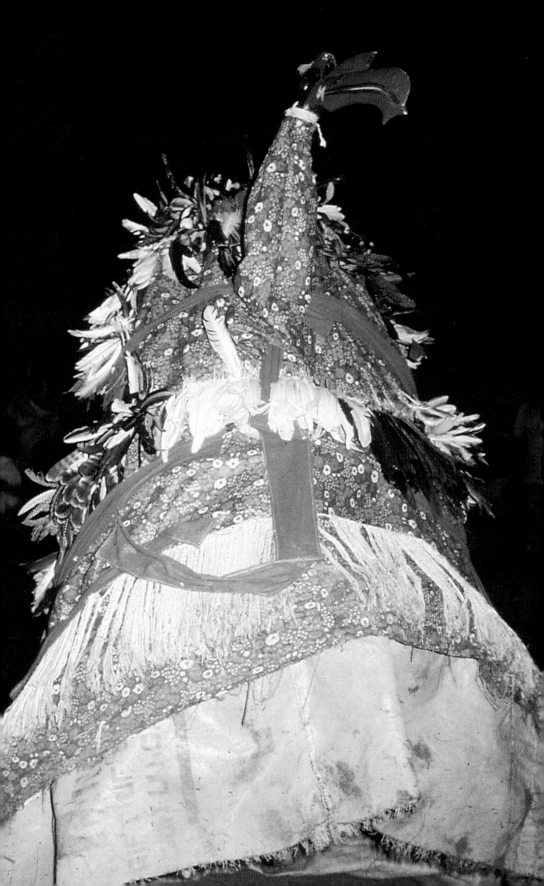

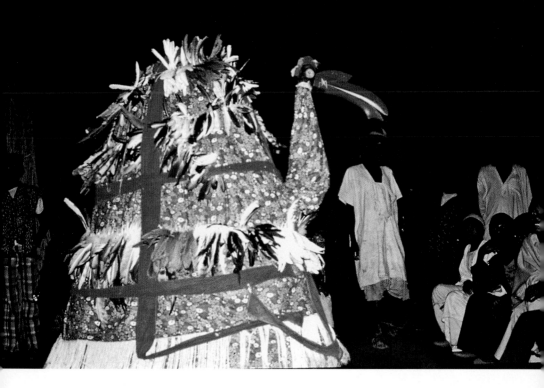

Plate 13. *Kònò* greets members of the audience, 1978

Plate 14. Spirited *Ntomoni* dancer, 1978

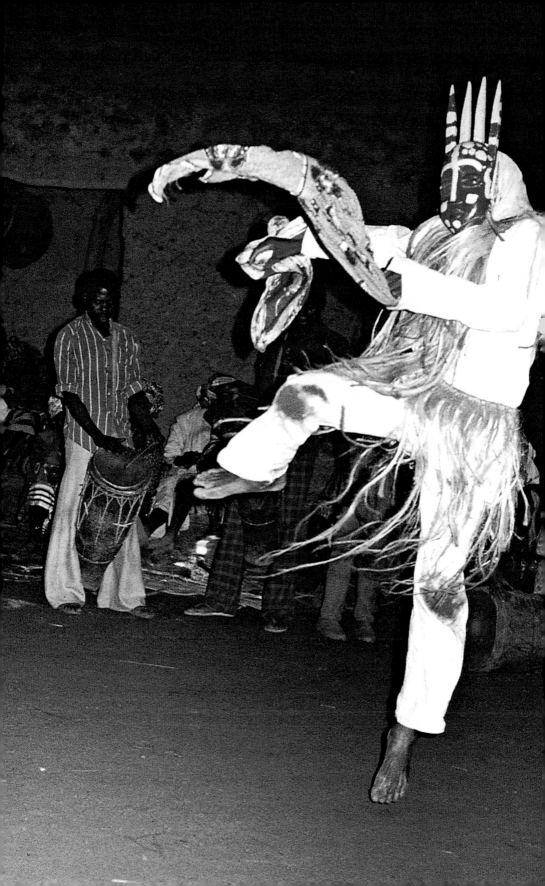

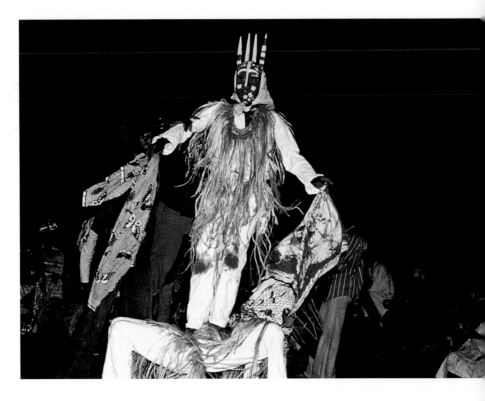

Plate 15. *Ntomoni* perched on the stomach of the other dancer, 1978

Plate 16. *Kònò* falls over, 1978

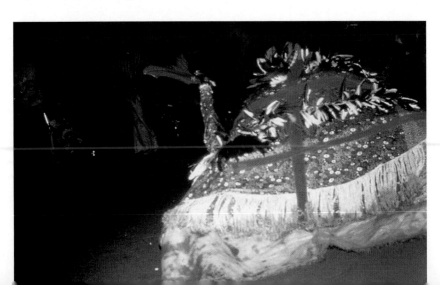

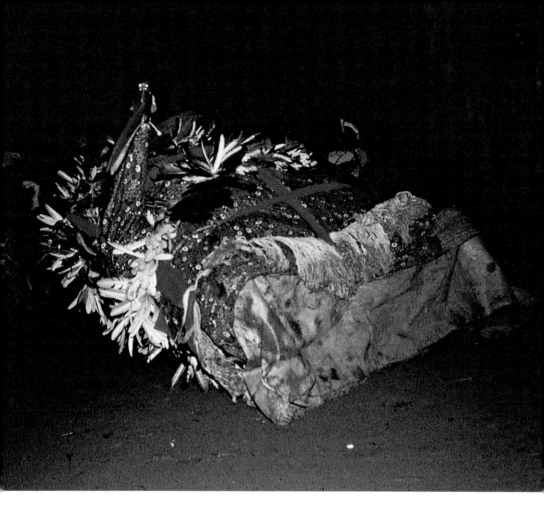

Plate 17. *Kònò* on his side, looking around, 1978

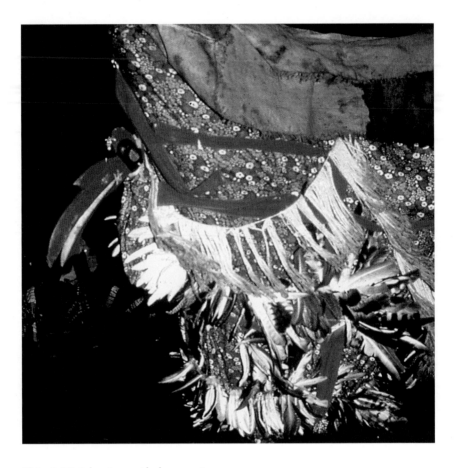

Plate 18. *Kònò* dancing upside down, 1978

Plate 19. *Kònò* reveals the inside of his masquerade, 1978

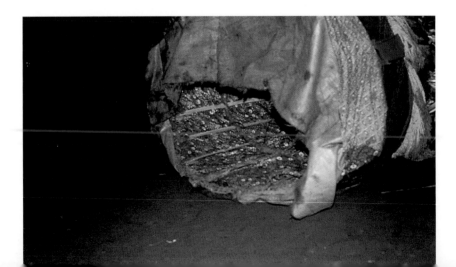

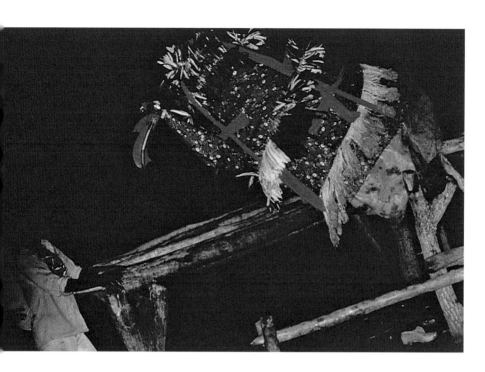

Plate 20. *Kɔ̀nɔ̀* leaps off the bleachers, 1978

Plate 21. From left to right: Sidi Ballo and his brother, Solo, with the author, 1998. *Photo by Kassim Kone.*

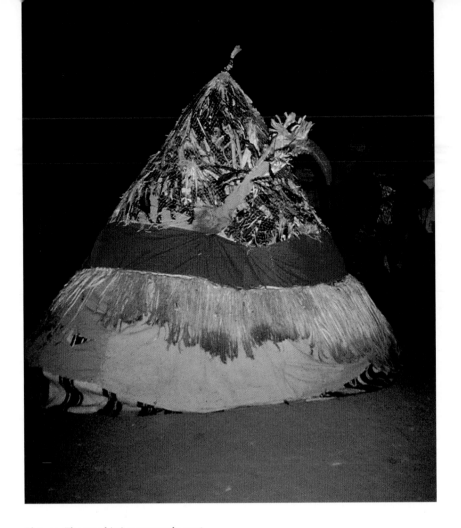

Plate 22. The new *kònò* masquerade, 1998

Plate 23. Child of the *kònò*, 1998

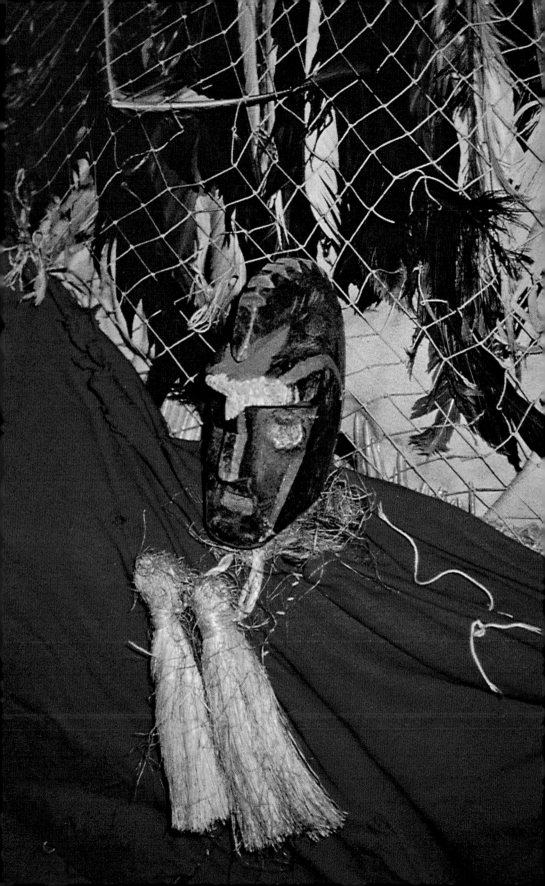

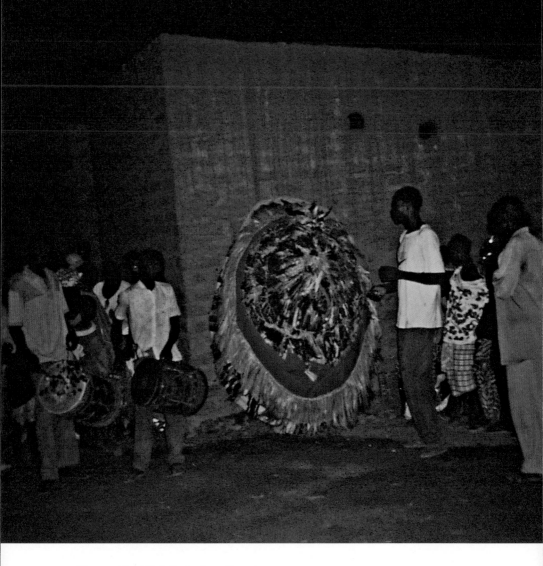

Plate 24. New *Kònò* climbs the wall, 1998

an instance of unsophisticated speech. They may also assess your relationship with them, while considering the things you own or are capable of doing, to determine if giving you the object and simultaneously obliging you might not be a worthwhile investment or possibly lead to some fun later. This can become a heady game of psychology and social strategy, with people psyching each other out and trying to anticipate each other's responses several moves in advance. At the same time, smart people can usually find ways to avoid giving the object in the first place, with or without causing the initial praise-giver embarrassment, and possibly deploying piquant banter similar to that used in joking relationships.

We have here a high-stakes version of what Carrithers (1992, 58–60) calls "higher-order intentionality," Dennett (1987) calls "intentional stance," and Whiten (1991) calls "mind-reading," whereby people use their understanding of the human condition to imagine how a state of affairs may break down into numerous sequential actions by the involved parties and how those actions may ultimately turn out. This kind of forward thinking is also a foundation for the effectiveness of strategies deployed by artists as aesthetics.

The appreciation and praise of art extends even to those forms of sculpture that many Americans or Europeans find inchoate, disordered, or repulsive. The masks of the powerful secret initiation associations such as Kòmò, for example, may look to many Western eyes like monstrous assemblages of unsavory materials. But to Mande initiates of the association, they have a structure and organization, a visual rationale that is well suited to their capacities as sculptures empowered to do dangerous work in the world (McNaughton 1979; 1988, 129–45). They are viewed as scary things (*nyanfèn*), obscure objects (*dibifèn*) designed to fight dangerous antisocial forces that that are also shrouded in obscurity (*dibi*), so that Kòmò masks can be called *dibi faga dibi*, "obscurity-killing obscurity." Their aesthetic and practical strengths coincide. In fact, they amplify each other by amassing sculptural parts and surface coatings that are considered simultaneously to be decoration (*misiri*) and entities of articulated energy (*basiw*).

The accumulation of these components is appreciated by association members, who understand the effective use of individual components and overall composition. Thus Kòmò masks can be described as "sweet" or "tasty" (*duman*), even though their intention is to inspire awe and fear (McNaughton 1979b, 1988, 129–45).

Beyond sculpture, there is more vocabulary for describing and evaluating the aesthetic character of performances, which Arnoldi (1995, 103) elegantly presents. Many components must come together to produce a "successful entertainment," *nyènajè nyana* (Arnoldi 1995, 207). A key word for many of them is *cogo*, which Arnoldi (1995, 102) translates as "manner, way, or style," and Brink (1981, 9) describes as the cultural knowledge needed to create or identify

any Mande form of art or artistic expression. In the youth association from which Sidi Ballo's itinerant performances emerge, people

> regularly use the term *cogo* to describe the *nyi* or "goodness" of the form emergent in performance. They speak of *dònsen cogo* when discussing the pattern of the dance steps, and use the phrase *dunun fò cogo* to talk about the pattern of the drum rhythms. The melody and phrasing of songs are encapsulated in the phrase *donkili da cogo*. People use the phrase *nyènajè cogo* to talk about how the event is structured, organized, and patterned. In lieu of *jako,* performers often use the term *tèrèmèli,* bargain, or *tigè,* to cut, to describe how they revise and creatively play with the basic structure of a song, drum rhythm, or dance. (Arnoldi 1995, 103)

Kone (1997) notes that *tèrèmèli* is sometimes used to refer to the role of a backup singer, who responds to the lead singer by "bargaining the song," *ka donkili tèrèmèli.* He adds that *cerotikè,* "to cut in the middle," or "to cut in between the flow of the song" indicates a form of *jago* in which the music's tempo is doubled. Brink (1981, 11) says this cut in the middle also syncopates the beat.

Expert drumming can be recognized with the praise *dununfòlaba* (good drummer), literally, "the one who makes the drum speak in a grand way." Virtuoso drumming can be praised with *dununfòlangana,* which identifies the performer as a hero, literally, "the heroic person who makes the drum speak." Or, you can simply say *dunun ka di,* "good drumming" (Kone 1997).

We can also look at dancing. *Dònkèla* is the word for dancer. *Don* means "dance." *Kè* means "to do or to make." *La* is a suffix that locates the action. *Dònkèlaba* makes the word "good dancer," by adding *ba,* which means big or grand (Kone 1997).

Kone notes that there are two powerful ways to offer high praise to an excellent masquerade dancer. You can use the massive compound word *dònkèladalawaraba,* which likens the dancer to a big, fierce beast, specifically a lion. It literally means "someone who has a lion's status in dancing." This is considered the highest status, so it is high praise. A simpler way to say it is to call the masquerade dancer a *waraba,* lion (Kone 1997), praising by likening to powerful, fierce, intelligent, and highly regarded creatures.

As with the words used to describe elements of plastic art, such as *jako* or *masiri,* these words used to describe and evaluate performance are flexible and subject to individual iteration. They suggest a vitality of thought and a propensity to aesthetic analysis that reflects the rich, dynamic qualities characteristic of Mande masquerade performance.

In addition to these words for describing and assessing performance art in conversational contexts, formal praise can be built into the structure of a per-

formance. Such praise capitalizes on the Mande value of success from hard, intelligent work, shifting it into the realm of the artistic. As positive critique, it is highly appreciated by performers and immensely enjoyed by audiences. First, it is beautiful to hear, and praising beauty with beauty is fine praise indeed. Second, it is encouraging and supportive, which is good for anyone, including seasoned professionals such as Sidi Ballo, but is especially welcome by young *ton* dancers who have worked hard and have begun to earn such praise. Third, it is public and formal, making it a matter of acknowledged record and thus all the more rewarding. We have already seen that Mande place great value on oral history, so there is widespread sensitivity to public proclamations of people's accomplishment. Praising people for their beautiful performing right in the songs they are dancing to is elegant and delightful.

Earlier, I described a song the young ladies sang at Dogoduman that began by praising the young dancers wearing *Ntomoni* masks and then praised the other two masked dancers and even fleetingly touched on Sidi Ballo. That was the fourteenth song performed. The very first song also praised the *Ntomoni* masked dancers and is rich with imagery that demonstrates Mande aesthetic sensibilities. It was performed by the two young ladies with calabash drums:

> Didn't you see the little doe,
> the little doe antelope?
> Didn't you see the little antelope?
> See the little *Ntomoni* antelope of Dogoduman.
> the little antelope.
> See the one whose speech is gentle,
> the little antelope.
> See the one whose mid-section is like
> the path to a little village,
> the little antelope.
> Whose mouth is full of grains of rice,
> the little antelope.
> Didn't you see the little antelope?
> the little antelope.
>
> *Aw ma sinèninw ye,*
> *sinèninw?*
> *Aw ma sinèninw ye?*
> *Dogoduman ntomonin ye.*
> *sinèninw.*
> *Kumakan ko mògòlandi ye,*
> *sinèninw.*
> *Cèkisè dugusira ye,*
> *sinèninw.*
> *Da fallen malo gèsè la,*

sinèninw.
Aw ma sinèninw ye,
Sinè?
(Camara, McNaughton, and Tera 1978, 3/1)

Sinè is a gazelle, a major character in youth association masquerade and one of the most beautiful animals in the wilderness. It is graceful and elegant in appearance but also strong and full of endurance. In addition, because it is delicate and beautiful, it is considered to be full of the energy called *nyama*. To be praised as a gazelle is extremely rewarding. To be praised as a little gazelle, a doe, is even more gratifying, because in Bamanakan, adding the diminutive (*ni*) to the end of a person, place, or thing in the right contexts amplifies the beauty by invoking the image of something fresh, tender, innocent, and pristine. It is an affectionate form of praise.

This song features Mande comparisons of beauty. A path to a little village is like a beautiful, sensuous line in a landscape that leads to something lovely and welcoming. A mouth resplendent with teeth that resemble pretty little grains of rice is certainly something wonderful—the perfect source of gentle speech. Of course, the mask-wearers' mouths and mid-sections are not visible. But their fine dancing is an accomplishment that emerges from what they are as people, so what they are is praised with the value of beauty. Had the song been longer, it could have said the dancers' necks are like lovely little calabashes and their eyes are like stars.

As the *Ntomoni* masked dancers left the arena after their first appearance, the same two young ladies sang a very short song (just four lines), which was repeated many times by the full young ladies chorus. It basically tells the dancers that they are worthy of a headband (*jala*) that is a sign of honor in the youth association: "My *jala* is for you" (*Ne la jala y'I ye*).

The first song praised the persona of the dancers. The third song likened the dancing ability of all the masked Dogoduman performers to things of beauty. It devotes a section to each of the masks, with such lines of praise as:

It comes out with sweet little dance steps.
O bi bò ni dònsennin ye.
It comes out with agility, virtuosity.
O bi bò ni kènèya ye.
It comes out with sweetness in their hearts and souls.
O bi bò ni nisòndiya ye.
It comes out with a quality that brings happiness to everyone.
O bi bò ni kolandiya ye.
It comes out smiling.
O bi bò ni yèlè misèn ye.
(Camara, McNaughton, and Tera 1978, 3/4–6)

Thus, in three songs dedicated to the young Dogoduman dancers, one gives value and appreciation to their dancing abilities, another gives value and appreciation to their characters, and the third declares them worthy of reward. All three create their effect by likening accomplishment to beauty. Clearly, this is an environment where artistry and beauty are held in high regard.

There were also songs at Dogoduman that offered praise to Sidi Ballo. One said he was a hero (*nyana*). Another offered him the headband (*jala*) that can be likened to an award or a medal of honor. Mayimuna Nyaarè sang this song, and it included such lines as:

> There are not enough words to praise someone who is good.
> Kulanjan, there are not enough words to praise you.
>
> *Fò ti mògò banna.*
> *Kulanjan, ko ti mògò banna.*
> (Camara, McNaughton, and Tera 1978, 3/33)

Later, the song asks that Sidi and all his siblings be excused from death, "*Saa ka yafa ima, balima saya*" (3/34), meaning, "May they be so famous that their names live on in oral history even after their bodies have left this world." A few lines later Mayimuna sings:

> I traveled to the east.
> *Kulanjan*, I traveled to the big cities.
>
> *Kulanjan, ne ye galo yaala.*
> *Ne ye kòròn yaala.*
> (3/35)

And then she lists Bamako, Mopti, and even Dakar, and says in all of them she never saw a star as bright as Sidi's, whom she refers to with his powerful praise name, Kulanjan: "*Kulanjan, ne m'i loto nyòon ye.*" Mande say that everyone has a star in the sky, and their brightness varies according to their worthiness. Kings and heroes have very bright stars, and Mayimuna Nyaarè sings that Sidi Ballo does too.

Further along, Mayimuna sings several lines telling Sidi (Kulanjan) not to marry a beautiful women, but rather a woman who knows Mande tradition as well as Sidi exemplifies it and who can divine the deep desire of his soul, his deepest qualities, as well as his physical desires:

> The woman who knows tradition,
> She is your right wife.
> Oh, the woman who can divine the deep desire of your soul,
> She is your right wife.

Oh, the woman who can divine your physical desire,
She is your right wife.

Danbè dòn muso,
O y'i muso ye.
Ah, dungò dòn muso,
O y'i muso ye.
Ah, sago dòn muso,
O y'i muso ye.
(3/38–40)

Finally, after all of these sentiments are repeated, often several times, Mayimuna says Sidi cannot be praised enough, and:

Bird Kulanjan,
My arms are on my back for you.

Kulanjan Kònò,
Ne bolo bèn u'kò i ye.
(3/41)

The young ladies' chorus praise Sidi too when they tell him he is so accomplished artistically that he is the one who makes orphans forget their unhappiness (*Fala naani Kònò*). They say his speech is as beautiful as the delicate ring that sometimes forms around the moon, the "cream of the moon" (*kalo dègè*): *Kumakan ko kalo dègè*. They sing that he is worthy of entertaining kings at court: *Masa sigi barodennin*. They call him a beautiful little child: *Denmisèn nciinininyo*. And they tell him to walk like the son of a king: *I faamaden taama* (4/40–44).

When she seeks to rehabilitate beauty in the West, bringing it back from neglect and even denigration by numerous scholars, Elaine Scarry (1999) describes how beauty saves lives, how it can be strategic, how it encourages exploration and self-correction, and how it relates to truth. She finds it to be a most relevant aspect of the enterprises we consider human. The same can be said for Mande.

Thus, Mande people have created a sensual and intellectually lively aesthetic environment. Through a rich vocabulary of description and critique and a lovely approach to public praise, there exists a lush semantic field in which to roam. And through an appreciation of beauty and affect, artists and performers gain the opportunity to develop abilities that enrich their communities. That enrichment goes beyond what outsiders perceive in a mask or a maneuvering masquerader. More accurately, the social and personal experiences people bring to their engagement with art and performance constitutes an enrichment that actually helps determine what they see, because form is more than it appears to be.

7

FORM RECONSIDERED
IN MANDE LIGHT

When I watched the Dogoduman bird dance, the artistic force of it played me like a piano. Afterward, whenever I tried to imagine why, I always concluded that it only just began with spectacularly articulated form, at least as I was conceptualizing form. To be sure, there was ample beauty and astonishment, elegance and poetry, in the ways performers looked, drummers played, and singers sang. But there was more. In my mind the look and sound of the performance was somehow being instantaneously and constantly augmented. It was not just that content kept getting stuck to sound and appearance, although that certainly was happening. It was also that content and form did not really seem to be separate things.

This fusion of elements and the larger phenomena it engendered was *affect,* a kind of aura that could engulf audience members with impact and inspiration, a sense of significance, a desire to contemplate and explore ideas, and even an easy inclination to let the artwork become a valuable part of one's ongoing experience as a person in the world. This aura of affect is an often ineffable yet also tangible and sometimes nearly visceral atmosphere that seems almost to radiate from artworks and other elements of expressive culture. It can reach into the deepest ranges of our being with the same kind of powerful, even awesome presence that people frequently associate with the grandest of events or the grandeurs of nature. It is built, to be sure, from the intelligent and

skillful union of form and content. And individual viewers contribute to it significantly, so that there is a perpetual dialogue at work among artists and audiences. But ultimately, this phenomenon of affect is a vaster thing than its components, a thick, rich, and frequently complicated amalgamation of contributions not easily dissected. It is, in a very real way, an important part of the power of art.

The red of the carved bird's head is an example of affect's synergy. It was not just color painted over an object. It penetrated to the core of the sculpture's character and contributed to your impression the very instant eyes met it, making the bird more punchy and punctuated, edgy in an aggressive way that possessed just a touch of disquiet and even playful threat. All that was compounded simultaneously by Sidi Ballo's manipulations inside the masquerade and by his high-speed movement around the arena, the lurching and the leaning sideways, and the stopping or brushing by you with ominous proximity.

Later, as I learned more about the praise name Kulanjan and the rich spectrum of power and prowess it invoked, I could not think about or see pictures of that red head without simultaneously responding to a measure of additional power. It took material form, a kind of added weight, a sense of enhanced potency. The head was no longer the same thing for me as when I first saw it. More than that, because part of what the praise name Kulanjan invokes is the legendary leader Fakoli, seeing Sidi Ballo's intensely red bird's head instantaneously sent flashing waves of fleeting thought through me—little pinpricks of bright light about the legendary Fakoli abandoning Sumanguru, aligning with Sunjata, helping create the Mali Empire, and promoting the expansion of the powerful Kòmò secret spiritual association.

This was not deliberate thinking, though I could start with just the seeing and then head in the direction of focused thought if I wanted to. But the shaping of the bird's head through perception was freighted with much faster sensations. Thoughts and values transmuted into a visceral presence, and this transmutation was not the result of mere knowledge. By the time I went to Dogoduman, I had been steeped in Mande ideas about blacksmiths for years, had spent every day with the blacksmith Sedu Traore for nearly a year, and had experienced smiths as an outsider on the inside. I was not just very familiar with the Sunjata epic and its tales of Sumanguru, the supernatural knowledge and powers at play, and the travels and treaties and deployment of military expertise; I loved the epic and saw in the protagonist Sumanguru Kante a hero in his own right, as many Mande do. Being an honorary smith myself, my last name was Kante. In other words, my interior life was littered with personal contemplation and feeling about these heroes and West African history. The epic was for me an experience, a serious part of my being. So I did not apply it to perception. It leaped up out of me and into that shiny red bird's head the

second I saw it or thought about it. If I had been born Mande, that head would be different for me. If I were a Mande bard, it would be different still.

Another example of form's larger dimensions—of its reality beyond simple appearance—is the way I see Sidi Ballo's whole masquerade. Everything I have said about it indicates emphatically that it was an impressive construction, animated by Sidi into a formidable, often spectacular, sometimes awesome presence. I saw it right away as all that, and I still do. Yet from my very first impression of it and throughout all these intervening thirty odd years, it is also for me something very different and quite unlike most Mande perceptions, I'm sure. That thick red ribbon, which Sidi used to cover the interior armature and add punctuation to his arena maneuverings, made of the whole masquerade for me a giant Yuletide wedding cake. In my initial perception that substantial ribbon became first the wrapping of a Christmas present, and then instantly thereafter the piping of an enormous wedding cake. I cannot escape this. It is the immediate and enduring result of my perception, and I find it absolutely delightful. I enjoy the added complexity of experience it provides. I do not think this complexity is that different from a Dogoduman citizen seeing a wild bush buffalo masquerade cavorting with a masquerade representing a Fulani woman. In life, the buffalo is a living terror, tough and mean and happy to mess unpleasantly with people. Seeing it head over heels in love with a Fulani lady in a dance arena is just as wondrous and funny as having Sidi Ballo's masquerade flash back and forth as a spectacularly potent entity in the world and a giant Christmas wedding cake.

FORM AND AESTHETICS RECONSIDERED

Form is clearly a protean phenomenon and, I think, more complex and instrumental than art history writings generally suggest. It is a far more dynamic ingredient of our lives, far more embedded in experience, and therefore much more a part of the processes by which we respond to and create our social worlds.

It is all too easy to consider form and aesthetics as falling outside the realm of serious social processes. In the West, art often seems estranged from life, and the marginalization of aesthetics and form is an unfortunate byproduct. Modern Mande approaches to art in life offer an alternative best understood by realizing first why form and aesthetics are fundamentally important.

Modern Western societies have tended to separate form and content in much the same way that, until recently, they have compartmentalized body and mind.[1] Form is often considered the material outcome of physical skills and aesthetic sensitivity as well as the medium through which symbols are transmitted and moods are projected. It is the configuration of something

(Prown 1980, 197), an object's organizing principle, its arrangement or structure, its "disposition in space" (Maynard 1996, v). Some scholars consider form the raw substance of style, the material articulated to produce a distinctive body of characteristics (Sieber 1993).

Thus, form becomes the appearance of things: their shape, volume, organization, composition, color, and texture; the play of light and shadow over them; and the interaction of positive and negative space within them. Aesthetics are the rules for arranging and evaluating those components and the effects they produce. This reduces what form really is.

Art history has usefully deployed this reduction of form to identify visual composition or to distinguish the way art looks from what it means (its symbolism) and how it works (its function). Form and aesthetics become tools in studies of style, historical development, and artists' biographies. They also serve excellently in analyses that explore the emotional impact of art on viewers. This compartmentalization, separating parts from the whole, facilitates discussions about art and can help us comprehend works of art so long as we put the parts back together again. Often, however, we do not reassemble them, which leaves form hanging unnaturally all by itself as appearance.

Rich form, that is, form considered fully—significant form, as we have described it—is shape and composition, and simultaneously a plethora of immaterial, ethereal elements brought into tangible focus. This is reflected by some authors. Maynard (1996, v, 312) reviews the term's development from the Greek *eidos,* the identifying look of something, its visual signature, to a more abstract sense of essence, "the characteristic nature of a thing—whether visual or not." Williams (1985, 138) observes that the Western concept of form has "spanned the whole range from the external and superficial to the inherent and determining." Hardin and Arnoldi (1996, 10) observe in studies of African art a growing interest in the ways that social situations and people's ideas contribute to an object's form. Brink (2001, 237) sees the forms in art as containing information about a society's values and worldviews. Glassie (1989, 76) makes a similar observation, saying ideas are built into the forms of folk art. Prown (1980, 197–98) argues that the formal configurations we call style are actually complex bodies of information about object makers' and users' values, attitudes, and assumptions. All this suggests that while form can be viewed as matter in specific relationships, there is significantly more, a materialization of far more complex entities. Joshua Taylor made a strikingly sensitive statement relating to this some thirty years ago:

> Looking at a work of art is a distinctive use of the mind. Every sculpture, painting, or graphic work provides us with a new mental activity which might very well have the power to engage all our functions from memory to muscular action, from seeing to touch. To be sure, such engagement requires

a commitment on the part of the viewer; one has to be disposed to act, but it is only from such a thoughtful, personal encounter that the experience of art has meaning and sensible judgments can be made. (1975, 7)

Art has power because it is a crucible of thought and value. But it has more power still with the realization that the ideas and emotions lodged in form are actually part of form's composition because of the nature of perception.[2] Perception is a process of swift thought, where imagination engages experience. It is the organization of sensory, cognitive, and material resources that we create as we comprehend, think, and function in the world. For viewers, discerning form involves instant acts of evaluating and synthesizing, made possible by our previous experiences. We do not just see or hear a form. We construct it with our minds, senses, and bodies all working in indelible consort. We examine incoming data against other things in our experience; find interest in the similarities and differences; make judgments about them; and instantly start imaginative processes of synthesis, abstraction, expansion, and reduction to create an interpretation that gives recognition or identity, meaning, and value. Artists create form with essentially the same processes but often with the added dimension of trying to imagine what sorts of social, intellectual, and emotional materials their audiences transmute into material form in particular situations and contexts.

This makes form two things at once. Joined in a single entity are elements of both shared and individual experience. More than matter, form is the articulation of collections of ideas, feelings, and experiences that emerge from people's lives and coalesce around something being heard, viewed, felt, or contemplated. Often these ideas and experiences are complex and not easy to put into words. Often they contradict or conflict with one another. And often, too, they change and grow along with people's experiences. But always thoughts and feelings are embedded in the very act of perception, so that the things we consider to be components of form—shape, texture, color, volume, mass—are just flash points.

So quickly do processes of analysis, comparison, and synthesis follow on the heels of initial sensation that we cannot really be aware of something seen without simultaneously taking its measure. We begin to engage form by relating it to things that bear meaning and emotion for us. Often enough, we are not even self-consciously aware of making these associations—we may not feel we are engaged in contemplation or deliberation. Nevertheless, synapses are carrying us rapidly to associations that somehow seem to be the natural outcome of viewing. No matter how vague, abstract, or fleeting these associations may sometimes seem, they are nevertheless a part of the grand sweep of physical and mental activity that joins perception and cognition to our worlds of apperception.

Consequently, form is not simply received. Rather, it is something we are always in the process of constructing, and its building blocks emerge from each of our shared and unique histories of knowledge, skills, and experiences. This gives form a special life based on its vitality as a phenomenon contiguous with our experiences, a phenomenon that shapes our experiences. So form can be considered the organization we impose through perception on the nebulous and enigmatic, culturally charged and ever-changing constellation of material, conceptual, emotional, and social resources that constitute our experience and from which we fabricate the social and visual structures that punctuate and direct our lives. Clearly, form is powerful.

Form's power in experience and imagination is more than conceptual and emotional. The physicality of engaging form is vitally important. Being at a masquerade performance, for example, means more than just seeing. Every sense is receiving data—sights, sounds, and smells are pouring in. When a masquerade such as Sidi Ballo's big bird sweeps past, its very mass and weight are sensed and engaged. And when audience members are called out to dance, a whole new set of bodily motions are incorporated into experience. This physicality, this utilization of the body, senses, and mind all rolled into one, is how we explore and learn in the world (Dewey [1934] 1980, Healy 1990, Jackson 1989, Johnson 1987). It is an important part of what perception invokes when experience and imagination make form, and an important explanation for why form can seem to possess so much of the potency of life.

So form's resources include all those visual elements we have noted, plus all the social and cultural formulations through which we live and with which we produce our experiences, plus the memorable encounters and engagements, contemplations and revelations that have composed our personal histories and physical presence in the world. All these things fuel the lightning-fast analysis and evaluation that becomes perception. Few people can view pictures of New York's World Trade Center without having an instant reaction that goes well beyond the acknowledgment of two tall, squarish buildings, for example. Everyone can think of similar examples. Years ago Claus Oldenberg (1977) demonstrated this dynamic capacity that is the potency of form with an extensive display of twigs and various other odds and ends that Americans simply could not see as anything other than guns.

This view of form as the instant materialization of the immaterial is really just a shift in our thinking, but it has significant consequences. Characterizing form in this richer way is simply a speeding up and conflating of the sequential process of art analysis that Panofsky refined and helped to make an important art historical tool (1955; see also Kleinbauer and Slavens 1982, 65–68).[3] Scholars seeking to comprehend an artwork move from object recognition to iconography (identifying signs and attributes) and then to iconology (identifying the

more diffuse ideas and themes that compose a culture). Local viewers stuff it all into the rapid perception of form, then add more later as they contemplate and enjoy what they have perceived.

This little shift brings form to vibrant life, and if we neglect it, we dissipate its affect. We misconstrue form and neuter its power by associating it primarily with taste and connoisseurship or by viewing it as part of the superficial surface of things, allegedly distinct from deeper realities, or by divorcing material form from its conceptual and psychological components. This trivializes art. By seeing form as the window of our experiences and remembering that it comes into being through dynamic processes that articulate the very stuff of our lives, we begin to understand why art and artistry all around the world can be so compelling and are so necessary.

As imposed organization, the form we create is an essential outcome of everything we do, both within the domain of art and beyond it.[4] Making form is a basic instrumental process that reaches into every niche of human existence to help us create our experiences or make vague or amorphous experiences more tangible. It is, in effect, our primary medium of exchange in the negotiations and maneuverings that constitute our lives. This centrality gives form a tremendous load of potential power.

Artists and viewers create artistic form in much the same way that people create, interpret, recreate, and change social form, the institutions and practices that shape, encumber, and facilitate our lives. Ideas, sentiments, points of view, schemes, rules, procedures, and histories—these are the kinds of resources we use. We shape them by thinking, discussing, and acting in the world.

This relates artistic form to all types of cultural and social formations, from social institutions such as inheritance systems or community governments, to beliefs and practices such as baptism and the concepts that validate it. Not only are they all the organization we impose on resources, but they are all consummations of complicated social and personal activities, while also being embryonic elements in the ongoing construction of other social forms. They are part of the vigorous but not always self-conscious activities by which people are perpetually contemplating, evaluating, sustaining, or changing their worlds.

Since artistic form and social form are really not that different as processes and as products, it is no wonder that elements from our social and artistic worlds constantly compound and inform one another. To get a sense of that compounding, it is useful to consider how local and foreign viewers perceive the same object. Any number of Mande artworks are visually stunning. We need not rely only on the thrills of Dogoduman for our examples. Door locks, youth association masks, woven or printed cloth, mosques, the old iron lamps, or Ci Wara headdresses can all simply ripple with visual acumen and instantly

take your breath away, even in a Western museum where there may be little contextualizing material.

Many Mande people are also smitten with the shapes and compositions they find in their art. But for most Mande people, the image of an antelope headdress will also provoke a more complex response that melds social and artistic forms. They know, without even self-consciously considering it, that most antelope headdresses belong to associations that celebrate and promote good farming, often with spectacular dancing and lovely singing. They may well have attended or competed in an annual hoeing contest, or danced an antelope headdress because they won such a contest. At some point, probably many times, they will have heard the evocative praise songs that honor farmers at festivals. They know about and may belong to the Ci Wara farming association. They may well know stories about the farming deity Ci Wara, and probably know that Ci Wara also means "great farming beast," a praise name for farmers that references the prodigious strength and capacity of wild creatures as a metaphoric measure of prowess.

Along with all this, they perceive the sculpture in relation to what they have actually seen or heard about the sleek, strong, elegant beauty of actual antelopes. They will very likely know that antelopes are said to overflow with *nyama* and know also that beauty in abundance in nature, people, or objects, is also a generating source of that potent energy. They may know wonderful anecdotes about antelopes and their interactions in the animal world and the world of people through folk stories, hunters' tales, and proverbs.

These are the ideas and activities that punctuate living as a Mande person. They fuel imagination, offer pleasure, provide a means with which to measure events and situations, and contribute some of the resources people articulate to construct a life. To have lived with and experienced these ideas and activities primes you to see antelope headdresses complexly and proactively. Seeing the form releases an instant wash of feelings, sentiments, notions, and recollections that will patinate and shape perception. The antelope you see as a Mande person will not be the same as a Westerner perceives, even if you are looking at the same one.

Form's constant rearticulation is, of course, the stuff of art and social history. The immediacy that grounds both social and artistic form, which makes them important right now, resides in the sensate and social worlds that contribute form's constituents, the raw materials of our thoughts and actions. Particular people with particular knowledge, skills, experiences, and imaginations articulate these raw materials. As people and situations change, so also do forms, in a never-ending movement that is history.

So form can be conceived of as larger and more complex than art historians have generally imagined it. The same is true of aesthetics, and especially of the common link between aesthetics and an insular realm of sensory pleasure

and beauty. Since Baumgarten in 1735 used *ästhetik* to denote a "science of sensory perception" (see Robinson 1996, 1: 79; Seel 2005, 2–4), Western aesthetics has emphasized beauty, taste, pleasure, sensitivity, the sensuous, assessments of quality, and detached contemplation or rarefied experience isolated as special from everyday life. Even a popular dictionary such as *Merriam-Webster's Collegiate Dictionary* (10th ed., 1993) defines aesthetics as dealing with "the nature of beauty, art and taste and with the creation of beauty or art." It includes the phrase "aesthetic distance," defined as a frame of reference created by artists through technical devices to differentiate art from reality psychologically. Relating aesthetics to beauty can be fine, but not when both are shunted off from the world that is their wellspring.

That isolation contributes to a debilitating separation of art from life (Williams 1985, 32–33). If form can be so rich, we should not artificially filter the wealth away. Even if we were talking only about beauty, it would be worth recognizing in our understanding of aesthetics that form can be all the more beautiful when it germinates from the swift dialogue, embedded in perception, between physical composition and the ideas, emotions, and activities that punctuate our fulsome panoply of experience.

A broader conceptualization would describe aesthetics as strategies artists and audiences apply to the organization of sensory, cognitive, and material resources to produce impact (artists' perspective) or understand it (audiences' perspective). Like the shift in thinking about form, this shift is small but consequential. When artists articulate the physical components of shape and composition to instill character such as sleek, sweeping, elegant, beautiful, turgid, ponderous, heavy-handed, stark, zippy, or staccato (we could make a longer list if we wanted to), the results affect our perception, encouraging aspects of our imaginations, foregrounding elements of our experience, and influencing what we actually see. The physical form of Sidi Ballo's carved bird's head—its mass and weight, its curves and color—enabled, encouraged, and nourished the perception of power and the compounding of that perception as I added information. Sidi Ballo used aesthetics to amplify impact.

When form results from aesthetic contemplation, experimentation, and skilled action, it produces the potential to be deeply compelling, because aesthetics are more than formulas for manipulating physical material. They draw upon tangible and tacit elements from the social and personal worlds in which we live and work. Sidi Ballo and Mayimuna Nyaarè share social worlds with their audience. There is considerable common knowledge, much everyday working together, and ample solidarity in realms of value and belief. Thus, artists know a little something about what their audiences feel and think. When they build compositions, they can try to articulate all the components to anticipate audience response. In this way, aesthetics are closely related to the concepts of higher order intentionality and mind-reading discussed by Carrithers (1992,

58–60), Dennett (1987), and Whiten (1991) to show how people engage each other successfully by imagining the responses of others to things they say or do. In aesthetics, this anticipation is expanded to consider a broad spectrum of social and cultural resources, and refocused to emphasize action that produces rich form, the form beyond appearance, built from imagination and experience.

Thus, just like form, aesthetics goes beyond art. People use aesthetics with everything from films to masquerade performances, from Bamako market salespersonship to all manner of other professional environments, as they try to shape or understand outcomes. People use aesthetics much of the time, according to their personal knowledge and abilities, in ways they think will be pleasing, satisfying, judicious, effective, good. As strategies of organization and evaluation, aesthetics is about accomplishment in the broadest sense and is applicable to artworlds, lifeworlds, and all those zones where art and life merge.

Images, both audio and visual, harbor tremendous power because artists and audiences orchestrate the collision of material form with personally significant thoughts and feelings, which change and grow as people explore them through the accumulating experiences of their existence. If those thoughts and feelings are deeply embraced, or if their visual articulation is managed with skill and effective strategy, an image can become a profoundly memorable and moving thing. This sort of articulation was resoundingly perfected by Sidi Ballo. Witness his carved red bird's head. His virtuosity resulted from his capable orchestrations of physical and social resources both in the construction of his masquerade and in the choreography of his performances.

MANDE FORM AND AESTHETICS

Since form emerges from experience, it must possess much that is culture-specific. Mande form includes components not necessarily recognized in the West. Most prominent would be the force called *nyama*, which is a natural part of most things and can be articulated and manipulated by spiritualists, herbalists, and artists. It may not be visible (though its effects are), but it is nevertheless an important part of many of the resources used to create Mande form.

We have seen that *nyama* contributes to the structure and character of everything in the physical world, while also animating it. It is life force, a prerequisite resource for every act and a natural byproduct of all action. Because it is so powerful and is so subject to the articulation of artists, many Mande feel it is always present in works of art such as music, sculpture, and performance.[5] This is one reason some people think that even the most be-

nign public and secular sculptures possess power and should be treated with care.

Other potent forces closely relate to *nyama,* creating an aggregate of energies that can be viewed as distinct but also can be lumped together. For example, there is *tere,* which is viewed as luck or chance but also as a form of energy like *nyama,* except that it is a natural part of people that cannot be augmented through human action. It can be positive or negative and must be considered as people interact. There is also *baraka* (or *barika*), a form of spiritual power that many associate with Islam but that is thoroughly incorporated into Mande. It is widely conceived of as very positive, resulting from benevolence, grace, and proper social behavior. But it can significantly augment the overall power of a person to accomplish difficult, dramatic, and dangerous acts. All of these are embedded in and part of Mande form.

We have seen that individuals respond differently to *nyama.* It can be considered awesomely, staggeringly powerful, and it is generally considered dangerous. Some see it as a moral force in a cause-and-effect configuration that restrains many people from acting out jealousy or covetousness because they believe the energy attacks people who misuse it. Many people consider it largely negative, or evil, and are often loath to discuss it. But even when it is viewed in this light, there is an interesting corollary. Kone (1998) notes that many people often cannot think of how *nyama* might be positive, but if they stop to consider it, they realize that it is the cause of many positive things in their lives.

Most people agree that *nyama* can be amassed, articulated, and activated to accomplish things. It naturally concentrates in various types of materials (such as bone, horn, hide, feathers, vegetation, and worked metal) and can be accumulated in many different kinds of forms. Thus, when Mande people perceive form or the materials that compose it, they know that *nyama* may be present, along with its capacity to transform matter and events. Some people—blacksmiths, hunters, soothsayers, spiritual leaders, healers, sorcerers, political leaders, and many performers, for example—will be acutely aware of this. Others know it but don't give it much thought. All form has the power to affect people. Mande form adds this other kind of power, giving a new dimension to the idea of affective, significant form.

The reality of *nyama* comes richly into play in Sidi Ballo's masquerade performances. Children, senior women, Kòmò members, hunters, and blacksmiths all have different perspectives and experiences with *nyama.* But everyone understands its power. People know it is associated in varying degrees with imagery, that some masquerade dancers use it extensively, and that smiths are among society's most potent *nyama* wielders. Most people would know in advance that Sidi's masquerade performance is more *nyama*-laden than others. And the presence of vulture feathers is visceral proof of that.

While danger and fear seem frequently to come as part of the *nyama* package, people are multidimensional and so respond to the power in more complicated ways. Thus, its presence at a public performance can also create titillation and drama. When Sidi shape-changes, when he charges right up to people, when he brushes closely by audience members, people feel that fear mixed with thrill that Americans feel in horror or science fiction films. And when Sidi opens an apparently empty masquerade cone to the audience, the evening's theatricality is consummated in marvel and wonder. Sidi was a master at articulating every kind of form, and *nyama* was one of his favorite resources.

There need not be a Mande word that corresponds to the Western "aesthetics" in its rarefied, isolated, artworld sense. We have, however, already encountered a word that captures the sense of affective strategy, while retaining strong connections to practical life and social experience. The word is *cogo* or *coko*, which means the way of making something, the solution, method, or procedure for doing something. It works for evaluating artworks and for describing how they are constructed (Arnoldi 1995, 103; Bailleul 1981, 29; Kone 1995a, 26–27). As generally used, the word maintains an emphasis on the instrumentality (ability) behind making or doing things. It is conceptually related to *nya*, a word signifying "means," the information and wherewithal to accomplish a particular end, often in the extraordinary world where *dalilu* knowledge comes into play.

Cogo encompasses a variety of elements. It identifies the essential components of an art object or performance, including those that contribute to its construction and those that explain its appropriate use. Brink (1981, 9, 10) says that in one sense it is the cultural knowledge people use to "initiate, order and identify their aesthetic expression." In another it is the frame that individual artists use to infuse particular works with embellishment and innovation. Arnoldi (1995, 102, 103, 205) notes that in the Segu area puppet theater, *cogo* is used to indicate the social goodness of the form that emerges from a performance. Tera (1977) observed that many people use it simply to refer to an artist's or artwork's style. It can even be used to describe a person's response to a meal or anything else that might involve the senses (Bird, Hutchison, and Kanté 1977, 119). Thus, it is a versatile word. But one of its most helpful features is its application to both ends of the creative spectrum, from making things of all kinds, to assessing and evaluating them. It suggests an everyday sensitivity to rich form, and it carries into discourse the ways that social and individual goodness play with each other.

Searching for African words that mean art or aesthetics has been a stumbling block for Western scholars. But often they have sought words that isolate and compartmentalize art. To search for words that marginalize is to perpetuate a misunderstanding of both African and Western art. Skilled and passionate professionals such as Sidi Ballo would not conceive of themselves as toiling

around the edges of Mande's serious business. And scholars would be silly not to see what Sidi does as art.

Remember, it has been argued that without words like the West's terms for art and aesthetics, there is no art as the West understands it, but rather something else—artistic perhaps, but much more functional, an instrument at work in social processes. Why, however, should we encourage definitions that diminish instead of empower, in Africa or the West? Why should we foist notions on Africa that can easily be perceived as bankrupt in the West?

Mande words like *cogo* and *lojè fèn* (something to look at) create frames that allow art to be embedded in society's life and simultaneously spill out of it. This very mobility amplifies its power by making it special and fundamental at the same time. Many Westerners, in fact, experience art in just this way. So why not learn from Mande and revitalize the intent of the terms we use? Something Sidi Ballo said more than once sticks in my mind when I ruminate over that dimension of the Western art industry that wants art to be elite and removed from the mundane, an instrument of money and stature. It is Sidi's statement about why he dances: to show the grandness and value of Mande culture. For Sidi Ballo the art of masquerade is certainly special. But from the nature of its form to the mechanics of its aesthetic construction, it draws from and celebrates the everyday.

8

A MANDE AESTHETIC
PROFILE

In no way did Sidi Ballo just dance at Dogoduman. He made a continuing string of on-the-spot decisions based on what had occurred up to any given moment and how the audience had responded. He took into account the character of his performance colleagues that evening, so he knew what he could do to complement and capitalize upon their abilities. Years before he ever arrived at Dogoduman, he had made hosts of aesthetic determinations regarding his bird's head and masquerade costume, his repertoire of gestures and motions, and his spectacular feats. Then he spent years refining and reconsidering so that his performances always represented a kind of culmination of aesthetic acumen. That was a major reason for his success and why I found Dogoduman such a staggering display of beauty and power. But Sidi did not like talking about any of this. He found it monumentally uninteresting, and it taxed his patience.

Aesthetic matters are treated quite differently on the ground than they tend to be by scholars. In the flow of perception, thought, and creation, aesthetics seems less abstract and academic. As an example, scholars can divide aesthetics into two different sorts of components. There are principles—such as juxtaposing harsh geometric elements to forcefully articulate the essence of such things as human faces and bodies or adding a riot of organic items and sacrificial matter to produce affect and power (McNaughton 1979, 1988). And

there are elements—such as conical projecting breasts, bold jutting buttocks, and slender waists, which are favored as being beautiful (Ezra 1986, 18–21). Such distinctions could be useful in contemplating how aesthetics work. But most people, even artists, would not stop to categorize their art making or viewing in these terms. To be sure, aesthetic deliberation can be self-conscious and very focused. But often it just happens as part of making or interacting with works of art, so that principles and elements blend together in a dynamic mélange of artistic engagement.

Many people are not interested in talking about aesthetics. Some would find such conversations strangely precious. Others would say they painfully elaborate the obvious. Still others just want to act or react with artistry, not suck the adventure out of it with too many words. Still others would not be able to articulate their behavior in an aesthetic frame. Even artists have different thresholds of tolerance for aesthetic discussions. The sculptor Sedu Traore was willing to talk about aesthetics with me but found it odd that I wanted to discuss things that were so self-evident. Sidi Ballo found aesthetic talk genuinely tedious.

There is also the issue of aesthetic uniformity. The citizens of Dogoduman would not have provided a consensual description of their aesthetics. Some would never claim they had an aesthetic even though they constantly assess and judge the things they see, hear, and do. The same is true for the citizens of my own town, Bloomington, Indiana. Art historians talk about the aesthetics of epochs and areas such as Renaissance Italy or 1950s Los Angeles. But people in the midst of life, making art or engaging it, are never so uniform as to have the same aesthetic predilections and interests. They are as varied in their engagement of art as they are in all their other life activities.

In every society, many basic aesthetic conceptions enjoy widespread popularity—which is why art history can generalize about periods and why scholars can talk about Bamana style or Yoruba style, for example. But real life and real art are always far more diverse and interesting than those generalizations suggest. Individuals are complex, their experiences varied, so they differ widely in what they like and how they think artworks should be put together. Individuals in groups such as youth association branches, hunters' associations, blacksmiths in a community, or town council elders may have a shared history of experiencing art or using art to accomplish goals, and they may hold certain relevant aesthetic values in common. So too do whole communities because of such moments of coming together as masquerade performances or town-wide celebrations. The artists in a larger region—the sculpture-making blacksmiths, or the history-performing bards, or the youth association masquerade players—may interact through art regularly, be aware of one another's points of view, and share many aesthetic assessments and preferences. But to say there is a Mande aesthetic, or

an American aesthetic, or a European aesthetic is to utter only a partial truth.

Some Mande people have created detailed structures of aesthetic principles. But most Mande would not say there is a rigid body of principles that guide the making and evaluating of art. They have likes and dislikes and a range of ideas about artistry from highly pragmatic to deeply philosophical, and not everyone thinks or cares about them equally or agrees on all of them.

For example, some people, both artists and audiences, are strongly interested in a relative verisimilitude (*hakika*). They think sculpture is best when it possesses enough abstracted but recognizable characteristics so that people or animals are readily identifiable (McNaughton 1988, 102–11, 143–45; Arnoldi 1995, 102). Arnoldi notes that Mande mark this verisimilitude by calling the sculpture the "namesake" (*tògòma*) of that which it represents, and this gives the sculpture the same moral force as namesake relationships between family members of different generations.

Other Mande are particularly interested in innovation. They like sculpture to possess features that make it distinctive (McNaughton 1988, 102–11, 143–45) or performances that incorporate new masquerades, new dance steps, or new songs or that create new combinations of these components (Arnoldi 1995, 99, 121, 125, 126). Innovation is a value applied broadly across Mande society. Using a common Mande metaphor of mind (*hakili*) and stomach (*kònò*), it can be said of innovative people, be they sculptors, performers, or leaders: *U kònò cèmènen don*, "Their insides are inscribed with know-how," and solutions to dilemmas simply unravel out of them (Kone 1997).

Some people are especially interested in the play between regularity and the expectable on the one hand, and irregularity and surprises on the other, be the work a puppet performance, a hunter's epic, or one of the old iron lamps now largely out of use (Arnoldi 1995, 121; Bird 1971, 1972; McNaughton 1988, 117).

All of this qualifies the materials that follow. I am not delineating a Mande aesthetic. Instead, I am presenting a number of aesthetic ideas that Mande use in various ways to create artistic form or ideas that connect to other zones of Mande enterprise but are so entangled with aesthetic considerations that they become indistinguishable from aesthetic principles.

I have assembled this aesthetic profile by thinking first of Sidi Ballo's art. But it also emerges from my work with sculptors and smiths and the hunters' bard Seydou Camara. It incorporates the work of Judith Mahy on performance in the Beledugu region, Mary Jo Arnoldi's work with youth association puppet theater in the area around Segu, and Barbara Hoffman's work with bards in Bamako and the Beledugu. It complements the findings of James Brink (1981, 2001), who presents a complexly layered and richly proactive intermeshing of

two major qualities in Mande aesthetics and ideology, one summed up by "goodness," the other by "tastiness." It relies very heavily on ideas from Kassim Kone's extensive work with performance, masquerading, cloth, and pottery making, first in the Beledugu and more recently in western Mali, and also on ideas related to me by linguist Kalilou Tera (a former Malian government researcher). It is by no means complete or comprehensive. Rather, it offers a glimpse of the sorts of concerns that artists can use to articulate form. In particular, it presents the aesthetic paraphernalia that Sidi Ballo cobbled into grandeur.

JÈYA: CLARITY

When Sidi Ballo brings his masquerade to rest periodically, audience members can see it clearly. The embellishments of red strips and feathers and the cloth sleeve containing the highly mobile bird's head are easy to read during these stationary moments, and his costume is recognized as one of the widely used patterns for bird masquerades. But when the masquerade is racing around a dance arena, the feathers rustle in a blur of motion while the bird's head can become hyper-animated, the sleeve just plain lost in the shuffle. Sometimes the bird stops nearly on top of an audience member and rears up dramatically, changing shape in the process and becoming decidedly ominous. Other times the masquerade's overall shape seems to change in transit from cylindrical to flattened and almost spatula-like. The bird's head can be articulated, sometimes mimicking a real bird, other times becoming a swirling, flashing dance baton. All of this partakes of play between two interwoven Mande aesthetic concepts.

At the core of Mande aesthetic ideas, in fundamental tension and delightful interaction, *jèya* and *jago,* structure and spice, clarity and embellishment, are in constant compositional play with one another. Together they offer a nearly endless range of options for the design of art. We can look at them separately, but we must remember that artists constantly blend them to suit their desires and the needs of particular situations and viewers do not always agree on whether specific elements of an artwork constitute one or the other.

Jèya, the structure-part of this complementary pair, has many meanings in several different contexts that all share a common core in a broader social and philosophical field. *Jèya* means "bright, light, bleached, white," or "to wash or make proper." It can mean "cleanliness, neatness, tidiness," or "purity, innocence, virginity." It is "authenticity and the action of attesting, certifying or justifying," or "assuring or persuading." And finally, it can mean "clarity and precision, straightforwardness and easy discernibility" (Bazin 1906, 161; Bailleul 1981, 85; Kone 1997; McNaughton 1988, 108, 143).

In various artistic and social situations *jèya* denotes a quest for funda-
mental characteristics in the sense of basic, crucial elements or similarity to
established patterns (McNaughton 1988, 108). It relates to *kolo,* meaning "core,
kernel, bone, the essential heart of things or activities." It also relates to *jèlèn,*
from the verb *jè,* "to bleach, make white, clean, clear, or proper," which makes
tacit reference to an authenticating past. It can be said of something, for ex-
ample: *A jèlèn don,* "It is crystal clear," meaning it corresponds to the prece-
dents of the past, of tradition, so there is no doubt about it (Kone 1997). Another
related word is *yeelen,* "to brighten, make clear, or enlighten" (Bailleul 1981,
219). Yet another related word, *jèlènya,* means "innocence, loyalty, honesty"
(Bazin 1906, 158).

Brink (1981, 9–11; 2001, 240) notes useful cultural and historical dimen-
sions to *jèya.* He says it can refer to the accumulated wisdom that underlies
any particular art form, that is, to a collection of ideas "handed down to the
living from the ancestors," ideas that have undergone generations of experi-
mentation and change, to take their present form. Of course, the experimenta-
tion continues in the present, so the next generation may receive a rather
different form with which to experiment.

There are nuances to *jèya* as well as to related words. Take, for example, its
sense of clarity and straightforward discernibility. Using the word *foni,* "to
spread out, open up, show," for example, you can say of a sculpture whose
hands are articulated with fingers open and palms out: *A be tege foni jira.* That
literally means that the hands are shown open, but it indicates a generous,
truthful person who hides nothing, particularly no instruments of malevolent
sorcery. Of a living person you can say: *A tege foni do,* meaning that his or her
hands are open in the sense of straightforward or righteous social and moral
action. Or you can say of a person: *A ye fonisere ye,* "he or she is frank, coura-
geous, and generous" (Tera 1977).

JAGO: EMBELLISHMENT

The spectacular feats and special elements that Sidi Ballo performed can be
described as *jago.* Youth association members around Bamako use the term to
identify performance articulations that go beyond basic masquerade dancing
to produce the special qualities that distinguish individual performers.

When considered in relation to *jèya, jago* (or *jako*) refers to the decoration,
embellishment, and innovative aspects of art. In one sense, it is the extra atten-
tion and care that is given to something basic—a sculpted form, a drum pat-
tern, a dance step, a song, or a masquerade performance—that brings it to life
and makes it stimulating, provocative, or memorable. But many would say a
primary goal in Mande artistry is to generate stimulating, provocative, and

memorable creations, and for them *jago* becomes both an important ingredient of good art and a criteria for assessing it. It can also refer to variation in artists' personal styles, because good Mande artists often innovate with form. Remember, *jako* also means "business" and is considered the excitement and attractiveness added to make works more salable. Thus, *Ka jago don jiribara la,* means "to put marketability into wood working" (Kone 1997). *Jago* as embellishment for success also applies to performance to help bring large audiences, garner enthusiastic reception, and encourage contributions of food, drink, and artists' fees.

Brink (1981, 10; 2001, 239–41) notes that *jago* "refers to the elements of form which are 'added on' to basic configurations so as to embellish them, distinguish them from others of the same type, activate their energy flow and, on the whole, give them a renewed life and identity in the context of the living community." There is sophistication in this Mande interpretation of the play of the new against the template of the already established because it captures very nicely the pleasure and excitement people can feel when they engage individual artworks that are part of a tradition. This is just the feeling many Mande experience in the face of bird masquerade variation that we explored when discussing the Dogoduman cast of characters. It is true of antelope headdresses too, and door locks, other masquerade characters, cloth, basketry, songs, and epics—in fact, virtually every genre of Mande artistry.

In an important social way, then, *jèya* links art to people's pasts, while *jago* is a vehicle for making it contemporary. Artists of all kinds talk about *jago* as if it were a principal strategy in their repertoire of abilities (Mahy 1975), and they clearly use it to generate their own styles, which is what the sculptor Sedu Traore meant when he likened *jago* to handwriting that allowed the works of different artists to be distinguished. It is interesting that artists as well as viewers do not always agree on what elements of a work constitutes *jago* and what should be considered more fundamental (*jèya*).

The play of fundamental structure and spicy embellishment is one argument against simplistic distinctions between "contemporary" and "traditional." Within the complex reality of making, using, and thinking about art, "contemporary" and "traditional" are in a constant state of renegotiation. This is not articulation within a framework of opposites: *jèya* and *jago*, or "traditional" and "contemporary." Rather, it is the dynamic and often deeply imaginative manipulation of bits and pieces, elements and ideas, that make characterizations of contemporary or traditional difficult and arbitrary. *Jèya* and *jago* subtly push into each other, not in conflict (Kone 1997), but rather in a way that suggests opportunistic playing with conceptual and material resources, the application of aesthetics to form. Both "contemporary" and "traditional" contain each other within themselves, one of the things that makes art exciting and potent anywhere you find it.

Sidi's masquerade offers a good example of this play between grounding clarity (continuity) and innovative originality (individuality). It shares with other bird masquerades the basic structure of cloth stretched over a wood frame, with a carved bird's head that emerges on a pole from a cloth sleeve. But variation and inventiveness play important roles. We have seen that some masquerade frames are light and flexible, whereas others are heavy and rugged. Some are shaped like a very large cone, others like a dome, and still others like a pup tent. Some are covered with cloth exclusively. Others use varying amounts of real feathers, with some using all feathers and no cloth. Needless to say, there is also great variety in the cloth and in the details of the carved bird's head. Finally, there is variety in the presence, length, and degree of hazard provided by the burlap or sisal fringe at the masquerade's base. Twice Sidi has created masquerades from all this possibility. Each was different, but both were uniquely Sidi Ballo.

Sidi's choreography also blended the structure of tradition with the spice of innovation. For example, he transformed strategies of motion from the youth association bird masquerades in the broad Bamako region, as described by Imperato (1980, 54). In these *ton* performances, the bird masquerade entered the dance arena slowly, repeatedly taking a few steps and then stopping, while the head looked around as if the bird were exercising wariness and caution. It stopped in the arena's center as a song of praise was sung and then raced around the periphery, came to a dead stop, and repeated the whole pattern of motion several times.

In 1978, Sidi's strategy was to roar into the arena full speed, tossing all caution to the wind. He used the several-steps-and-stop routine but modified it so that he did not fully stop but only seemed to hesitate as he shook his costume from the inside to create visual vibrations that matched the drum rhythms. Instead of making the bird's head seem to look around cautiously, he made it jut forward and backward like a bird strutting. And then he repeatedly rocked the whole masquerade over as if it were about to fall.

Any audience members expecting the choreography Imperato describes would have been surprised and excited by the differences. Interestingly enough, however, in 1998 when I saw Sidi perform again, he had changed his performance approach to much more closely resemble that choreographed entrance sequence described by Imperato.

NYI AND *DI:* GOODNESS AND TASTINESS

The Dogoduman audience was spirited and attentive. They voiced their pleasure and their awareness of expertise, finesse, and spectacular performance

feats with frequent shouts of praise. In doing so, they were expressing their appreciation of the goodness and the tastiness—*nyi* and *di*—of the event.

Like structure and spice, goodness and tastiness are a complementary pair of concepts that divide the realm of the positive into two quite different but often permeable and overlapping categories. In many ways they are parallel to structure and spice, with goodness being loosely linked to clarity and established structure, while tastiness is loosely linked to embellishment and innovation. Mande use "good" and "tasty" to express their responses to artwork and all kinds of other things that people make and do. Goodness and tastiness give nuance to clarity and embellishment with reference to shared ideas and individual predilections and the complex play that can occur between the two.

Nyuman is a noun for "good," sometimes in the sense of morally right or socially correct, and *nyi* is its adjective form. *Nya* or *nyè* means to be good in the broad sense of proper, accepted social practice. *Diya* is a noun for another kind of good, with a more tangibly sensual and personal orientation of tastiness or pleasure, and *di* is its adjective form. Using *di* for good invokes a consumer's vantage point and suggests a judgment based on personal experiences and interests. Both of the noun forms can also be used as verbs, creating a sense of agency and action.

Brink (1981, 3–6; 2001, 238–39) notes that in art *nyè* can be a special kind of goodness: "basic ordering characteristics, those qualities which give form an identifiable and appropriate shape in time and space." This goodness provides a cultural frame of knowledge for an artwork's creation, evaluation, and social use (Brink 1981, 5). It offers canons, on the one hand, and expectations, on the other, so it can be constraining. But many artists mix in twists and innovations so that their art plays on expectations transformed. Sidi Ballo did that frequently at Dogoduman, with innovative sequence and in numerous other ways. Slamming into walls at high speed, for example, and levitating atop bleachers were innovative. Falling over, dancing on an upside down masquerade, and revealing the "empty" inside of his costume were provocatively innovative.

Brink (1981, 3) defines *diya* as "tastiness or pleasure . . . those qualities which emerge to challenge, develop, embellish, improvise or change" the goodness of *nyuman*. This usage signals dynamic potential, because those "tasty" qualities stimulate people's "interest, imagination, emotion, involvement and action," and they are also charged with *nyama,* the energy of action (5). This kind of tastiness is a major part of the moving power of art (6), because it involves much skill and strategy, and it produces the energy of action (*nyama*). It is obvious how readily it can be applied to Sidi Ballo's maneuverings in a dance arena and even to the way he flexed the structure of his masquerade costume to change it repeatedly from conical to flat.

One of art's defining characteristics is its relevance to people's shared experiences and also to the reveries and internal dialogues of their interior lives. This combined relevance is a source of tremendous clout. The Mande play of goodness and tastiness offers a glimpse of why this is so.

At Dogoduman, Mayimuna Nyaarè sang many songs about tradition, doing things correctly, and respecting the proper accomplishments of productive and decent citizens. Her songs were good in content and in delivery, but they were also tasty in delivery. Sidi Ballo offered numerous instances of performing within the expected parameters of masquerade tradition and numerous break-out moments. He was constantly both good and tasty. The young ladies' chorus sang of youthful admiration and desire, songs that were very tasty, with deliveries that were very good. The drummers led by Sori Jabaatè were very good at playing and also offered up an ample measure of tastiness, just as Sidi Ballo's apprentice Sibiri Camara did in his job of accompanying and complementing the master masquerader.

This terse synopsis is already oversimplified because, in the personal experiences of audience members, good and tasty are more complexly intermeshed, and people's perspectives and personal histories encourage divergent points of view on just what is good and what is tasty. The point, however, is that art offers a significant forum where the personal and social fuel each other, test each other, and encourage the exploration of self and society. The bird dance near Saturday City was an occasion for entertainment and pleasure. But it was also a venue where individuality and solidarity, personal taste and public consensus, individuals' desires and community well-being, shared perspectives and unique interpretations could all simmer together in a cauldron of contemplation and action. Opportunities for social and personal analysis abound in this forum. Indeed, they are facilitated by the subjects and topics circulating through the event, from those suggested by masquerade characters to those suggested by themes and imagery the songs generate. Audience members can become architects, arranging and rearranging what is good and what is tasty in relation to each other, plumbing the possibilities and creating new configurations.

This opportunity that art provides is by itself a source of power, an instrument people can use for personal and social development. But the fact that the good and the tasty, the shared and the personal, come so fluidly together in the experiencing of art is a source of profound power. Relevance and affect collide in an atmosphere of intimate significance that always possess the potential of joining people together while also allowing individuals to be themselves.

EXPANDING AESTHETIC FIELDS OF PLAY

Thus far we have examined a pair of concepts that characterize expression across a range from simple or clear to complex or stimulating, and another pair of concepts that describe responses to those qualities as manifest in artwork. From here we can spin out to encompass broader ideas and values, some of which are among the most powerful, catalytic, and complex in Mande social worlds.

One could argue that these broader concepts need not be treated as aesthetic elements, but rather as ideas, values, and activities that bear on the world of art. But it is equally appropriate and important, I think, to consider them as components of form and as part of the *cogo,* or way of making and doing art. They play very strong roles in the shaping of artworks and performances, and they are as solidly seated in the art world as they are anywhere else. In fact, in the world of art they often receive some of their most subtle and nuanced articulations. Viewing them as elements of a Mande aesthetic environment helps emphasize the point that art should not be isolated from social and personal life.

AESTHETICIZING *NYAMA*

Many Mande bird masqueraders are not overly involved with the energy of action, although most people would say there is no avoiding it completely in the arts. Sidi Ballo, on the other hand, was steeped in *nyama.* He considered it a primary part of his preparations for performance and a major force in the performances themselves. There is no doubt that for him it was a major ingredient of form and therefore flowed within the purview of aesthetic strategies.

We have already found *nyama* important in numerous ways. Its link to art is fundamental: it really is a part of form, it is articulated by artists, and it is used in art to generate potent affect—as well as sheer spiritual power. Mande say that all art forms originated in the bush with wilderness spirits or animals. They were brought into human society by enterprising and imaginative people, often hunters (Arnoldi 1995, 101; Brink 1981, 4–5; 2001, 239). Everything associated with the bush, from spirits to wild animals, is laden with *nyama,* and art is no exception. *Nyama* is also generated as a byproduct of the activity that pours into the creation of art. And, interestingly, it is amplified by beauty.

Nyama does not reside in all artworks equally. Its greatest concentrations occur in arts devoted to ritual activities. In those settings *gundow,* artists'

professional secrets, and *daliluw,* recipes for manipulating energy, are heaped into the art when it is made, and more may be added as it is used. *Nyama* is also present, however, in the most secular, public, and supernaturally benign creations, such as youth association masquerades and performances. More *nyama* emanates from amulets used by masqueraders. And more still may be produced by those compositional elements that constitute *jago.*

With *nyama* as a component, Mande articulations of form can become quite involved. Aesthetic strategies conflate with principles from the science of the trees, *jiridòn.* Kòmò headdresses, for example, are awash in sacrificial materials and the visceral, organic ingredients of numerous *daliluw* recipes. These materials must be there for power to be amassed and launched into the working world.

At the same time, those materials must be arranged in ways that make sense as a Kòmò mask. That is where the idea of established, successful precedent comes into play as *jèya.* Beyond this sense of "tradition," these same elements can be arranged in different ways to generate spice and surprise, interest and individuality. Some assemble an abundance of bird feathers and quills, producing an almost measurable sense of energy swirling up out of the top of the mask in a splendid aviating display. Others are far more earthy, suggesting the very wilderness from which many of their ingredients derive. The mask in the Indiana University Art Museum presents a zigzag row of businesslike teeth, but set beneath the mouth on the lower part of the jaw, as if the energy of the mask allowed them to resituate themselves (see McNaughton 1988, plate 73). In 1978 I showed many pictures of Kòmò headdresses to a variety of blacksmiths intimately familiar with the association and its artwork. The mask from the Afrika Museum in Berg-en-Dal, Holland (McNaughton 1988, plate 72), was many people's favorite, and several smiths used the term "sweet, tasty" to praise it. Thus, in some Mande artworks the manipulations of *daliluw* join the articulations of tradition and innovation to produce satisfying spiciness, which in turn produces more *nyama.*

Do Mande view *nyama* as a real force or as a metaphor? Both, and often simultaneously. As a power with tangible effect, it is a major part of the beliefs and practices that constitute *kokòròw,* the "old affairs that concern everyone." It is essentially present in everything (*nyama be a la,* "*nyama* is there"), and it is always a feature of action, both as a prerequisite for doing things and as a by-product of doing them. At the beginning of many ceremonies and events, even popular public performances such as Sidi Ballo's bird dance, you are likely to experience a little ritual designed to get rid of negative *nyama* or turn it into something positive. The words used with the ritual are: *Nyama gèn, an ka nyama gèn,* "Chase the *nyama,* let's chase the *nyama*" (Kone 1997).

So on the one hand, this energy is widely perceived as real. But on the other hand, it also floods into every activity of human interest—from farming and hunting to sculpting and masquerade performing—as a metaphorical way of characterizing intensity, efficacy, and accomplishment. And its metaphorical presence gets so thoroughly intertwined with its perceived reality that for many people it is not proper or easy to separate them.

Nyama can never really be considered fully controlled. Blacksmiths, bards, and other *nyamakala* clans, along with sorcerers, cult leaders, and hunters, all exact a certain measure of domination over this energy. But even they are sometimes humbled by its elusiveness and sheer potency. Sidi Ballo capitalized on this characteristic of *nyama*—to be always at the edge of breaking dangerously free. His masquerade's vulture feathers could be viewed as radiating *nyama*. When the strings they were suspended on came untied during moments of great action, the visual effect of raggedy loose ends, combined with the sense that energy was swinging free, could generate a characterization like the Western idea of a loose cannon—unpredictability and potential danger excitingly at large.

Sidi's frequent shape-changing also put audience members in mind of *nyama*. From flattened to fully round, from shoulder height to very tall, Sidi pushed and pulled on the masquerade scaffolding to give the impression of an entity or being constantly reconfiguring itself through the power of the energy that inundated it.

People believe that too much of this potency in art can come unleashed and undermine an artwork's social goodness. And, good or bad, it can have a powerful effect on members of an audience. Brink, Kone, and Sidi Ballo agree, it has "the potential to drive the individual out of control, that is, beyond culture and into a psycho-social state which is said to resemble at its extremes the wildness and unpredictability of the bush or the entropy of the primordial void" (Brink 1981, 5). However, as Brink also notes, this same power, the power caught up in "tastiness," has the potential "for bringing individuals together in a state of oneness or communitas, in which they experience themselves as a moral and spiritual community" (1981, 5). Thus, Kone (1997) says this force so frequently discussed by Mande as negative can have a very positive effect in art as well as in life. So too, embellishment and innovation, in their manifestation as tastiness, *diya,* can acquire their own agency. People unlock forces they cannot control, and the outcome can be awesome and unpredictable. At the same time, art is an effort to control those forces, because power is one of the resources that form organizes. So in an abstract but very real sense, art is form managing power (Arnoldi 1995, 106; Brink 1981, 4). Clearly, *nyama,* as an element of Mande form, needs to be engaged with aesthetic strategies.

YÈRÈMINE: RESTRAINT

One strategy for managing *nyama* is restraint, *yèrèmine,* literally, "to catch yourself." This is important where too much embellishment or innovation can be overpowering. Sidi Ballo, for all his power and his bold, dynamic performance strategies, was also an absolute master of restraint. He knew when to hold back for the sake of keeping too much overwhelming beauty at bay. But he also knew how to use holding back as a resource to fuel both the excitement and the overall elegance of his performances.

Kone (1997) elaborates on this concept of holding back or catching oneself with the example of singing. One way of saying "to sing" is *ka dòònin fò,* which means "to say a little." Saying a little is the restraint that protects audiences from the overwhelming *nyama* of saying it all. It is managing *nyama* through constraint. An axiom that uses a Mande metaphorical link between mind and stomach spotlights this restraint by indicating a wise form of behavior: *ka dòònin fò, ka dòònin to I kònò,* "to say a little, to keep a little in your stomach."

Keeping a little means judiciously holding back, and it applies to singing, sculpting, dancing, and everything that people can make beautiful or potent. It is an effective aesthetic strategy that even applies to public speaking as a concept called *kumakolo,* the "bone of speech." It is important to evaluate your audience in the context of your goals and then to be smart and talented enough to know when and how to be subtle, understated, simply direct, emphatic, bold, or provocative. If all of that is brought together carefully, an effective speech is created. If a speech is too embellished, the *nyama* in all that affect could easily become engulfing. To some, the speech would seem like hyperbole, while others might be put in actual jeopardy of being overwhelmed by the energy of action overly articulated. Sometimes artists want to overwhelm, as we shall see. That is usually in specific circumstances, however, and with the hope that a measure of direction and energy management can also be applied.

It is a tribute to Mande philosophical thought and Mande popular imagination that this energy of action, so deeply equated with knowledge and power, is as deeply equated with beauty. Things that are the most beautiful, the most tender, the most gentle, the most vulnerable, simultaneously possess the largest quantities of *nyama.* That is a wonderful idea, which squares nicely with human experience. The loveliest antelope in the bush, for example, is considered the tiny, delicate, duiker (*mankala* or *mankalan;* some people just call it *sineni,* generic "little antelope"), but it possesses so much *nyama* that hunters believe it is one of the most dangerous animals they can kill (Tera 1977, 1978). It is also widely believed that the most beautiful women—who are sometimes considered to be those delicate little antelopes transformed into people—also possess the largest quantities of *nyama,* in the form of *tere,* or luck (Kone 1997),

the variant of energy that we encountered before, which is inscribed in every aspect of a person's life. *Tere* is awesomely powerful, easily overwhelming, and can take positive or negative forms. It is possible to offset its unwanted effects to some degree, but only through serious ritual procedures and the use of am- ulets. Thus it is often said that men who marry or have a romantic relationship with the most beautiful women must either be crazy or powerful enough themselves to ignore the aesthetic admonition of restraint (Kone 1997).

Kone notes another way of referring to restraint in the face of embellish- ment and beauty with this proverb:

Don't fill your mouth with dry couscous,
unless you have enough spittle already there
to soak it.

Kan'I da fa basijalan na, n'a nyiminji t'I da.

Couscous is widely considered absolutely delectable by Mande. But when it is dry, it can absorb huge amounts of liquid, thereby swelling up to an aston- ishingly large volume. If, in the face of all that flavor, you do not exercise the restraint to be prepared for it, you will find your mouth so grotesquely swollen that you are an embarrassment to yourself and repulsive to others, or worse (Kone 1997).

The proverb parallels a particular way of thinking about *nyama.* Too much *nyama,* or even smaller quantities gone out of control, can be conceived of as a swollen, writhing, festering mess. In fact, John and Faith Lewis (1974) once attended a *ton* performance where a masquerade character heaped satire on the Kòmò association and its blacksmith leaders with a raggedy costume of cloth that swelled so preposterously that it suggested a festering pile of garbage gone gaseous and out of control. The enormous, bulky costume gave the ap- pearance of being so bloated and swollen that it could not really be controlled by its dancer. Since real Kòmò masquerades, with their large and horrific hori- zontal masks, proclaim an extraordinary amount of control over *nyama,* this youth association masquerade was an extremely humorous farce. Its creators were playing with language, because *nyama,* spoken in another tone, means garbage and feces, something spoiled and gone to maggots that are writhing out of control. The proverbial mouthful of couscous can become a little like that, an uncontrollable mouthful of *nyama.*

Thus, this Mande principle of artistic restraint acknowledges a metaphor- ically lush union between beauty and the energy of action. As Kone (1997) says, in sculpting, performing, or any form of art making, talented artists could of- ten make things much more beautiful than they are, even when they are ex- ceedingly beautiful already. But that extra beauty was held back because it could have been dangerous. Its affect could have proven unbearable.[1]

At Dogoduman, Sidi Ballo constantly played with restraint. Every time he thrust his masquerade to the apparent brink of falling over and then pulled it safely back, he showed restraint's value in the sense of self-control averting danger. When he clacked his beak at Mayimuna Nyaarè, it was never for too long, just long enough to punctuate the moment without becoming offensive or senseless. A most interesting manifestation of restraint was indirect, and I would not have even recognized it if not for the comments of a fellow audience member. Toward the end of the performance, after hours of precision dancing, the dramatic fall, the upside-down dancing, and the revealed invisibility, the bird did something new. He stopped at the base of the public bleachers, which were around four feet tall. Somehow Sidi appeared to leap with ease, or rather, levitate to the top—I thought he looked like an elevator rising. Then he danced on the bleachers for a few minutes and jumped off.

The jumping was dramatic, in that pit-of-your-stomach, almost uncomfortable way. But the apparent levitation for me bordered on the astounding. Like other things I had seen the bird do that evening, I could not understand how he had accomplished this. No matter how much expertise he possessed, it seemed impossible to just rise up onto those bleachers as he had done. It was as if all the energy that seemed to swirl around the event and all the agile capability that radiated from Sidi's masquerade coalesced around an act to produce an extraordinary feat.

People all around me had clearly been anticipating this levitation with relish, but many members of the audience believed Sidi capable of much more. As I expressed my awe, an older man near me said that what Sidi had done was nothing, because when he was a younger performer, he would leap right up into trees.

Later, Sidi assured me that he could still ascend in his masquerade to any height he liked, because he possessed an amulet that helped create that capacity. He pointedly cultivated with me the notion that he could do much more than mount bleachers with apparent ease. It seemed clear that many people in the audience that night believed he could too.

Shared experience and imaginations linked to the moment are a powerful force in a performance audience, and they contribute to the shaping of the event. At Dogoduman, people believed Sidi Ballo could execute a fantastic feat but saw him instead hold back—although his bleacher levitation was fantastic in its own right. Sidi capitalized on the concept of restraint to amplify the aura of power and accomplishment that inundated his performance.

Sidi Ballo thrived on the union of embellishment, beauty, and power. Being comfortable with the use of *nyama*, he infused it into his performance whenever he could. First, there was the perceived power that radiated from the strings of vulture feathers. Then, there was the *nyama* generated with every spectacular routine, many extremely difficult, and thus producing great

masses of energy. Along with the production of energy, his spinning, swirling, and listing back-and-forth movements around a dance arena established visual and conceptual spice across a spectrum of domains, from elegance to eerie majesty. Sometimes, when he made the masquerade swiftly rotate like an enormous top while swirling around the arena and moving the bird's head in big sweeping figure eights, he was the absolute image of fluid, supple, swift beauty. And when he played the crowd psychologically—with his stops near people that generated crackling electric tension or his channeling of their anticipation into something less expected—you understood that he was a master at arranging the entire character of a performance. From beginning to end, in all of its details and in its entirety, Sidi created what could be interpreted as "the bone of speech" (*komakolo*) writ large into performance, often stunning, often understated, and always loaded with the play of anticipation and release. Sidi's Dogoduman performance demonstrated the expert use of restraint.

AESTHETICS IN PERFORMANCE PROTOCOL

Restraint also manifests in performances as concern for protocol. This was particularly applicable to Sidi Ballo, who was one of those performers driven by a passion to make masquerading a profession and to make a grand name for himself in the process. Many performers are on a quest for fame. They want to be so good that they will acquire renown, so that their names and performance accomplishments will become part of local oral history. One aspect of Sidi's career that he now thoroughly enjoys is that his grandchildren will live in a world that honors his name. So people such as Sidi are concerned to find ways to make themselves distinctive, to exceed the abilities of other performers and acquire as much favorable audience attention as possible. Many performers work very hard at this.

But these performers walk a razor's edge, because while they are searching for fame, they do not want to attract particular kinds of attention. They are anxious not to acquire negative attention from individuals who could be provoked into jealousy because jealousy (*keleya*) often results in sorcery (*suya* or *subaaya*), which can ruin a performance and damage a career (Camara 1971, 1978; Kone 1997; Tera 1978). To accommodate these potentially divergent needs, these performers employ a variety of strategies before and during performances that are so embedded into the sights and sounds of the event that they literally are part of its shape.

An example of this concern came out during Sidi Ballo's Dogoduman performance. The lead drummer, Sori Jabàate, was a good player. Well into the performance, the young ladies' chorus offered him a short song of praise.

It began: "Hey, formidable *Jeli*" (*Ee, Jeli Cèba*). *Cè* means man, and *ba* means "big, ripe, mature," among other things. In this context, it is a term of praise that likens the drummer to an elder who has accrued noteworthy wisdom and substance to become a person of clout. Then came the line: "No one can be sweet to everybody" (*Mògò tè dya bèe ye*). This line means that while your accomplishment may please many, some people will be jealous (Camara 1978).

This is a sensitive issue, because the list of potentially jealous people at any performance is substantial. Among them are other performers in the same peer group and other people of the same age who might envy pronounced accomplishment and the fame that goes with it. Also included are prominent members of the audience who might feel offended by the satire in performances, particularly if it is projected at them. Senior and retired performers can be particularly worrisome, because they want to bask in the glory they have accrued and not see it diminished by younger performers. It is said that you do not want to step on the toes of someone bigger, even if you are better or more powerful then they are in every way but one. That one way, just one little professional secret, perhaps an action-enhancing amulet or *dalilu,* could be your undoing (Kone 1997).

So, while trying to stand out, artists also try to exercise humility by incorporating into their performances gestures of respect for others. If they are singers, for example, they may sing lines that ask audience members or other performers to "excuse" them, to apologize in advance, as it were, for anything that might be considered offensive. That is one of the things Seydou Camara, the hunters' bard, used to do at many of his performances when he sang the lines

> Eee spirit woman Wentere free my hand,
> So I can play a little for the world.
> Cherished genie woman Wentere free my hand,
> So that I may speak a little.

> *Ee jina muso Wentere lee, n' bolo bila*
> *N' ye dòonin fò di nya ye*
> *N kanin jina Wentere, n' bolo bila*
> *N' ye dònin fò*
> (Camara, McNaughton, and Tera 1978, IV/64–65)

That may not sound like an apology, but everyone understands it as one. Similar apologies are even performed when the singer is a *hòròn* (noble) and there are *nyamakalaw* in the audience, since it is technically the *nyamakalaw,* not just the bards but even the smiths and leather workers, who are sanctioned speakers in Mande society.

These gestures of humility extend beyond a concern for jealousy, into the realm of pure respect. Sometimes both are involved and it is impossible to separate them. At Dogoduman, Mayimuna Nyaarè sang a long song about the importance of personal accomplishment that was meant to praise Sidi Ballo's expertise and, of course, prompt the desire in others to accomplish things. Right in the middle of it, Mayimuna offered an apology to her own mother: *Ne woloba jalen, Kòni ka solonto n'ye,* "May my own mother excuse me."

As accomplished and as senior as Mayimuna was, she nevertheless found it appropriate to ask her mother's pardon for performing in public. On one hand, that was considered by audience members to be a fine gesture of unpretentiousness in a society that greatly honors age, and it thus enhanced Mayimuna's stature as a singer. It was highly appropriate as an element of performance protocol. On the other hand, these lines were heartfelt and sung because the spirit moved her. Often in society, the procedures set up to guide behavior (some might say constrain behavior) actually facilitate response to need.

Another way of singing respect is with the line we encountered before that says you are helpless before the prowess of another (Kone 1997). You can sing, for example: *Ne bolo bè n'kò I ye,* "My hands are on my back for you" (Camara, McNaughton, and Tera 1978, 3/40). This implies a position of submission for the person with so much skill and is a strong form of praise. In an extremely long song of adulation for Sidi Ballo, the longest song of the evening, Mayimuna Nyaarè used this line several times, demonstrating the strength of protocol's penetration into performance. Mayimuna herself was the focus of other people's respect, and she was also Sidi Ballo's senior. But to heap respect on Sidi and to make important points with audience members about role models, it was smart for Mayimuna to use so much punctuating praise.

Drummers, dancers, and singers alike can use another strategy of humility and respect. They can imitate senior performers or resurrect the styles of retired or even deceased performers. This manipulation of form is a means of making senior performers laugh and enjoy themselves; it flatters them and proclaims esteem. At the same time, it is a means of gaining respect from those being imitated and from the audience as well, and it also offers the performers the opportunity to think more and learn more about their own performance style and capabilities. It makes them more artistically introspective (Kone 1997).

Sidi used a well-known gesture to show his respect at Dogoduman. Often when Mayimuna sang, he would settle near her and seem to listen quietly, sometimes making contemplative sounds with his voice disguiser. He would do the same thing with elders and leaders in the audience. Of course, for the sake of spice, Sidi sometimes clacked his beak as a sign of impudent laughing when Mayimuna sang. That created tension, which, through his whole

demeanor and earlier behavior toward Mayimuna, Sidi converted into audience pleasure. Thus, Sidi slammed protocol against playful disrespect to generate humor.

AESTHETICIZING OBSCURITY

While many in the Dogoduman audience found Sidi Ballo's ascension onto bleachers to be the evening's crowning moment, others were equally captivated by Sidi's opening up of the masquerade bottom to unveil his invisibility. Obscurity is one of the most profound concepts in Mande artistry and everyday life. It is at once poetic, practical, tremendously powerful, and full of a kind of worrisome majesty that should never be ignored. Sidi was expert at bringing it into play by changing shape in numerous ways, for example, to imply an instability and therefore supernatural quality of form. His audience responded to this with grand appreciation, and it was very much a part of what made Sidi Ballo successful.

Sorcery and *nyama* are foundations that bring this Mande concept into play, and secrecy is another active ingredient. Obscurity, *dibi,* stands on its own as a fulcrum in Mande thought and action, and it also creates another interactive set with *jèya,* or clarity. As with structure and spice, clarity and obscurity are opposites in some senses but are also often in complex, complementary relationships that erase any hard lines between them. *Dibi* is potentially ominous obscurity and darkness (McNaughton 1979, 1982a, 1982b, 1988, 143–44). It is an opaque, mysterious conceptual space that can be likened to wilderness or night. And like both, it is a natural habitat of *nyama,* spirit beings, and human sorcerers. It is not a geographic space, except that it can be said to be everywhere, as a kind of abstract, ethereal other world. Or it is the underside of our own world, a less-visible world of serious supernatural business. Everything that happens there—all the activities of spirits and sorcerers, all the transformations and reallocations of energy—register in entities or events in our visible world, which means they generally must be reckoned with. *Dibi* is a place of action and consequences, and it can be scary.

Dibi contrasts, complements, and interacts with *jèya* in complex patterns of mutual engagement. Both can be present and active at the same moment in the same object or during the same event. *Dibi* leans toward secret, hidden, and private, whereas *jèya* is open and public. When people do things alone, other people think they may be invoking the powers of sorcery. While *jèya* is oriented toward sharing and sociality, *dibi* is oriented toward the personal and often the selfish. It is frequently perceived as antisocial and malevolent. Thus the proverb: *Su ye dibi ye,* "The darkness of night is the darkness of *dibi.*" Here

darkness is likened to *dibi* as malevolent. The masking darkness of night camouflages reprehensible acts (Kone 1997).

While *jèya* is about clarity, discernibility, and the readily knowable, *dibi* is about mystery, confusion, subterfuge, and the unknown. This ominous character is suggested in these lines from a Mande song:

> Something is in obscurity.
> Obscurity is not empty.
> Nothing is in obscurity.
> Obscurity is not empty.
> Obscurity is serious (bad).
> Obscurity is not for amusement.
>
> *Ko bè dibi la.*
> *Dibi lankolon tè.*
> *Ko tè dibi la.*
> *Dibi lankolon tè.*
> *Dibi ma nyi.*
> *Dibi tè tulon dòn.*
> (Tera 1977, 1978)

Dibi possesses an important quality of relativity. To be ignorant is *dibi*. But to study is *yeelen*, "to brighten, make clear, enlighten." Through knowledge, what is obscure to many becomes clear to some. Thus, there are these axioms:

> Ignorance is *dibi*.
> Study is enlightenment.
> Ignorance (black-headedness) is *dibi*.
> Knowledge is enlightenment.
>
> *Kalanbaliya ye dibi ye.*
> *Kana ye yeelen ye.*
> *Kunfinya ye dibi ye.*
> *Donniya ye yeelen ye.*
> (Tera 1977, 1978; see also Kone 1995a, 48)

These axioms apply to sorcerers and to performers such as Sidi who possess sorcerer's abilities. Such people are said to be able to see in *dibi*, which is why they are described as having *sunyè*, "night vision" (Kone 1997); that is, sight into the deep, secret workings of the invisible world of *dibi*, so that articulations may be effected on the network of powers that reside there. That special vision can also be called *sunyarò*, and with it, Sekuba Camara explained, you can be in Bamako but see all the way to the Wasulu, hundreds of miles south. Another name for it is *nyefilatigi*, "master of two kinds of eyes"—eyes for regular vision and eyes for seeing into *dibi* (Camara 1978). This is one

aspect of the relativity of *dibi*. People who become familiar with its contents and potential make it useful to them and thus gain enlightenment for further action.

Many artists, such as sculptors, amulet makers, and performers, work in that space too when they create objects or events that are purposefully infused with the energy of action. Performers must be concerned with *dibi*. If they are attacked by sorcery, the attack will come "in *dibi*" (*dibila*). Seydou Camara said these attacks come to singers quite frequently and are often the cause of good, strong voices going weak and bad. Sidi Ballo said it was extremely important for performers to be wary of these attacks and pointed out that they take many forms—an excellent dancer can go lame or become paralyzed, for example. Thus it is important to know about *dibi* and to be able to take counter or preventative measures. This is one reason successful performers may be heavily fortified with amulets (*sèbènw*) and other secret things (*basiw*).

Because the darkness and obscurity of *dibi* is relative and also contains great potential for enlightenment and capability, many performers enter *dibi* willingly to help them find an edge. In addition to all the hard work and study required to cultivate sophisticated performance skills and strategies, a major means of gaining distinction and ultimately fame is through the aggressive acquisition of *gundow*, "special knowledge" or "professional secrets." And the conceptual space where these secrets can be found is, naturally, *dibi*.

These professional secrets include an array of strategies. Some involve what to eat or drink the day before, the night before, and the day of a performance. They can also involve restrictions on sexual activity. They involve the acquisition of particular kinds of *daliluw*, which can include the purchasing or making of many amulets or formulas of special ingredients to drink or rub on the body before a performance. Some *gundow* are oriented toward audience engagement. They are tips, patterns of behavior, and often also amuletic prescriptions that will help performers captivate audiences.

Some *gundow* are designed to generate theatrical *dibi*. An excellent example was Sidi's invisibility, presented in that grand moment of his performance when he opens his costume to the audience, challenging them to find him inside. Everyone looks in, some with flashlights, but no one can see him, even though there is nowhere else for him to be. Truly, as the song says, *dibi* is never empty. To do this, Sidi had found an owner of an amulet called *dibilan*, "*dibi* is here," and purchased the *dalilu* for it. Before performances, he tied it around his forehead and became invisible. Sidi said that it would have the same effect were he to wear it in broad daylight while walking down the street. He would be invisible.

So we can think of *dibi*'s affecting invisibility as an element of form or a phenomena to be aesthetically manipulated and also as a space in which artists work, along with herbalists, sorcerers, diviners, and spiritual leaders. As many

gundow as performers might have, and as much expertise with *dibi* as they may possess, some still enlist the backing of even more powerful individuals. Sometimes they are especially skillful sorcerers, called *somaw* (McNaughton 1988, 49). Sometimes they are *moriw,* Muslim marabouts with expertise in *dibi* (Kone 1997). These backers can advise and teach performers. But they can also send their expertise into the less visible world on behalf of performers, working from afar to help shape art.

In the experience of life, clarity and obscurity constantly shift back and forth into each other according to the nature of individuals and situations. For example, many acts and objects that overflow with obscurity for large segments of the population are clarity for blacksmiths, bards, and sorcerers who are experienced in the realms of *daliluw* recipes and *gundow* secrets. And obscurity becomes clarity for performers such as Sidi Ballo who work hard to understand and benefit from that subtle realm. In fact, one of the most exciting and frustrating aspects of Mande social life is the uneven and highly individualized distribution of all kinds of knowledge, particularly the kinds of knowledge that lead to power. Seydou Camara used to sing about this as both a tribute and a critique with the words:

> One knows one thing.
> Another does not know it.
>
> *Dò na dò lòn.*
> *Dò m'o lòn.*
> (Camara, McNaughton, and Tera 1978, V/94–101)

Thus, the boundaries between clarity and obscurity can be difficult to establish. That leads to social complexity and perplexity. It can also lead to artistic spice of the kind Sidi Ballo constantly deployed with exciting expertise.

BADENYA AND *FADENYA* CONSIDERED AESTHETICALLY

I observed Sidi Ballo outside the dance arena in friendly conversation with people he had not met and did not know. He was wonderful to watch and hear because he had a way of talking to people that was modest and bold at the same time. He sat relaxed in a chair, the image of languid sociality. He spoke in a quiet way that nevertheless projected a presence to which people knew they should pay attention. With queries, statements, and jokes, he would push people to talk but then back off if he sensed they were becoming uncomfortable. He would even joke a little about himself and laugh softly,

which had the effect of putting others at ease even as he pushed them. Sidi
Ballo was a master conversationalist, and this mastery was built on a combi-
nation of intelligence, sensitivity, and long experience engaging people. Just
like the way he walks, this ability to be bold but ingratiating percolates
through his being and spills out into performance, where it is one more rea-
son for his spectacular success. He is expert at using a pair of concepts that
are as prominent and deeply embedded in both art and the everyday as any
ideas in Mande culture: *badenya* and *fadenya*. In a more dangerous frame,
this pair of ideas is embedded in the world of sometimes intense competition
among artists in which sorcery becomes a means to advance at the expense
of others.

Mother-childness and father-childness—*badenya* and *fadenya*—are many
things in Mande. They are concepts people use to help explain social behavior,
and they can be used to guide behavior or to develop strategies for behavior in
specific situations. They are thus concepts that infuse mores into the social
landscape while also being elements of Mande social theory. Earlier, when we
considered Sidi Ballo's character and rise to fame, these concepts offered use-
ful insight into how he constructed a successful career.

In art, they appear as major themes of some of the best-known songs and
epics, such as the Sunjata epic and the hunters' epic *Kambili*.[2] Their complex-
ity and multifaceted characters are woven into the fabric of these oral art-
works, where they can be seen as both principles of action and instruments of
analysis, just as in social life. Sculpture and masquerade skits use *badenya*
and *fadenya* as themes to be enjoyed and contemplated in the form of char-
acter attributes or features of theatrical situations. On top of all this, they are
palpable elements of form because, like *nyama,* their presence in audio, vi-
sual, and verbal compositions generates affect, and also because they have
value as powerful structures of thought and emotion that percolate through
people's lives. Mother-childness and father-childness are embedded in the
strategic organization of formal resources, making them a proper part of aes-
thetics.[3]

As concepts that emerge from experience, mother-childness and father-
childness link the range of human emotions and dispositions—love, solidarity,
hate, jealousy, ambition, competitiveness, confidence, and insecurity—to be-
liefs and values, social behavior, and cultural constructions such as the Mande
concept of the hero (*ngana*) or the principle of constraint and shame (*malo*), or
the principle of restraint in art making. From the microcosm of family to mac-
rocosms of community and society, they are knotted into each other. Together
they help map the play of cooperation and solidarity against competition and
fissure, to capture with practical elegance the spectrum of situations and mo-
tivations that characterize the human condition in all its paradoxical, real-life
complexity.

If we quickly review these concepts, we can consider their infusion into the form of art. At the microcosmic level of home, mother-childness identifies an ideal but theoretical relationship between siblings who share the same father and mother. They are cooperative, generous, supportive, and understanding of one another. Father-childness identifies a relationship between siblings who share the same father but have different mothers and therefore, theoretically, compete for family resources, status, and accomplishment.

At the macrocosms of community and society, mother-childness becomes all the aspects of a person's personality and behavior that work toward the immediate common good, the smooth flowing of community life, with compliance, acquiescence, and selflessness being featured personal attributes. *Badenya* (mother-childness) emphasizes personality traits that are open and fathomable, and it is therefore oriented toward the straightforward, easy, uprightness of *jèya* (clarity). *Fadenya* (father-childness) becomes all the aspects of a person's personality and behavior that work toward the advancement of individuals over society, no matter what the cost in terms of friction, disruption, and even destruction. It emphasizes personality traits that readily accommodate secrecy, subterfuge, and cunning, and it is strongly oriented toward the opaque power of *dibi* (obscurity).

Lest we see them as a dichotomy, Mande nuance shows the fluidity of these concepts. For example, the word *sinjiya*, "breast milk mother," can be used to express a strong mother-childness relationship not bound to blood. *Sin* means breast, *ji* water, and *ya* is a post-position that locates the maker or doer. The explanation for the term is that children who have shared milk from the same breast possess a close, strong bond; their lives are drawn tightly together. Generally, children of the same father and mother share the same breast. But should a hungry child's mother be absent, the issue of whose breast will be used becomes critical, because forever after, that woman's birth children and the child who received the gift of milk will become linked in special ways. They could never marry, for example, and they become *baden*, "mother-children," to each other (Kone 1997).

It can also be the case that where, in theory, there should be the competition of father-childness, in practice it is absent, because social life is complicated and so are people. Kone notes that Mande use the word *kulusijala* (belt) in a proverb that offers a rationale for this exception and variation. The word is from *kulusi* (pants) and *jala* (strip of cloth that holds them up). It is used to show how a *fadenya* situation or relationship may also be considered a relationship of *badenya* by using the metaphor of the belt. The buckle and tongue of a belt are much closer to each other than they are to a breast, meaning siblings who share a father but have different mothers and are therefore usually conceived of as bearing a *fadenya* relationship, are actually of the same essence and can be considered equal, so that they may also be considered to

share *badenya*. Thus the proverb: *Kulusijala ka surun sinji ye*, "The belt buckle and tong are closer than breast milk" (Kone 1997).

Badenya can be used aggressively, in the spirit of *fadenya*, by putting people in social situations where common rules of proper, harmonious behavior create obligations to give resources they do not want to give or to undertake activities they do not want to carry out. Gifts and hospitality can be extracted from people just by paying them a visit or making statements that enact mother-childness principles of generosity, selflessness, and solidarity (Brett-Smith 1994). Sometimes people succumb to such unkind manipulation, but socially savvy individuals know ways of extracting themselves or even turning the tables on the perpetrators. Mother-childness and father-childness are not blueprints for behavior or rules against which people must always fight. They are foils against which different people behave in different ways, according to their knowledge and skills, dispositions, and desires.

The fluidity and intermingling of *fadenya* and *badenya* can be seen in many arenas. Heroes (*ngana*), for example, are frequently exceptionally father-childness oriented, and in fact are often held at a distance because of their potential danger and destructiveness. But they are necessary and welcome in troubled times, and often their actions in uneventful times contribute to society's vitality. Sunjata, legendary founder of the Mali Empire, was a man much feared as a hunter, hero, and decidedly father-childness persona. He did not hesitate to be ruthless. But his legendary accomplishments indicate an individual whose dynamism and capabilities saved the Mande and built something grand. Father-childness is sometimes another way of saying creativity.

On the less heroic plane of everyday life, father- and mother-childness also commingle. Take a competent market woman, for example, a *tabali tigi*, master or owner of the table where a stock of wares is displayed and business is conducted. Many *tabali tigiw* are tough and tenacious bargainers with the clients who buy from them, the vendors who provide them with stock, and the other salespeople with whom they compete for location and shoppers. In that rugged business mode, their behavior is *fadenya*. But it may be aimed at providing for a much-loved family, which makes it also *badenya*.

Remembering that they are complex and not to be used simplistically, *badenya* and *fadenya* become excellent analytical tools that help to show how people in situations can generate social force that is centrifugal or centripetal,[4] feeble or robust, and that is broadcast from a center of action out into other individuals and situations, where centers become multiple and action becomes complex. This is why they can be powerful themes and symbols in the arts. As strategies of behavior they possess great potential to stimulate action and generate consequences, and it is always advantageous to have the means to ma-

nipulate or at least try to manage them. That is why they get caught up in aesthetic strategies.

Mande experience, as articulated in the great oral epics, proverbs, and youth association masquerades, suggests that mother-childness can lend itself to placidness, meekness, and contentment with the status quo. Father-childness emphasizes rugged individualism and personal accomplishment, and it is perceived as opportunistic in a hard-knocks world. In the face of uninspired social inertia or a threat such as another group's empire building, father-childness can be what saves society or brings it back to vibrant life. In fact, in one sense, father-childness is a social and moral commentary on how people acquire their worth, as indicated in the proverb *Tògò tè c'bèè den na*, "It is not the children of all men that bear a name" (Kone 1997). As Kone notes, "Real fame is won. It is not the fame that one inherits from one's forebears that counts, but it is the personal fame that one obtains for achieving great deeds that counts." This is a potent motivating force in Mande, given viability and depth in Mande arts such as masquerade and the great oral epics.

On the practical plane of performance, father-childness is strongly associated with artists' quests for fame. It is part of the inspiration behind embellishment (*jago*) and the acquisition of special expertise (*gundow*) that draws performers into the realm of *dibi*. It is also a major force behind the jealousies that constantly arise and the troublesome, malevolent sorcery that may result. There is strong competition in performance, and not only is it obvious to audiences, it is often created by those audiences as they respond to the personalities and abilities of performers. Competition between performers can be quite persistent and stealthy, as the following proverb observes: *Fadenya kolen: o ma jï*, "Rivalry and competition, even when washed, do not become clean" (Kone 1995a, 30). The implication is that no matter how honest competitors and rivals may appear to each other, they always have personal schemes they will not share.

There can also be much cooperation in performance, so that again, mother- and father-childness become entangled with each other. In fact, good performers often pay sensitive attention to other performers and cultivate the ability to follow them, complement them, support them, or lead them, all while standing their own performative ground and even shining. Kone (1995, 6) notes a proverb that characterizes the relationship between people whose common goals temper their conflicts of interest: *Badenya kïlï bï sisi a tï mïnï*, "Brotherly fighting may smoke, [but] it won't burn." Thus, as competition, cooperation, and complicated assemblages of both, mother-childness and father-childness are social concepts that impregnate the behavior of performers to become aesthetic considerations.

As co-dependent concepts that both guide and explain complex behavior, mother-childness and father-childness permeate all sorts of events and

activities. No wonder they are infused into the forms that artwork takes. Music is a good example. Music groups such as drum and *balafon* orchestras distribute instrument parts across their members in a way that compartmentalizes rhythms. Each member holds down a segment of the whole arrangement on their instrument. Sometimes a segment seems simple, like the two or three beats per measure that some of the drummers might be playing. But pay attention to where those notes fall. In a four-beat measure (counted by Westerners as 1-e-&-a 2-e-&-a, etc.) notes are often placed counter-intuitively all over the "e's" and "a's" and sometimes in between them so that thirty-second or sixty-fourth notes are produced and an uncanny fluidity is achieved. With four or five musicians each doing different parts, the effect can simultaneously be elegant, poetic, and sophisticated, and yet at the edge of chaos. To hold it together demands great mind-body skill on every musician's part, along with a steely but easily enacted ability to conceptualize the whole composition while being sensitive to any changes fellow musicians may establish. Awareness of what everyone else is doing, coupled with maintaining one's own complementary place within such a complex whole, is the essence of *badenya*.

At the same time, each individual musician must possess a stalwart ability to stay self-focused. When they are learning, individuals must try hard to concentrate on their own parts in spite of the fact that listening to other parts creates an almost magnetic attraction that can throw off their own parts. If a musician gets lost in what others are doing, notes will migrate out of place and the whole piece will fall apart. For skilled musicians with ample experience, this self-focus becomes easy and comfortable. It is a kind of staking out and holding their own territory, a kind of *fadenya*.

In a typical drum and *balafon* orchestra, such as the drum orchestra of Dogoduman, there will be at least one lead performer whose job is to pop himself spectacularly out of the rhythmic flow. His notes—fast, slow, staccato, turgid, lithe, completely off beat, completely out of time—become a dynamic pattern that breaks away from everything else while simultaneously complementing it with an effect so complex, crisp, and fluid that it approaches the sublime. This breaking away is done with rhythm and tones. A good *jembe* drummer, for example, can generate a minimum of three very different tones on his instrument. Breaking away is also accomplished with flamboyant gestures. A virtuoso drummer draws attention to himself and distinguishes himself from the ensemble with hand and arm motions, dance movements and postures, and facial expressions. The entire audio and visual effect constitutes magnificent articulation and produces immense amounts of *jago*. It too is the essence of *fadenya*. No wonder these soloists, after finishing a lengthy display of marvelous accomplishment, sometimes stride toward audience members, head thrust forward, with a look that states emphatically

to listeners: "I know how good that was, and I know you do too." At Dogodu-man the lead drummer, Sori Jabaatè, partook of these gestures and this kind of playing often enough to make it obvious that he was quite a good musi-cian.

As a masquerader, Sidi Ballo constantly used the play of mother-childness and father-childness to generate piquant social-artistic tension. Performers are expected to draw attention to themselves and their abilities, and this is father-childness behavior. But even within the sanctioning frame of masquerade entertainment, actions that bear the character of individual-ism and an aggressive setting forth of self carry consequences. One needs to be perceptive and skilled enough to pull it off—working with the drummers and singers and not against them, challenging and entertaining audience members without abrasively offending them, being bold but not annoying or pugnaciously intrusive into audience space. Sidi's aggressive command of the dance arena, his rapid charges and sweeps against the very brink of the audience, his dips and thrusts, and his tipping nearly over while rushing pell-mell toward audience members were all marked with the social weight of *fadenya*. A lesser performer could have been dragged down by that weight.

When the bird circled around the respected elder singer Mayimuna Nyaarè and clacked his beak satirically at her, he was using *fadenya* to generate delightful tension. When he parked before elders and other audience members or hooked them with his carved head and pulled them into the arena, he ac-complished the same thing. When Sidi rushed swiftly past rows of audience members, close enough to create a breeze and sometimes even brush against them (it was shocking how close he could come to us at Dogoduman without actually hitting us), he evoked feelings of tension and disquiet that erupted up out of the play of *fadenya* and *badenya*. And since such moves were always perceived in combination with the abundant presence of vulture feathers on his costume, for example, or shape-changing in several of his gestures, the strangely exciting threat of aggressive behavior would be linked to the power of *nyama* both present in the feathers and suggested in the shape-changing. That made the experience of his masquerade performances quite different from what they would have been had Sidi deployed different materials and tactics.

Thus, these twinned ideas of *badenya* and *fadenya* splash back and forth between art and social life. Performance protocol, the principle of restraint, and the articulation of constant negotiations between mother- and father-childness all come together in the play of aesthetics. In the hands of less com-petent artists, this can drag an event into mediocrity. In the hands of skilled artists, it can elevate a performance into something grand and truly memora-ble. At Dogoduman it was grand and truly memorable.

VIRTUOSITY

When talented Mande artists perform, complex interplay between structure and spice, social goodness and personal tastiness, clarity and obscurity, mother-childness and father-childness emerges from hard-earned expertise. Musicians such as Mayimuna Nyaarè, masquerade dancers such as Sidi Ballo, bards such as Seydou Camara, or sculptors such as Sedu Traore are at any given moment the sum total of all their knowledge, skill, aspirations, and activities—their experience in conjoined artistic and social worlds. Some artists become competent, others do not. Some acquire virtuosity (*kènèya*) and earn reputations, expanding clienteles, and often very good livings.

Kènèya literally means "agility" or "suppleness," and it invokes ideas about skillful articulation (Arnoldi 1995, 121; Brink 1981, 12; McNaughton 1978, 3/5). It occurs outside the world of art, but it may still be characterized with reference to artistry. A person who is full of social finesse and flexibility can be called *kotebaden*, "theater's child" (Kone 1997). Brink (1981, 12) characterizes it within the world of art, in a way that brings together many of the ideas we have discussed:

> *Keneya* in music and dance, for example, consists of improvising within the format provided by the given rhythms and dance steps, in such a way that the aesthetic identity of these configurations is never lost even though they are broken down, played with and otherwise submitted to the creative "cleverness" of the performers.

Such virtuosity has the power to create that special unity between performers and audiences that is called *jama*, a solidarity beyond everyday life that is seen as almost spiritual (Brink 1981, 12).

The articulation of aesthetic concepts that leads to virtuosity need not be overly deliberate. Sometimes they are engaged with forethought and deliberation; sometimes they are an almost habitual part of an artist's creative flow. Sidi Ballo is a practical man who finds conversation about aesthetics boring. Once, in 1978, I asked him several aesthetic questions, to which he responded that he was about to become very tired. But Sidi's virtuosity brings all the phenomena of artistry into play quickly, fluidly, with a precision and finesse that impresses almost everyone. He packs a performance with so much precise articulation that the audience can indeed come together with impactful, memorable shared experience to gain that nearly spiritual solidarity called *jama*. No wonder the town of Sikòròni wanted him to dance in their youth association so much that they gave him a house.

In a performance, the concepts we have just considered are not facilely detached from one another. Sidi Ballo's bird dance at Dogoduman was a swirl

of activity that produced, as it unfolded, a grand amassing of sensations, images, and thoughts, and in the process generated its own in-the-moment experience for audiences. Few viewers would be inclined to pull themselves out of that moment to scrutinize its aesthetic components, though many viewers would readily respond analytically, almost without having to think about it, to songs, gestures, and skits; and most viewers did respond repeatedly with vocal praise to things they found impressive.

So dissecting a performance to locate its aesthetic elements is an act of scholarship that may not reflect an audience's experience or appreciation. Moreover, it is a linear description of a whole event that is built by the parts colliding in complex and often rapid, even simultaneous patterns. There is a compounding effect, an interacting of components that qualify and amplify one another to encourage states of experience that defy easy analysis. Written descriptions can never capture that experience, but to summarize what gives Sidi Ballo virtuosity, we can try to give a sense of how aesthetic components at Dogoduman coalesced into something marvelous.

Mande enjoy clear structure and the quest for compositions that express essences. They also enjoy complexity, complications, and contradictions, which they view as the tasty, satisfying, spice that artists use to confound clear structure. Sidi Ballo was very good at establishing clear structure and then disrupting it with spice. His carved bird's head was elegantly designed with enough mass and weight to suggest impressive prowess without specifying a particular kind of bird (Sidi actually did not care what kind of bird viewers thought it was). Its bright red paint amplified the idea of prowess, as if it were a powerful bird of prey. Vulture feathers suggested a big, impressive bird but also the vulture, cagey eater of carrion and bearer of much *nyama*.

Sidi's masquerade used a variety of strategies to radiate an image of terrific power, both physically and supernaturally. Even the praise name Kulanjan denoted spectacular prowess. But during the performance, Sidi bobbed the head up and down, as if it were a bird on the ground looking for scraps to eat, like a courtyard chicken instead of a bird of prey. When the bird hit the wall and the dust settled, the head popped up and looked around as if baffled by its present upended state. It did the same again later, when Sidi caused the masquerade to topple over. These gestures of surprise suggested the antithesis of prowess, which added contradiction and generated humor. People laughed, clearly enjoying the complications.

Sidi also swiveled the head around, left and right, as he traveled about the arena, creating a sense of active, animated presence and the impression that the bird was observing people. Since everyone knew Kulanjan might decide to park right next to you the very next instant, this audience scanning could generate thrilling tension. Then suddenly the head would begin to swing around in large figure-eight patterns, dashing the impression of sentient bird against

the rocks of abstract motion. This play between representation and abstraction was much appreciated and added yet more spice and interest.

Sidi often played embellishment and obscurity against each other in ways that enhanced spiciness. When he squatted low inside his masquerade so the burlap fringe did not show and then stretched up while moving or reared up while parked next to audience members, the resulting change in the costume's shape was impressive and elicited perceptions of objects and beings laced with high levels of the energy of action. The same was true when Sidi pressed hard against opposite sides of the interior of his masquerade, causing it to flatten. Shape changing added spice to clear structure and invoked *dibi* as well. So did lurching jaggedly while speeding around the dance arena. Of course, this complicated clear structure, but it also suggested *nyama* dangerously free of artistic management. Remember, people's experience with *nyama* includes the ever-present possibility that experts manipulating it will lose control, thereby unleashing potential catastrophe. In that world of entertainment where real blurs with contrived, Sidi played with that uncertainty, making spiciness skyrocket. Add the bright red head, the vulture feathers, the seemingly unrestrained sweeping around the dance arena, coupled with sudden, lengthy, episodes of stillness, and the excitement was palpable.

More performance strategies teased out the supernatural effect produced by this cloth and wood articulation that was a bird of prey, a satirical bird, a *nyama*-laden creation—that was simultaneously hilarious and scary. Sometimes the masquerade appeared to romp around the dance area as if propelled by legs. Other times, even when moving with pronounced velocity, it seemed to hover on air. For me, the effect of seeing romping and hovering back to back was stunning.

Then there was the burlap fringe, the length of which added the spice of potential performance disaster from tripping and tumbling to the ground. Sidi made that fringe come in and out of view constantly as the costume was raised and lowered or tilted from side to side. I never forgot about it, and yet, when it was visible, I felt a kind of surprise that it was there because its drab and dirty gray contrasted so much with the colorful, richly articulated rest of the costume. It looked ragged, like an unseemly private underbelly that is not supposed to be seen. It suggested obscurity. Of course the ultimate obscurity at Dogoduman was Sidi's invisibility when he opened that ragged costume bottom to the audience and they looked beyond the burlap to see apparent emptiness.

All that play between structure and spice frequently got tangled up in mother-childness and father-childness, as when Sidi clacked irreverently before Mayimuna Nyaarè. The concept of constraint and shame (*malo*) was also involved, as when Sidi parked so very close to audience members or pulled them out to dance, drawing everyone's attention to them. That can feel un-

comfortable, but within the frame of masquerade, it can also be exciting. Different people would respond in different ways to all this, but the mixture of impressions and emotions that Sidi's articulations produced created an atmosphere of anticipation, thrill, and pleasure to which the crowd voiced resounding approval.

Near the end of the evening at Dogoduman, when Sidi Ballo's bird head actually drank liquid from the calabash, several ideas swirled into play. First there was the play of masquerade versus real bird activity. Then there was the apparent sorcery and *nyama* suggested by this ersatz bird doing something impossible. Then there was the generosity and honor in Sidi being offered the calabash, bringing ideas of mother-childness and father-childness into action with ideas about hard work and accomplishment. When we sort out these parts of a single act, they lose the richness of being all bundled together. Together, they constitute aesthetics and social concepts melded into experiences that are bigger than a description can suggest.

We have already considered restraint in relation to leaping from bleachers before people who believed he could leap into trees. Sidi also embodied restraint through the seemingly effortless compounding of motion. At base, there was the graceful sliding across the dance arena. Add a spinning-top rotation, grand figure-eight curves and sweeps, a big red bird's head inscribing its own bold figure eights as if it were a large baton—and remember that it was all executed with fluid ease, without skipping a beat, and with no rough edges. Given all this, virtuosity simply leaps into your mind. It was easy to ask what he couldn't do and to imagine that he was exercising cool, competent control inside his masquerade.

I experienced Sidi's constant toying with toppling over and the final fall as repeated instances of tension, relief, and, finally, release. Restraint produced both the tension and the relief, as he went to the edge of disaster and pulled back. But another kind of restraint prevailed when he finally toppled over, because close observation revealed the fall to be carefully orchestrated and tightly controlled.

For me, that fall, the dancing upside down, and the revealed invisibility all clustered together in a crescendo of expertise to epitomize Sidi Ballo's aesthetic acumen. Visually, it was spectacular. The fall was apparent disaster elegantly staged. The subsequent upside-down dancing was like the phoenix rising from the ashes, and the invisibility was a step into another world, where so much Mande thinking coalesces around ideas of power. All the other senses supported that visual splendor, with the drum orchestra subtly switching back and forth between calming and exhilarating rhythms, and the words of the songs playing prominent roles in heightening that splendor into the realm of ideas and emotions. All night long those ideas came rolling at me—mother-childness and father-childness, constraint and shame, responsibility and

accomplishment, the work and value of heroes, the virtues of tremendous skill, the presence of great power in the world, and people's hard-earned ability to harness it. All this came on the nonexistent wings of an incredible bird and from the persona of every other performer. Perception mingles so many divergent forms of resources that when they all come together in exquisite articulation, perhaps partly through happenstance, but largely through expertise, the result is a compelling experience that makes you realize how important it is to have good artists in the world. Sidi Ballo, the bird masquerader, is one such artist.

9

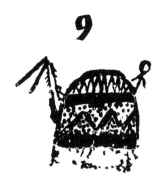

AN AESTHETIC
OF AFFECT

THE AESTHETICS OF STRETCHING THOUGHT

When art announces itself with the attributes that distinguish it from every-
day life, a frame of special time and place is perceived that offers audiences
opportunities. One is the opportunity to revel in aesthetic engagement, which
people can do in everyday situations too, but perhaps not as freely. This is aes-
thetic distance, a freedom to ignore quotidian concerns and plumb artistic
composition or just to enjoy the pleasures that composition offers.

Another opportunity is for contemplation and reflection. The ideas and
emotions artworks inspire are instruments for exploring life's actual situations
and testing one's own perspectives and sense of self against those situations.
Art time is a temporary haven from life in real time, and in art time people can
benefit from reflexive and analytical moments that loop out from the aesthetic
and pour back into the everyday.

Often these complementary opportunities for enjoyment and reflection
are not simply offered by artworks themselves. They can be vigorously hurled
at audiences with aesthetic power by artists intent on providing audiences
with a thick, rich, intense experience. Good artists know how to manipulate

material and conceptual form to encourage strong responses. The ideas and emotions much Mande art skillfully orchestrates are intended to play with the thoughts and emotions of ordinary life so effectively that listeners and viewers can be nearly, or completely, overwhelmed. The concept of holding back does not prevent artists, in many situations, from trying to have a powerful impact on their patrons.

In this kind of intense artistic environment, distance and detachment—aesthetic removal from workaday worlds—are a little bit of fiction. Far from isolating people from the experiences of life, a Kòmò performance, an evening with bards, or a bird masquerade all become experiences potentially as catalytic and profound as any life-changing business deal, social moment, spiritual event, or philosophical revelation. If art can create time and space out of phase with daily life, it can also provide a direct path back. When it is good and people are ready to engage it, art helps them inscribe their evolving personal history with meaning and significance. Art can have affecting power.

Oriented to entertaining visual and audio composition, to configurations of form that please, Mande aesthetics is equally oriented to affect, influence and action. Mande artists of all kinds use strategies that aim to make their works compelling and memorable. Not every viewer or audience member finds appearance and meaning equally interesting, of course, because like everywhere else, people's orientations and responses vary. Many people watching Sidi Ballo did not think about his performances beyond their intense entertainment value. But many Mande find that being agreeable to the senses and being rich with intellectual and emotional significance both complement and necessitate each other.

The Mande world that artistry articulates and influences includes numerous ideas and experiences that relate to concepts such as clarity and obscurity, the power of *nyama,* mother-childness and father-childness, the character and value of heroes, the lessons and wisdom in history, social good and personal good, and the goal of raising audiences above themselves to spiritual solidarity. The epics of bards and the songs sung at masquerades, the feats of Kòmò dancers and masqueraders such as Sidi Ballo, and the motifs and compositions of sculptures and costumes, all inspire images and impressions that swell up out of real lives to make people think, feel, and act. Performances are particularly vital, because their media-bridging impulses are brimming over with contemplative and emotional material with which audience members can make themselves very busy. Aesthetics helps performers deliver these materials effectively, so performance artistry is very socially oriented.

Mande audiences expect that performers will try to make them think, as suggested by the axiom "Every festival is an opportunity for educational dialogue." That may be why the language used in songs often emphasizes words or constructions that encompass both an idea and its opposite and why the idea

of death is invoked at such ebullient celebrations as baptisms and weddings. Such strategies create contemplative perspectives that keep all the poles of life in view so that the grand and wonderful ones can be all the more appreciated (Kone 1997).

This nearly didactic orientation applies across the spectrum of arts, even in venues that seem to aim mostly at fun, such as youth association theater and puppetry. Arnoldi (1995, 21–22) notes that "actors use masquerade, dance, music and song to comment upon moral values, the conditions of existence, and the ambiguity and indeterminacies that arise in social relationships in the everyday world of experience." She adds that theater uses parody, irony, and satire to support or challenge well established elements of Mande ideology such as "the official hierarchies of age, status, and gender" (149–50). In other words, performance art may be designated play, but play can be serious business (see also Brink 1978, 1982).

We can view praise for singers as an example of this deeper purpose in performance. Appreciative listeners can say of an excellent singer, *A kan ka di,* "His or her voice is good." But a beautiful and effective singing voice is only one criterion by which the quality of singing is judged. Another is the meaning of the words being sung. So fuller praise would be *A ka dònkili ka di,* "His or her song is good," and refers specifically to the meaning of the lyrics. Or, people could say: *A kòrò ka di,* "Its meaning is good" (Kone 1997).

Audiences most certainly care about the affective nature of these interfused formal, cognitive, and emotional materials. Good songs well performed should be deeply moving, and that is most possible when they offer the materials to construct a powerful message. Good songs then become memorable for many people, so much so that they only need to hear the melody or the rhythms associated with them, and they fill in the lyrics and find themselves emotionally involved.

The potency of this interfusing even informs a stereotype that many Mande maintain about their social life. Fact or fiction (or both), it is often feared by men that their girlfriends or wives will run off with musicians. Their rationale is that the music in its totality—the affect emitted by its intertwined components—is so deeply significant and moving that women simply cannot help themselves (Mahy 1975).

Kassim Kone is passionate about this point. Praise of voice alone is incomplete praise of the quality of a person's singing. Thus the proverb: *Dònkili man di, a koro de ka di,* "The song is not good unless the meaning or significance is good." What counts about the meaning and significance is that listeners are made to think, even think deeply. So people say of a good singer: *A ka dònkili be mògò miiri janya,* "His or her songs stretch people's thought" (Kone 1997). No wonder the hunters' bard Seydou Camara (1978) used to announce himself in his songs as a singing bird who made the stupid intelligent and gave

circumspection to those who are not circumspective. He accomplished that with his choice of words, the way he delivered them, and the way he shaped their affect with his harp and his performing persona. He is the perfect example of why form is more than audio or visual shape.

Performers like Sidi Ballo can be just as oriented toward meaning and significance as singers, and praise for them includes the recognition that what they communicate is good and important even though it is also, just like songs, subject to great variation in interpretations. Sidi Ballo affects audiences with more than dazzling choreography, and it could be said of him as readily as of any excellent singer that he stretches people's minds. He may not aim at delivering a specific message, except that Mande culture is alive, well, and worthy. But his performances are so aesthetically successful that you could say: *Sidi Ballo ka kònò ye mògò miiri janyabaga ye,* "Sidi Ballo's bird masquerade is the agent of people's deep thought," the idea of agency being registered with the suffix *baga*. From initial perception to later contemplations, Sidi's bright red bird's head has certainly been that for me.

The proverb quoted above that says good songs project good meaning and significance uses the word *di* for "good." Remember, *di* emphasizes personal good: agreeable to the senses, pleasurable, and tasty; while *nyi* emphasizes social good: in a good state, healthy, wholesome (see, e.g., Bailleul 1981, 45, 167). This distinction could lead you to believe that *di* is used for things less serious, but that is not the case. *Di* can be a concise but complete form of praise that encompasses conceptual as well as sensual components. It refers both to the surface of things and to that which lies beneath (*a kòrò*), something that cannot be directly engaged by the senses, something that is hidden, invisible, and, as Kone notes, actually occurs in your mind (Kone 1997).[1]

From another perspective, *nyi* and *di* do suggest an interesting contrast that bears on social significance. *Nyi* carries a sense of social memory and judgment. *Di* is more for personal evaluation. Kone put it in an elegant frame by saying that "it is taste that is felt with the eyes or ears, as the tongue would feel the taste of sugar, salt, or oil" (Kone 1997). In other words, it is personal, tactile, immediate, and vividly tangible, no matter how elusively abstract it may also be.

Thus, people may say of a song, for example: *A ka nyi, nka a ma di n'ye,* "It is (socially) good, but it does not please me." Or they can say: *A man nyi, nka a (kòrò) ka di n'ye,* "It is not (socially) good, but it (the meaning) pleases me," in which case the implication would be that the song, or the Kòmò association, or a Sidi Ballo performance is considered ugly, unpleasant, or in some way negative by broad community standards, but the speaker nevertheless finds it attractive, satisfying, affective, or conceptually right.

Such sentences are not just options that Mande languages offer. Mande individuals frequently see things, interpret things, and evaluate things differ-

ently. So this way of distinguishing ethos from individual assessment and judgment by using *nyè* or *di* offers a glimpse into the play of individuals and groups. It also shows the finer textures that can be involved in social appraisals of art.

We have seen above (and see Arnoldi 1995, 101–106; Brink 1981), that *di* (pleasurable, tasty) and *diya* (tastiness) express sensually agreeable embellishment. They also refer to the features of artworks or performances that stimulate "interest, imagination, emotion, involvement and action" (Brink 1981, 5). They reference the successful communication or expression of sensate, cognitive, and emotional materials. They are particularly interesting words because in artistry there is more to influence and affect than deep thought. Mande artists often want to move people, literally move them outside themselves, to make them, at least temporarily, into something else, or take them, temporarily, someplace else. The phrase *ka miiri janya,* "to stretch the mind," is still at work here. But the implication is that the mind is stretched right out of the head so that it can wander away and come back (Kone 1997).

This is an elegant conceptualization for the play of contemplation and emotion caught up in experience. One wanders off to recollections, strong feelings, or the examination and exploration of old thoughts in new ways or new thoughts entirely. And all of this is rolled into one. It is not thought and emotion but rather the two as one (Goodman 1984, 5–9), an experience that emerges from our whole embodied, sensate, cogitative, active selves (M. Johnson 1987) caught up in an experience that pours real life into artistry and artistry into real life (Dewey 1934).

Often there is more, for this movement beyond one's self can involve encounters with *nyama.* The energy of action is directed at people by masters of speech—for example, the bards and hunters' bards whose expertise involves the articulation of *nyama* along with the articulation of words and sound. But since all words and acts are charged with *nyama,* this energy can also emerge from singers who are not bards, such as Mayimuna Nyaarè, or it can simply rush up out of a performance's intense action and infuse a member of the audience. No matter how it happens, when people at a performance are infused with *nyama,* they are cast into a mind-body state so intense that something will have to give.

An easy escape is available for people who have lost themselves to *nyama.* They can give a gift to the performers that will dissipate the energy in a harmless way. This is called *ka nyama bo,* "to make the *nyama* go." Other phrases for this act include *ka nyama gwen,* "to chase the *nyama*"; *ka nyama lasuma,* "to cool the *nyama* down"; and *ka nyama fifa,* "to fan the *nyama.*" When you see people dancing behind performers, using wicker cooking fans to sweep the air, they are very likely fanning the *nyama* bristling up out of the performer. It is a striking, dramatic gesture that is potentially literal and metaphorical

simultaneously. For some people, *nyama* is actually being fanned away. For other people, the fanning is metaphorical punctuation, suggesting that the performer is so talented, so hot with expertise, that the energy of action just flows out like steam. And for many people, the fanning is both dissipating energy and recognizing the metaphorical value of *nyama* as a measure of talent and affecting performance.[2]

Sometimes when *nyama* is considered to be swelling up out of a performance or a performer and engulfing audience members, persons caught up in the energy might not think or choose to dissipate it. The result can be embarrassing, even shocking public behavior, something that causes shame. Or the result may be an act of malignancy, a deed that causes hurt or trouble for people, something to be deeply regretted. Or the result can be a great deed of much benefit to a family, a community, even a whole society; something to be grateful for; something that produces renown. All of this can result from an infusion of *nyama* in the midst of a performance.

Even masquerade dancers can be thusly infused by singers during a performance (Kone 1997). It happens quite frequently. When we talked, Sidi Ballo could not emphasize enough how important good singers are to masquerading. He said they can charge you to a point where you will execute movements or gestures in your performance that you did not intend to try, that in fact you did not consider yourself capable of doing. It is not just the *nyama* in speech that causes this; it is also the *nyama* that comes smoking out of a beautifully sung song.

Many people said to me that without good singing you cannot have good dancing or good masquerading. Yaya Traore, the former bird masquerader and mentor of Sidi Ballo, said with conviction that good singing empowers bird masquerading. Without it, a bird dancer will not be able to do much because *A fari bè faga,* "his muscles will be dead," meaning he will have no inspiration. But a good singer will fire up a masquerader's heart and infuse him with profound power, *sitaniya,* the power found in potent amulets, secret, sacred objects, and words charged with huge amounts of *nyama.*[3] He will perform moves and feats he never imagined possible. Bafing "Walkman" Dumbiya, Sikòròni's youth association leader in 1998, said a bird masquerader cannot dance at all until a singer has sung him a song. If the singing is not good, the dancing will not be good either. If the singing is very good and slings praise at the dancer, the performance can become heated indeed. At Dogoduman, Mayimuna provided Sidi with plenty of excellent singing and plenty of high praise, with results that Sidi considered measurable. He said she made him perform better, the perfect example of complex agency fruitfully at work among people. I think the Dogoduman young ladies' chorus did the same thing for the Ntomoni dancers. Yaya Traore summed it up like this: "To see the body of the man inside the cage unwrap, *walanwalan,* it is the words of the singer that have

reached him under the cage." He used "unwrap, unwind, spread out," to mean successful execution by the masquerade dancer (Kone 1998).

The infrastructure of Mande performance facilitates its orientation toward inspiring action through affect. The act of praising audience members at a performance provides an excellent example. People can be praised (*majamu, mabalima;* there are many other words and phrases for it) with songs or recitations that address them, their ancient or recent ancestors, their clan's distinctions generally, or their professions. Praise is proper acknowledgment for accomplishment. When it comes from bards, it is also an excellent source of income for the bards doing the praising, because one is obliged to pay them, both to dissipate the *nyama,* if that is what is desired, and to show that you are worthy of the honor. Praising can also be critical and challenging, by calling to your attention people of more accomplishment than you.[4]

But praising is also something Kassim Kone calls blowing your ego, and what he means is expressed in this axiom about the possible consequences of praise: *Ka I mabalima k'a fili a jèrè ma,* "to praise you to the point that you do not recognize yourself." It means that praise can inflate you and make you mistake yourself for something or someone else, lose your sense of yourself, and lose a sense of your capacities, so that the next thing you know, you have achieved something grand, something you never would have dreamed yourself able to do (Kone 1997). Indeed, you would not have been, if not for the fact that a performer made you wander away from yourself and infused you with *nyama,* thereby giving you new perspectives on yourself and new capacities to act.

Praise can be so radioactive with this potency that you can be touched when it was intended for someone else, so that in effect an innocent bystander is infused with the energy to act. Kassim said that this is how things happen: "People decide to take the initiative, to strive to accomplish something, simply because they were at a performance where praise was directed at someone else. And when the praise is directed at you, the energy it can instill is twice as strong" (Kone 1997).

This is part of the rich paradox of *nyama.* We have seen that a great many Mande consider it to be fearsome as well as awesome, and many say it can only be terrible and negative (Kone 1997). Yet *nyama* can be activated and directed by experts in ways that lead to very good things for people and society. It can bubble up out of a performance and lodge in people. Both as beauty and as power it enters them, goes to the heart of their being, and explodes them into motivated action. Thus there are these moments when, as a perceived reality, a metaphor, or both, the overwhelming weight of this energy affords people valuable opportunities often previously unimagined.

This power of art does not affect everyone, nor does it affect anyone all the time. The issue of unpredictable consequences is always at play. Some people

will never take Sidi Ballo's bird masquerade beyond the level of pleasant or theatrically stimulating entertainment. Other people will feel the same way about Mayimuna's singing, or the performances of the youth association, or of bards or hunters' bards.

Still, virtually everyone seems to find some performances galvanizing. There can be that particular night, when the situation is right, that people who have seen Sidi Ballo perform five times before will this time be moved outside themselves and cast into deep thought. Thus, the possibility of potent affect is always there, and Mande aesthetic concepts nourish it effectively.

AESTHETIC AFFECT AT WORK

Performances create aesthetically charged environments. Audience members may focus on particular elements or be caught up in the whole event, with sights and sounds compounding each other. For example, the words of songs delivered in effective harmonics and rhythms get stuck to the visual elements of costume and choreography and vice versa. That amplifies the impact of each part so that meanings and values become more potent and socially motivating. This is aesthetics' social clout.

That clout was often in evidence at Dogoduman, and it was frequently applied to one of the evening's prominent themes—hard work and skill acquisition to develop worthy excellence in life's enterprises. As people watched the bird perform marvelous and miraculous feats, they heard songs that heaped grand praise on accomplishment. These components—dancing that demonstrated worthwhile, tangible achievement, and beautiful songs full of socially charged and elegant praise—readily mixed together in audience members' heads so that mind stretching was always a possibility.

An excellent example is Mayimuna Nyaarè's performance of three songs for blacksmiths. Using aesthetic strategies of performance, her lovely singing generated a quality of beauty that led to enjoyment, stimulated thought, and encouraged action. Remember that praise for a singer includes the structure of a song—its phrasing and tempo, for example—as well as the quality of the voice and the meanings of the words. Singers often reconstruct songs, adding and subtracting words or phrases so that lines are recontextualized in relation to each other and the song suggests new sensibilities, nuances, and interpretations. This artistic license is part of the play of structure and spice, but it is frequently aimed at specific local situations and designed to generate affect.

Like many other singers, Mayimuna Nyaarè took advantage of language characteristics. Mande languages can be used to deliver crisp, clear messages. But they are frequently used in more complicated ways, where multiple inter-

pretations, intricate nuancing, and great sensitivity to context all come into play. It is another testimony to form's complexity.

Compound words are good examples. Mande often join words together to create compound words that create new meanings. Such words can be quite stimulating because frequently their component words express ideas that seem contradictory or in conflict. Often, too, the meanings of compound words are dependent on the exact context in which they are used. Frequently, people will use the same word, compound or not, to express very different things. At one moment, a word can be used to praise an individual or a group, and at another moment that very same word can be used to critique, belittle, and insult. Furthermore, compound words can be highly ambiguous, so that no matter what the context, there are many ways to interpret them, or even no obvious ways at all.

Kassim Kone says that all this ambiguity and complexity leads Mande people to say of their languages (such as Bamanakan): *Bamanakan ka gwèlèn,* "The Bamana language is hard." They mean their language has this pronounced capacity to be both perplexing and intellectually stimulating. Often adults, even elders, continue to ponder words and phrases they heard years or decades ago, which makes their language into a kind of forum for philosophical thought and delightful fuel for internal dialogues.

Songs often partake of this language complexity, as the three blacksmiths' songs Mayimuna sang in the middle of the Dogoduman performance show. The first seemed to critique them. The second encouraged them. The third praised them. The first song addressed young blacksmiths, both as hypothetical subjects and perhaps (if the shoe fits) actual persons whom everyone in the audience knew. That kind of ambiguity makes people wonder, makes people think, so it helps capture listeners' attention. The song began with a very hard hit by using the word *nantan*, "antihero," in a three-line refrain repeated four times as the song moved along:

Oh, antihero, oh.
Weak young blacksmith.
The antihero is always full of regret.

I yoo nantan yo.
Numu kamalen nantan yo.
Nantan ni mònè.
(Camara, McNaughton, and Tera 1978, 5/22)

Sekuba Camara (1978) spoke at length about the word *nantan*, "antihero," which also means "useless" (Kone 1997). He said it is used to denote the opposite of a hero. In the Mande world of performance, and rippling throughout Mande thought and action, the concept of the hero plays a

powerful inspirational role, as we have seen. The hero, *ngana,* is a person brimming with competence and capacity, confidence and daring (Bird and Kendall 1980). Heroes consistently play central, illustrious roles in the great epics and stories about Mande history and social life. The antihero is a person who is never successful, always afraid, cannot do anything right, and is very weak—in other words, a creature who garners no admiration and no sympathy.

Sekuba associated the word *nantan* with *na,* which means, among several other things, "to come," and he linked his association to the idea of destiny. Destiny (*dakan* or *nakan*) is another enormously important concept for Mande people. It encompasses a complex combination of the preordained and the ability to enhance or improve it, along with the necessity to always live up to it. Mande say that people of destiny are individuals who can cut a grand path through history and have a significant effect on the lives of others. Sekuba said that the antihero, the *nantan,* is devoid of destiny, anonymous, like someone who did not come.

Living on in oral history is an important idea that complements the Mande concept of destiny. As a matter of general ethos, it is highly desirable to accomplish so much in life that one's name lives on. As Sekuba Camara put it, if you do that you will still die, but not completely. Thus the saying: *Saya yèrè yèrè ye: bò fu, sa fu,* "Real death is: to be born for nothing, and to die for nothing" (1978).

This saying and the line in Mayimuna Nyaarè's song characterize people who never do anything important. Taken literally, it would apply to many people in any society who simply move along through relatively uneventful lives. But history and memory are local as well as regional, and accomplishment is relative. Parents and spouses of competence and good character gain renown down the generations in their own families and in their own towns, and that is a noble enough aspiration to counter the foreboding of Sekuba's saying. Local oral histories often honor the names of individuals who did not become famous everywhere but are nevertheless well remembered in their areas, often across quite a few communities, for their abilities in business, religion, medicine, government, farming, or any other worthy line of work. Accomplished blacksmiths from generations ago, for example, may never have been heard of three hundred miles away. But locally their names and work are remembered. Their children and grandchildren are honored in the songs of bards. Their favorite bellows rhythms can become emblems that contemporary blacksmiths use to honor them. A powerful work ethic abides in Mande, and it can be enacted to prevent the complete death in Sekuba's saying. The mediocre and lazy, however, do not escape it, and it is to this lack of motivation, discipline, effort, and dedication that the first three lines of Mayimuna's song speak.

There is another irony here that also involves working hard and becoming all that you can be. Mayimuna Nyaarè's song uses the word *kamalen* to refer to the young smiths. We saw earlier that *kamalen* identifies a time in young men's lives when they are active and full of vigor, when they are in the process of building their destinies into reality (the corresponding phrase for young women is *sungurun* or *npogotigi*). It is a time for bold action and brave, determined behavior, no matter what the field of play. Thus, in the line translated as "Weak young blacksmith," juxtaposing *kamalen* with *nantan* has the effect of sucking all that is praiseworthy away from youth and leaving a hollow shell. The same reduction occurs many lines later with reference to an elephant. Thus, this song begins inauspiciously for those who could find fault with themselves and continues in the same vein, elaborating defects:

> You claim you are a blacksmith.
> You don't work wood.
> You claim you are a blacksmith.
> You don't sculpt wood.
> Young smith who doesn't make hoes.
> I am speaking to you.
> Young smith who doesn't make mortars.
> I am addressing you.
> You are an elephant who can be carried on one's shoulders.

> *Ko i ye numu ye.*
> *E tè yiri dila.*
> *Ko i ye numu ye.*
> *E tè yiri bò.*
> *Numu kamalen daba dabali.*
> *Ne bè n'i ye.*
> *Numu kamalen kolon bòbali.*
> *Ne bè n'i ye.*
> *Kamankun na samakè ye.*
> (Camara, McNaughton, and Tera 1978, 5/22)

As is the case in animal symbolism over much of Africa, few creatures can suggest as much massive, muscular, awe-inspiring, and often regal force as an elephant. But to be an elephant so insubstantial as to ride on people's shoulders is indeed to be a hollow shell, all trappings and no substance—thoroughly inadequate.

More lines amplify the critique. Here are some excerpts:

> You claim to be a smith.
> You can't make an axe.
> Sliver of rock among pieces of rock.

You claim to be a smith.
You don't know the world.
Weak leader among the group of elephants.

Ko i ye numu ye.
I tè jele da.
Farakuru rò farakò yo.
Ko i ye numu ye.
I tè dinyè dòn.
Samakulu rò samaka yo.

That is the song's final line, and it contains one last ironic barb. When the word elephant (*sama*) was used before, *cè* (or *kè,* man or male) was attached as a suffix. This time that suffix is intentionally corrupted to *ka*. We translated the result as "weak elephant," but that simplifies something subtler. As Sekuba Camara pointed out, it is an example of something that looks like something it is not. Deforming a word you have associated with a person implies that the person is not really a good example of what the word refers to, in this case, a male elephant. Thus, the inadequate smith is no leader or even an elephant among elephants. He is a sham.

Kassim Kone knows this song well and says there is another way to sing it. Instead of corrupting *samakè* to *samaka,* the *kè* is left intact, which makes that line mean "Male leader among the group of elephants." Then, a final line is added: *Ne b'i wele,* "I am calling for you," and the implication is that the singer is calling for one who is not there (Kone 1997).

As we consider the nature of form and the importance of affect, it is worth remembering that Mayimuna Nyaarè is not singing the lines of a rigidly established song. It exists as a general template, to be sure, and many singers can choose to perform it just as they have heard it sung by others. But any number of variations can be created by the additions and subtractions a singer makes. Good singers make choices based on knowledge of the audience. In this song, for example, Mayimuna frequently adds linguistic complexity to invoke more emphatically a play on ambition, motivation, and personal responsibility—all ideas that are contained within the Mande notions of mother- and father-childness, the time of youth, destiny, and the desire to be remembered in history.

By performing this song, Mayimuna was not heaping criticism on all of Dogoduman's blacksmiths, who numbered about six. In fact, when she sang it and the two that followed, the smiths formed a line in the arena and danced. Dancing to songs sung publicly for you is considered an honor in Mande, and when these three songs were finished, one of the smiths gave a gift of money and thanked Mayimuna for the distinction she had bestowed. This first song had the principal effect of praising talented and hardworking blacksmiths

(and, by extension, members of every other profession) through the vehicle of spotlighting its antithesis. Clearly, the dancing blacksmiths could identify themselves with the elephants of substance, with the pieces, not the slivers of rock.

But at the same time, in that subtle psychological world of aspiration, self-appraisal, and potential guilt, this song offered any smith, and everyone else not quite happy with themselves, a direct descent into hard-edged introspection. Even some of the smiths who danced might wonder if they had actually lived up to the honor. And if, among the audience, there were young sons of smiths who were not taking their apprenticeships or future profession seriously, this song would heap a battery of stinging critique upon them.

The next song Mayimuna performed offered encouragement to young smiths—or again by extension—anyone who is inadequate but still has potential. Its lyrics were more gentle. Like the first song, this one also employed the rich complexity of Mande language to create a powerfully evocative sensibility that becomes a part of the song's poetics because a carefully chosen word that is the song's linchpin is repeated nine times over the course of twenty-eight lines.

The first smith song used the intentional corruption of a word to amplify the conception and feeling that the lyrics produced. In this second song, a particular word is employed to create simultaneous references to states of being and their opposites, which has the effect of encouraging listeners to think about the situation the song describes. No wonder many Mande say that every festival is an opportunity for educational dialogue!

The word is *jabaliya*. It is a compound construction that transforms its first part, *ja*, "dryness," into its opposite, so that it means the one that does not dry up, like a fountain or spring, a source of life (Kone 1997). The second song begins with a refrain that includes the following lines:

> Be generous.
> There is pain in death.
> But it is never too late.
>
> *Jabaliya.*
> *Ko nyani ye saya ko rò.*
> *Ke tè tèmè.*
> (Camara, McNaughton, and Tera 1978, 5/23)

In Mande songs, full sentences are often drastically reduced, and a single word can carry a great deal of meaning and value for people who are familiar with its use. This refrain is an excellent example, because without explicitly saying so, it implies for experienced listeners that, while there is tremendous sadness in death, being generous and giving the best of yourself so that you are

like a fountain, a source of life, will reduce the sadness of death for you and your loved ones as much as any earthly action can. And if you have not given all you can or become all you can be to facilitate that giving, it is never too late to change, to make something of your life before you die.

Reducing full sentences in songs is a powerful element of Mande aesthetics. It is called *kumakolo*, "the bone or kernel of speech," or *kumakoroma*, "speech with a bottom; meaningful speech." It is used by singers, statesmen, and all kinds of people who depend on effective public word-craft to persuade, influence, or get other people to think. It works because people have many shared experiences of real-life situations, but it only works effectively when singers or speakers choose words that plunge listeners into those experiences. While I presented *kumakolo* earlier as an example of clarity and clear structure (*jèya*), in this song its dependence on people's experience gives it the quality of both clear structure and spice. It's just that Mayimuna is letting her listeners add the spice.

That is why *jabaliya* is such an interesting word to use here to create the meaning "be generous." The shared experience of its use in this part of the Mande world allows it to radiate the idea of mother-childness generosity in a framework of social responsibility and personal effort. A more straightforward choice would perhaps have been *fonisire*, which also means generous. But many Mande liken generosity and the personal character and work it depends on to moisture, whereas dryness can be used to describe people who have never developed their social character, who have never put forth the proper effort, and so, in effect, have dried up. *Ja* means "to become dry or desiccated." *Bali* transforms that into its opposite, "be wet, be moist," while *ya* is another suffix that locates the action of staying moist with an actor, in this case the people whom the song addresses. In the context of this song and its refrain, the Dogoduman audience's shared experience would encourage them to understand *jabaliya* as "be generous, try to give the best of yourself, try to improve yourself" (Camara 1978, Kone 1997).

The song goes on to capitalize on *bali*'s nature as on oppositional or negative suffix by offering up the following lines:

Little smith who can't sculpt wood.
Try to give the best of yourself.
Blacksmiths don't cultivate a cemetery.
Little smith who can't work iron.
Try to give the best of yourself.
Blacksmiths don't cultivate a cemetery.
Little smith with no distinction.
Try to improve yourself.
Blacksmiths don't cultivate a cemetery.

Numukènin jiridòn bali.
Jabaliya.
Numuden kulu tè sèlèdo sène.
Numukènin nègèdòn bali.
Jabaliya.
Numuden kulu tè sèlèdo sène.
Numukènin jala don bali.
Jabaliya.
Numuden kulu tè sèlèdo sène.
(Camara, McNaughton, and Tera 1978, 5/23)

"Can't sculpt wood" and "can't work iron" are both created with *bali.* The words used are compound and condensed. For example, *jiri* means "wood." *Dòn* means "knowledge." Together they form "knowledge of woodworking." Adding *bali* to the end generates an opposite condition. It means a lack of knowledge, an inability. There are, of course, other ways to say this. You could say *Numu tè sè ka jiri baara,* "The smith can't work wood," or *Numu tè sè ka jiri tigè,* "The smith can't sculpt (shape or cut) wood." But *jiridòn bali* says much more, because it brings in the idea of appropriate knowledge and brings both the positive and negative conditions of knowing and not knowing how to work wood to our attention. It does all this in an economical five syllables and has the added benefit of creating an audio-conceptual link to the use of *bali* in the refrain and in every line that comes after an indictment of inadequacy.

> Little smith who can't sculpt wood (*jiridòn bali*),
> Try to give the best of yourself (*jabaliya*).

The poetics of this construction are wonderful, because the rhythm that the repetition sets up is beautiful, while the repetition is transformational. Every time it occurs, the conceptual movement is from something negative (*jiridòn bali,* for example, the inability to sculpt wood), to something positive (*jabaliya,* "try to give the best of yourself"). This is social aesthetics in action. This is a smart song. This is irreducibly rich form.

The repeated line *Numuden kulu tè sèlèdo sène,* "Blacksmiths don't culti-vate a cemetery," is a very evocative and poetic way of saying that true black-smiths devote their hard work to making life better and that anything less than their best might not hold the cemetery at bay. *Numu* means "blacksmith." *Den* means "child." But the two words joined like this means "true smiths," accomplished smiths, genuine and honorable children of the profession. This is in sharp contrast to the construction *numukènin,* used throughout the song to refer to the incompetent "little smith." *Kè* indicates male gender, and *nin* (or *ni*) is a suffix that makes its referent diminutive. Not always, but in this case, it

is an insult, a slight that highlights inadequacy. (In other contexts calling someone a "little smith" would in fact be strong praise.) Thus, the song's word-play repeatedly generates tension between the idea of an honorable child of the profession and an ignoble little practitioner.

Finally, in this line there is the word *kulu*, which means, as it did in the song before, a group, as in a herd of elephants or the collective members of the smithing occupation. For those in the audience who care to notice, its use by Mayimuna Nyaarè links the first and second songs, encouraging their contemplation in relation to each other.

In this graduated ascent up blacksmithing accomplishments, the third song offers good smiths spectacular praise, the highest praise any professional could ever hope to receive. It begins with a simple, elegant phrase that is once again packed with evocative nuance:

Oh smiths, oh blacksmiths.
True smiths are the eradicators.

Numuw yo, numuw yo.
Sabu lasa ye numudenw ye.
(Camara, McNaughton, and Tera 1978, 5/26)

Sabu means "cause or reason." In the context of this song, Sekuba said its meaning expanded to "principal or major cause" and expanded again to include someone who provokes something. *Lasa* means "to oppose, prevent, hinder, end." Together, they refer to people so powerful that they can prevent the cause or reason for a consequence, thereby preventing the consequence by nipping it in the bud of causation. Kassim likened this degree of power to being able to prevent a baby from being born or a tree from bearing fruit (Kone 1997). Sekuba translated it in the song as "someone who destroys the foundation of a catastrophe," the eradicator of misfortune (Camara 1978).

To understand the sense of this, it is necessary to understand the roles that smiths have played in Mande societies. Iron making and working is an ancient profession in this vast region of West Africa. It began before the time of Christ, and it was linked very early on to complex society, professional specialization, and commerce (S. McIntosh 1984, R. McIntosh 1998). Also early on, blacksmith practitioners coalesced into a collection of professional clans, and through focused effort and happenstance a monopoly on iron work developed, along with a rationale to make the monopoly seem natural. This rationale is linked to Mande ideas about the system of energy we know as *nyama*.

Given their link to *nyama*, it could seem almost natural that smiths developed expertise and reputations as herbal doctors, soothsaying specialists, and sorcerers; and these reputations grew into a popular imagery of blacksmith potency that has made them major players in the practice of Mande religion

(McNaughton 1987). In the song, *sabu lasa* implies that smiths are *dalilutigiw,* masters of the recipes of spiritual power that can make things happen or not happen in the world (Kone 1997). To many Mande it seems equally natural that smiths became the leaders of the Kòmò, with its *nyama*-laden instruments such as the headdresses we know today (McNaughton 1979). Thus it came to be viewed as normal and customary for smiths to hold positions of leadership in nearly all of the religious associations, even though numerous non-smiths held such positions, too.

Iron smelting (the manufacture of usable iron from ore) gradually diminished as a consequence of colonialism. But the huge numbers of smelting furnace remains across the Mande diaspora—by now there is sometimes so little left of them that they are known principally by legend—indicate that smelting used to be a major enterprise; and the great structural variety in those furnaces indicates that over centuries blacksmiths experimented extensively with their iron manufacturing technologies. Today, as in the past, virtually every town has one or several families of smiths. Dogoduman had at least six such families living both within its boundaries and in the Saturday City blacksmith's hamlet, a mere three hundred yards away. In 1978 smiths could be found nearly every day making the tools and utensils that everyone depends on—from the array of ceramic vessels that women of blacksmith families create, to the iron and wood cooking, farming, hunting, and fighting instruments that are made by the men. Smiths make the stools that everybody sits on, the mortars and pestles that everyone uses to prepare their grain, and most of the guns that hunters today and soldiers yesterday have used. Smiths, in short, are central to Mande life. Without their enterprise, living could indeed be a catastrophe. Clearly, their works help to eradicate misfortune.

Mayimuna Nyaarè's third song extolled the ancestors of smiths. The poetic device it uses is the popular image of iron smelting, the reference word being the smelting furnaces (*gwanw*) that used to dot the landscape, sometimes in enormous clusters, but that have now largely crumbled back to their foundations in the earth from which they were made.

Smelting has come to be viewed as the blacksmiths' enterprise par excellence. It involved tremendous work (days or weeks of gathering ore and the wood for proper fuel) and so reflected a widely held view that smiths often have arduous work ethics. Smelting took place in the wilderness and thus invoked ideas about the dangerous animals, spirits, and energies that abound in that uncivilized space, and the powers necessary to deal with them. Smelting involved a tremendous transformation of material, from a rock-like state to one of supple, malleable, useful iron. And it involved a lengthy furnace-firing procedure, sometimes as long as three days, which was grounded in much technological and ritual activity.

Smelting and smelting furnaces seemed a bit like miracles, and that is the gist of this third song's lyrics. In twenty-six lines, several products are listed as having been created through miraculous processes, so that the song generates a delightfully mysterious characterization. Here is a sampling:

> When they go to fire the high furnace.
> The stronger transforms the weaker into a hoe handle.
> When they go to fire the high furnace.
> One transforms another into a pretty little mortar.
> Real smiths are the masters of sorcery.
> When they go to fire the high furnace.
> Some of them transform their mouths into bellows.
> When they go to fire the high furnace.
> The stronger transforms the weaker into the bellows' little wind.
> Real smiths are the masters of sorcery.

> *U maa don gwan tugu la.*
> *Kelen bi kelen kè dabakala ye.*
> *U maa don gwan tugu la.*
> *Kelen bi kelen kè kolonin ye.*
> *Suya tigi ye numudenw ye.*
> *U maa don gwan tugu la.*
> *Kelen b'i da kè fan fana ye.*
> *U maa don gwan tugu la.*
> *Kelen bi kelen kè finyènin ye*
> *Suya tigi ye numudenw ye.*
> (Camara, McNaughton, and Tera 1978, 5/26)

This song articulates the aura that has grown up around Mande blacksmiths by depicting them as so extraordinarily potent with *nyama* that they can transform each other into the products that people depend on. On the other hand, smiths in real life are the neighbors of their clients and often also their friends, and in that vein they are perceived as people. Their habits and characters as individuals become well known to their communities just like everyone else's. And as often as with everyone else, there are smiths whose habits and characters leave something to be desired.

Thus, a song that praises smiths as the eradicators of misfortune does not apply to all blacksmiths, carte blanche. In fact, this song is simultaneously a challenge and a critique for every smith who may have felt that the first song Mayimuna sang applied at least in part to him. The lyrics of this third song are an excellent example of a Mande pattern of artistic coercion that the bards and hunters' bards have made so well known. By invoking the accomplishments of a family, a clan, or a profession's ancestors, the accomplishments of contemporary practitioners are also being held up for close scrutiny. Therefore, in an interesting way, the first and third songs Mayimuna sang for smiths are not so

very different in effect, though they might seem worlds apart. Along with the second song they are a balanced approach to both praise and critique, an approach with a broad spectrum of access to the hearts and minds of audience members.

Mayimuna Nyaarè was a smart performer. She knew how to use aesthetics effectively as strategies of social action so thoroughly enhanced with artistry that it was hard for her work not to have an effect on people. But there is another interesting element that further heightened the impact of her smiths' songs, and this involved Sidi Ballo.

All except the very young at Sidi Ballo's Dogoduman performance knew he hailed from the clans of smiths and had in fact once been a practicing blacksmith. The identity of smiths is as much linked to their clan membership as it is to the actual work they do, so even though he had changed professions, as he performed to Mayimuna's songs, he could readily be conceived of as a smith of profound accomplishment, the epitome of what the songs extolled.

There is another amplifying feature, the praise name Kulanjan, which was called out by the Dogoduman audience more frequently than any other. Here is a name with a complex history and numerous interpretations, some of which are regional and others arcane enough so that many people might not consider them. All of them, however, associate power with this blacksmith-masquerader. We will consider them here, instead of in the next chapter on meaning, because they give insight into Mayimuna's singing virtuosity.

Some Mande say Kulanjan is the name for an aquatic bird; others say specifically that it is a pelican. Indeed, hundreds of miles to the east in the Segu region, a youth association bird masquerade is named Kolanjan and seems to represent a pelican (Arnoldi 1995, 82). Still other Mande say it is not the name for pelicans, but rather a praise name for them, because they are considered to be expert hunters of fish. It can also be a praise name for eagles, who are expert hunters of everything. Sidi said in 1998 that it refers to the marabou stork, which is another impressively capable hunting bird. And finally, some say it is used to refer to human hunters, again by way of praise.

All these birds are highly regarded by Mande for their hunting prowess. Eagles, like hawks, are always honored as most impressive observers, divers, and prey snatchers. They are often linked to Mali's great heroes of the past. Pelicans are most impressive too for their ability to pluck fish from water. Imperato (1999) notes that another name for pelican is *tala dun kònò,* which means "blowfish-eating bird" and refers to the pelican's ability to swallow large fish whole. This constitutes noteworthy and unusual power.

The marabou stork (*sajume*) is a prodigious hunter that feeds on carrion. Its presence is seasonal, and its arrival announces the beginning of the rainy season, when many youth association masquerades and independent bird masquerades are held. This bird is said to be enchanted, with miraculous capabilities like the ability to disappear only to reappear somewhere else

(Kone 1998). Sidi noted that, with his *dibilan* amulet of invisibility, he can do that too.

Acclamation for hunters is an important part of this praise name's meaning because expert Mande hunters (*donsonw*) hold positions of great stature and authority, liberally mixed with awe and not a little fear. Historically, hunting has been for Mande a vocation, avocation, and passion of brave, bold, tough, perceptive, smart and talented men, with all of these attributes focusing on the ability to track animals and stay alive in the wilderness. Hunting has been a major pathway both to sorcery and to military might (Cashion 1982; Cissé 1964; Levtzion 1973, 56–58; McNaughton 1982b). Mande hunters are often considered to have been the movers and shakers behind the monumental chapters in Mande history, and they are just the stuff from which heroes are made.

Thus, it is significant that Kulanjan is also the praise name for a specific eagle that taught the family of the legendary hero Fakoli how to hunt (although some people, including Sidi Ballo, say it was a marabou stork, not an eagle). The oral traditions say that Fakoli was a blacksmith like Sidi Ballo and also the nephew of Sumanguru Kante, the legendary blacksmith-sorcerer king, who aggressively ruled an emerging Mande state called Soso (originally part of the Ghana Empire) in the early thirteenth century after Ghana had fallen.

Ultimately, Sumanguru tried to consume another Mande group, the Maninka, headed by another legendary hero, Sunjata Keita, also a renowned hunter. The struggle between these two antagonists and their armies was monumental. It is a major chapter of the Sunjata epic (J. W. Johnson 1986, Niane 1982), one of the best-known epics in Mande West Africa. As the struggle reached an apogee of apparent stalemate, the traditions say that Sumanguru stole Fakoli's wife, and Fakoli switched allegiances to help bring down his uncle. Fakoli's popular image is as a fearless fighter, brilliant military strategist, fearsome sorcerer, and astute diplomat whose speeches never failed to win converts to Sunjata's cause. He was, it is said, an excellent master of that aesthetic strategy called "the bone of speech." He is a point of reference for many Mande when they hear the praise name Kulanjan. In fact, the praise name is not only for the eagle (or marabou stork) that mentored the Fakoli family; it is also, by extension, one of Fakoli's own praise names.

There are more ideas associated with the praise name Kulanjan. It also means "long" (*jan*) "anvil" (*kulan*), and in this interpretation becomes a reference to a blacksmith's working anvil, so potently charged with the energy of action (*nyama*) that it has become a threatening thing, an animate object that can levitate and fly of its own accord and attack people like a fierce bird, with enough weight and force to kill them. Sekuba Camara and Kalilou Tera likened "the long anvil's" capacity to the tough, controlled, but furious rush of an attacking eagle.

In Mande, creatures or things that possess awesome and potentially dangerous or deadly power are often selected as metaphors of praise for artistic achievement. It is an emphatic way of saying that virtuosity makes you helpless before it. It is also an effective way to suggest that outstanding artistic achievement has the social potency to move, affect, and even overwhelm people. For example, another praise name that the Dogoduman singers often incorporated into their songs about Sidi Ballo was *dankelen,* which literally means "isolated one" and refers to a wild animal so smart and strong that it has managed to grow very old, and in the process it has become so exceedingly dangerous that other animals of its kind choose to stay away from it. Thus it is said to "walk alone." Interestingly enough, in popular thought such beasts are considered particularly inclined to attack people.

The meaning for this compound word is not derived straightforwardly. *Dan* is defined in Bamana dictionaries (Bailleul 1981, 38; Bazin 1965, 107) as "escape." But Sekuba pointed out that it can also be used to mean isolated in the sense of being forgotten by a social group. *Kelen* can mean "one, single, or solitary" (Camara 1978). Kone notes that *dan* can mean "limit," and *dankelen* can translate directly as "limit one to oneself." For Mande, it invokes the dual image of people who are self-sufficient but also so laden with the extraordinary powers of *nyama* that they are too dangerous to be anything but alone (Kone 1997).

A related word that delivers similar praise is *dankòròba,* which literally means "very old and isolated." Sekuba suggested that the term is a kind of amplification of *dankelen,* an old, solitary wild beast who has grown all the older and therefore all the more powerful. There is even a time of night that is named after people and creatures who are described by this term. *Dankòròbaw yaala tuma* means "the time the *dankòròbaw* walk about." It is the late hours of the night when only the powerful come out, such as predator animals (particularly hyenas, *namaw, surukuw*) and very old men (*cèkòròbaw*) and sorcerers (*subagaw*). It is considered, in fact, a natural time for these beings to be out. But for everyone else it is dangerous because wilderness spirits (*jinnw*), obscurity (*dibi*) and antisocial sorcery (*suba* or *subaya*) abound. To be abroad at these late hours requires exceptional power, the power that derives from secret things (*basiw*), power recipes (*daliluw*), the energy of action (*nyama*), or the spiritual energy inherited from good mothers and maintained through proper living (*baraka*) (Camara 1978, 3/39). Heroes often possess these prerequisites, as do hunters and many blacksmiths. Blacksmiths with as much artistic accomplishment as Sidi Ballo would seem to be particularly good candidates for venturing out in these treacherous hours.

When performers are really good, praise names are slung at them quite frequently from the audience, so that at Dogoduman I repeatedly heard "Eeh Kulanjan!" ("Hey Kulanjan!"), as people all over the arena, all night long, offered up their appreciation. That praise did not mean the same thing to

everyone proclaiming it. But for all it was an accolade of potent accomplishment offered to a grand performer who was also a blacksmith.

Mayimuna's three blacksmith songs, then, had more than Dogoduman's smiths as referents. They had the event's featured performer, whose accomplishments and expertise were broadly acknowledged and frequently praised, and whose performance character invoked great smiths from Mande history in ways that gave the three songs all the more punch and made them all the more persuasive. The result was a most effective articulation of Mande aesthetics.

Besides the six smiths in the Dogoduman audience and Sidi himself, Sidi's apprentice, Sibiri Camara, was also a blacksmith, as were all but one of the drummers. The vast majority of audience members were not. But blacksmiths, with their power, responsibilities, and strong work ethic, are among several ideal subjects (with hunters and heroes, for example) for generating circumspection about personal accomplishment in any enterprise at all. Mayimuna delivered these three smiths' songs with elegance and power, and when the smiths danced to them, it was easy to see that successfully employed aesthetic strategies contribute to a sense of solidarity and challenge that can only be good for communities.

These strategies involve choices of all kinds, made from knowledge and ability. At Dogoduman, Mayimuna Nyaarè had much of both, and the aesthetic acumen she demonstrated was the noteworthy result. I have lingered on Mayimuna's accomplishment because it demonstrates several fine things about Mande performance. First, it shows how extremely intricate and involved aesthetic considerations can be. Mayimuna's wordplay, for example, offered strong testimony to a wealthy artistic environment, as did her choice of songs. Her song choices also showed how oriented toward social potency art is, and how aesthetic strategies prime people to be affected, sometimes intensely. Her blacksmiths' songs were particularly affective, and they added tremendously to the evening because they incorporated local smiths, a tribute to good smithing, the ideal of good smithing as an instrument of broader social evaluation and critique, and a vehicle for audience self-examination—and all of this as a highly charged artistic foil against which the hugely talented blacksmith-masquerader Sidi Ballo performed a dynamic, stunning, intricate, and endlessly captivating demonstration of the virtues of accomplishment writ large in a dance arena.

In short, Mayimuna's aesthetic choices and artistic abilities intermingled very effectively with Sidi Ballo's to shape the event in ways that could not have existed had these two particular performers not been engaged. The intersubjectivity and the synergistic character of complex agency are as important in artistic landscapes as they are in every other zone of human enterprise. But complex agency is particular people intertwined, and the results that are achieved bear the attributes and character of those individuals.

Part 4

MAKING MEANING
WITH A BIRD

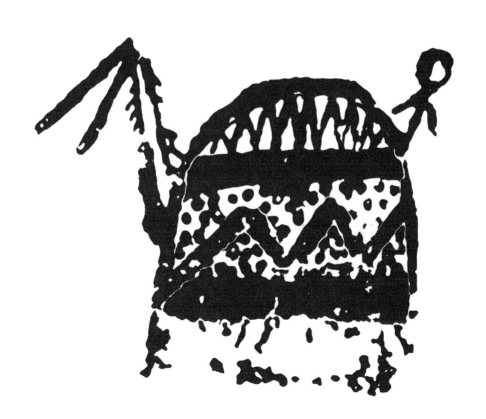

10

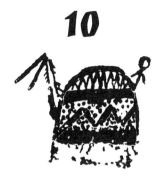

EXPANDING THE
BEHOLDER'S SHARE

At Dogoduman, most of the imagery from masquerades and lyrics was so familiar that the audience shared interpretations of what they heard and saw, at least in large measure. The very format of that evening near Saturday City was infused with common community experience.[1] Multimedia public performances staged by youth were widely encountered events, so people understood this performance's structure, its participants, and the characters presented. Audience members appreciated the hilarious nature of a wild bush buffalo and a Fulani maiden finding love in the wild. They understood the hunter's skit. They could interpret the meaning of not cultivating a cemetery or having your hands on your back before superb accomplishment. Young people would have different perspectives from older people, and the very young would need to listen and learn how their friends and family members responded to and talked about the elements of such performances, to start to get the gist. But there was a very large umbrella of overlapping understanding present that fine June evening, combined with high levels of affect that people also shared and the sense of solidarity and community produced by the event and its stunning performances.

For performers and audience alike, however, there was also much individuality in the ways people saw and heard things, the values they placed on performance components, and the elements they found particularly moving or

relevant to themselves. This facet of the Dogoduman bird dance was equally compelling and also grounded in experiences that make up personal histories and interior lives, those experiences that make people different. It is just that those experiences have supple, porous boundaries with shared experience. Given the nature of internal and social dialogue, and the effects of people living and working together, personal and social experiences spark back and forth between each other, bringing us again the phenomenon of individuals intertwined, this time engaging art. Moreover, art has the profound capacity to accommodate our grandest degrees of sociality and our most intimate interior spaces. In fact, art is often the spark between the personal and the social.

Such is art all around the world. That it is primed to oblige and facilitate the interpretations of both groups and individuals is, along with aesthetic affect, an enormous part of its clout and staying power. This is true for expressive culture generally—from performance arts to visual arts, from music to literature, and all across the false divide that separates high and low arts, fine arts and so-called crafts. And it all goes back to the union of form and perception.

Perception as the swift formulation of sensation run through experience is the source of art's flexible and constant relevance. Form's protean nature and indelible connection to people and their experiences—the fact that just seeing form is actually an act of creating it from the interactions of shared social existence and the dialogues of interior lives—affords art vitality and dynamism of uncanny potency, at least for people and societies that are receptive to it. Form is that fundamental place where the power of people as individuals with personal histories full of knowledge, skill, and experience engages the power of people in groups full of experience expanded exponentially, with no power lost and tremendous synergy gained. If imagery seems to be alive and possessed of its own volition, a notion several scholars have found interesting,[2] it must be substantially because this triad of form, affect, and meaning emerges from our very essence as unique individuals intertwined into profound sociability. The processes we use to create and interpret form are fundamental to our very nature, so form partakes of the life we find in ourselves. That gives a bird masquerade and every other category of art a special kind of animation.

Thus art harbors co-dependence. Shared meanings and values are extremely important. They grant art its capacity to enter social discourse and be instruments of social action. Personal responses are equally important. They are loaded with nuance and variation, which constitute a whole new landscape of opportunity for personal development that flows out into social discourse and participates in the shaping of society.

But personal experiences with art are not common art history topics. Just as it is easy to miss the realm of individuals in the broader worlds of social interaction, it is easy to miss the personal experiences and interpretations that result during communal encounters with art. It is far simpler to ascertain what

people share in their engagement with art than what they experience individually. Often scholars have not even considered the personal experience of people, and just as often prevailing circumstances would have made such consideration essentially impossible. Practically speaking, we cannot interview every person who experiences a work of art. But if we could, what would we learn? Interior lives are not always accessible to discussion or analysis by scholars, and the effect of artworks on individuals is not always easily explained with words. The fullness of an art experience within us—the meanings and values we give it and the internal dialogues it joins—frequently resist straightforward explanation. Thus we stand at a gaping lacuna. Much of what we need to know is beguilingly beyond our reach. We want to understand how people engage individual artworks. We want to know what the bird dance at Dogoduman meant to people. But we cannot—at least not exactly.

We can, however, consider the possibilities that personal experience offers, alongside an understanding of the shared meanings that circulate through an event. We can try to see the breadth of interpretations that might be available to people at a bird dance. First, however, I want to consider an approach we can take to meaning that accommodates its vagaries and acknowledges the limits of our understanding but still invokes a spectrum of potential.

EXAMINING THE BEHOLDER'S SHARE

The art historian Ernst Gombrich (1961) coined a useful phrase—the beholder's share—to express the distribution of responsibility in creating meaning for art. That was in the middle of the twentieth century, a century of bountiful scholarship across a spectrum of disciplines devoted to unraveling the surprisingly complex problem of how people produce interpretations and give value to art, literature, and everything else in expressive culture and our daily lives. Many perspectives were deployed in this research, and many paths were followed. I present mere fragments, a terse sketch of a small portion of all the work that was done. It shows why, however, we are now better able than ever before to consider what makes meaning so rich and fluid, and why it is so profoundly fused to affect, value, and significance.

Beginning in 1900, the Italian philosopher Benedetto Croce ([1902] 1992) worked on a very broad theory that placed aesthetics at the center of human existence as a fundamental and crucially important activity of the senses and the mind that converted incoming sense material, what he called brute sensory stimulation, into form. For Croce, form was not what the senses bring us, nor was it passive, static, or neutral. Rather, it was the end result of a process he called intuition, which produces order and practical knowledge, and allows us to function in the world. He considered the creation of form

through intuition as uniquely human. It is at once a representation of the world and an active expression in which content is an inseparable component. Croce would seem to have been a phenomenologist and an action theorist far ahead of his time.

In his now-classic esoteric and nearly spiritual 1934 exploration of art and people in the world, the philosopher John Dewey presented perception as a phenomenally active and even adventuresome activity undertaken by bodies, minds, and senses working as one and in sync with their environment. He pitted perception against recognition, describing the latter as perception cut short by identifying familiar patterns or characteristics. Perception fully pursued can lead to near reveries of engagement, exploration, and discovery in the world or in an artwork. For Dewey, the activity of perceiving an artwork is as creative as the activity of making it (Dewey [1934] 1980, esp. 52–53).

The phenomenology of Maurice Merleau-Ponty also contributed importantly, though perhaps less directly. He argued in 1945 that the real world, the world that matters, is that which we experience with our situated bodies. Our bodies—our indelibly unified physical, sensual, and intellectuals selves—play tremendously active roles in exploring and learning about the world, and this dynamic engagement both fuels and characterizes perception. People are connected to the world so deeply that phenomenology asserts there is not really a boundary between our interior lives and our interaction with what happens beyond us.

In the middle of the last century, Rudolf Arnheim published several art history studies that asserted the strong role of thought in perception (see esp. 1969 and 1974 [1954]). He showed how seeing even the most basic forms and compositional features of art involved numerous critical mental processes. Then Gombrich (1961, 181–290; 1972, 17) presented his idea of "the beholder's share," a characteristic of perception by which people project "life and expression" into images from their own experiences.[3] He devoted more than a hundred pages (1961, 181–287) to what he called a psychological examination of how expectation and imagination complete indeterminate forms by calling upon viewers' experience. Sometimes, he wrote, pictorial clues are linked to people's practical familiarity with the world (202). Other times compositional clues are less resolved and there is a freer play of imagination (182–241). Michael Baxandall (1972) expanded Gombrich's idea of practical familiarity in a study of the common experiences that viewers of fifteenth-century Italian art had at their disposal as they interpreted the artwork of their time. Thus Dewey, Arnheim, Gombrich, and Baxandall laid a rich foundation for understanding how common life experiences help people produce shared interpretations of art.

The widely renowned cognitive scientist Julian Hochberg began to publish articles in 1962 that demonstrated the presence of thought in the most funda-

mental levels of perception. In addition, he explored the important role of personal experience in the recognition of imagery in painting.[4]

Meanwhile, other authors worked on personal interpretation and interior life. Nelson Goodman (1976, 1978, 1984) developed a philosophy of meaning that applies concisely to the arts. It emphasizes experience and creativity in our transformation of the information we all receive about the world into multiple new worldviews, all of which co-exist and are equally valid. He gives the power of making meaning to individuals, even though many individuals may share many aspects of the worlds they create. His work richly illuminates the importance of people's internal dialogues and interior lives. It was paralleled in anthropology by developments in action theory (Ortner 1984), and in sociology by the development of structuration theory (Giddens 1979, 1984). In both, people can be viewed as using the beliefs, practices, and institutions they encounter and engage as resources for creating new social institutions, beliefs, and practices. Shortly thereafter, Michael Jackson (1989, 1996) began providing eloquent explorations of phenomenology's relevance to making meaning and living life, insisting that we take seriously how people experience their worlds.

Scholars of literature from diverse fields such as philosophy, psychology, and comparative literature have developed similar ideas about the production of interpretation in both personal and social spheres, seeing reading as an act and readers as the actual producers of meaning.[5] Emphasizing interior lives, Robert Coles (1989) explored how individuals insert themselves into the characters and narratives of literature and remake them into forums for the examination of their own experiences and vehicles for experimenting with the larger meanings of human life. For him, the production of meaning is more than creative involvement with art—it is an instrumental engagement with life itself. In this way, interpretation and experience become so entangled that they may not be easily distinguished from one another. The novelist Richard Price acknowledges this power of the imagination with a character in *Samaritan,* who says of the stories he writes: "Even if they're not true ... they've set up house in us, they're part of us, they are us" (Price 2003, 37).

These authors and many more have moved us toward an exciting and useful comprehension of meaning. While they have taken very different paths, they moved in the same direction, helping us to understand that there is action in abundance in the processes of perception that produce meaning. Just as form is freighted with affect because we put it there, so too is it replete with nuanced meanings deposited on it by us.

The realization that people construct meaning every time they engage art is no small scholarly achievement, because it is almost counterintuitive. A disconnection generally exists between how meaning works and how it seems to work. Scholars used to imagine that elements in compositions and performances carried meaning to audiences. We thought artists poured

information into their creations by using visual units of a virtual language consisting of motifs and attributes infused with symbolism. Art viewers then received and responded to these meanings transmitted by the works. Believing meaning to be in form was almost a natural conclusion drawn from observing social behavior, because in practice, people frequently do treat meaning as if artworks possess it. The activity that moves perception to interpretation can be quick and without conscious deliberation, leaving people unaware that they have done so much work. In effect, we behave as if meanings are in images, and so in one sense, they truly are, even when artists or viewers do not agree on what the meaning actually is.

Feeling that meaning resides in artworks gives them immediacy and visceral affect. It is another part of the power of form, a reason why art can seem alive. So simply to say that people construct meaning might be to ignore the degree to which they take meaning to heart. As Jerome Bruner says: "It requires the most expensive education to shake a reader's faith in the incarnateness of meaning" (1986, 155). Sometimes too, people know very well that they have infused a work with meaning. Yaya Traore, Sidi Ballo's former mentor, did this with the original bird's head Sidi gave him. Nevertheless, in his practical reality, that sculpted red head possessed tremendous meaning.

Meaning does not haunt art in isolation. Rather, it is almost always linked to value, often in powerful manifestations that produce strong connotations of significance. Kassim Kone shared an example of this with me in the form of his response to a line from an epic he had just been reading that moved him most profoundly. It was a seemingly simple line about riding a horse to a certain site. It just seemed informational to me. But the bard had phrased it in such a way, with great elegance and just a little punch, that it plunged directly into Kassim's knowledge of the events the epic described and events in other epics, and it simply grabbed him with terrific intellectual and emotional force. Kassim was aglow with the significance of this line. His enthusiasm was infectious.

There is a line in the Sunjata epic that creates the same kind of explosion in my head. In many versions it is *Ka Mande wulu yala,* "to run the Mande dogs." It comes after much drama and daring, after numerous episodes about the sorcerer king Susu Mountain Sumanguru, Sunjata's great general Fakoli, fearsome serpents and magic *balafons,* and the several kinds of power it takes to vanquish a foe and make an empire. Some versions of the epic do not even include it, because they end when Sunjata defeats Sumanguru. But in other versions there is a little more. Sunjata sends people to the land of Jòlòf to buy cavalry horses. The Jòlòf king seizes the horses and replaces them with dogs, saying the Mande and their king are only good for running canines, not horses.[6] This insulting larceny so enrages Sunjata that his head swells to huge proportions and lifts the thatched roof off a building as if it were his hat.

The great general Tura Magan asks to lead an army against Jòlòf, is refused, and lays himself in his own grave until Sunjata relents and lets him go. Magan then defeats Jòlòf and conquers many western lands for the empire (J. W. Johnson 1986, 99). It is this defeat of the Jòlòf king that is invoked with the phrase "running the Mande dogs"—thereby packing into one little line a woeful underestimation of power, horribly miscalculated arrogance, the dedication and profound abilities of Sunjata's people, and an image of commanding cavalry roiling over the Western Sudan.

I hear "He ran the Mande dogs," and I see the great sweep of the savanna and imagine history-making events there—exhausting treks, exiles and allegiances, strategies and sorcery, huge fields of iron smelting furnaces to arm both sides, and the play of military and supernatural action across vast battlefields. I think of my trip with Kassim to the mountain at Kulukòrò, where Sumanguru disappeared when Sunjata defeated him, to his shrine in that town, to Sumanguru's own town, Soso, the shrine for his mother, and the cave where he planned his attempt to make an empire.[7] I think of the kind of power it must have taken to defeat such a man as Sumanguru, and I think of the many kinds of power in Mande, from personal capacity, to birthright, to social networks, to military might, and to sorcery. I think of the glorious and intimidating abilities of Mande blacksmiths, from Sumanguru Kante and Fakoli to Sidi Ballo himself. Sometimes I contemplate all these things quite deliberately, even singling out some for additional rumination. Other times I do not actively focus on any of it but nevertheless feel it all washing over me. I hear the line "He ran the Mande dogs" and a chasm of ideas and emotions opens up to me.

It is obvious from experiences such as Kassim's and mine that ideas, concepts, and attributes can be so intimately mixed into value and significance that it becomes impossible to sort them out. Perception and experience pitch the imagination into constructions of feeling and worth as inescapably as they initiate more ruminative thought processes. Thus, Goodman (1984, 8) notes that it is simply impossible to separate emotions and feelings from cognition. They are interdependent and are only pulled apart when people seek to analyze their experiences. No wonder art itself can provide such powerful experiences.

Because viewers and audiences produce meaning and value, the role of artists becomes more complex. In fact, artists do not have to care what their work means to viewers or even try to guide people to particular states of interpretation. So viewers can be on their own, though not necessarily adrift. When artists and viewers share much social experience—habitats of thought and action, local histories and perspectives—there will be numerous points of commonality as both build meaning into form.

But often artists want to cause reflection, influence people, and induce the stretching of minds. Sidi Ballo, for example, wanted to provide enormous

enjoyment for his audiences, and he very much wanted to present them with the value of their own culture. He was open-ended about specifics, however. He wanted his masquerade seen as a powerful bird of prey or a potent carrion eater. Several times in 1978 and 1998 he told me it represented a vulture (*duga*). But his most prominent praise name, Kulanjan, means marabou stork, hawk, and several other powerful entities. This ambiguity was fine with Sidi. He was happy to have all that conceptual potency rolled together and joined to the actual power of his performances, because the meaning and value Sidi cared most about was the finesse and power in his performance itself. He wanted people to be entertained to the point of awe by his feats and impressed with their significance as spectacular action grounded in virtuosity and sorcery. Beyond that, you were free to add whatever you might choose.

ATMOSPHERES FOR ARTWORKS

A most important question is how people arrive at the meanings and values they link to artworks. This is where art becomes a venue for interaction, exploration, and often social or personal change by serving as an intersection where communal and interior lives meet and fuel each other. Artworks are gathering places, creations that draw people together to engage the senses, each other, and the ideas and emotions that flow out of both. In the process of all this action, it is as if those ideas and emotions were in the air around the art, full of vitality and the potential to inspire discussion and thought.

Walter Benjamin had the idea that artworks emit auras, a kind of virtual personality with which people interact (1968, esp. 158).[8] I think that notion stems from the same sense of aliveness, of evocative presence, that floats around art because of the experiences people bring to it through the process of perception. To understand a little better how art can be seen to harbor the interpretations people create, I want to use the metaphor of atmospheres.

The social commerce of dialogue and shared activities that surrounds making and engaging art engulfs artworks in atmospheres, charged environments of potential meaning and value. When people make art, perform it, or see it, ideas and emotions from their interior lives bleed out into shared experience centered on the art. People talk, and ideas flow into this discursive atmosphere. Individuals listen and watch, and their own notions and emotions join the atmosphere, to be shared with others when discussions ensue. Communal and personal interpretations infuse this atmosphere, shaping the forms it surrounds, because people sustain it with their thoughts, their actions, and their interactions.

Think of all this as cognitive, emotive, and social substance launched by audience members into the air around Sidi Ballo's bird, where it stays over

time as people attend performances, think about, talk about, and engage the masquerade. Of course, people must keep these elements of potential interpretation in play. Neglected items will fall out. But art atmospheres are hothouses of experience and imagination, and they are sensitive to both groups and individuals. One person, off on a hunting trip, traveling to visit family, or called across the country to fulfill a blacksmith's commission, can see or hear something that they feel resonates with Sidi's masquerade, and so something new is added to the atmosphere. Through dialogue, that resonance can gain links to other elements in the atmosphere and may even become part of broadly shared interpretations. But even if that hunter, mother, or blacksmith never mentions it to anyone, it is also, as a part of his or her own memory, a part of the atmosphere.

Someone hears a story that Kulanjan, one of Sidi Ballo's major praise names, refers to hunters as well as birds of prey. Someone else hears that it invokes the fearsome potency of blacksmiths, which seems apt since many know Sidi belongs to the blacksmiths' clans. Yet another person discovers Kulanjan refers indirectly to the great Sunjata general Fakoli, so we move from highly respected bird of prey to the knowledge and valor of hunters, to the grand history and culture of the smiths, to associations with the epic founding of the Mali Empire. If these people talk to others who know Sidi Ballo's bird dance, individual experience weds social dialogue, and a masquerade's atmosphere develops broad new currents of flow. This is how the material in an artwork's atmosphere can morph and grow, with new ideas replenishing, amplifying, and expanding old ones, and all of them subject to the action of individuals, to dialogue among them, and to the creativity of human imagination. Experience fuels perception, and art is an instrument that facilitates the accumulation and exploration of experience.

Since a work's atmosphere is always changing and always relative to individuals as well as groups, presenting all the elements in it is not possible. It is not even likely that it will be completely the same for different people. If a work's atmosphere is an overarching assemblage of all the cognitive items people have found relevant to it, individuals will add to it and draw from it differently. Some people will not be aware of the relationship between the praise name Kulanjan and the Fakoli family, for example. Other people will not care, will not find that link inspiring, or will not give it a second thought because they find more personal resonance with other items in the atmosphere. Thus, an artwork's atmosphere is permeable to the point of effervescence. It is not exactly tangible or even real except as a useful, metaphorical way of imagining how meaning and value can be related to art. Scholarly understandings of a particular work's atmosphere must be provisional; they can never be as nimble as the people actually using the art. But by gathering as much material as possible, we can at least begin to see the kinds of potential an atmosphere possesses

and how people might engage it to enjoy themselves, to think about themselves and their society, and even to develop ideas and strategies for acting in their communities. Atmospheres may not be entirely real, but they are certainly helpful.

The items such an atmosphere contains are the very resources people can arrange and articulate to forge the shapes of their lives and their society. Mande in their time of youth, for example, can think about what they see Sidi Ballo do, think about the ideas and inspiration that swirl around the praise name Kulanjan, and resolve to take bold steps that move them in new directions as entrepreneurs, students, or local leaders. They can fashion arguments from Sidi Ballo's masquerade atmosphere that justifies such behavior—the esteemed prowess of birds, the daring of hunters, the worthy results of dramatic action reflected in the Mali Empire's founding. Elders, on the other hand, can use ideas from that atmosphere to justify adherence to the status quo—aligning Sidi Ballo's performance accomplishments, for example, with the value of tradition about which Mayimuna Nyaarè sings so poetically, or merging blacksmith potency suggested in the praise name Kulanjan with the hard work and responsibility Mayimuna valorized in her three blacksmiths' songs. Plucking items from the atmospheres of expressive culture can fuel endless dialogue, stimulate all kinds of thought, and play serious roles in the business of society. Productive synergy abounds in the atmospheres of artworks.[9]

The important thing to remember is that these atmospheres exist because people make and remake them, and think and act in their midst. When Sidi Ballo performs, individuals scattered around the dance arena utter exclamations of astonishment and occasional brief commentary. They express anticipation and awe with a hush. They exclaim their appreciation and satisfaction with shouts of Sidi's praise names. And sometimes they stop paying attention to the performance and enjoy a moment of quiet discussion or frivolity with a nearby friend. All of this lies at the heart of a performance. And though an observer might experience the audience in a more homogeneous way, to each of the individuals in attendance the performance will have its own reality. This adds relevance and vitality to art. Given all this activity, all this coming together of experiences, artworks are indeed teeming with life.

CREATING IMAGE ATMOSPHERES

So atmospheres for works of art are virtual, a metaphorical means of usefully thinking about how meaning and value flow around art. They are effervescent, shimmering into and out of focus and shifting their parameters as people engage in activities and discussions centered on a work. And they are relativistic,

shifting their contents according to the knowledge and interests of people interacting with art.

Since meaning is the product of perception indelibly joined to experience and imagination, atmospheres must vary from person to person, and they must change as people move and grow through life. I gradually assembled the atmosphere I will present for Sidi Ballo's bird masquerade. It is derived from conversations and interaction over many years with Sidi, with the blacksmith Sedu Traore and members of his family, with the hunters' bard Seydou Camara and his son Sekuba Camara, with my friends Kalilou Tera and Kassim Kone, and with many other people in Mande communities. It has also been shaped by the scholars I cite and by my ruminations through this synergetic mass of information.

The sources of my atmosphere for the bird masquerade range across much time and space, from the Bamako, Wasulu, and Beledugu regions to Segu and San, and they span much of the twentieth century. For example, I talked to many people in the towns around Bamako, south along the road to Buguni, east just a little along the road to Segu, northwest just a little along the Mande Plateau, and southwest on the road to Kita. Sekuba Camara had lots of information that came from his home area south in the Wasulu, whereas Kalilou had spent much time talking to adults and elders in the areas around Segu and San, and Kassim has worked and traveled extensively in the Beledugu around Kolokani and in Mande regions well to the west of the Niger River and south in the core of the Mande heartland.

This may seem a broad base of information to apply to one bird dance near Saturday City. But I assembled it in much the same way other audience members would have assembled their own Sidi Ballo bird dance atmosphere. I talked to people about a work of art that excited me. All of them had talked to other people, and that produced a domino effect of intellectual, emotional, and social information flowing into my atmosphere for Sidi. The difference is that I went out of my way to gather as much information as I could, including published sources. I wanted to be as inclusive as possible so that I would have an idea of what Dogoduman citizens or any of Sidi Ballo's other audiences could have to choose from. Yet even with that effort, we can be certain that my atmosphere contains but a modest percentage of relevant materials from Mande worlds of thought.

It is reasonable to ask if an art atmosphere's materials could range this wide, either geographically or chronologically. The answer, of course, emerges from the ordinary activities of people, and, at least in the case of many Mande people, the answer is yes. It used to be popular to say that researchers worked from privileged perspectives, because their access to source materials seemed more far-reaching than the access possessed by local people. But a great many Mande have an array of sources just as large and broadly dispersed through

time and space as mine. I do not doubt that many have even vaster arrays. Many Mande people travel, so the songs and stories, the masquerade characters, the beliefs and values, ideas, and local theories of distant towns and regions are not so remote. Moreover, Mande people put a premium on knowing history and thinking about it, so atmosphere materials can easily pass down through generations, gathering nuance, new twists, and momentum along the way.

Ample numbers of Mande citizens have long partaken of an international sensibility—the spirit of travel and adventure—intertwined with an ethos that places great value on knowledge. To be sure, plenty of people are born and raised in one area, do not travel much, and are content with a modicum of knowledge about their world. But large numbers of Mande people are strong advocates for the acquisition of knowledge, and many Mande are very mobile. Although he is referring to globalization, Arjun Appadurai (2003, 4) makes a statement that nicely characterizes Mande when he says that few people "do not have a friend, relative, or coworker who is not on the road to somewhere else or already coming back home, bearing stories and possibilities." These people can be cornucopias of ideas, beliefs, activities, perspectives, and values that their friends and neighbors experience by extension.

West African societies have been traveling and exchanging ideas for more than two millennia. It is part of a massive and irrepressible predisposition for commerce and entrepreneurship, exploration and adventure. There is even a special word for it, *yaala*, "to travel, wander, peruse, survey, scour." Sekuba Camara (1978) defined it thus: "to wander, see and discover; to learn things you don't know." It is a highly valued enterprise, and people traveling for all kinds of reasons, from business trips and job opportunities to family get-togethers or the call of adventure, are likely to embrace some degree of this spirit of exploration. Often it is the rugged individualism and personal accomplishment side of *fadenya*, "father-childness," that catapults them out into the world. (Bird and Kendall [1980, 15] elegantly call it centrifugal force.) Just as often, the embracing network of social interaction pulls them back home and encourages them quite specifically to share whatever they have gained abroad.

Most travelers and knowledge seekers depart and return numerous times. Abroad and at home, they share their experiences and what they have learned. Like everyone else in the world, Mande people spend much time talking to each other across a range of orientations, from delightful and often intense banter, to serious exchanges of information and perspectives, and even to formal economic transactions involving the purchasing of knowledge in the conjoined realms of herbal medicine and sorcery. This results in a human chemistry of variation and diversity, a mixing and merging of social phenomena sustained by a curiosity that is both practical and philosophical.

People travel for many reasons. Blacksmiths sometimes enter the market system, traveling each day to a different city market to sell their products. Some actually migrate, as did Sibiri Traore, the namer of Saturday City, in order to find better markets for their specialties, such as certain tools or sculptures. In times of state and empire building, smiths traveled with armies and were captured and moved to new places by their conquerors. Smiths also traveled to the areas of gold production, where they worked with traders to develop new markets. As sorcerers and Kòmò association leaders, they were and are often called upon to visit clients at considerable distances. In my bird masquerade atmosphere, there is a bird story involving the powerful smith and Kòmò leader Nerikoro traveling to meet the deceitful client Bankisi Sediba in a hunters' epic Seydou Camara used to perform.

Smiths who develop reputations for specific products such as sculpted door locks or various types of masks can be paid by clients to travel long distances to fill orders. And clients also travel just over the hill or across two hundred miles of savannah and more to purchase the products of well-known blacksmiths.

There are also itinerant performers, such as Sidi Ballo, who spend much time on the road. Bards and hunters' bards (*jeliw* and *donson jeliw*) travel very frequently and often great distances. Many bards regularly cross international boundaries to satisfy clients' demands. The hunters' bard Seydou Camara was based in Bamako, but his reputation extended hundreds of miles. I remember that when he returned from a commissioned performance in Segu, some two hundred and fifty miles east, he had a spectacular new pair of grandly embellished pants. I asked him how he got them, and he smiled and said, "They liked me very much in Segu" (1971).

Other artists also travel widely, sometimes quite frequently. A woman who specialized in repairing calabash containers used to come to Senu, a small town south of Bamako, every market day when I was there in 1971. On the road to Buguni, Senu was part of a small circuit of towns that held markets on consecutive days, and this lady worked at each of them regularly. On occasion she would come to Senu on days when the market was closed if she had a lot of commissioned work to do.

Many merchants travel these market circuits, both small and large, to earn their livings. Some travel considerable distances on long overland or river routes that take them quite widely abroad into the world. Seydou Camara, who was himself the head of a Kòmò association branch, used these business people specifically as examples of why it was important for Kòmò to offer "passport initiations," so that frequent travelers could be official Kònò members even though they did not participate much or know much association lore. They paid a fee for this special membership and swore an oath of secrecy, and it allowed them to avoid fines and hassles should they happen upon a Kòmò

meeting far from home. And, on their travels, in the markets and restaurants and town squares and host homes, these entrepreneurs were spreading and receiving ideas and stories that end up in atmospheres surrounding works of art (Camara 1978).

Hunters do a lot of traveling, and historically, they did even more. Formal fraternities of hunters, the *donson jow,* exist everywhere, each generally including members from several different towns, several social and professional situations, and several ethnic backgrounds. Members hold meetings, celebrations, joint hunts, and public performances together and share information about hunting, the people and places where they hunt and travel, the esoteric mysteries of the world, and the spiritual forces they encounter and manipulate in their hunting. Curiosity and adventure are focal points of hunters' lives, and often they wander quite broadly to satiate their urge for game and interesting experiences. Knowledge and the power of sorcery are also hunters' focal points. There is a Mande phrase, *dali masigi,* which means to travel about in quest of such knowledge and power (Kone 1998).

The blacksmith Sedu Traore was also a passionate hunter, as were many of his best friends. He was a member of a regional hunters' association. At the end of each year's agricultural season, after months of making and repairing farming tools and doing a little farming of his own, Sedu would take a personal vacation. He would head out on a long-distance trek, visit hunting friends, some living a hundred miles from his home, and hunt with them.

Lengthy trips of hunting and adventure have long been enterprises of prestige and pleasure among hunters. In times past, when game was more plentiful and travel less encumbered with colonial and postcolonial restrictions, hunters might spend weeks, even months in the bush, exploring and encountering all manner of new things. Oral tradition relating the founding of the city of San, as told to me by Kalilou Tera in 1978, offers an excellent example.

In the thirteenth century, a hunter named Koyita began a hunting journey from the Mande heartland southwest of today's Bamako. He traveled with his dog for a very long time, tracking wild beasts. Ultimately, overcome with thirst, hunger, and exhaustion, he collapsed some three hundred miles from his starting point in an alien environment. In the shade of a fig tree thicket, he gave himself up for dead, but his dog was not quite so tired and found an old well nearby. Drinking to slake his own thirst, the dog then dipped his tail in the water and walked back to Koyita. The hunter licked moisture from his faithful dog's tail and then followed the drops (surely so small and quickly evaporating that ordinary men—non-hunters—would never have been able to find them) back to the well. Then, adequately revived, Koyita looked around and found himself in paradise.

He was very close to the Bani River, which flows into the Niger River. He found creeks with many fish and much game all around. Farming land was

plentiful, and there seemed much to be exchanged with people already living in the area. There was already much cultural diversity in the area. Today there are people of many backgrounds, including Bamana, Bobo, Bozo, Fula, Manianka, Maninka, Marka, Songhai, and Soninke, and occasionally Tuaregs.

So Koyita returned to the Mande heartland and organized his family and hunting friends for a massive move to this paradise. Standing at the edge of one of the rich creeks, he told the new arrivals: *An ka san kè ya*, "Let us stay a year here." If the year was good, they would settle permanently. *San* means one year. *Kè* means to spend. Sankè became the name of that creek, and San became the name of the town. At the end of that year they were happy and successful, saying: *Ah, San diyara!* "Ah, the year has been pleasing!"

Ultimately, San became a crossroads of trade, and today it is a large and pleasant place indeed. Every year its founding is remembered in a three-day celebration called San Booben. And the hunters, grand travelers par excellence, are featured performers.

Like hunters, Fula (Fulani) cattle herders travel quite broadly. They move seasonally in order to keep their herds in green pastures near water. At their stops along the way, these travelers have relatives (because many Fula are also settled in towns), friends, and business associates (who rent their fields for grazing), so there are plenty of opportunities for social engagement and the sharing of experiences. Fula have joking relationships (*senenkun* in Bamana, *sananku ya* in Maninka) with many of the people they encounter on their travels. Often they sit around telling stories together and exchanging interesting ideas and perspectives, tremendous fuel for artwork atmospheres.

Spiritual and herbal specialists also travel and receive travelers. West African traditions of herbal medicine, which produce both physical cures for ailments and quantities of the energy of action for more supernatural activities, can be very specialized. Accomplished practitioners can have a wide-ranging clientele and may travel hundreds of miles to diagnose and treat patients. A very famous expert, Satigi (Serpent Master) Sumaoro, for example, regularly came up to the Bamako area from his home to the south in the Wasulu, and he had clients all along the way. On the other hand, Sedu Traore told me of a well-to-do Malian businessman living in Dakar who traveled all the way back home to purchase a particular type of amulet from a particularly well-known expert.

In West Africa, Muslim marabouts (*moriw*), the holy men of Islam, are also held to possess spiritual powers to cure illness and ill fortune, safeguard travelers, enhance business deals, engage antisocial sorcery, and the like. Some of these experts also acquire tremendous reputations and receive long-distance clientele. In the summer of 1978, many citizens of Bamako were anxiously anticipating the arrival of a traveling Muslim holy man from Nigeria, nearly three thousand miles to the east. This spiritual specialist, a Hausa, regularly went on long trips abroad to offer his services all across West Africa.

In addition to travel for the acquisition of amulets or medicines, people make pilgrimages to famous shrines, which can be found scattered across the Mande landscape. One such shrine is located near the Niger River town of Kulikoro, where the two great adversaries Sunjata Keita and Sumanguru Kante fought each other for the last time. After incredible battles and even more incredible strategies, Sumanguru was finally defeated at this spot (J. W. Johnson 1986, 176; Niane [1960] 1982, 66–67).

Today there is a shrine there, humble in appearance (a decorated stone, some odds and ends, surrounded by a little fence) but said to be so powerful that it can grant visitors any wish they make (Fane 1971; J. W. Johnson 1986, 176, 218). A priest maintains the shrine, and people visit to make sacrifices, some coming from hundreds of miles away. Kassim, his cousin Mussa, and I visited the shrine ourselves in 1998. We arrived in late morning, and there was already evidence of three previous visitors that day. At Kulikoro one can find many attitudes and perspectives about Sumanguru Kante, so travelers gain new experiences that become fodder for image atmospheres.

A different sort of pilgrimage is related to *yaala,* "to travel for knowledge and adventure," and *dali masigi,* "to travel on quests for knowledge and power." The now worldwide flow of Mande individuals who seek employment or education far from their homes has been common for many centuries but became more popular in the colonial and postcolonial periods. Often the flow is from smaller farming communities to larger metropolises, and international boundaries are frequently crossed. Today Mande people travel to Paris, Brussels, and other places all over Europe. When Russia was the Soviet Union, many Mande went to Moscow as students. Japan, New York City, Santa Fe, San Jose—these and many more places have become Mande destinations for work or education. In fact, this penchant for travel goes well beyond Mande to encompass a diversity of West African residents. It is the subject of Jean Rouche's delightful and provocative film *Jaguar* (1954), and of Paul Stoller's ethnographic novel *Jaguar: A Story of Africans in America* (1999).

This survey of mobility gives perspective on image atmospheres. Strong strands of eclecticism and curiosity, adventure and entrepreneurship put a wide array of sources at people's disposal. Everyone's personal history is different: knowledge, skills, dispositions, perspectives, values, and emotions are diverse among Mande, as they are among Americans.

Moreover, every person's history is dynamic, changing with new situations and experiences. Anytime, anywhere, a person may hear a new proverb or folk story, see a particular sculpture, attend a particular bard's performance, hear people discussing birds in the market or in the woods, or engage friends or a market salesperson in a discussion about bird imagery on a newly produced textile. Thus, the building blocks for image atmospheres are diverse. Travel and our predisposition to social discourse cause them to be dispersed

like seeds broadcast in the wind. Certainly, in any given community or region there will be numerous interpretations of bird masquerades and every other kind of artwork that are widely shared. But as we can see, there is also opportunity for people to build their own interpretations and add them or not to local artwork atmospheres.

Any time people want, watching a bird dance, or in the quiet of their homes, or on a walk along a path to Saturday City, they can ramble with their imaginations through these image atmospheres, exploring interpretations, creating new ones, and employing and examining them against the contingencies that compose their ever-changing lives (Jackson 1982). On our trip to Soso, ancient home of Sumangugu Kante, Kassim and his cousin Mussa watched fleet, majestic birds of prey maneuvering above the bush. They identified the birds and talked about their prowess. Images of Sunjata's general Fakoli, whose family was taught how to hunt by birds like these, flooded in and commingled with recollections of Sidi Ballo's performance in 1978. For me, new juxtapositions produced fresh appreciation and extended contemplation on Sidi Ballo and the value of accomplishment in people's lives.

11

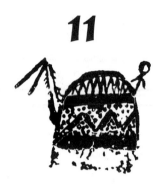

AN ATMOSPHERE
FOR SIDI BALLO'S
BIRD DANCE

Many catalysts for meaning and value punctuated the dance space at Dogodu-man. There were the topics of the songs, the ways they were delivered, and the particular words used with their rich allusions to other stories, proverbs, mo-res, and axioms. There were the stage presence and skills of all the performers; the thoughts about responsibility, hard work, and success they might inspire; and the powerful feelings the music itself generated in people. There were all the dancers, the characters they represented, and the nuances through which those characters traveled as people thought about choreography and the color, shape, and other compositional features of costumes and masks. There were the gestures and dramatic movements that Sidi Ballo executed for many hours as he worked his way through the performance. And there were the elements of his masquerade, from the red ribbon and vulture's feathers to the powerful-looking carved bird's head and the dangerous-looking burlap fringe. All of this could easily generate an assortment of artwork atmospheres, or one big one, depending on the interests of particular audience members and on the ways they engaged the performance. So vast a thing could occupy an entire book.

For example, the cloth that covered the masquerade was a factory print with hundreds of little flowers. You would only see them when the masquerade was right next to you. They were lovely, but audience members could also relate them to the more abstract triangle patterns on *bogolanfini* (mud cloth) that invoke for many Mande ideas about the science of the trees, herbal medicine, and sorcery. Or they could leave mud cloth out of it and see the myriad flowers as representing the wilderness loaded with its cornucopia of provisions for herbal medicine. This fits with the power Sidi endlessly demonstrated in his performances and his own widely acknowledged deployment of sorcery. These ideas and beliefs, the emotions and values associated with them, and even recollections of personal experiences with sorcery could all go into a person's image atmosphere for Sidi Ballo's bird masquerade. Or they could just be flowers.

That flower-covered factory cloth was mostly blue, which contrasted nicely with the red ribbon. Mande who enjoy color symbolism could have played with this intertwining of red, often interpreted as heat, aggressiveness, potential danger, and *nyama;* and blue, often interpreted as reasoned thought, tranquility, and the cool (*suma*) refreshing water of a quiet little spring. Hunters, blacksmiths, herbalists, sorcerers, and any number of other audience members could have had a grand time contemplating the use of herbal science to sensibly harness the energy of action and added all this to their masquerade atmospheres.

We noted earlier that vulture feathers are considered laden with much *nyama.* Too much exposure to them is said to encourage leprosy. So the large numbers of these feathers gathered on Sidi's masquerade would generate an exciting disquiet in many audience members, particularly as the masquerade rushed past or stopped near them. This feeling could readily be combined with the red of the ribbon and the weighty-looking bird's head, the flowers on the factory print, that treacherous burlap flap, and the daring acts of tipping, falling, and becoming invisible that punctuated a Sidi Ballo performance, all in an image atmosphere.

But for me the most obvious Dogoduman focal point around which an atmosphere can grow is the masquerade's identity as a bird, a bird that could be humorous but also powerful. There is much we can consider, and that is what will occupy this chapter. Just for ease in organizing the material, I divide it into three categories—birds and knowledge, birds and prowess, and birds and artistry. Though this arrangement helps to show how complicated an artwork's atmosphere can be, in reality few audience members would have divided up their thoughts and feelings like that. And to add to the fullness that was Dogoduman, Sidi Ballo's masquerade was not the only bird performing.

BIRDS AND KNOWLEDGE

For many Mande, birds suggest ideas about knowledge. They say birds mediate between the sky and people by making accessible wisdom held by spirits and other celestial forces. Birds are linked to knowledge of the heavens, "celestial knowledge" (*san fe donni*). An example of this comes from creation myths given to Dieterlen in the mid-1900s: when the first Mande ancestors died, their spirits became birds that gave gifts of knowledge to the world's first black-smiths, who used them to improve human life (1951, 156).

Zahan (1960, 258, 369), noted that the toucan (*dole*) represents divinity and is a master of speech who signals the coming of the planting season each year, while the vulture (*duga*) represents longevity, sharpness of mind and senses, and all-knowing divinity. White falcons (*sege ji*) stand for people with deep intelligence who can understand mysterious things in the esoteric initiation society for senior men known as Kòrè (1960, 268). Interestingly, another kind of falcon (*sege*) stands for superficial people. Mande have developed a number of initiation associations (*jow*), such as Ntomo, Kòmò, Kònò, and Kòrè, that use high levels of secret knowledge. The one for young boys (Ntomo or Ndomo), whose mask types were adapted to the youth association at Do-goduman, relates birds to thought and to knowledge about people's spiritual essence (1960, 61).

Much lore exists about vultures. My colleague Kalilou Tera learned interesting stories about them when he worked as a government researcher over much of southern Mali. In children's stories, vultures are featured as particularly patient and wise. One story goes like this:

> The vulture sat on a dead branch waiting, when a black bird came along and greeted him. The black bird said "Elder brother, I want to be like you, you are so wise." The vulture thought that would not be possible, but the black bird said he would try. So the vulture said, "OK, let's wait."
>
> They saw an antelope fall to the ground, near death. The black bird said: "That's meat for us," and started to fly over to it. But the vulture said: "No, don't do it!" "Why not, I'm starving," said the black bird, to which the vulture replied: "See, I said you can't be like me."
>
> So the black bird said "OK," and they waited some more. Then the antelope died, and again the black bird wanted to go eat it, and again the vulture said: "Don't go." This time, however, the black bird went anyway, and was promptly killed by a hunter.
>
> To which the vulture said: "I told you to be patient." (Tera 1977)

Tera says that in the *jow* initiation associations, vultures are considered the owners of deep celestial knowledge. They know such things as when the

rains will come, if an epidemic is imminent, and what will happen to the souls of the deceased. In the Kòrè association, vultures represent the supreme degree of knowledge people can attain (Zahan 1960, 15, 17).

A wonderful Mande hunters' song that Seydou Camara used to perform puts vultures in a different light, as wisdom's antithesis. Sekuba Camara (1978) paraphrased it thus:

> A hunter made a deal with a vulture to kill a much-coveted lion and thereby bring great prestige upon himself. The vulture told the hunter to come into the bush the next day and play dead. The vulture would bring the lion and at the appropriate moment explain: "Ah look, a hunter for us to eat." As the lion approached with his guard down, the hunter would be able to kill him.
>
> They went their separate ways, the hunter to tell his wife and the vulture to strike a deal with the lion. The vulture told the lion that he had tricked a foolish hunter. Relating the story, he said an easy meal would be at hand, so long as the lion did not, in fact, let his guard down and pounced with unexpected speed upon the hunter. Both agreed it was an excellent plan.
>
> Meanwhile, the hunter told his wife about his subtle negotiating and his anticipated glory the next day, to which she replied that he was indeed a fool, and that vultures could be counted on to strike more than one deal in any situation. More a hero than her husband, she resolved to accompany him the next day to give the vulture his just deserts.
>
> Arriving at the agreed spot, the hunter lay down and played dead, while the wife concealed herself in the bush. When the unsuspecting creatures came, the women surprised the lion and scared it off. Then she grabbed the vulture by the throat. She told him what he had already discovered, that his deceit had not gone well. And as she said so, she turned the vulture upside down on its head and began grinding it into the dust of the bush as if she were preparing grain for lunch with a mortar and pestle. The vulture's head began to smoke as feathers broke or were pried away. And that is why vultures today look so preposterously disheveled.

This story does not negate the vulture as sage or diminish appreciation of its knowledge. It plays with premises and expectations and complicates people's beliefs and notions. It is one more thing in an atmosphere's discursive space to add variation and encourage additional ranges of interpretations.

Mande knowledge has esoteric and practical aspects, and divination or soothsaying falls on the practical side. Its goal is to garner reasonable and well-rounded understandings of situations past, present, and future, so that useful action can be planned. Experts train for years to become skilled at various prognosticating techniques.

Birds are linked to divination, and various birds have soothsaying value. Cashion (1982) learned from the hunters' bard Seydou Camara that a small

black bird called Siba (or Sigwè) appears as an omen of misfortune (3: 166). The owl is said to see everything, in both daylight and darkness (2: 335). One divination technique involves communicating directly with birds to gain glimpses of their knowledge of human affairs. Other technique uses images of birds that are said to speak. There is an important moment in the Mande hunters' epic *Kambili* when, after several diviners fail, Bari the Omen Reader speaks with a sculpted bird. Seydou Camara sang:

> The bird of omens was the speaker of omens.
>
> *Tiyèn-kònò le tiyèn-kan fòla.*
> (Bird et al. 1974, line 768)

Birds are also linked to educational acts or the imparting of information, often in the context of bards performing for clients. Seydou Camara, who died in 1981, was a good example. He was a gutsy, powerful performer with a philosophical disposition and a predilection for social analysis and critique. Good bards and hunters' bards possess expertise on a musical instrument or voice or both, and huge amounts of knowledge about people, situations of all kinds, and the histories that brought people and situations together. They tailor performances to capture audience's imaginations, and they often do so in the guise of educating their listeners. Seydou sometimes introduced himself to audiences with the line: "I am the singing bird of Kabaya" (his home town). He sometimes described himself in song with lines such as these:

> I am a bird who preaches.
> I make the stupid intelligent,
> And give circumspection to those who are not circumspective.
>
> *Ne ye waajuli kònò le di.*
> *N' bè nalomay lakiya,*
> *Ka fatòy sòn hakili la.*
> (Camara 1978, 3/26)

Bards do often teach in their performances, offering explanations for all sorts of events, historical personages, and legendary characters. They also motivate, inspiring people's imaginations and building fires in their hearts so that they will think and act for the good of family, community, or society. And since bards are not without their own vested interests and agendas, what they call education can also be manipulation.

Similar education, inspiration, and manipulation through the metaphor of birds was observed in the Mali emperor's court. In 1352, the Arab traveler Ibn Battuta ([1929] 1984, 329), observed bird masquerades performing at the court of the leader of the Mali Empire, Mansa Souleyman:

On feast-days . . . the poets come in. Each of them is inside a figure resembling a thrush, made of feathers, and provided with a wooden head with a red beak, to look like a thrush's head. They stand in front of the sultan . . . and recite their poems. I was told that their poetry is a kind of sermonizing in which they say to the sultan: "This pempi which you occupy was that whereon sat this king and that king, and such and such were this one's noble actions and such and such the other's. So do you too do good deeds whose memory will outlive you." . . . I was told that this practice is a very old custom amongst them, prior to the introduction of Islam, and that they have kept it up.

We cannot say what these bird heads and costumes might have suggested back then. We may be safe in surmising that some of the associations that birds have today for Mande were also at play in the days of the empire. It may also be reasonable to think that contemporary bird masquerades such as Sidi Ballo's can inspire ideas about knowledge.

BIRDS AND PROWESS

We need a little background to appreciate the links between birds and prowess. It is axiomatic in Mande that knowledge leads to power and that power is a complicated business (Lukes 1978; Arens and Karp 1989). Power comes in many forms: through clan affiliations, destiny, or proximity to great personages present and past. It also comes from the grace generated by one's mother (*baraka*), as a byproduct of her mastery of "proper" family and other social relations. And it comes from the understanding and skill that garners and harnesses the energy of action (*nyama*). Power that derives from different sources is often used in different spheres, and individuals and collectives usually possess combinations of several different kinds. Of all the kinds of power a person can have, the kinds predicated on knowledge that enables action often lead to the greatest accomplishments and renown.

Because many people have power—often several different kinds—the consequences of one person's actions are never certain in advance. They become enmeshed in the knowledge, power, and actions of others. This is complex agency (Hobart 1990, Kratz 2000).

We can see prowess as a step beyond knowledge and power. It involves knowledge and the abilities to examine, analyze, synthesize, and evaluate. It involves high levels of power, often in combinations of different types. And it involves collections of skills and abilities, experiences and expertise that make successful action more likely in a world complicated by the knowledge and power of many other people. Success is not guaranteed by prowess, but it helps a great deal. People's success at a task in the world can be due to destiny

(*dankan* or *nankan*). But it can also come when people have developed their knowledge and power to points of refinement that allow them to act more effectively than others. These are the kinds of people we earlier called heroes (*nganaw*).

Some people possess ample knowledge but never exercise it to attain prowess. They are *doma* and are highly valued for their advice and counsel even though they are not associated with action. A *doma* is quite different from the "antihero" (*nantan*) Mayimuna Nyaarè sang about at Dogoduman, who possesses no knowledge or power, who never tries to accomplish anything, who fears everything and is never successful.

Mande people who want to act need *nya*, "means," the requisite power and ability to do something (Bird and Kendall 1980, 16; McNaughton 1988, 154–56). It may take the form of birthright that gives certain privileges or access to certain resources. It may take the form of knowledge of *jiridòn*, "the science of the trees," and the possession of *daliluw* herbal and occult recipes for making things and accomplishing things (McNaughton 1979, 1982a, 1982b, 1988). The idea of means is so important that the Mande epics focus more on the accumulation of means for action than on the action itself (Bird and Kendall 1980, 19). In the realm of sorcery, a person can say to an adversary: *N bè n bolo su i nye na*, "I will dip my finger into your eye," which means "I will put my finger in your means," to understand and dominate your power (Tera 1977, 1978). In everyday activities "means" can help people to be more successful. In grander, harder, more consequential activities, "means" can help a person become a hero.

We can recall from Mayimuna Nyaarè's songs at Dogoduman that behaving heroically is not just founding empires or fighting off conquerors. Farmers and blacksmiths full of knowledge, skill, and hard work, for example, can be heroes; and that kind of prowess is admired all around as a cornerstone of Mande ethos. But in popular imagination, hunters and grand state-building heroes, such as Sunjata, serve as measures for how deep prowess can run. A brief look at them will let us understand bird imagery better.

Hunters (*donsonw*) are grand figures in Mande oral traditions. They are tough, armed, and able. The phrase "rugged individuals" fits them well. They enjoy the challenge of spending time in dangerous spaces, and the most talented hunters love to pit their skills against the most robust and crafty of wild animals. There is far less game now than before colonialism, but there are still challenges. Hunters' associations (*donson jow*) are still active, and an aura of prowess still surrounds their quotidian presence.

Hunters' expertise is impressive, from the seasonal ecology of wilderness flora and fauna, to the geography of hills, plains, and water worlds. They know how to hunt while not being hunted. They know how to stay healthy, fight infections, and protect themselves from fever and fatigue. They must also deal

with wilderness spirits and occult forces, both major parts of the bush. These forces can be made into allies but can be very dangerous. So knowledge about them is an important part of hunting ken, making good hunters into good sorcerers. In short, hunters possess impressive credentials.

Great Mande heroes, leaders, and state-builders, have (or have access to) the same kinds of abilities as hunters. They also have a tremendous will to succeed. In his epic, Sunjata was born crippled, unable to rise or walk. At a galvanizing moment in the epic, he uses sorcery to leave his disability behind, then strides forth with the steps of a giant, uproots an enormous baobab tree with his bare hands, and gives the leaves to his mother for a sauce (Niane 1965, 18–22).

Such heroes are often ruthless, so driven to accomplish their deeds that they may use any means available, no matter how troublesome or destructive. Often they change society dramatically, which may be good but is also disquieting. Often too they want wealth, prestige, more power, and fame, as well as a name that will live in oral tradition after they have gone. So heroes are complex and even fearsome characters (see, e.g., J. W. Johnson 1986, lines 1461–75).

Many Mande see metaphorical similarities between birds of prowess and people of prowess, such as hunters and heroes. For example, birds' finely tuned long-distance vision is considered nearly supernatural. Vultures are said to see a termite from three kilometers up, and bigger prey from a distance of one hundred kilometers (Tera 1978). Birds' ability to dive from great heights to pluck up prey is equally impressive. Eagles, hawks, storks, pelicans, and the like are appreciated for their hunting skills.

Hunters and heroes can be praised by likening them to birds. Some hunters have praise names such as *Samata Kònò,* "Elephant-Seizing-Birds," or "Elephant-Eating Birds" (Camara 1978). Arnoldi (1995, 166–67) notes that a particular masquerade character in the youth theater around Segu is *Baninkònò,* which represents the Abdim's stork and symbolizes the tremendous power of master hunters, as also do lions. Vultures are great metaphors for master hunters. In fact, hunters and warriors model their hats after the head of a vulture as a kind of emulation and proclamation. Kassim Kone recorded a proverb that acknowledges this borrowing: "The hunter's hat looks nice on the hunter, the vulture says it surely looks nice on him too" (Kone 1995a, 106).

Birds can suggest the competence and success of Mande warriors and heroes. The vulture is a good example. A very famous song called *Duga* ("The Vulture") is performed for great warriors, and it is often said that warriors have been willing to go to great and dangerous lengths to earn the right to have it sung in their honor (Camara 1978; Bird and Kendall 1980, 21).

Birds of prey figure prominently in accolades for the bold and powerful. In a praise song for Sumanguru Kante, the great blacksmith-sorcerer king, four towns founded by the Kante family are mentioned, pointing out Kante

power. Then two lines associate Kante expansion with an awesome but almost casual ease:

> The hawk and the eagle,
> Happily descended at home.
> (Tera 1977)

Mande say it can take many generations for residents to be considered natives instead of strangers (*dunan*). But the Kante birds become natives with the greatest of speed and ease.

Kalilou Tera remembers hearing this song performed by Bazumana Sissoko, "The Blind Lion," one of Mali's most renowned bards. After some references to hunters, more praise with birds followed:

> Bird between two rivers.
> The bird who stays in the sky
> can claw the earth.
> If he lands,
> he will dig a well in the rock.
> Patriarch of Sosso,
> Good Evening.
> (Tera 1977)

In these lines, the breathtaking power of birds is rendered overwhelming through an amplification of scale: a raptor so huge or magical it claws the earth without descending, and, when it does descend, its staggering power can excavate rock. We begin to see that birds, particularly birds of prey, roam heavily through Mande imagination.

Also in Mande imagination, knowledge and capacity are intimately commingled in configurations of *nya*, "means," the wherewithal to do something successfully. We have seen that a major component of means is sorcery, the use of special secret knowledge to marshal and manipulate arcane, occult spirits and forces that act in the world at the invisible level of its structural underpinnings. Birds can provide access to those secrets through *san fe donni*, "celestial knowledge." So sometimes great sorcerers are said to become birds. In fact, there is a name, *sukoro*, for sorcerers who have the power to turn themselves into birds (Camara 1978).

Another word, *sabu* or *sababu*, "reason" or "cause," works a bit like *nya*, "means," to identify the basis of prowess, with special emphasis on the secrets of sorcery that empower it (Cashion 1982, 3: 153). *Sabu* is the word Mayimuna Nyaarè used at Dogoduman in her song glorifying the technological prowess and supernatural abilities of blacksmiths. It would fit quite nicely into an image atmosphere on Sidi Ballo's masquerade performance, since he too was a

blacksmith laden with sorcery and a bringer of fine things to large populations.

In the hunter-hero's epic *Kambili,* as sung by Seydou Camara, a powerful blacksmith-sorcerer displays his power to transform into a bird. In the story the birth of a hero is sought for help in troubled times, and diviners are called to solve the mystery of who will be the mother of the hero. It is the great warrior-leader Samori, one of the last empire builders in the Western Sudan, who calls in the diviners. Diviner after diviner fails, and Samori has them executed. Then he calls Nerikoro, expert diviner and leader of that most powerful Mande initiation associations, the Kòmò. Nerikoro fails too, but Samori cannot kill him. Instead, Nerikoro transforms himself into a bird:

> Saying his powers were not for earthly battles
> . . .
> The Komo thus changed himself into an eagle,
> And rose up into the clouds, flapping.
> And went to light on a mountain at Kona.
> Since that time, Nerikoro has not been seen.
> (Bird, Koita, and Soumaouro 1974, lines 619, 650–53)

It is said that Nerikoro is still living on that mountain, some hundred years after Samori's own death.

In another epic story, Nerikoro is attacked with malevolent sorcery and scores of armed men by a covetous challenger named Bankisi Sediba, who wants to expand his own power by killing the famous Kòmò and sorcery master. Sediba tries all sorts of attacks but is nevertheless destroyed. At one point in the story, Nerikoro transforms himself into a *warasa* bird, which is as big as a vulture, with a red beak and red claws. It flies high in the sky and is very powerful and respected for its hunting abilities (Camara 1978). In the form of this bird, Nerikoro turns his enemies' gunpowder into cold water and makes their machetes as limp as the knotted strings of spit amulets (*tafow*). Then he foretells the coming of the French and flies away (Seydou Camara 1978).

The Kòmò initiation association is a major site for sorcery. It is headed by powerful blacksmiths and uses visually and supernaturally awesome horizontal headdresses in its social and spiritual activities. The prowess of Kòmò leaders and their masks often blend together in people's minds so that together the two become something that transcends ordinary human life. This combination of lethal prowess can be referred to simply as a bird. In the lines of songs that honor blacksmiths and the Kòmò association, that bird's powers are suggested by stating that if a wing falls off or is cut off by a protagonist, it will regenerate (Sekuba Camara 1978).

There are many words for sorcerer. *Subaga* or *subaa*, for example, are widely used. But a very interesting word is *soma*, which can simply mean sorcerer but often is used to identify a sorcerer of pronounced prowess. Mande sorcerers often duel, and thus they are always at risk because others who want to gain power or make names for themselves can challenge and attack, frequently without warning. They may use secret recipes (*daliluw*) for harmful medicines that can be put in one's food or flicked on one's skin with a casual gesture. These include deadly mystical poisons (*korotiw*) that are sent through the air on the wings of insects or through supernatural animation. Great sorcerers must be able to detect and counter these attacks as well as inflict them. There are many stories about these duels, some featuring well-known people.

Somaw itching for a fight or angling for more fame used to shave their heads clean except for a little tuft they had made into a braid, which identified them as challengeable. Victorious *somaw* who had killed another sorcerer wore as a symbol of their triumph a real bird's head attached to a cap on their heads (Sekuba Camara 1978).

Imagine this information in an image atmosphere for Sidi Ballo's masquerade performance. First there is the weighty, powerfully shaped, bright red bird's head, flexing about on a nearly three foot pole as if it were, by turns, a bird in the world or a virtuoso dancer's baton. Then there are the actual feathers, powerful feathers, vulture's feathers. Then there is all that red, in the head and on the costume—referencing aggressive, dynamic, bold behavior. Then there is the perceived weight and mass of the whole masquerade as it rushes past audience members with a loud displacement of air and a very certain sense of potency. Then there is the delicately exploding floral pattern on the printed cloth, certainly for some audience members just screaming *jiridòn*, the science of the trees. And then there is the nearly falling over, potently in time with the music, and the shape-changing, and the real falling over, the dancing upside down, and the apparently empty cone of the costume. In an image atmosphere, for many people it could be as if Sidi Ballo were a kind of *soma* in masquerade.

Mande identify two basic power sources for sorcery: spirits and energy. There are ancestor spirits (*bènbaw*) and wilderness spirits (*jinnw, jinaw, jinèw*), which are wild, potent, often invisible creatures that can also assume a multitude of shapes and do virtually anything they want in our human world, although their own world is considered to be a separate, parallel, intersecting domain. Spirits can kidnap people, control people, and create all kinds of problems in human affairs, from illness and poor harvests, to bad marriages, travel disasters, and defeat in war. If they choose, they can also help make life bountiful and sweet. So people, particularly the power players in Mande society, such as sorcerers, hunters, blacksmiths, heroes, political

leaders, and even some successful business people, may negotiate mutually beneficial relationships with particular spirits. They offer sacrifices to the spirits in return for assistance in their activities. Indeed, one of the hunters' epics in Seydou Camara's repertoire, called *Famori,* is largely about the quest for a wilderness spirit (Cashion 1982, vol. 2). As it happens, like those earliest ancestor spirits that Dieterlen (1951) reported, wilderness spirits also often take the shape of birds.

The other resource of potent sorcery is *nyama,* the power that activates our hearts, pumps blood through our veins, and animates our minds and souls. It gives life to all that lives and can exist independent of corporal entities as if it were free-floating electricity. It is as potent as anything on earth, and we might say that its invisible configurations constitute the underpinnings of everything we see in our visible, substantive world. It can be harnessed by people with the proper knowledge and power, and in their hands it can be manipulated to do good or ill.

Spirits also manipulate *nyama* and are loaded with it themselves. As I've noted, certain types of people, such as blacksmiths, bards, well-trained hunters, and heroes, possess a great deal of *nyama.* In fact, a major part of a hunter's training is to acquire the means to amass and control *nyama.* When they kill animals, they must avoid being overcome by that which death releases, but rather must "harvest it" to amplify that which they already possess.

Animals possess much *nyama.* Some, frequently the most beautiful, possess more than others. Birds are often among the creatures said to possess the largest amounts. That brings us back to Kulanjan, the praise name for Sidi Ballo's bird masquerade. Remember that the name refers to birds of prey, honoring their prowess. Remember too it is also used to honor great hunters; and furthermore, it refers to a mythic blacksmith's anvil so charged with sorcery and the energy of action that it flies and attacks of its own accord, as if the anvil were itself a bird of prey.

Thus, the praise name Kulanjan suggests a complement of interacting ideas, each adding luster to Sidi's masquerade. Not everyone knows all these references, but some do and some know more. From the accomplishments of hunters and heroes to the expertise of sorcery, prowess, in the guise of an imaginary bird, is a phenomenon Sidi Ballo hoped to thrust at his audiences for their pleasure and contemplation.

Sidi's is not the only bird masquerade associated with prowess, however. Near Segu, in the town of Kirango, Arnoldi (1995, 15–16, 99–100, 128, 191) reports an enormous bird masquerade used as a character in the *ton* youth association theater. Called Mali Kònò, "The Bird of Mali," it stands seven feet tall, with a beak one meter long and a wingspan of several yards. It moves majestically, often gliding, "seemingly effortlessly, around the circle as if in flight," and pantomimes the act of hunting fish and swallowing its catch from time

to time. This character was created by the Kirango youth association in 1960 to celebrate Mali's independence from French colonialism that year.

Arnoldi states that the very powerful Kirango Kòmò association branch disbanded in the 1950s, but former members and non-members alike recall its extreme power as an institution of sorcery and social influence. When the Mali Kònò bird masquerade was invented, its creators decided to give it the Kòmò rhythms for its performances. This would "capture the audience's attention" and "heighten its appreciation of the character" because most citizens of Kirango still linked the Kòmò rhythm to "an awesome and powerful force" (Arnoldi 1995, 99–100). Thus, imaginative inventors of art pulled an audio resource into a bird masquerade atmosphere to enhance the sense of prowess felt for the country's proud move into independence.

In 1978, I did not ask Sidi much about the meaning of Kulanjan. In 1998, I did. This is when he said it is the Maninka name for the marabou stork, called *sajume* in Bamanakan. A large black bird with a white belly, it feeds on carrion and is also a prodigious hunter. Its presence is seasonal, its arrival announcing the beginning of the rainy season, which is also when much Mande masquerade dancing begins.

Kulanjan seems particularly appropriate as praise for Sidi's masquerade, because marabou storks also do surprising things that fit very well in this image atmosphere. They suddenly disappear, and then they reappear somewhere else. Like vultures (*dugaw*), they are said to be exceptionally empowered with both knowledge and *nyama*. They are held to be enchanted because they do miraculous things and can also hurt people. For all of these reasons, people are loath to kill them. But at the same time, marabou storks are believed to entrust themselves to people, because they will nest in the same family's house for generations.

Sidi Ballo said it was a marabou stork that taught the Fakoli family how to hunt. Then, Sidi said, Fakoli, like the marabou stork, did things that surprised people. Everyone knows Fakoli was a general of Sunjata who helped swing the tide of war against the blacksmith-sorcerer king Sumanguru Kante. Members of Sidi Ballo's audience familiar with the association of Kulanjan with Fakoli can thus draw thoughts and emotions about one of Mali's grandest eras—the time of Sunjata and the Mali Empire, when prowess and accomplishment abounded in plentitude—into their consideration of Sidi's masquerade performance.

BIRDS AND ARTISTRY

Sidi Ballo was not the only bird performing at Dogoduman. Mayimuna Nyaarè also stood out as accomplished and forceful, and we can add to our consider-

ation of an atmosphere for performing birds by exploring some of the meanings and values that people might associate with her. Mayimuna, like other good Mande singers, could be called a bird.

Mayimuna Nyaarè is part of a constellation of grand, interconnected traditions. It would be hard to find cultures more enthralled and serious about audio artistry than Mande. Bards and hunters' bards constitute traditions of music, history-telling, and social activism now known the world over for their professionalism and artistic accomplishment. Many have become contemporary international recording artists. Mande leaders and powerful families have for generations had bards specializing in knowing those families' histories and concerns specifically associated with them. This practice may be more than a millennium old. Folk stories, proverbs, and axioms are widely used and held in high regard by enormous segments of Mande populations. They can be complex, are given much social cachet, and are frequently used in ways that demand sophisticated oral and social skills. On the other hand, popular music, generally performed by musicians not born into bard clans and including the songs that abound in the youth associations, is popular in the extreme. People love these songs, adapt them to their own performance situations, and think about them in relation to the issues and situations that they encounter in their lives. Many young people aspire to become popular musicians and will dedicate much time and energy toward that goal. Given this atmosphere of appreciation, it is not surprising that Mali's national television station airs hours of music videos, and people congregate around television sets during the midday hours to view, discuss, and enjoy them.

Mande think birds make exceedingly beautiful sounds and so are apt symbols for singers. It is said that in the ancient past birds taught humans how to sing, and today great singers are praised as birds.

When Mande think of singing birds, they certainly may think of bards and hunters' bards such as Seydou Camara. But outstanding singers also emerge from outside the bards' clans, the internationally known Salif Keita being a good example. Women who sing for the youth association likewise need not be bards.

It is worth recalling some of the ideas that permeate music. Remember, music is *dònkili,* "the egg of dancing," and in an older usage, "a call to dance" (Kone 1997). Music is the cornerstone of performance, and its influence as an art form of provocative power cannot be separated from the power of sculpture and dancing. This is because singing birds are not just beautiful to hear. We have seen that beauty incorporates content, and songs are valued aesthetically for what they say as well as how they sound. We have also seen that birds are linked to knowledge and prowess, and beauty is linked to the power of *nyama.* Thus when we consider singing birds, we are covering a lot of Mande conceptual territory.

Seydou Camara, the hunters' bard, is a helpful example. He knew he was an effective performer, and he frequently referred to himself as a bird, acknowledging his expertise and promoting his credentials to add authority to his performances. In the lines of his songs he would say he was the singing bird, or the string-playing bird, referring to the six-stringed hunter's harp (*donson ngoni*) that he played with virtuosity. In one of his lines, he refers to the different styles of bards by singing:

> Every bird has its style of chirping.
>
> *Kònò bèe n'a kasibolo le.*
> (Cashion 1982, 3: line 203)

And in a strong sequence of lines he names his mother (Dama) and says:

> Dama gave birth to a whole-night-singing bird.
> . . .
> Dama gave birth to a harp-lute bird.
> Numunjan Dama gave birth to killer bird.
> . . .
> Dama bore a powerful bird.
> The beloved bird of Mali.
> The hunters' lion-toppling bird.
> The farmer's lion-toppling bird.
>
> *Dama wololen konsikònò la.*
> *Dama wololen ngonikònò la.*
> *Numujan Dama wololen kònòjugu la.*
> *Dama wololen kònòjugu la.*
> *Mali nikan kònò le.*
> *Sènèlalu jarabi kònò le.*
> (Cashion 1982, 3: lines 224, 228–29, 231–34)

"Whole-night-singing" refers to his endurance and the depth of his repertoire—he was strong enough and knew enough songs to sing all night. Lion-toppling expresses the depth of his affective artistry.

Earlier we noted that Seydou described himself in performances as the singing bird who made people intelligent and provided them with circumspection, an allusion to his own knowledge and his artistic ability to generate reflection in others. So for singers, the bird metaphor brings beauty, knowledge, and prowess together as partners in generating affective form, the artful expertise of singing. This we saw in action with Mayimuna Nyaarè's production of the three blacksmith songs at Dogoduman.

Good singers use performance aesthetics to spark, inspire, shame, cajole, and otherwise influence audience members. They link the audio and visual forms of their performances to the conceptual and emotional forms associated with the Mande institutions and practices that punctuate the experiences of individuals in ways that encourage individuals to do things: to work harder, accomplish more, go to school, amass more resources for the family, or earn a name that will be remembered. Good singers use physical, social, and emotional form to move people into action. Part of their aesthetic strategy involves joining beliefs and practices to ideas and emotions by creating musical stories that can get rolled up in people's own experiences.

The intertwined concepts of mother-childness and father-childness are a good example. Just as Mande people use them frequently to explore situations, understand fellow citizens, and plan strategies for living in the world, singers and other performers shape rhetorical and visual forms that use these concepts to influence people to think and act. To do this, they frequently invoke hunters and heroes—both the grand kind, such as Sunjata Keita, and the everyday kind, such as the blacksmiths in Mayimuna's songs. Singing stories about the deeds of worthy people from bygone times has high entertainment value in Mande. But it also offers a measure of accomplishment that can be used to push people into considering their own weight in the world.

Thus, Seydou Camara sang in the epic *Famori*:

> If you don't praise the dead, the living will not perform great deeds.
> If you praise a stinking wound, it will pour forth fresh blood.
>
> *N'i ma su kòrò tando, nyinama tè monè la.*
> *I bara jeli jugu tando, a ji kura bòla.*
> (Cashion 1982, 2: lines 326–27)

This is one reason Seydou Camara used to tell his audience, in the midst of an epic, to "hold your ears open," *ka tolo malu*, which means to listen intensely, listen carefully, and figure out the meaning of what you hear (Sekuba Camara 1978). As an audience listens carefully, an expert singer can weave a poetic structure that has tremendous impact.

Like many lines in Mayimuna's blacksmiths' songs, lines in Seydou Camara's hunters' epic performances could spring on you with provocative power. "The dancers of the hero's dance have diminished" (Bird et al. 1974, line 2), implies that there are fewer heroes now than in the past, and that is a challenge to act. "Great buffalo fighting is not easy for the coward. Great buffalo fighting is not easy for the unsure" (lines 24–25), indicates the awesome difficulties and dangers that must be overcome to act. "A woman chaser doesn't become a hunter, And become a man of renown" (lines 28–29), means

a person preoccupied with such pleasure will never muster the physical and spiritual strength required to act heroically. "The mourner never leaves the house" (line 31), implies that preoccupation with the sadness of loss will leave one not tough enough for any serious action. "The world has cooled off" (line 74), means that the heat generated by people of passion and ferocity has diminished and heroic action is therefore not at the moment probable. "Ah! The hero is welcome only on troubled days" (line 170), suggests the havoc that a hero brings but also the importance of heroes if society is to survive. "Hot Pepper of the Game, good evening!" (line 343) praises great hunters by likening their prowess to the challenging heat of spicy cuisine. Heat is a metaphor for danger, difficult undertakings, aggression, war, and trouble of all kinds. "The little man fell flopping about like a tramp in the cold" (line 507) describes a charlatan diviner beheaded by the leader Samori. Situated in a social milieu where concepts such as "father-childness" and "mother-childness" are strongly at play, lines like these can go straight to the heart and galvanize audience members.

Striking as those words can be, we have seen that more than words are used to fire up audiences. Through pacing, punctuation, volume, and timbre, singers produce impact. So does the instrumental accompaniment. Seydou, for example, would leap into prolonged and evocative harp solos just after making a telling point. And as he played, he would often dance around the edges of an audience, catching your eye as if indicating that this was all very relevant to you, especially. At Dogoduman, Mayimuna Nyaarè often emerged from the dance arena's edges to tour its central spaces, drawing attention to the way she carried herself and gestured. There was a kind of modesty in her carriage and her vocal delivery that characterized her audio and visual appearance. But just beneath the surface, modesty met confidence and competence, where these divergent human features fused into a public persona that was captivating like Seydou Camara's harp playing.

Because singers can direct lyrics at types of people, families, and even individuals in their audiences, all this audio artistry can feel quite personal. And given the concept of *malo* (shame), that kind of attention can be disquieting, particularly when people think they do not measure up to the characters in the songs, or when they have aspirations they have not yet met. Furthermore, *nyama* always flows with the singing of songs, so a swirling crescendo of potency can be delivered by singers to inspire audience members. No wonder Seydou could sing:

> The wing descending makes its noise.
> Should Camara's arrow miss you,
> Lighting will have missed you.
> Seydou, make your harp-strings sing for me!

Kaman jiginna; kaman di nun-kan bò.
Kamara biyèn bar'i jè,
San-kalama bar'i jè.
Sedu, k'i nò ngònin-juru fò n ye!
(Bird et al. 1974, lines 286–89)

In an episode of the hunters' epic *Famori,* Seydou Camara brings this potency to a head. The story has a bard urging the hunter on to greatness by goading him into a massive hunt. Famori responds by killing off all the game in an area several towns large, saying he will make people diarrhetic with meat. Meat became so plentiful in the storehouses of families that there was no longer any reason for vendors to try to sell it, and people grew concerned. This goes on for dozens of lines, and then comes an explanation:

> It is not the fault of anyone,
> But the string-playing bird.
> He had mocked Famori very much,
> The dedicated one with the moving mouth.

> *Mògò si nò tè,*
> *Juru-fò-kònò nò a di,*
> *A sigilen Famori rò kojuguya,*
> *Bilakojugu da-rò-furanin.*
> (Cashion 1982, 2: lines 1500–1504)

Even wild bush animals worry when these dedicated mouth-movers perform to hunters:

> A horse-antelope fears not the gunshot,
> . . .
> It fears the sound of the strings in the compound.

> *Dagwè ma siran mugu kan nyè.*
> . . .
> *A sirannin ngoni kan nyè so.*
> (Cashion 1982, 2: lines 287, 289)

So singers are birds, and birds inspire an array of ideas about knowledge, power, prowess, and artful expertise. Prowess in frames of action, such as state-building or people-protecting earns individuals the title *ngana,* "hero." The counterpart of prowess, artful expertise, in the frame of action called performance, earns bards an equivalent title, *ngara,* and earns all great performers the honored distinction of possessing *kènèya,* virtuosity. In this way, very good singers bear resemblance to birds, both in their beauty and in their clout.

Though Mayimuna Nyaarè was not a bard, this atmosphere of artistic potency graced her performance at Dogoduman. It added to the imagery of the event. It enhanced the luster of the masquerade performance. And it spilled out of the performance domain of song and into the domain of the dancing bird. At Dogoduman, bird met bird, and image atmospheres swelled with the consequences.

THE MEANING AND VALUE OF FORM

From the beginnings of perception to the ends of contemplation, a bright red and dramatically sculpted bird's head, perambulating magnificently atop a red-bedecked, feather-covered, stunningly mobile cloth cone offers all kinds of possibilities. So does the modestly stately comportment of Mayimuna Nyaarè as she voyages with another bird across Dogoduman dance space. There are the pleasures of being well entertained, the satisfactions and sense of solidarity that can emerge from reflecting on the heroes of Mande history, the challenge of wondering how your own life stacks up against accomplished individuals, the awe and sense of significance that comes from considering the powers of sorcery that Sidi Ballo has joined to aesthetics—all these in every degree of combination are possible. This exponential aggrandizement of resources, from form to meaning, is a cornerstone of art history's usefulness as a discipline.

Meaning as a process or as a result is surely one of the most interesting aspects of art. It can seem so attached to form, so much a part of it, that decades of art historians treated it as fixed and innate, misunderstanding the active way it is made and ignoring one of art's sources of great strength. Art's vitality rests largely on the way form rolls into people's experiences, imaginations, and social interactions. Even when meanings seem well-established, individuals can still experience them as fresh and new. And meanings can be unique in many ways to individuals, while simultaneously sharing many features with the meanings made by others.

This makes form resemble language. By accommodating so readily the personal and the social, it serves naturally as a vehicle by which people can think about and forge lives together. Through discussion, empathy, and doing things with others, we gain access to the ideas and values that constitute the meanings we are each always composing around form, and that enhances the effectiveness of our social interactions while at the same time making them more complex. When we make meanings together, that enhances the community and solidarity that helps manufacture culture as shared experience and mobilized group identity (Appadurai [1996], 2003, 13). As we do all this, there is also the pleasure and satisfaction we experience as we discover and play with one another's meanings. People can exchange their ideas and perspectives

whenever they have a conversation. They banter about what things mean and take delight from the exchange. This happen in spots as mundane as taxi cab stops in Bamako and as special as the shrine of Sumanguru's mother in Soso. Whenever it happens, it means individuals together are adding to and rearranging atmospheres of meaning. This is part of what *jama* means, when Mande use it to indicate more than just the audience, but the unity performance can help them achieve (Brink 1981, 8).

We must be sure to see meaning in its full panoply. It is not just that which can be put into words or even concrete ideas. It carries values and a sense of significance, the sentiments and feelings that may at times be linked to words but often float around them and seem hard to explain. Such things were very much the currency of Sidi Ballo, and they are substantial even if they seem at times as intangible as *nyama* is invisible. Both produce effects and both end up in atmospheres of meaning.

Feelings and values are often caught up in the actions that make the fabric of a performance. These actions include the special tricks and gestures of a Sidi Ballo. But they also include the moments between a featured masquerader's appearances, when community members come out to dance or when the men and women of the youth association circle the arena en masse, performing their own special steps and routines. Feelings and values are even caught up in the act of audience members sharing the experience of a performance together.

Thus, many kinds of meaning cascade together at masquerade performances. While much of that meaning is shared and much is forged together, all of it has elements contributed from the personal experiences of individuals. People are not interchangeable, so different audience members make different atmospheres of meaning, showing that the value of individuals extends from artists to viewers. As in social life itself, the value of individuals extends into the value of groups and vice versa, emphasizing the significance of individuals intertwined.

And, in the midst of all this is Sidi Ballo's masquerade performance. Audience members could construct a number of interpretations about it. They could assert a body of meaning around the significance and value of personal accomplishment. Indeed, the choruses' songs encouraged them to do that with the praise they heaped on Sidi. Because Sidi's virtuosity included sorcery, audience members could contemplate and evaluate for themselves the fearsome and the useful aspects of that whole world of power. Because Sidi's masquerade represented a bird of prowess and prey, audience members could develop rich constellations of cogitation on hunting, the wilderness, knowledge, capacity, fighting, politics, and statecraft, while also calling to mind some of the most galvanizing events and characters in Mande history. Thus, thanks to Sidi, his viewers, and the nature of meaning itself, the bird dance I saw near Saturday

City offered a wellspring of potential access to the big ideas and activities that people use to make Mande culture.

Therefore, form and aesthetics, organized resources and the strategies for organizing them, slide automatically into the creation of meaning and value; while meaning and value slide into actions frequently enough to allow us to say that aesthetic strategies and the construction of meaning are ultimately responsible for many of the important things that happen in society. Form should never be imagined as separate from meaning; aesthetics should never be considered as distinct from social force; and art should never be relegated to the margins of what a society considers important. These are some of the significant things that Sidi Ballo teaches us.

CONCLUSION

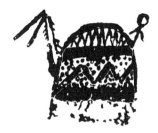

BIRD MASQUERADING
IS ALIVE AND WELL

*Nko sisan fana dinye bè—The world is still
developing (people's minds are changing)*

Those are the words Yaya Traore, Sidi Ballo's former mentor, used to indicate
that changes never stop as new dancers take up bird masquerading. In June of
1998 I returned to Mali after twenty years. My friend and colleague Kassim
Kone had graciously invited me to come with him and stay at his brother Ma-
du's house in Bamako's far northern suburbs. We planned to visit some sites
well known in the oral traditions of the great sorcerer-blacksmith king Suman-
guru Kante and see Sidi Ballo again. In 1978 Sidi had lived in Sikòròni. We had
no idea if he would still be there, but at least we knew where to begin looking.

On our first full day in Bamako, waiting for a public transportation van
(*duruduruni*), we struck up a conversation with a neighbor, a young man
named Dumbiya. Naturally, we asked if any bird masquerading was going on.
The answer was yes, most certainly. In fact, we had missed a nearby perfor-
mance by just two weeks.

Then Dumbiya told an exciting story. Not long ago in Baguinda, which is
a small agricultural community immediately south of Bamako, there had

been a bird masquerade competition. In Baguinda there are two bird mas-
querade groups, apparently owned by competing factions of the town, and the
town was in the midst of a relocation debate, with one faction wanting to stay
where they were and the other wanting to move to a nearby site suggested by
the government. Allegedly out of pure happenstance, the faction in favor of
moving had planned a bird masquerade performance for just after the deci-
sion was made to move the town. Even though the performance had long been
scheduled, the town took it as a victory celebration, a bit of highly public and
pleasurable revelry that the other faction saw as poking fun at them. So the
rival faction used their bird masquerade troupe to stage their own perfor-
mance, by way of suggesting their own strength, solidarity, pride, and righ-
teousness. It was a battle of the birds, and by Dumbiya's account it was most
exciting.

We learned from Dumbiya and many other people that numerous bird
masquerades exist in various small towns all around Bamako. Generally, they
are part of the youth association, but even those can be commissioned to per-
form around the region on their own. The day before we arrived there had
been a *kònò tulon* (bird celebration) just outside of Bamako, over the hill to the
northeast at Nafaji. A performance was coming up in Hamdali, a western
neighborhood of Bamako on the very night we would be in Sumanguru's
northern town of Soso (though fortunately, Madu is a professional photogra-
pher and attended it in our absence). We even learned that a bird masquerade
performed annually at Sikòròni, where Sidi Ballo had told me he lived twenty
years ago. Clearly, bird masquerading was alive and well.

Meanwhile, Fajene Kone, another of Kassim's younger brothers, rode his
mobilette into Sikòròni with pictures of Sidi's 1978 performance. There he
found an active branch of the youth association, the very one that Sidi had
performed with until he retired and moved to a suburb right at Bamako's edge.
So Kassim and I went to Sikòròni and talked to the present *ton tigi* (leader of
the *ton*) and several members of the present dance troupe. We also met the el-
der Yaya Traore, who had been Sidi Ballo's sponsor and a *ton* leader when Sidi
was an active dancer. And we learned how to find Sidi.

Yaya Traore had many fine things to say about Sidi. He, you will recall,
was the man who expounded on the arduous, exhausting nature of dancing
within "the cage," *kònò sansara,* of a bird masquerade and said that the aver-
age career for these masquerade dancers is only five years.

Bafing "Walkman" Dumbiya was the current Sikòròni *ton tigi.* He was
smart, humorous, and extremely serious, and his organization was very strong
and well-disciplined. He was thirty-nine years old and remembered Sidi and
his performance abilities. Like Yaya Traore, he talked extensively about the
importance of power in bird masquerade dancing. Like all *ton* performances
and many other forms of public entertainment, *kònò dòn* is considered play

(*tulon*). But both Yaya and "Walkman" indicated that you have to have power to play, the kind of power that comes from *daliluw* and *nyama;* and to be good, you have to have a lot of it.

Finally, on July 1, we saw Sidi Ballo. Excitement reigned. I showed him a notebook full of pictures from the 1978 performance. He showed me a photograph of me dancing at that performance. At fifty-eight he was fit and thin as a rail, bounding when he walked as if he were a young athlete. He did not see as well at night, but he had the same powerful awareness that he had twenty years ago, the kind that takes in all manner of social things and responds with startling swiftness. His voice has gotten a little higher, and I swear there are times when he almost sounds like a bird.

He said he had retired a mere three years ago but still performs at least once a year. Mostly now his very talented younger brother, Solo (see plate 21), operates the masquerade, and it is not the same one Sidi used in 1978 at Dogoduman. I'm not sure when, but as Sidi increasingly felt his age, he decided to completely transform his masquerade to make it a little more manageable (and a bit safer) for a person not quite so lithe as he was in his twenties and thirties. At some point the original carved bird's head had broken, so he carved a replacement. And to accommodate the drastic changes he made to the masquerade, he also completely transformed his choreography and inventory of movements and feats.

Sidi said he wanted to stage a festival for us two days later on the fourth of July. Solo would do most of the performing, but he would dance a little. Just a little because, as he kept telling us, "Patrici, I am an old man, I cannot dance for more than ten minutes." But he danced for one hour effortlessly. He worked the arena with aplomb, and we saw in action all the changes he had made to masquerade, maneuvering, and his special feats.

Remember that, at least in the area around Bamako, masquerade dancers tend to have short careers, and then exhaustion sets in or they just move on to other things. Sidi, however, was far too dedicated, far too impassioned, to want to stop bird dancing. So it is little wonder that after three decades of successful performing, as Sidi began to feel his age, he sought strategies to keep his performance marvelous while accommodating weaker night vision and lessened agility.

The very light, bent wood scaffolding from 1978 was replaced by numerous thick, tall poles, assembled into a hollow cone that was quite large at the bottom (see plate 22). The top half of this cone was covered with a thick, impressive matting of large black vulture feathers, far too numerous to count, mounted upside down and held against the masquerade with a virtually invisible white plastic mesh. These feathers were mostly recycled from the long strands of vulture feathers on the old masquerade. In their midst, he made a little porthole so he could see out more easily. But the vulture feathers were so

densely packed that they masked the porthole. You could not see it even if you looked for it.

On this new masquerade, Sidi included a pouch, attached at about waist level, on the opposite side from the spot where the bird's head emerges in its sleeve. A little sculpted figure resides in the pouch (see plate 23), which Sidi calls the "child of the *kònò*" (*kònòden*). It is reminiscent of the small cloth and wood hand puppets that Imperato (1980, 48, 54) saw attached to youth association *kònò* masquerades three decades earlier in the Bamako region, although those were removed from the pouch and manipulated as the bird sat stationary. Sidi's "child of the *kònò*" was not designed for manipulation. It was designed for power. He told us he incorporated it to add *nyama* to the masquerade, suggesting it is loaded with the energy of action.

The several bands of red cloth arranged like Christmas ribbon over the old costume were now gone, replaced with a wide band of the same red, wrapped horizontally around the middle of the masquerade. Below that was a long ring of white rope-like fibers, dyed light red at the tips and very reminiscent of the fiber fringe worn by one of the *Ntomoni*-masked dancers at Dogoduman. It is a fringe used quite commonly in *ton* masquerades around Bamako. This fringe was on top of a wide band of nearly white material that recalled the dangerous burlap band Sidi had used to such dramatic effect on the old masquerade. Indeed, part of its function was to remind audiences of that old masquerade and the feats Sidi had performed within it. Now, however, it was not dangerously underfoot.

Instead, all of these attachments were anchored to a thick locally made country cotton cloth blanket such as is widely used in Mali, embellished with black, white, and occasional red stripes. This blanket extended beneath the poles of the masquerade frame as far as the burlap had on the old masquerade. But this cone was nearly eight feet in diameter, so there was a safety zone in the middle for Sidi's feet. He still had to be careful when he moved at speed, but not nearly as careful as in the old masquerade.

The ramifications of this masquerade transformation were severe. The new masquerade could not be tipped over, and it had that safety zone for the feet. But every single dramatic move that Sidi performed at Dogoduman was now impossible, because all the costume's flexibility was gone, as was the light weight. Leaping over benches, climbing into bleachers and jumping off them, listing precariously from side to side, slamming horizontally into buildings, and, of course, dancing on the top of an upside down masquerade were now all out of the question. So was lying horizontally on the ground and opening the bottom of the costume, because there was no way to get onto the ground horizontally. One would think that rapid motion around a dance arena would be impossible now too because this new masquerade's added weight and rigidity made just lugging it about a challenge.

But if all this loss was negative, it certainly did not show in Sidi's performing or in his ability to draw an audience. As Kassim and I watched him perform in 1998, he was still a commanding presence in the dance arena. Not only had he completely redesigned his masquerade, he had also completely redesigned his choreography so that his motion and all of his gestures had an entirely new look.

The visual triplets he used to do, and the deep listing from side to side, were designed to help keep his motion complex, eye-catching, and thrilling. In 1998 he had all new moves. Instead of the triplets, he generated a huge swaying motion like a buoy caught in rough seas. The entire masquerade seemed to roll as if it were on a pivot suspended in mid-air, while simultaneously it rose up and then swept back down in such an exacting, regular pattern that you could keep time by it. This motion was downright hypnotic and eye-catching in the extreme. He tended to do it at the end of a series of long runs across and around the arena, so that it finished off a burst of bird energy with a kind of visual refrain. It was as if the bird were having you take stock of what you just saw, with a motion so interesting that you could not stop looking at it.

Instead of the radical dips from side to side, Sidi modified this rolling pitch. He raised it up higher off the ground and swayed it farther to left and right so that you perceived it as an elevated dip that thrust up and out, instead of out and over. It had the added effect of making the entire masquerade seem light as a feather, quite an accomplishment if you knew how it was constructed. Thus, with the new masquerade and its demands, Sidi had not lost any visual excitement. He just created a new set of moves to dance it.

Very prominent in this new set of moves was a kind of motion he could create in the lower half of the masquerade. At moments well suited to punctuation that countered and contrasted with the huge swaying motion, he would suddenly make the band of fiber fringe, the band of white cloth beneath it, and the heavy cotton blanket beneath both shoot outward horizontally and then arch back against and beneath the frame. He did this repeatedly and very rapidly, making the moving parts seem almost liquid, as if they were waves spreading outward in concentric circles from a stone thrown into water. This was very impressive visually, even more so when you try to imagine the strength and precision needed to create the effect. The whole masquerade must be lifted and lowered swiftly and with power to create the waves, but subtly enough not to give the audience the impression that the masquerade is being rapidly lifted and lowered. This is absolute strength and finesse, the very essence of Sidi Ballo.

Another essence of Sidi—the passionate and effective use of *daliluw* and *nyama*—was also at work in the new masquerade and choreography. There were not that many more vulture feathers in the new costume. But because they were clustered in a mass instead of being strung in long bands, they

seemed a lot more numerous. That added excitement, thrill, and a touch of anxiety for audiences, since vulture feathers are loaded with *nyama,* and everybody knows it. That piquant sense of danger was exacerbated by Sidi in this new masquerade, because, as with the old one, he frequently dashed past audience members at so close a range that he virtually brushed up against them.

On top of all this re-invention in both the masquerade and its animation, in spite of the new weight and cumbersomeness of the costume, rapid motion was indeed still an option. Sidi moved this masquerade across the arena and did circles around it with lightning speed. And it was clear from the masquerade's orientation that often Sidi was running sideways or backward while supporting the heavy frame and manipulating the bird's head on its long pole in huge, dramatic, sweeping arches, or thrusting it out toward the crowd, or jutting it left and right as if it did not weigh a thing. This new carved head had to be lighter than the old one, because it had no bulbous articulations and was slim, almost pencil thin. But it was still hard wood and mounted on a long heavy pole. And with the added weight of the new solid frame and the years added to Sidi's age, the work he was doing inside that masquerade was nothing short of staggering.

And remember, Sidi had made a porthole among the vulture feathers so he could see out. But when he ran sideways or backward, the porthole remained facing to the front, so he could not see where he was going. Seeing through a mat of vulture feathers, plus a thick cotton blanket, and between a forest of wood poles, is simply impossible. Therefore, careful maneuvering at high speeds was even tougher in this masquerade than it was in the old one, where he only had to look through thin factory cloth. *Daliluw* could help produce the kind of radar he needed, but after so many years of experience in dance arenas, Sidi could calculate distances without even consciously thinking about it, and he had a fine-tuned sense of where people were and where they might move.

Even his dramatic feats were not entirely lost, though they were transformed. Lying on the ground with the masquerade bottom open to the audience had been one of his most admired and spell-binding moves. What Kassim and I saw instead was Sidi pushing the masquerade straight up while tilting it sharply back, numerous times, so that the bottom of the frame popped out toward the audience, revealing the same sort of emptiness people used to see when the bird was prone on the ground.

While Sidi could no longer leap into the air and slam horizontally into a wall, he had a new move that was entirely different but generated comparable drama. At the conclusion of a set of rapid turns about the arena, he settled very near a house wall. Slowly the masquerade became horizontal, as if it had been rotated on a central axis. Now the bottom of the costume, where the wood frame was nearly eight feet in diameter, was pressed sideways, entirely against

the wall (see plate 24). And then it levitated. It rose up on the wall so that no part of the masquerade remained on solid ground, while the still-horizontal bottom continued to hug the wall. It stayed there for many long seconds and then settled back down to earth. If you try to imagine how Sidi could have positioned himself within the wood frame, and how he could have maneuvered it to accomplish this effect, you find yourself baffled and once again in awe of this masquerader's prowess.

Sidi still had lots of power, the kind that comes from strong character, hard work, aesthetic acumen, and *daliluw* and *nyama*. When we looked at the pictures from 1978, he kept pointing out amulets, and he talked with delighted but serious passion about how important they were, and how they kept him performing and kept him alive. Competition in Mande will always play itself out in the arena of sorcery, where other performers or even audience members may feel they have the power to "try themselves on you." Sidi, as usual, was prepared for that.

Thus, in his late fifties Sidi Ballo was still as fit and athletic as a gymnast or ballet dancer. He was nimble of mind and full of the same capacity for artistic judgment that had helped him build his career. He took the adversity that age was bringing as a compositional challenge and thus reinvented himself as a masquerade dancer, with spectacular results. Kassim, raised on Mande rural theater and a good judge of performance accomplishment, was as thrilled by Sidi's 1998 performance as I was. Sidi may have been older and even semi-retired, but he was still extremely good.

That Sidi so thoroughly transformed his performance is a tribute to his dedication and artistry. It bespeaks a highly imaginative and talented artist adjusting with panache to the changing circumstances of his life, and it is certainly worth documenting by a discipline concerned with artists' biographies. But the years this transformation added to Sidi's already long career are also worth recognizing, because for a large region around metropolitan Bamako, Sidi's voice remained a part of the ongoing dialogue about contemporary life in which both urban and rural people constantly engage, be it in conversations and actions or in contemplation about themselves and their situations.

It is noteworthy that Sidi's nearly forty-year career was located in the suburbs of Bamako and the numerous small towns up on the plains between Bamako and Kolokani during a period that has seen tremendous changes in political leadership, government infrastructure, educational and cultural institutions, and economic opportunities. These days, with 40 percent of Africa's citizens being urban and enormous cities such as Bamako continuing to absorb young and old alike into lifestyles that have both good and bad to offer, affective entertainment that enters the play of ideas and actions by which people define themselves and plumb the values that compose their lives is important.

Categorizing things as contemporary or traditional can ignore the rich, complex, and subtle social processes that complicated individuals instigate and engage. We could say that Sidi's masquerade and performance celebrated essentially conservative Mande values. But it is more accurate to say they made tangible many features of Mande culture that have helped people forge fruitful, successful, rewarding lives. Old and new may often seem to clash, but often too they are so entangled with each other that we cannot easily sort them out. I find it gratifying that Sidi's perspective on Mande social life, dynamically articulated in an art form that was itself embedded in change, remained so long a part of the multitude of voices considering how one might live in twentieth-century central Mali.

Sidi Ballo developed a spectacular career through extremely hard work and the refinement of finesse, both of which earned him real merit. This thin, strong man with brains and ability is not to be taken lightly. Bird masquerading is indeed alive and well in Mande, and may it long be practiced by individuals such as Sidi Ballo.

ART HAS A HUMAN FACE

It was sheer luck that put me in Saturday City the night before Sidi Ballo performed at Dogoduman. Had I not been a member of that audience, I wonder what I would think now about form, aesthetics, performance, and individuals. Sidi Ballo did not spend decades influencing only Mande. He spent thirty years influencing me, all because one night in 1978, I saw a bird dance.

Other individuals have influenced me substantially. Sedu Traore, the blacksmith, was most certainly one. A man of noteworthy professional accomplishment, possessing great skill and much knowledge, he excelled at working wood and iron but also at divination, various herbal cures, and amulet-making. He was quietly humorous and full of delightful interest in all the twists and turns one encounters while living in our world. At the same time, he had a deep sense of ethics and was full of conservative interpretations of what Mande society is and what people should be. Perhaps this is why he was frequently called upon to serve as a social advisor and mediator. More than anything else, I learned from Sedu how fine it is when so many positive personal and professional qualities are joined in one man.

Seydou Camara, the hunters' bard, is another individual who touched me deeply. He was such an excellent harp player and such a powerful singer that his performances in the world of hunters' music were as accomplished as Sidi Ballo's were in the world of masquerade dancing. Seydou was also profoundly knowledgeable. He was an encyclopedia bubbling over with information about the ideas, beliefs, institutions, and activities that circulate through Mande his-

tory. He never hesitated to evaluate and critique, often in his conversations and sometimes in his songs, whatever he felt did not serve people well. He spoke and sang with great authority and passion, and I can still hear his gravelly voice shooting densely packed rapid-fire lines out into his audience. At home or at a hunters' dance, he had immense amounts of energy. Feeding into all this was the fact that he belonged to a famous blacksmiths' family that claims direct descent from Sumanguru Kante, the sorcerer king who fought Sunjata Keita. Seydou's songs and personality rippled with a knowledge of sorcery and its history, and this amplified the impression of his personal energy. More than anything else, I learned from Seydou that people can control tremendous internal power and intensity, converting it into collateral that helps them to succeed and be a positive force in their world.

I have also met individuals who showed me the less pleasant side of Mande life. I met a smith, for example, who seemed always to be smug and was frequently pugnacious. He was quite willing to inflict negative sorcery on people for malicious reasons or even just for the fun of it, negative sorcery in the form of painful skin infections that could plague a person for years. Here was an individual one did well to avoid.

But it is the people like Sedu Traore and Seydou Camara who frequently infuse my thoughts. I cannot teach or write without thinking about things they said or did. In fact, I can't live my own life—working, traveling, playing with my children—without their being with me. The same is true of Sidi Ballo.

I certainly could and possibly would have met other people with Sidi's infectious influence. But what he was in 1978, coupled with what I was then, made meeting him a watershed for me. He is like Seydou Camara in the ways his knowledge, prowess, confidence, and intensity tumble out into people's perceptions of him. But he is less philosophical and more emphatically matter-of-fact about life. For more than twenty years I found it very hard to write about him because I never stopped feeling that I could not do him justice. Perhaps now I have—or at least I have helped show what a person like Sidi can be to a society and the people he meets in it.

The weight of individuals in society should be obvious. Literature is full of the consequences people produce, and we should not treat them as all lumped together so that their effects disappear into the woodwork of cultural resources and social formations. On the other hand, we should not dramatize artists' biographies while isolating them from the traffic of human society. The individual I have emphasized here is extraordinary in many ways, but so are many other artists in societies everywhere.

There are as many fine artists in Africa as there are anywhere in the world. Sculptors, metal workers, musicians, painters, performers of all kinds, photographers, weavers, architects, book designers, fashion designers, Web page

designers, calabash carvers—there is no shortage of media, both old and new. Many of these artists have led lives of considerable interest, and, like Sidi Ballo, Seydou Camara, and Sedu Traore, many have engaged their communities in ways that are worthy of scholarly attention.

Contextualizing art by linking it to real people helps bring the art to life. It lets us see more clearly the intellectual, emotional, and social cornucopia that art can be. Sidi Ballo's masquerade sitting in a museum display would be wonderful. But it is even more valuable to know something about the experience of Sidi performing: to know what went into it and what Sidi himself is like, how he worked with other artists such as Mayimuna Nyaarè, and what sorts of things audience members can bring away from performances such as that at Dogoduman. Art has a human face, and by trying to understand that face we can comprehend the art with more of the richness and vitality that is its natural birthright.

NOTES

1. The Performance

1. I was at the dance arena and did not witness this. But Sidi described his activities to me several times, and made it clear that his attitude about it was business-like, tinged with a certain amount of pleasure. Engagement with the less visible world varies widely, being characterized by the personalities and experiences of the people involved. I want to emphasize that many Mande find this world fearsome, many find it dangerous but manageable, and many find dealing with it adventuresome and rewarding. Sidi Ballo enjoyed it. In an earlier publication (1988, 11–15), I examine the ways supernatural actions and worlds have been perceived by Westerners and presented by Mande.

2. I learned from Sidi later that it was made of bamboo and resin, but I never saw it. It sounds like a cross between a whistle and a flute.

3. I first saw Sidi Ballo's bird masquerade costume just before the Dogoduman performance. Only later did Sidi explain its construction to me, at which time he also drew a picture of it. But I had seen masquerade costumes before and already had a reasonable idea of what Sidi had to work with inside his own.

4. As happens many times during the Dogoduman performance, the audience's understanding of the world is used as a resource by dancers to create drama, titillation, or burlesque through movements and gestures that cast expectations into new frames of reference. It is a mainstay of youth association performance strategies. Its satirical side is explored by Brink 1980.

5. Some Mande, even members of the audience that night, claim that dancers have died from such accidents, or lost a lot of blood. There can be an aura of potential danger around masquerade dancing that has the effect of amplifying the accomplishment of good dancers by suggesting that it is at times a high-stakes art form.

6. Frames made of this scaffolding are occasionally seen sitting outside the homes of youth association masquerade dancers. People are familiar with them. But Sidi's manipulations of his were masterful. When he changed the masquerade's shape by squishing it together or squatted down so that it appeared to shrink, he was performing feats that impressed even excellent dancers (Traore 1998).

There is considerable variation in masquerade frames. Arnoldi (1995, 2–4) illustrates

frames from the Segou region some 150 miles to the east and describes their construction. They are quite different from frames I saw in the Bamako region.

7. It is to help him accomplish feats such as these that he made sacrifices before the performance. In all of our conversations, Sidi made it clear that in his view it pays for performers to possess supernatural powers.

8. This performance resembled quite closely break dancing, which grew up in America in the very late 1960s and 1970s. Mande youth association performance includes a strong genre of acrobatics, at which many young men become quite expert. Given the premium placed on creating new characters and skits in the youth association, break dancing would be an excellent innovation. Thus, what I saw at Dogoduman may well have been another example of the constant trans-Atlantic intercourse of music and dance that has long been enriching expressive culture.

2. How to View a Bird Dance

1. Interestingly enough, the first appearance sequence was an exception. To start the event with a certain drama and pizzazz, two masked youth association dancers came first, and then came the younger, unmasked dancers. Starting with this altered sequence struck me as an effective way to establish a more potent atmosphere, and it allowed the unmasked dancers to be a kind of refrain, or the response part of a call-and-response musical sequence.

2. Research by Aden (2003) indicates that precolonial community youth associations had strong financial and social links to Kòmò, a major social, spiritual, economic, and indirect political force in Mande societies.

3. The dynamic nature of this bubbling cauldron of creativity cannot be overemphasized. Arnoldi (1995) brings its vitality to readers on virtually every page of her book, and the publications by Brink and Imperato do likewise. In 1978 Kalilou Tera and Sekuba Camara endlessly impressed upon me the value of this artistic intensity and its spirit of innovation, and Kassim Kone, who has carried out much research on performance, could not agree more.

3. Sidi Ballo at Dogoduman

1. Arnoldi (1995, 24–29) presents an overview of published descriptions of youth association masquerading from the late nineteenth century to the present. This is an area of inquiry for which we could use many more reports. It would be extremely useful, for example, for researchers all over West Africa to collect oral traditions and local accounts of bird imagery and masquerades.

4. A Closer Look at Sidi Ballo

1. Arnoldi presents a cogent picture of interaction, competition, and creativity between youth association branches; see especially, 1995, 35–37.

2. Although I have not seen a program or official participants list, I am quite convinced that this was FESTAC 77, the Second World Black and African Festival of Arts and Culture. I would love to have an eye-witness account of how Sidi Ballo was

received in Nigeria. For information on the festival, see Apter 2005 and Monroe 1977.

3. In 1998 I asked him if he still smoked, and he said no, it's bad for your health.

4. A useful cross-section of scholarly perspectives on joking relationships can be found in Doumbia 1936, 358–362; Hopkins 1971, 101; Jackson 1977, esp. 153–56; Labouret 1934, 101–104, and 1939; McNaughton 1988, 10–11; Paques 1954; Paulme 1973; and Simmons 1971, 17. My friend and colleague Kassim Kone is a passionate participant in joking relationships. When we were in Mali in 1998, I learned an immense amount about them from talking to him and also from watching him engage in them.

5. I have discussed elsewhere (McNaughton 1988, 11–18, and 1995) the various views that Mande people have of this power and the negative impressions that researchers sometimes harbor.

6. This is not to say that all *daliluw* owners are decent, ethical citizens. Like most other things in every society, there is plenty of exemplary behavior, plenty that is not, and plenty that falls somewhere in between.

7. In a now-classic article on the Mande hero, Bird and Kendall (1980) show how social forces of stability and change are intertwined and co-productive, wedding individuals and groups to their mutual benefit. See also Bird 1972 and Bird, Koita, and Soumaoura 1974.

5. Individuals Intertwined

1. The concept of the *individual* has not found straightforward lodging in scholarship. Lukes (1973) notes that its close cousin, *individualism,* has been steeped in ambiguity and confusion since the nineteenth century, and he wrote an entire book to clear it up. The *person* has been a frequent subject of study in social science, but often as a generic, elemental unit of society conceptualized within examinations that resolve around social structures and patterns. This contrasts with my use of the word *individual* to signal a person whose knowledge, skills, experiences, and perspectives are constantly at play with the structures and practices of society.

2. The concept of variety in artists—generally translated as talent or success—is common in writing about Western art. Art history literature is laden with the implications that artists can be divided by caliber into first-rate and lesser-rate practitioners. There are numerous problems embedded in this approach to distinction, but there is at least the recognition that all artists are not the same. Too often in African art studies artists have all been lumped together in a society or a genre as if there were no differences among them and therefore no consequences of affect or influence in the range of the work that they do.

3. To list Apter 1992, Arnoldi 1995, Barnes 1986, Beidelman 1986, Boone 1986, Fardon 1990, Hoffman 2000, Jackson 1982, Kratz 1994, Reed 2003, Riesman 1986, Schildkrout 1978, Stoller 1989, and Strother 1998, does not even begin to scratch the surface. But these are some of the authors that have had the strongest influence on me.

4. Our preeminent Africanist art history librarian, Janet Stanley of the National Museum of African Art, recently performed a quick search for citations in scholarship on individual African artists, and she encountered more than a hundred, of widely divergent length and scholarly orientation, but on artists from all over the continent.

5. Candace Keller has spent a year working closely with Malick Sidibé and several other Malian photographers. Her excellent research demonstrates convincingly that many so-called "traditional" Mande concepts are enormously important to the work of this world-class photographer.

6. Every student of African society will no doubt have favorites among the many volumes and essays now forging fresh conceptualizations of African individuals and their agency. Among mine are Barnes 1986, Beidelman 1986, Feierman 1990, Jackson 1989, Jackson and Karp 1990, Karp and Masolo 2000, Lan 1985, and Reed 2003.

7. Some of the most exciting social science research over the past forty years has taken the form of *action theory* or *praxis theory* (Ortner 1984) and a particular variant by Anthony Giddens (1979) called *structuration theory*. Here important groundwork was laid for understanding the importance of individuals. The latest step in that understanding can be called *complex agency,* where the importance and potency of individuals is both acknowledged and understood within a complex matrix of many people contributing to the outcome of social processes. Excellent studies articulating complex agency are Kratz 1994 and 2000. See also Hobart 1990.

8. The classic text on ancient happenings in the Western Sudan is Nehemia Levtzion's *Ancient Ghana and Mali* (1973), currently being revised by a team of scholars. A useful reference for Malian history is Pascal James Imperato's *Historical Dictionary of Mali* (1977), while a detailed and imaginative glimpse of ancient activities of early Mande people can be found in Roderick James McIntosh's *The Peoples of the Middle Niger: The Island of Gold* (1998), which offers an extensive bibliography. For an excellent overview of the entire ancient Western Sudan, see Graham Connah, *African Civilizations: An Archaeological Perspective* (1987), chapter 4.

9. For some three decades, Susan and Roderick McIntosh have been excavating in the middle Niger and elsewhere in the great plains around the Niger and Senegal Rivers. Known for integrating their archaeological findings with scholarship in history, folklore, anthropology, and climate, they have been presenting fresh new perspectives on complex society, professional specialization and the integrated development of local and regional resources since 1981, when they wrote about the enterprising happenings at ancient Jenne-Jeno. Téréba Togola, former head (now deceased) of antiquities in the Republic of Mali, was dedicated to a thorough reconstruction of the country's rich past, and his own publications (such as 1993, 1995, and 1996) are important contributions to an understanding that grows increasingly complex with each new publication.

10. Roderick McIntosh (2000, 159–67) presents an interesting interpretation of the roles hunters may have played in the ancient Western Sudan.

11. Michael Jackson has been a leader and most sensitive proponent of this perspective. Several chapters in *Paths toward a Clearing* (1989) demonstrate how stories about individuals bring a society to life. Another extremely effective example that also brings art and spirituality together emphatically, is Paul Stoller's *Fusion of the Worlds: An Ethnography of Possession Among the Songhay of Niger* (1989). As phenomenological anthropology, accounting for lived experience is accruing considerable collateral in social science. The edited volume *Things as They Are* (Jackson 1996) offers a useful cross section. A much more radical form, which blends in personal narrative of the experiences of the researcher, is Jim Wafer *A Taste of Blood: Spirit Possession in Brazil-*

ian Candomblé (1991). For some scholars, such as myself, inspiration for the value of lived-experience narratives came half a century ago when Laura Bohannan (1954, using the pen name Elenore Bowen) wrote a personal narrative of her work with Tiv that provided warmly human glimpses of the lives of people around her. More obvious examples are life stories, of which *Nisa: The Life and Words of a !Kung Woman* (Shostak 1981) is a well-known example.

12. I have cited Riesman (1986) three times in the space of a handful of pages because he is the author of a now-famous study of how the person has been treated in ethnographic literature. It is a treasure trove provided by a scholar who was brilliant. He begins his examination by noting its importance as a topic since the 1930s. With sensitivity and insight, he reviews a rich cornucopia of approaches. Across a spectrum of African societies there have been studies of how people are linked to spiritual beings and principles as well as to each other and to their communities. There have been studies on the nature of the life force and its complexities in people; on the relationships between speech and people; on the metaphorical relationships between parts of people and such social forms as weaving, architecture, or blacksmith's equipment. There have been examinations of people's metaphysical links to other entities in the world, such as agricultural seeds or the animals viewed as people's totems. There have been explorations of people's psychological, social, and moral being, and on the status, powers, obligations, and roles of people in society. People's passage through rituals of transformation, into adulthood or marriage, for example, have been explored. Their conceptualization of and responses to numerous forms of hardship and distress have also been studied. Finally, the nature of knowledge and how it relates to people has been considered, as has the nature of social action and the roles individuals play in it.

Within this wealth of research it becomes obvious that a most important issue has been the interplay between person and groups, social institutions, and the established beliefs and practices (social forms) that help characterize a society at any given moment. Do individuals, as Western scholars conceive of them, exist in African societies? Are people defined by the knowledge, skills, and drive they possess, or are they defined by their situation and relationships to other members of society? Can people exercise appreciable autonomy and independence, or are they constrained to occupy niches and play roles outside their own choosing? Is personal creativity important, or is it subsumed within the joint activities of conglomerations of people? Do people habitually think about their social realities in critical, analytical, evaluative modes, or are they too powerfully driven by their societies' systems, codes, and ideologies to be reflective? Do individuals have the capacity to affect the course of events, or are they simply caught up in a flow that ultimately imbues them with their identity? All of these queries emerge from the more basic question of what exactly is an individual in particular African societies—or, indeed, in any historical or contemporary society—and Riesman's extensive essay sheds valuable light on the many ways these questions have been addressed.

13. This potency of art as manifest in the West has been the subject of two helpful studies, Elkins 2001 and Freedberg 1989, each of which in its own way describes the difficulties of discussing the power. Elkins even examines the phenomenon of people striving to avoid that power. A much older study (Kris and Kurz 1934, translated into

English in 1979) explores the issue from the vantage point of how artists are perceived.

6. Sidi Ballo's Aesthetic Milieu

1. Students of bodily experience, the indelible union of body and mind, and the dynamic mediations between habitus and agency would find Sidi Ballo a tremendous asset in promoting the perspective that our sensual-corporal-cognitive selves are so thoroughly united that separating them is arbitrary and that ultimately it is as if we think with our bodies as well as our minds. The growing and very useful bibliography on these intersecting intellectual perspectives includes Csordas 1994, Desjarlais 1992, Jackson 1989 and 1996, Johnson 1987, McNeill 1992, Merleau-Ponty 1981, and Sudnow 1978. John Dewey [1934] 1980 offers much for this perspective in his phenomenological assessment of people and aesthetics.

2. Setting Plato aside, Dissanayake (1992, 39–40) and Wolff (1993, 12–14) say the origins of aesthetics in philosophy were dependent upon the Western formulation of the category called art, which began in the fifteenth century and took much of its present shape in the late eighteenth and early nineteenth centuries. Williams (1985, 31–33, 40–42) offers useful perspective on the origins of aesthetics in philosophy. Eagleton (1990, 15, 16) describes aesthetics' philosophical origins as "the strange new discourse" that attempted to bring feeling and sensation under rational control, as "a kind of prosthesis to reason, extending a reified Enlightenment rationality into vital regions which are otherwise beyond its reach."

3. To begin to touch the surface of these issues, see, for example, Dewey [1934] 1980, Croce [1902] 1997, and Sircello 1972. The essays in Gaut and Lopes' 2001 compendium on aesthetics offer a most helpful overview. Kleinbauer and Slavens (1982, 5–7) give a very concise thumbnail overview, and Wolff (1993, 68–94) offers a constructive perspective from the vantage point of a sociological orientation.

4. This "modern" Western view of art, held in many academic and high-culture circles, emphasizes artists struggling to communicate emotions and audiences taking rarified pleasure in beauty and such related splendors as the sublime, frequently with little substantive reference to realities outside the work of art. Barricading art from the rest of lived experience disempowers art, by severing it from all the particulars of life that provide people the very means to interpret, evaluate, and give social and emotional value to artwork. The power art has in people's imaginations and collective lives depends on myriad lines of connectedness to personal and communal histories. Perhaps that is why Fratto (1978, 135) calls "art" a useless and misleading "synthetic Western category." Many studies in the sociology of art would not go this far but do offer a critique of art in isolation that began to be seriously heeded in art history only a handful of decades ago. See, for example, Bourdieu 1984, and Halle 1993. An extensive examination from a sociological perspective is provided by Wolff 1993.

5. The works of these scholars are commonly gathered under the labels "critical theory" and "postmodern studies" and frequently brought together under the banner of the "anti-aesthetic," a wide range of writers from many culture zones—philosophy, criticism, art history, gender and area studies, and social sciences. Foster ([1983] 1991, xv) characterizes the anti-aesthetic as bringing social, economic, and political rele-

vance, purpose, and history back into the aesthetic domain. The essays in that volume are a worthy read and show some of the range of disciplines involved in this new focus on aesthetics. The spring 1997 (vol. 56) issue of *Art Journal* is another excellent cross-section of the topics that come under consideration in this new orientation, and the introduction by Grant H. Kester (pp. 20–25) offers an excellent overview of the complexities incorporated into aesthetics.

6. *The Traditional Artist in African Societies* (1973), edited by d'Azevedo, was groundbreaking, with many other authors making valuable contributions. Roy Sieber wrote a useful commentary on Westerners grappling with African aesthetics, and on the whole this book seemed to foretell fine things to come. Robert Plant Armstrong's three books are beginning to garner a following in Western art studies. See V. Y. Mudimbe's (1984) review of the last book, *The Powers of Presence,* for a most useful perspective.

Several African scholars have addressed various aspects of aesthetics. See especially Abiodun 1994, Ebong 1995, Lawal 1974, Memel-Fote 1968, Okpewho 1977, and Onyewuenyi 1984. Books and edited volumes that include African aesthetics, though few in number, include Armstrong 1971, 1975, and 1981; Blocker 1994, Boone 1986, Coote and Shelton 1992, Hallen 2000, Hardin 1993, Jopling 1971, Ravenhill 1980, van Damme 1996, and Vogel 1980.

7. See Kester 1997 and Scarry 1999 for useful discussions and refutations of this view against beauty. A very strident assertion of the "anti-aesthetic" position is presented by Jones 1999. A hailstorm of debate about beauty began in 1993 with Dave Hickey's *The Invisible Dragon,* which ignited harsh criticism as a return to elitist and ivory tower linkages between beauty and pleasure. But Kester 1997 notes that authors extending back to Schiller and Hegel have explored aesthetics as an instrument of morality, measured reason, and democracy, even though their writings may often be somewhat ambiguous.

8. Langer (1942, 1953, and 1957) and Armstrong (1971, 1975, and 1981) grappled mightily with this profoundly important and difficult issue of power. Both wrote in complicated and difficult prose, perhaps reflecting the complexity of their subject and the reverie its contemplation cast upon them. Armstrong (1975, 21–26) heaped pages of criticism on Langer for confusing the referencing of symbols with the actual power in objects and acts, and for trying to submit feeling to reason. V. Y. Mudimbe's 1984 review of Armstrong's work on aesthetics is hugely supportive. Rosaldo's review (1972) of *The Affecting Presence* is more qualified.

9. Most Africanist scholars do not suffer from this delusion. But strikingly large numbers of students enter my introductory African art classes every year with the impression that African people have no aesthetics. Even more surprising is the fact that many historians of Western art are under the same impression.

10. Arnoldi (1995, 22–23) presents an excellent examination of *nyama*-laden artwork. See also Brink (1980, 95).

7. Form Reconsidered in Mande Light

1. In fact, the body-mind disenfranchisement bears on aesthetics and artistry because it polarizes somatic and intellectual experience, thereby masking the very nature

of experience in the world. Experience is a melding of the body, mind, and senses, and thus it must factor into aesthetics most powerfully whenever perception comes into play. David Sudnow (1978) wrote very insightfully about the mind-body schism and the wonders of rediscovering the link through music. Since then, several other serious scholars, such as Mark Johnson (1987) and David McNeill (1992), have engaged the topic. The noted educational psychologist Jane Healy (1990) has written on the importance of the body in learning. In ethnography, Michael Jackson (1989) has written very convincingly on the need to restore considerations of the body, especially in his introduction and chapters 7–9. Paul Stoller (1989) presents a most dramatic exploration of these links in his treatment of possession and divinatory experience.

2. Much research is now taking place in cognitive psychology that pertains directly to form as more than physical appearance. An old distinction, in philosophy and then psychology, existed between sensation and perception. Sensation is supposed to be "pure response to the outside stimulus, without the benefit of all our memories and knowledge of the world" (Pelli 1997). Perception incorporates that knowledge. Significantly, however, there seems to be no evidence that sensation in the above sense ever actually occurs.

3. Panofsky's iconology (1955, 26–54) is not simple or straightforward in its formulation or application. Africanists have taken issue with aspects of it, sometimes rather severely. See Blier 1988 for an informative examination.

4. This is one reason aesthetic considerations can be appropriately and usefully applied to objects and acts that fall outside the domain of art. Kester (1997) acknowledges the importance of applying aesthetics beyond art, and so does Seel (2005, xii). That scholars are increasingly willing to consider aesthetics' relevance to other enterprises, instead of insisting they are what distinguishes art, is a very healthy step toward the reintegration of art and life in the West.

5. It is a matter of degree. Some artworks, such as those used in the powerful secret religious association and on altars, literally broadcast enormous volumes of the energy called *nyama*, whereas most people would agree that public artworks, such as masquerades, can be considered far down on the scale of spiritual potency. Here, as in so many other arenas, however, individuals come into play. Some public dancers, such as Sidi Ballo, acquire large amounts of *nyama* and use it in performance.

8. A Mande Aesthetic Profile

1. This idea should find resonance with many Western readers. In American popular music, for example, there are references to the power of beauty to overwhelm admirers and cause them to do foolish or dangerous things. In the film *American Beauty* (Sam Mendes 1999) there is a scene of a small whirlwind that a young man has filmed and that he describes as so beautiful as to be virtually overwhelming.

2. *Kambili* was one of the hunters' epics that Seydou Camara used to perform as a masterpiece of power and eloquence. His version, as recorded and translated by Bird, Koita, and Soumaoura (1974), provides a stunningly beautiful idea of how profound the Mande oral arts can be and how affective they can often become to members of Mande audiences. For its Bamanankan publication, see Soumaouro, Bird, Cashion, and Kanté 1976.

3. According to Candace Keller, who has just completed research with Malian photographer Malick Sidibé, his work overflows with strategies and structure that directly relate to the Mande concepts of mother-childness and father-childness.

4. The classic article on this is Bird and Kendall 1980, 13–26.

9. An Aesthetic of Affect

1. Care must be taken here, because *kòrò* can also refer to a "literal translation" of something.

2. It can also be true that a gesture such as this fanning becomes in a particular context or particular community simply part of the formal proceedings, so it may not be so strong an index of expertise.

3. Yaya Traore was using a word that essentially means "the power of Satan is here" in a Mande usage that borrows the potency of the biblical character to suggest the tremendous forces afoot in the West African world of power objects and speech.

4. At times paying is also just to get an aggressively annoying bard out of one's face, because bards have the ability—and sometimes the inclination—to be very pesky, either as a device for earning income or because they genuinely feel a particular person needs to think about something or change something in his or her life, and this sort of uninvited, unpleasant attention can be a catalyst to that end. Kendall 1982 examines aspects of this behavior. Hoffman 2000 thoroughly explores bards' motivations for behavior.

10. Expanding the Beholder's Share

1. In a wonderful article grounded in the idea of habitus, Arnoldi (2006) examines the way social activities create embodied realities that constitute much of what we would call shared experience and explain why so many elements in the local interpretations of artwork are held by people in common.

2. Most recently W. J. T. Mitchell (2005, 6–11, 87–105) takes up the issue in earnest, citing a number of relatively contemporary authors and devoting several pages to a discussion of what he calls idolatry, fetishism, and totemism—largely, however, without the benefit of any in-depth analysis of non-Western thought on the issues. More than three-quarters of a century ago, Kris and Kurz ([1934] 1979, esp. 61–90) addressed the issue of art's internal animation from the vantage point of magical verisimilitude.

3. Though first published in 1960, the contents of *Art and Illusion* were actually the A. W. Mellon Lectures in the Fine Arts, of 1956.

4. See Hochberg's collected essays in Peterson, Gillam, and Sedgwick 2007. Of special interest in that volume is Sedgwick, pp. 572–80.

5. See Bruner 1986, 24–25; Fish 1970; Iser 1974, 1978; Jauss 1970; and Tompkins 1980, ix–xxvi. Eco ([1962] 1989, 1990) discusses an "open" text, an ambiguity of structure that allows interpreters considerable latitude to create their own meanings. He generally associates this openness with modern works of literature and visual art, but other scholars see a substantial degree of openness and ambiguity as a condition of expression itself, no matter where, when, or upon what an act of interpretation is performed. Iser (1978) suggests that people have freedom in creating their interpretations

of all literature but are guided by clues in what they read. Fish (1970, 1980) examines the ways social engagement by particular groups in particular cultures create communities of ideas available to readers wishing to interpret writing.

Eco (1979, 1989, 1990) began writing the essays for his 1979 *The Role of the Reader* in 1959. But Iser (1974) wrote an influential work that helped gel much of this writing into the theoretical movement called reader-response criticism. For an overview of reader-response criticism, see Tompkins (1980).

6. See lines 2950–3080 of the Fa-Digi Sisòkò version published by J. W. Johnson (1986), although in this version the lines are a little different.

7. This trip was in the early summer of 1998, with Kassim, Musa Kone, and Akare Aden and Sherry Early.

8. For more extensive discussion on Benjamin's idea along a different tack, see Losche (1997) and Buck-Morss (1989).

9. Gidden's structuration, Nelson's meaning making, and Jackson's taking the given and articulating it into a life (note 2 above) all accord nicely with this idea of an atmosphere of potential surrounding works of art. One could add the metaphor of laboratory to the metaphor of an atmosphere because the contents of an image atmosphere are both fixed and flexible, substantial and permeable. They offer a genuine forum for experimenting with the beliefs and practices that compose social life.

BIBLIOGRAPHY

Abiodun, Rowland. 1994. "Understanding Yoruba Art and Aesthetics: The Concept of *Ase.*" *African Arts* 27 (3 July): 68–78, 102–103.

Abu-Lughod, Lila. 1993. *Writing Women's Worlds: Bedouin Stories.* Berkeley: University of California Press.

———. 1996. "Honor and Shame." In *Things as They Are: New Directions in Phenomenological Anthropology,* ed. Michael Jackson, 51–69. Bloomington: Indiana University Press.

Aden, Jonathan E. (Akare). 2003. "Anvils of Blood, Oaths of Iron: A History of Power and Association in the Komo Complex of the Western Sudan (West Africa) from the Nineteenth Century to the Present." Ph.D. diss., Indiana University.

Appadurai, Arjun. 1986. *The Social Life of Things: Commodities in Cultural Perspective.* London: Cambridge University Press.

———. [1996] 2003. *Modernity at Large: Cultural Dimensions of Globalization.* Minneapolis: University of Minnesota Press.

Appiah, Kwame Anthony. 1992. *In My Father's House: Africa in the Philosophy of Culture.* New York: Oxford University Press.

Apter, Andrew. 1992. *Black Critics and Kings: The Hermeneutics of Power in Yoruba Society.* Chicago: University of Chicago Press.

———. 2005. *The Pan-African Nation: Oil and the Spectacle of Culture in Nigeria.* Chicago: University of Chicago Press.

Arens, W., and Ivan Karp. 1989. *The Creativity of Power.* Washington, D.C.: Smithsonian Institution Press.

Armstrong, Robert Plant. 1971. *The Affecting Presence: An Essay in Humanistic Anthropology.* Urbana: University of Illinois Press.

———. 1975 *Wellspring: On the Myth and Source of Culture.* Berkeley: University of California Press.

———. 1981. *The Powers of Presence: Consciousness, Myth, and Affecting Presence.* Philadelphia: University of Pennsylvania Press.

Arnheim, Rudolf. 1969. *Visual Thinking.* Berkeley: University of California Press.

———. 1974. *Art and Visual Perception: A Psychology of the Creative Eye.* New version. Berkeley: University of California Press.

Arnoldi, Mary Jo. 1986. "Puppet Theatre: Form and Ideology in Bamana Performances." *Empirical Studies of the Arts* 4 (2): 131–50.

———. 1988a. "Performance, Style and the Assertion of Identity in Malian Puppet Drama." *Journal of Folklore Research* 25 (1/2): 87–100.

———. 1988b. "Playing the Puppets: Innovation and Rivalry in Bamana Youth Theatre of Mali." *TDR* 32 (2): 65–82.

———. 1989. "Reconstructing the History and Development of Puppetry in the Segou Region, Mali." In *Man Does Not Go Naked: Textilien und Handwerk aus afrikanischen und anderen Ländern,* ed. Beate Engelbrecht and Bernhard Gardi, 221–34. Basel: Universität Basel und Museum für Völkerkunde.

———. 1995. *Playing with Time: Art and Performance in Central Mali.* Bloomington: Indiana University Press.

———. 1996. "Material Narratives and the Negotiation of Identities through Objects in Malian Theatre." In *African Material Culture,* ed. Mary Jo Arnoldi, Christraud M. Geary, and Kris L. Hardin, 167–87. Bloomington: Indiana University Press.

———. 2001. "The *Sogow:* Imagining a Moral Universe through *Sogo bò* Masquerades." In *Bamana: The Art of Existence in Mali,* ed. Jean-Paul Colleyn, 77–93. New York: Museum for African Art.

———. 2003. "Symbolically Inscribing the City: Public Monuments in Mali, 1995–2002." *African Arts* 36 (2): 56–65, 95–96.

———. 2006. "*Ndòmò* Ritual and *Sogo bò* Play: Boy's Masquerading among the Bamana of Mali." In *Playful Performers: African Children's Masquerades,* ed. Simon Ottenberg and David A. Binkley, 49–66. New Brunswick, N.J.: Transaction.

Art Journal: Aesthetics and the Body Politic (Spring 1997): 56 (1).

Askew, Kelly M. 2002. *Performing the Nation: Swahili Music and Cultural Politics in Tanzania.* Chicago: University of Chicago Press.

Bailleul, Charles. 1981. *Petit dictionnaire bambara-français, français-bambara.* Amersham, Buckingham: Avesbury.

Barnes, Sandra T. 1986. *Patrons and Power: Creating a Political Community in Metropolitan Lagos.* Bloomington: Indiana University Press.

Bauman, Richard. 1977. *Verbal Arts as Performance.* Rowley, Mass.: Newbury House.

Baxandall, Michael. 1972. *Painting and Experience in Fifteenth-Century Italy.* Oxford: Oxford University Press.

———. 1985. *Patterns of Intention: On the Historical Explanation of Pictures.* New Haven, Conn.: Yale University Press.

Bazin, Hippolyte. [1906] 1965. *Dictionnaire bambara-français précédé d'un abrégé de grammaire bambara.* Ridgewood, N.J.: Gregg.

Beidelman, T. O. 1986. *Moral Imagination in Kaguru Modes of Thought.* Bloomington: Indiana University Press.

Belcher, Stephen P. 1999. *Epic Traditions of Africa.* Bloomington: Indiana University Press.

Bell, Clive. 1914. *Art.* London: Chatto and Windus.

Benjamin, Walter. 1968. "On Some Motifs in Baudelaire." In *Illuminations,* ed. Hannah Arendt, 155–201. New York: Schocken.

Bensman, Joseph, and Israel Gerver. 1970. "Art and the Mass Society." In *The Sociology of Art and Literature: A Reader,* ed. Milton C. Albrecht, James H. Barnett, and Mason Griff, 660–68. New York: Praeger.

Binger, Louis Gustave. 1892. *Du Niger au Golfe de Guinée par le pays de Kong et le Mossi.* 2 vols. Paris: Hachette.

Bird, Charles S. 1971. "Oral Art in the Mande." In *Papers on the Manding,* ed. Carleton T. Hodge, 15–25. Bloomington: Indiana University Press.

———. 1972. "Heroic Songs of the Mande Hunters." In *African Folklore,* ed. Richard M. Dorson, 275–94. New York: Anchor Books.

Bird, Charles S., John Hutchison, and Mamadou Kanté. 1977. *An Ka Bamanankan Kalan: Beginning Bambara.* Bloomington: Indiana University Linguistics Club.

Bird, Charles S., and Martha B. Kendall. 1980. "The Mande Hero." In *Explorations in African Systems of Thought,* ed. Ivan Karp and Charles Bird, 13–26. Bloomington: Indiana University Press.

Bird, Charles S., Mamadou Koita, and Bourama Soumaouro. 1974. *The Songs of Seydou Camara.* Vol. 1: *Kambili.* Bloomington: Indiana University African Studies Center.

Blier, Suzanne. 1988. "Words about Words about Icons: Iconology and the Study of African Art." *Art Journal* 48 (2): 75–87.

Blocker, Gene H. 1994. *The Aesthetics of Primitive Art.* Lanham, Md.: University Press of America.

Boone, Sylvia Ardyn. 1986. *Radiance from the Waters: Ideals of Feminine Beauty in Mande Art.* New Haven, Conn.: Yale University Press.

Bordieu, Pierre. 1977. *Outline of a Theory of Practice.* Cambridge: Cambridge University Press.

———. 1984. *Distinction: A Social Critique of the Judgment of Taste.* Cambridge: Harvard University Press.

———. 1990. *The Logic of Practice.* Trans. R. Nice. Stanford, Calif.: Stanford University Press.

Bowen, Elenore Smith [Laura Bohannan]. 1954. *Return to Laughter.* New York: Harper and Bros.

Brett-Smith, Sarah C. 1994. *The Making of Bamana Sculpture: Gender and Creativity.* Cambridge: Cambridge University Press.

Brink, James. 1978. "Communicating Ideology in Bamana Rural Theater Performance." *Research in African Literatures* 9 (3): 382–94.

———. 1980. "Organizing Satirical Comedy in Kote-tlon: Drama as a Communication Strategy among the Bamana of Mali." Ph.D. diss., Indiana University.

———. 1981. "Dialectics of Aesthetic Form in Bamana Art: An Introduction." Paper presented at Mande Art and Ideology symposium, University of Wisconsin–Milwaukee (organized by Patrick McNaughton).

———. 1982. "Speech, Play and Blasphemy: Managing Power and Shame in Bamana Theatre." *Anthropological Linguistics* 24 (4): 423–31.

———. 2001. "Dialectics of Aesthetic Form in Bambara Art." In *Bamana: The Art of Existence in Mali,* ed. Jean-Paul Colleyn, 237–42. New York: Museum for African Art; Gent: Snoeck-Ducaju and Zoom.

Bruner, Jerome. 1986. *Actual Minds, Possible Worlds.* Cambridge: Harvard University Press.

Buck-Morss, Susan. 1989. *The Dialectics of Seeing: Walter Benjamin and the Arcades Project.* Cambridge, Mass.: MIT Press.

Caillié, René. [1830] 1965. *Journal d'un voyage à Temboctou et à Jenne dans l'Afrique*

central, précédé d'observations faites chez les Maures Braknas, les Nalous, et d'autres peoples: pendant les années 1824, 1825, 1826, 1827, 1828. 3 vols. Paris: Editions anthropos.

Camara, Sekuba. 1978. Personal communication.

Camara, Sekuba, Patrick McNaughton, and Tera, Kalilou. 1978. Song transcription and translation notebooks from the Dogoduman performance. Notebook number precedes slash, followed by page number.

Camara, Seydou. 1978. *Bankisi Sediba*, a hunters' epic performed for the author in June.

Carrithers, Michael. 1992. *Why Humans Have Cultures: Explaining Anthropology and Social Diversity.* Oxford: Oxford University Press.

Cashion, Gerald Anthony. 1982. "Hunters of the Mande: A Behavioral Code and Worldview Derived from a Study of Their Folklore." Ph.D. diss., Indiana University.

Certeau, Michel de. 1984. *The Practice of Everyday Life.* Trans. Steven Rendall. Berkeley: University of California Press.

Cissé, Youssouf. 1964. "Notes sur les sociétés de chasseurs malinké." *Journal de la Société des Africanistes* 34 (2): 175–226.

Cole, Catherine M. 2001. *Ghana's Concert Party Theatre.* Bloomington: Indiana University Press.

Coles, Robert. 1989. *The Call of Stories: Teaching and the Moral Imagination.* Boston: Houghton Mifflin Co.

Connah, Graham. 1987. *African Civilizations: Precolonial Cities and States in Tropical Africa: An Archaeological Perspective.* Cambridge: Cambridge University Press.

Conrad, David C., ed. 1990. *A State of Intrigue: The Epic of Bamana Segu According to Tayiru Banbera.* Transcribed and translated with the assistance of Soumaila Diakité. Oxford: Oxford University Press.

Conrad, David C., and Barbara E. Frank, eds. 1995. *Status and Identity in West Africa: Nyamakalaw of Mande.* Bloomington: Indiana University Press.

Coote, Jeremy, and Anthony Shelton, eds. 1992. *Anthropology, Art, and Aesthetics.* New York: Oxford University Press.

Croce, Benedetto. [1902] 1992. *The Aesthetic as the Science of Expression and of the Linguistic in General.* Trans. Colin Lyas. Cambridge: Cambridge University Press.

Csordas, Thomas J. 1994. *Embodiment and Experience: The Existential Ground of Culture and Self.* Cambridge: Cambridge University Press.

Danto, Arthur C. 1981. *The Transfiguration of the Commonplace.* Cambridge: Harvard University Press.

———. 1986. *The Philosophical Disenfranchisement of Art.* New York: Columbia University Press.

D'Azevedo, Warren L. 1958. "A Structural Approach to Esthetics: Towards a Definition of Art in Anthropology." *American Anthropologist* 60: 702–14.

———. 1962. "Uses of the Past in Gola Discourse." *Journal of African History* 3 (1): 11–34.

———. 1973a. "Mask Makers and Myth in Western Liberia." In *Primitive Art and Society,* ed. Anthony Forge, 126–50. New York: Wenner-Gren Foundation.

———. 1973b. "Sources of Gola Artistry." In *The Traditional Artist in African Societies,* ed. Warren L. D'Azevedo, 282–342. Bloomington: Indiana University Press.

———. 1991. "Whatever Happened to Primitive Art?" *Anthropology & Humanism Quarterly* 16 (3): 102–107.

———, ed. 1973. *The Traditional Artist in African Societies.* Bloomington: Indiana University Press.

Dennett, Daniel Clement. 1987. *The Intentional Stance.* Cambridge, Mass.: MIT Press.

Desjarlais, Robert R. 1992. *Body and Emotion: The Aesthetics of Illness and Healing in the Nepal Himalayas.* Philadelphia: University of Pennsylvania Press.

Dewey, John. [1934] 1980. *Art as Experience.* New York: Perigee.

Diallo, Fadimata Sori. 1997. *Guide de Bamako.* Bamako: Editions Donniya.

Dieterlen, Germaine. 1951. *Essai sur la religion bambara.* Paris: Presses universitaires de France.

Dissanayake, Ellen. 1992. *Homo Aestheticus: Where Art Comes From and Why.* New York: Free Press.

Doumbia, Paul Emile Namoussa. 1936. "Étude du clan des forgerons." *Bulletin du Comité d'études historiques et scientifiques de l'Afrique occidentale française* 19 (2–3): 334–60.

Drewal, Margaret Thompson. 1991. "The State of Research on Performance in Africa." *African Studies Review* 34 (3): 1–64.

———. 1992. *Yoruba Ritual: Performers, Play, Agency.* Bloomington: Indiana University Press.

Drewal, Margaret Thompson, and Henry John Drewal. 1987. "Composing Time and Space in Yoruba Art." *Word and Image* 3 (July–September): 225–51.

Dumbiya, Bafing "Walkman." 1998. Personal communication.

Eagleton, Terry. 1990. *The Ideology of the Aesthetic.* Oxford: Basil Blackwell.

Eco, Umberto. 1979. *The Role of the Reader: Explorations in the Semiotics of Texts.* Bloomington: Indiana University Press.

———. [1962] 1989. *The Open Work.* Trans. Anna Cancogni. Cambridge: Harvard University Press.

———. 1990. *The Limits of Interpretation.* Bloomington: Indiana University Press.

Ebong, Inih A. 1995. "The Aesthetics of Ugliness in Ibibio Dramatic Arts." *African Studies Review* 38 (December): 43–59.

Elkins, James. 1996. "Style." *The Dictionary of Art,* ed. Jane Shoaf Turner, 29: 876–83. New York: Grove's Dictionaries.

———. 2001. *Pictures and Tears: A History of People Who Have Cried in Front of Paintings.* New York: Routledge.

Ezra, Kate. 1986. *A Human Ideal in African Art: Bamana Figurative Sculpture.* Washington, D.C.: National Museum of African Art.

Fabian, Johannes. 1983. *Time and the Other: How Anthropology Makes Its Object.* New York: Columbia University Press.

———. 1990. *Power and Performance: Ethnographic Explorations through Proverbial Wisdom and Theater in Shaba, Zaire.* Madison: University of Wisconsin Press.

———. 1996. *Remembering the Present: Painting and Popular History in Zaire.* Berkeley: University of California Press.

———. 2004. "Theatre and Anthropology: Theatricality and Culture." In *African Drama and Performance,* ed. Tejumola Olaniyan and John Conteh-Morgan, 39–45. Bloomington: Indiana University Press.

Fane, Magan. 1971. Personal communication.

Fardon, Richard. 1990. *Between God, the Dead and the Wild: Chamba Interpretations of Religion and Ritual.* Washington, D.C.: Smithsonian Institution Press.

Feierman, Steven. 1990. *Peasant Intellectuals: Anthropology and History in Tanzania.* Madison: University of Wisconsin Press.

Fernandez, James. 1973. "The Exposition and Imposition of Order: Artistic Expression in Fang Culture." In *The Traditional Artist in African Societies,* ed. Warren L. D'Azevedo, 194–220. Bloomington: Indiana University Press.

———. 1977. *Fang Architectonics.* Philadelphia: Institute for the Study of Human Issues.

FESTAC '77. 1977. London and Lagos: African Journal Ltd. and the International Festival Committee.

FESTAC '77 Souvenir. 1977. Special issue of *Indigo: A Black African Monthly.* Lagos: Pioneer Publishing Co. Ltd.

Finn, Peter. 2006. Personal communication.

Fish, Stanley E. 1970. "Literature in the Reader: Affective Stylistics." *New Literary History* 2 (1): 123–62.

———. 1980. *Is There a Text in This Class? The Authority of Interpretive Communities.* Cambridge: Harvard University Press.

Flores, Toni. 1985. "The Anthropology of Aesthetics." *Dialectical Anthropology* 10 (1/2): 27–41.

Foster, Hal, ed. [1983] 1991. *The Anti-Aesthetic: Essays on Postmodern Culture.* Seattle, Wash.: Bay.

Frank, Barbara E. 1998. *Mande Potters and Leather-Workers: Art and Heritage in West Africa.* Washington, D.C.: Smithsonian Institution Press.

Fratto, Toni Flores. 1978. "Undefining Art: Irrelevant Categorization in the Anthropology of Aesthetics." *Dialectical Anthropology* 3 (2): 129–38.

Freedberg, David. 1989. *The Power of Images: Studies in the History and Theory of Response.* Chicago: University of Chicago Press.

Fry, Roger. 1920. *Vision and Design.* London: Chatto & Windus.

Gaut, Berys, and Dominic McIver Lopes, eds. 2001. *The Routledge Companion to Aesthetics.* London: Routledge.

Giddens, Anthony. 1979. *Central Problems in Social Theory: Action, Structure and Contradiction in Social Analysis.* Berkeley: University of California Press.

———. 1984. *The Constitution of Society.* Berkeley: University of California Press.

Glassie, Henry. 1989. *The Spirit of Folk Art: The Girard Collection at the Museum of International Folk Art.* New York: Harry N. Abrams.

———. 1993. *Turkish Traditional Art Today.* Bloomington: Indiana University Press.

———. 1997. *Art and Life in Bangladesh.* Bloomington: Indiana University Press.

Goffman, Erving. 1959. *The Presentation of Self in Everyday Life.* Garden City, N.Y.: Doubleday.

Gombrich, E. H. 1961. *Art and Illusion.* Rev. ed. Princeton, N.J.: Princeton University Press.

———. 1972. "The Mask and the Face: The Perception of Physiognomic Likeness in Life and in Art." In *Art, Perception, and Reality,* ed. E. H. Gombrich, Julian Hochberg, and Max Black, 1–46. Baltimore, Md.: Johns Hopkins University Press.

Goodenough, Ward H. 1994. "Toward a Working Theory of Culture." In *Assessing Cultural Anthropology,* ed. Robert Borofsky, 262–73. New York: McGraw-Hill.

Goodman, Nelson. 1976. *Languages of Art: An Approach to a Theory of Symbols.* Indianapolis: Hackett.

———. 1978. *Ways of Worldmaking.* Hassocks, Sussex: Harvester.

———. 1984. *Of Mind and Other Matters.* Cambridge: Harvard University Press.

Gottlieb, Alma, and Philip Graham. 1993. *Parallel Worlds: An Anthropologist and a Writer Encounter Africa.* New York: Crown.

Gray, William, and Staff Surgeon Dochard. 1825. *Travels in Western Africa in the Years 1818–1821.* London: J. Murray.

Grosz-Ngaté, Maria. 1989. "Hidden Meanings: Explorations into a Bamana Construction of Gender." *Ethnology* 28 (2): 167–83.

Halle, David. 1993. *Inside Culture: Art and Class in the American Home.* Chicago: University of Chicago Press.

Hallen, Barry. 2000. *The Good, the Bad, and the Beautiful: Discourse About Values in Yoruba Culture.* Bloomington: Indiana University Press.

Hamdun, Said, and Noël King. 1975. *Ibn Battuta in Black Africa.* London: Rex Collings.

Hardin, Kris. 1993. *The Aesthetics of Action: Continuity and Change in a West African Town.* Washington, D.C.: Smithsonian Institution Press.

Hardin, Kris L., and Mary Jo Arnoldi. 1996. "Introduction: Efficacy and Objects." In *African Material Culture,* ed. Mary Jo Arnoldi, Christraud M. Geary, and Kris L. Hardin, 1–28. Bloomington: Indiana University Press.

Harding, Frances. 2002. "Introduction." In *The Performance Arts in Africa: a Reader,* ed. Frances Harding, 1–26. London: Routledge.

Healy, Jane M. 1990. *Endangered Minds: Why Children Don't Think and What We Can Do about It.* New York: Touchstone/Simon and Schuster.

Henry, Joseph. 1910. *L'âme d'un peuple africain: les Bambara, leur vie psychique, èthique, sociale, religieuse.* Münster: Aschendorff.

Hickey, Dave. 1993. *The Invisible Dragon: Four Essays on Beauty.* Los Angeles: Art Issues.

Hobart, Mark. 1990. "The Patience of Plants: A Note on Agency in Bali." *Review of Indonesian and Malaysian Affairs* 24 (Summer): 90–135.

Hoffman, Barbara G. 1990. "The Power of Speech: Language and Social Status among Mande Griots and Nobles." Ph.D. diss., Indiana University.

———. 1995. "Power, Structure, and Mande *Jeliw.*" In *Status and Identity in West Africa:* Nyamakalaw *of Mande,* ed. David C. Conrad and Barbara E. Frank, 36–45. Bloomington: Indiana University Press.

———. 1998. "Secrets and Lies: Meaning, Context and Agency in Mande." *Cahiers d'Etudes Africaines* 149 (38-1): 85–102.

———. 2000. *Griots at War: Conflict, Conciliation, and Caste in Mande.* Bloomington: Indiana University Press.

Hopkins, J. F. P., and Nehemia Levtzion, eds. 2000. *Corpus of Early Arabic Sources for West African History.* Trans. J. F. P. Hopkins. Princeton, N.J.: Markus Wiener; originally published by Cambridge University Press, 1981.

Hopkins, Nicholas S. 1971. "Mandinka Social Organization." In *Papers on the Manding,* ed. Carleton T. Hodge, 99–128. Bloomington: Indiana University Press.

Ibn Battuta. [1929] 1984. *Travels in Asia and Africa*. Trans. and selected by H. A. R.
 Gibb. London: Routledge and Kegan Paul.
Imperato, Pascal James. 1970. "The Dance of the *Tyi Wara*." *African Arts* 4 (1): 8–13,
 71–80.
———. 1972. "Contemporary Masked Dances and Masquerades of the Bamana (Bam-
 bara) Age Sets from the Cercle of Bamako, Mali." Paper presented at the Conference
 on Manding Studies, University of London, School of Oriental and African Studies.
———. 1974. *The Cultural Heritage of Africa*. Chanute, Kan.: Safari Museum.
———. 1977. *African Folk Medicine: Practices and Beliefs of the Bambara and Other
 Peoples*. Baltimore, Md.: York.
———. 1977a. *Historical Dictionary of Mali*. Metuchen, N.J.: Scarecrow.
———. 1980b. "Bambara and Malinke *Ton* Masquerades." *African Arts* 13 (4): 47–55.
———. 1983. *Buffoons, Queens and Wooden Horsemen: The Dyo and Gouan Societies of
 the Bambara of Mali*. New York: Kilima House.
———. 2001. *Legends, Sorcerers, and Enchanted Lizards: Door Locks of the Bamana of
 Mali*. New York: Africana.
Iser, Wolfgang. 1974. *The Implied Reader: Patterns in Communication in Prose Fiction
 from Bunyan to Beckett*. Baltimore, Md.: Johns Hopkins University Press.
———. 1978. *The Act of Reading: A Theory of Aesthetic Response*. Baltimore, Md.: Johns
 Hopkins University Press.
Jackson, Michael. 1977. *The Kuranko: Dimensions of Social Reality in a West African
 Society*. New York: St. Martin's.
———. 1982. *Allegories of the Wilderness: Ethics and Ambiguity in Kuranko Narratives*.
 Bloomington: Indiana University Press.
———. 1989. *Paths toward a Clearing: Radical Empiricism and Ethnographic Inquiry*.
 Bloomington: Indiana University Press.
———, ed. 1996. *Things as They Are: New Directions in Phenomenological Anthropology*.
 Bloomington: Indiana University Press.
Jackson, Michael, and Ivan Karp. 1990. *Personhood and Agency: The Experience of Self
 and Other in African Cultures*. Washington, D.C.: Smithsonian Institution Press.
Jauss, Hans Robert. 1970. *Literaturgeschichte als Provokation*. Frankfort: Suhrkamp.
Johnson, John William. 1986. *The Epic of Son-Jara: A West African Tradition*. Bloom-
 ington: Indiana University Press
Johnson, Mark. 1987. *The Body in the Mind: The Bodily Basis of Meaning, Imagination,
 and Reason*. Chicago: University of Chicago Press.
Jopling, Carol F., ed. 1971. *Art and Aesthetics in Primitive Societies*. New York: E. P.
 Dutton.
Jones, Amelia. 1999. "Beauty Discourse and the Logic of Aesthetics." *X-Tra* 2 (Spring):
 7–13.
Kanté, Nambala. 1993. *Forgerons d'Afrique noire: Transmission des savoirs traditionnels
 en pays malinké*. With the collaboration of Pierre Erny. Paris: L'Harmattan.
Karp, Ivan. 1980. "Introduction." In *Explorations in African Systems of Thought*, ed.
 Ivan Karp and Charles S. Bird, 1–10. Bloomington: Indiana University Press.
———. 1986. "Agency and Social Theory: A Review of Three Books by Anthony Gid-
 dens." *American Ethnologist* 13 (1): 131–38.
———. 1987. "Laughter at Marriage: Subversion in Performance." In *The Transforma-

tion of African Marriage, ed. D. Parkin and D. Nyamwaya, 137–55. Manchester: Manchester University Press for the International African Institute.

Karp, Ivan, and D. A. Masolo. 2000. *African Philosophy as Cultural Inquiry.* Bloomington: Indiana University Press.

Kendall, Martha B. 1982. "Getting to Know You." In *Semantic Anthropology,* ed. David Parkin, 197–210. London: Academic Press.

Kensinger, Kenneth M. 1991. "A Body of Knowledge, or, the Body Knows." *Expedition* 33 (3): 37–45.

Kester, Grant H. 1997a. "Learning from Aesthetics: Old Masters and New Lessons." *Art Journal* 56 (1): 20–25.

———. 1997b. "Aesthetics after the End of Art: An Interview with Susan Buck Morss." *Art Journal* 56 (1): 38–45.

Kleinbauer, Eugene W., and Thomas P. Slavens. 1982. *Research Guide to the History of Western Art.* Chicago: American Library.

Knauft, Bruce M. 2002. *Critically Modern: Alternatives, Alterities, Anthropologies.* Bloomington: Indiana University Press.

Kone, Kassim. 1995a. *One Thousand, One Hundred and Seventy-Seven Bamana/ Maninka Proverbs.* West Newbury: Mother Tongue Editions.

———. 1995b. *Bamana Zirin/Bamana Folktales.* West Newbury: Mother Tongue Editions.

———. 1995c. *Bamanakan Danyègafe.* West Newbury: Mother Tongue Editions.

———. 1997. Personal communication.

———. 1998. Personal communication.

———. 2000. Personal communication.

Kratz, Corinne A. 1994. *Affecting Performance: Meaning, Movement and Experience in Okiek Women's Initiation.* Washington, D.C.: Smithsonian Institution Press.

———. 2000. "Forging Unions and Negotiating Ambivalence: Personhood and Complex Agency in Okiek Marriage Arrangement." In *African Philosophy as Cultural Inquiry,* ed. Ivan Karp and D. A. Masolo, 136–71. Bloomington: Indiana University Press.

Kris, Ernst, and Otto Kurz. [1934] 1979. *Legend, Myth, and Magic in the Image of the Artist: A Historical Experiment.* Trans. Alastair Laing. New Haven, Conn.: Yale University Press.

Labouret, Henri. 1934. *Les Manding et leur langue.* Paris: Larose.

———. 1939. "La parenté a plaisanteries en Afrique occidentale." *Africa* 12 (3): 244–53.

LaGamma, Alisa. 2002. *Genesis: Ideas of Origin in African Sculpture.* New York: Metropolitan Museum of Art.

Lan, David. 1985. *Guns and Rain: Guerrillas and Spirit Mediums in Zimbabwe.* Berkeley: University of California Press.

Langer, Susanne K. 1953. *Feeling and Form.* New York: Charles Scribner's Sons.

Lawal, Babatunde. 1974. "Some Aspects of Yoruba Aesthetics." *British Journal of Aesthetics* 14 (3): 239–49.

Laye, Camara. 1971. *A Dream of Africa.* Trans. James Kirkup and Ernest Jones. New York: Farrar, Straus and Giroux.

Levtzion, Nehemia. 1973. *Ancient Ghana and Mali.* London: Methuen & Co.

Lewis, John, and Faith Lewis. 1978. Personal communication.

Losche, Diane. 1997. "Introduction: Anthro/aesthetics." *Australian Journal of Anthropology* 8 (1): 4–17.

Lukes, Steven. 1973. *Individualism.* Oxford: Basil Blackwell.

———. 1978. "Power and Authority." In *A History of Sociological Analysis,* ed. T. Bottomore and R. Nisbet, 633–76. New York: Basic Books.

MacDonald, Kevin Craig. 1994. *Socio-Economic Diversity and the Origins of Cultural Complexity along the Middle Niger (2000 B.C. to A.D. 300).* Cambridge: University of Cambridge Press.

———. 1998. "Before the Empire of Ghana: Pastoralism and the Origins of Cultural Complexity in the Sahel." In *Transformations in Africa: Essays on Africa's Later Past,* ed. Graham Connah, 71–103. London: Leicester University Press.

Mahy, Judy. 1975. Research notes from Kolokani-area performance studies. In possession of the author.

Masolo, D. A. 1994. *African Philosophy in Search of Identity.* Bloomington: Indiana University Press.

Maynard, Patrick. 1996. "Form." In *The Dictionary of Art,* ed. Jane Shoaf Turner, 11:312–14. New York: Grove's Dictionaries.

Mbiti, John S. 1969. *African Religions and Philosophy.* New York: Praeger.

McIntosh, Roderick James. 1998. *The Peoples of the Middle Niger: The Island of Gold.* Malden, Mass.: Blackwell.

McIntosh, Roderick James, and Susan Keech McIntosh. 1981. "The Inland Niger Delta before the Empire of Mali: Evidence from Jenne-jeno." *Journal of African History* 22: 1–22.

McIntosh, Roderick James, Joseph A. Tainter, and Susan Keech McIntosh, eds. 2000. *The Way the Wind Blows: Climate, History, and Human Action.* New York: Columbia University Press.

McIntosh, Susan Keech. 1984. "Blacksmiths and the Evolution of Political Complexity in Mande Society: An Hypothesis." Paper presented at the School of American Research Advanced Seminar on Complex Society in Africa, Santa Fe, New Mexico.

———. 1999. "Pathways to Complexity: An African Perspective." In *Beyond Chiefdoms: Pathways to Complexity in Africa,* ed. Susan Keech McIntosh, 1–30. New York: Cambridge University Press.

———. 2003. "Conceptualizing Early Ghana." Paper presented at the African Studies Association Annual Meetings, Boston.

McNaughton, Patrick R. 1978. Field notes.

———. 1979. *Secret Sculptures of Komo: Art and Power in Bamana (Bambara) Initiation Associations.* Philadelphia: Institute for the Study of Human Issues.

———. 1982a. "Language, Art, Secrecy and Power: The Semantics of *Dalilu.*" *Anthropological Linguistics* 24 (4): 487–505.

———. 1982b. "The Shirts That Mande Hunters Wear." *African Arts* 15 (3): 54–58, 91.

———. 1988. *The Mande Blacksmiths: Knowledge, Power and Art in West Africa.* Bloomington: Indiana University Press.

———. 1991. "Is There History in Horizontal Masks? A Preliminary Response to the Dilemma of Form." *African Arts* 24 (2): 40–53, 88–90.

———. 1992. "In the Field: Mande Blacksmiths." In *Art in Small-Scale Societies: Con-*

temporary Readings, ed. Richard L. Anderson and Karen L. Field, 3–8. Englewood Cliffs, N.J.: Prentice Hall.

———. 1994. "Bamana Kore Mask." In *Visions of Africa: The Jerome L. Joss Collection of African Art at UCLA,* ed. Doran H. Ross, 33–34. Los Angeles: Fowler Museum of Cultural History.

———. 1995a. "The Semantics of *Jugu:* Blacksmiths, Lore and Who's 'Bad' in Mande." In *Status and Identity in West Africa: Nyamakalaw of Mali,* ed. David C. Conrad and Barbara E. Frank, 46–57. Bloomington: Indiana University Press.

———. 1995b. "Animal Mask." In *Africa: The Art of a Continent,* ed. Tom Phillips, 499. Munich: Prestel.

———. 1996a. "Mask (*Ntomo*)." In *Africa: The Art of a Continent: 100 Works of Power and Beauty,* 166. New York: Guggenheim Museum.

———. 1996b. "Bamana." In *The Dictionary of Art,* ed. Jane Shoaf Turner, 3: 131–38. New York: Grove's Dictionaries.

———. 2001. "The 'Power Associations': Introduction" and "The 'Power Associations': The Kòmò." In *Bamana: The Art of Existence in Mali,* ed. Jean-Paul Colleyn, 167–83. New York: Museum for African Art.

McNeill, David. 1992. *Hand and Mind: What Gestures Reveal about Thought.* Chicago: University of Chicago Press.

Memel-Foté, Harris. 1968. "The Perception of Beauty in Negro-African Culture." In *Colloquium: Function and Significance of African Negro Art.* Dakar: First World Festival of Negro Art, 1966.

Merleau-Ponty, Maurice. 1981. *Phenomenology of Perception.* Trans. Colin Smith. London: Routledge and Kegan Paul.

Mitchell, W. J. T. 2005. *What Do Pictures Want? The Lives and Loves of Images.* Chicago: University of Chicago Press.

Monroe, Arthur. 1977. "FESTAC 77—The Second World Black and African Festival of Arts and Culture: Lagos, Nigeria." *The Black Scholar* 9 (1): 34–37.

Monteil, Charles. 1924. *Les Bambara du Ségou et du Kaarta.* Paris: Émile Larose.

Moore, Carmella C., and Holly F. Methews. 2001. *The Psychology of Cultural Experience.* Cambridge: Cambridge University Press.

Morgan, Hillary. 1996. "Art for Art's Sake." In *The Dictionary of Art,* ed. Jane Shoaf Turner, 530. New York: Grove's Dictionaries.

Mudimbe, V. Y. 1984. "Review of Robert Plant Armstrong, *The Powers of Presence: Consciousness, Myth, and Affecting Presence.*" *Canadian Journal of African Studies* 10 (2): 466–68.

———. 1988. *The Invention of Africa: Gnosis, Philosophy, and the Order of Knowledge.* Bloomington: Indiana University Press.

———. 1994. *The Idea of Africa.* Bloomington: Indiana University Press.

Murphy, William P. 1990. "Creating the Appearance of Consensus in Mende Political Discourse." *American Anthropologist* 92 (1): 24–41.

———. 1998. "The Sublime Dance of Mende Politics: An African Aesthetic of Charismatic Power." *American Ethnologist* 25 (4): 563–82.

Nader, Laura 1994. "Comparative Consciousness." In *Assessing Cultural Anthropology,* ed. Robert Borofsky, 84–94. New York: McGraw-Hill.

N'Diaye, Bokar. 1970. *Les castes au Mali.* Bamako: Editions Populaires.

Niane, Djibril Tamsir. 1965. *Sundiata: An Epic of Old Mali.* London: Longmans.

Nketia, J. H. Kwabena. 1988. "The Intensity Factor in African Music." *Journal of Folklore Research* 25 (January–August): 53–86.

Nunley, John W. 1987. *Moving with the Face of the Devil: Art and Politics in Urban West Africa.* Urbana: University of Illinois Press.

Okpewho, Isidore. 1977. "Principles of Traditional African Art." *Journal of Aesthetics and Art Criticism* 35 (Spring): 301–13.

Olaniyan, Tejumola, and John Conteh-Morgan. 2004. "Introduction." In *African Drama and Performance,* ed. Tejumola Olaniyan and John Conteh-Morgan, 1–8. Bloomington: Indiana University Press.

Oldenberg, Claus. 1977. *The Mouse Museum: The Ray Gun Wing: Two Collections: Two Buildings.* Chicago: Museum of Contemporary Art.

Onyewuenyi, Innocent C. 1984. "Traditional African Aesthetics: A Philosophical Perspective." *International Philosophical Quarterly* 24 (3): 237–44.

Ortner, Sherry B. 1984. "Theory in Anthropology since the Sixties." *Comparative Studies in Society and History* 26 (1): 126–66.

Panofsky, Erwin. 1955. *Meaning in the Visual Arts.* Garden City, N.J.: Doubleday.

Pâques, Viviana. 1954. *Les Bambara.* Paris: Presses Universitaires de France.

Park, Mungo. 1799. *Travels in the Interior Districts of Africa.* London: W. Bulmer.

———. 1815. *The Journal of a Mission to the Interior of Africa in the Year 1805.* London: John Murray.

Paulme, Denise. 1973. "Blood Pacts, Age Classes and Castes in Black Africa." In *French Perspectives in African Studies,* ed. Paul Alexandre, 73–95. London: Oxford University Press.

Pelli, Denis G. 1997. "Two Stages of Perception." Paper presented at the Theories of Vision Symposium, New York University, October 17.

Person, Yves. 1968. *Samori: Une Révolution Dyula.* 2 vols. Dakar: IFAN.

Peterson, Mary A., Barbara Gillam, and H. A. Sedgwick, eds. 2007. *In the Mind's Eye: Julian Hochberg on the Perception of Pictures, Films, and the World.* Oxford: Oxford University Press.

Philipson, Morris, and Paul J. Gudel. 1980. *Aesthetics Today.* Rev. ed. New York: New American Library.

Piot, Charles. 1999. *Remotely Global: Village Modernity in West Africa.* Chicago: University of Chicago Press.

Podro, Michael. 1982. *The Critical Historians of Art.* New Haven, Conn.: Yale University Press.

Postrel, Virginia. [2003] 2004. *The Substance of Style.* Reprint ed. New York: Perennial.

Price, Richard. 2003. *Samaritan.* New York: Alfred A. Knopf.

Prown, Jules David. 1980. "Style as Evidence." *Winterthur Portfolio* 15: 197–210.

———. 1982. "Mind in Matter." *Winterthur Portfolio* 17: 1–19.

Prussin, Labelle. 1970. "Sudanese Architecture and the Manding." *African Arts* 3 (4): 13–18, 64, 67.

Ravenhill, Philip L. 1980. "Baule Statuary Art: Meaning and Modernization." *Working Papers in the Traditional Arts,* nos. 5–6. Philadelphia: Institute for the Study of Human Issues.

Reed, Daniel B. 2003. *Dan Ge Performance: Masks and Music in Contemporary Côte d'Ivoire.* Bloomington: Indiana University Press.

———. 2004. Personal communication.

Riesman, Paul. 1986. "The Person and the Life Cycle in African Social Life and Thought." *African Studies Review* 29 (2): 71–138.

Roberts, Richard L. 1987. *Warriors, Merchants, and Slaves: The State and the Economy in the Middle Niger Valley, 1700–1914.* Stanford: Stanford University Press.

Robinson, Jenefer. 1996. "Aesthetics." *The Dictionary of Art,* ed. Jane Shoaf Turner, 1: 79. New York: Grove's Dictionaries.

Rosaldo, Michelle Zimbalist. 1972. "Review of *The Affecting Presence.*" *American Anthropologist* 74: 1460–62.

Scarry, Elaine. 1999. *On Beauty and Being Just.* Princeton, N.J.: Princeton University Press.

Schaffer, Matt, and Christine Cooper. 1980. *Mandinko: The Ethnography of a West African Holy Land.* Prospect Heights, Ill.: Waveland.

Schildkrout, Enid. 1978. *People of the Zongo: The Transformation of Ethnic Identities in Ghana.* Cambridge: Cambridge University Press.

Sedgwick, H. A. 2007. "Hochberg on the Perception of Pictures and of the World." In *In the Mind's Eye: Julian Hochberg on the Perception of Pictures, Films, and the World,* ed. Mary A. Peterson, Barbara Gillam, and H. A. Sedgwick, 572–80. Oxford: Oxford University Press.

Seel, Martin. 2005. *Aesthetics of Appearing.* Trans. John Farrell. Stanford: Stanford University Press.

Shaw, Rosalind. 2000. "'*Tok Af, Lef Af*': A Political Economy of Temne Techniques of Secrecy and Self." In *African Philosophy as Cultural Inquiry,* ed. Ivan Karp and D. A. Masolo, 25–49. Bloomington: Indiana University Press.

Shostak, Marjorie. 1981. *Nisa: The Life and Words of a !Kung Woman.* New York: Vintage Books.

Shusterman, Richard. 1989. *Analytic Aesthetics.* Oxford: Basil Blackwell.

Sidibé, Mamby. 1959. "Les gens de caste ou nyamakala au Soudan français." *Notes africaines* 81: 13–17.

Sieber. Roy. 1959. "The Esthetic of African Art." In *7 Metals of Africa.* Philadelphia: University Museum.

———. 1969. "Comments." In *Tradition and Creativity in Tribal Art,* ed. Daniel Biebuyck, 192–203. Los Angeles: University of California Press.

———. 1993. Personal communication.

Simmons, William S. 1971. *Eyes of the Night: Witchcraft among a Senegalese People.* Boston: Little, Brown and Co.

Sircello, Guy. 1972. *Mind and Art: An Essay on the Varieties of Expression.* Princeton, N.J.: Princeton University Press.

Soumaoro, Bourama, Charles S. Bird, Gerald Cashion, and Mamadou Kanté. 1976. *Seyidu Kamara Ka Donkiliw: Kambili.* Bloomington: Indiana University African Studies Center.

Sperber, Dan. 1974. *Rethinking Symbolism.* Cambridge: Cambridge University Press.

Stoller, Paul. 1987. *In Sorcery's Shadow: A Memoir of Apprenticeship among the Songhay of Niger.* Chicago: University of Chicago Press.

————. 1989. *Fusion of the Worlds: An Ethnography of Possession among the Songhay of Niger.* Chicago: University of Chicago Press.

Stone, Irving. 1963. *The Agony and the Ecstasy.* New York: Doubleday.

Strange, Georgia. 1990. Personal communication.

Strother, Z. S. 1998. *Inventing Masks: Agency and History in the Art of the Central Pende.* Chicago: University of Chicago Press.

Sudnow, David. 1978. *Ways of the Hand: The Organization of Improvised Conduct.* New York: Harper Colophon Books.

Tamari, Tal. 1995. "Linguistic Evidence for the History of West African 'Castes'." In *Status and Identity in West Africa: Nyamakalaw of Mande,* ed. David C. Conrad and Barbara E. Frank, 61–85. Bloomington: Indiana University Press.

Tauxier, Louis. 1921. *La religion Bambara.* Paris: Paul Geuthner.

Taylor, Joshua C. 1975. *To See Is to Think: Looking at American Art.* Washington, D.C.: Smithsonian Institution Press.

Tera, Kalilou. 1977. Personal communication.

————. 1978. Personal communication.

Thompson, Robert Farris. 1968. "Aesthetics in Traditional Africa." *Art News* 66 (9): 44–45.

————. 1973a. "Yoruba Artistic Criticism." In *The Traditional Artist in African Societies,* ed. Warren L. D'Azevedo, 19–61. Bloomington: Indiana University Press.

————. 1973b. "An Aesthetic of the Cool." *African Arts* 7 (1): 40–43, 64–67, 89, 91.

————. 1974. *African Art in Motion: Icon and Act.* Los Angeles: University of California Press.

Togola, Téréba. 1993. "Archaeological Investigations of Iron Age Sites in the Méma Region, Mali." Ph.D. diss., Rice University.

————. 1995. "Traces et techniques anciennes d'exploitation aurifère dans la zone de Sadiola, Bambouk." Paper presented at Mande Studies Association 3rd International Meeting, Leiden.

————. 1996. "Iron Age Occupation in the Méma Region, Mali." *African Archaeological Review* 13 (2): 91–110.

Tompkins, Jane P. 1980. *Reader-Response Criticism: From Formalism to Post-Structuralism.* Baltimore, Md.: Johns Hopkins University Press.

Traore, Dominique. 1965. *Comment le noir se soigne-t-il? Ou Médecine et magie africaines.* Paris: Présence Africaine.

Traore, Sedu. 1971. Personal communication.

Traore, Yaya. 1971. Personal communication.

————. 1998. Personal communication.

Travélé, Moussa. 1913. *Petit dictionnaire français-bambara et bambara-français.* Paris: Paul Geuthner.

————. 1929. "Komo ou Koma." *Outre-Mer* 1: 127–50.

Treat, Teresa A., Richard M. McFall, Richard J. Viken, and John K. Kruschke. 2001. "Using Cognitive Science Methods to Assess the Role of Social Information Processing in Sexually Coercive Behavior." *Psychological Assessment* 13 (4): 549–65.

Turner, Victor. 1974. *Dramas, Fields, and Metaphors: Symbolic Action in Human Society.* Ithaca, N.Y.: Cornell University Press.

van Damme, Wilfried. 1996. *Beauty in Context: Towards an Anthropological Approach to Aesthetics*. Leiden: E. J. Brill.

Vayda, Andrew P. 1994. "Actions, Variations, and Change: The Emerging Anti-Essentialist View in Anthropology." In *Assessing Cultural Anthropology*, ed. Robert Borofsky, 320–29. New York: McGraw-Hill.

Viken, Richard J., Teresa A. Treat, Robert M. Nosofsky, Richard M. McFall, and Thomas J. Palmeri. 2002. "Modeling Individual Differences in Perceptual and Attentional Processes Related to Bulimic Symptoms." *Journal of Abnormal Psychology* 111 (4): 598–609.

Vogel, Susan Mullin. 1980. "Beauty in the Eyes of the Balue." *Working Papers in the Traditional Arts*, no. 5–6. Philadelphia: Institute for the Study of Human Issues.

Wafer, Jim. 1991. *A Taste of Blood: Spirit Possession in Brazilian Candomblé*. Philadelphia: University of Pennsylvania Press.

Walton, Kendall L. 1996. "Aesthetics." In *The Dictionary of Art*, ed. Jane Shoaf Turner, 1: 171–74. New York: Grove's Dictionaries.

Watson, James D. 1968. *The Double Helix*. New York: New American Library.

Whiten, Andrew, ed. 1991. *Natural Theories of Mind: Evolution, Development, and Simulation*. Oxford: B. Blackwell.

Williams, Raymond. 1985. *Keywords: A Vocabulary of Culture and Society*. New York: Oxford University Press.

Wilshire, Bruce. 1982. *Role Playing and Identity: The Limits of Theatre as Metaphor*. Bloomington: Indiana University Press.

Wolff, Janet. 1981. *The Social Production of Art*. New York: St. Martin's.

———. 1983. *Aesthetics and the Sociology of Art*. London: G. Allen & Unwin.

———. 1993. *Aesthetics and the Sociology of Art*. 2nd ed. Ann Arbor: University of Michigan Press.

Wölfflin, Heinrich. [1932] 1950. *Principles of Art History: The Problem of the Development of Style in Later Art*. Trans. M. D. Hottinger. New York: Dover.

Wooten, Stephen R. 2000. "Antelope Headdresses and Champion Farmers: Negotiating Meaning and Identity through the Bamana *Ciwara* Complex." *African Arts* 33 (2): 18–33, 89–90.

Wright, Donald R. 1997. *The World and a Very Small Place in Africa*. Armonk, N.Y.: M. E. Sharpe.

Zahan, Dominique. 1960. *Sociétés d'initiation bambara: Le N'domo, le koré*. Paris: Mouton.

———. 1974. *The Bambara*. Leiden: E. J. Brill.

———. 1980. *Antilopes du soleil: Arts et rites agraires d'Afrique noire*. Vienna: A. Schendl.

INDEX

Abu-Lughod, Lila, 122
action theory, 219, 266n7
aesthetics, 2, 4, 31, 127–28; affect and,
 5; African art and, 112; *badenya*
 and *fadenya* in relation to, 179–85;
 components of, 158–59; definitions of,
 128–30, 153; everyday life and, 4–5, 10;
 form and, 147–54, 217–18; *malo* and,
 41; meaning and, 252; mind and
 thought expanded through, 191–98; in
 performance protocol, 173–76; post-
 modern "anti-aesthetic," 268n5, 269n7;
 singers' performance and, 247; social
 and personal experience in relation to,
 154; Western, 153, 268n2
affect, aesthetic, 1, 5, 158, 180, 192, 216;
 Mayimuna's song performance and,
 198–212; power of art and, 145–46;
 praise and, 197; stretching thought
 and, 191–98
African art, 2, 112, 129, 132–33
African societies, 111, 119, 259
Africanist scholarship, 114, 128–30, 269n9
age, significance in Mande culture, 39, 42,
 43–46, 58, 175
agency, 114, 194, 266n6, 268n1; complex,
 63, 117, 121, 196, 212, 237, 266n7; *di*
 (tastiness) and, 169; *nyi* (goodness)
 and, 165
amulets *(sèbènw),* 54–55, 77, 94, 174, 260;
 dangers of, 96; obscurity *(dibi)* and,
 178; *tere* (luck) and, 171; travel for
 acquisition of, 230

ancestor spirits *(bènbaw),* 242
animals, 167, 201, 211
antelopes: duiker, 170; headdress repre-
 senting, 112, 123, 152, 163; *nyama* of, 152;
 in praise songs, 141–42
anthropology, 219
Appadurai, Arjun, 226
archaeology, 119
architecture, 132, 267n12
Armstrong, Robert Plant, 129, 130, 131
Arnheim, Rudolf, 218
Arnoldi, Mary Jo, 42, 59, 69; on form in
 African art, 148; on Mali Kònò bird
 masquerade, 243; on Mande aesthet-
 ics, 139, 156; on puppet theater, 116, 123;
 on theater and Mande culture, 193; on
 verisimilitude, 160
art, 4, 97, 110; African art history, 112;
 atmospheres for artworks, 222–24,
 272n9; beholder's share in mean-
 ing of, 217–22; everyday life and, 191;
 as experience, 78–79; false divide of
 high and low arts, 216; human face
 of, 260–62; interior lives and, 123, 124;
 personal experiences with, 216–17;
 power of, 149; separation from life, 147,
 153, 167. *See also plates*
art history, 112, 114–16, 134, 216;
 aesthetics and, 129; artists as indi-
 viduals and, 265n2; form and, 147, 148;
 popularity of aesthetic conceptions
 and, 159; study of mental processes in
 perception, 218

Patrick R. McNaughton is Chancellor's Professor of African Art at Indiana University, Bloomington. He is author of *The Mande Blacksmiths: Knowledge, Power, and Art in West Africa* (Indiana University Press, 1988, with paperback reprint, 1993) and *Secret Sculptures of Komo: Art and Power in Bamana Initiation Associations* (1979). He participated in the creation and production of *Five Windows into Africa* (Indiana University Press, 2000), a CD-ROM companion to *Africa*.